DATE DUE

DEMCO 38-296

Hall of Fame Museums

Hall of Fame
MUSEUMS

A Reference Guide

Victor J. Danilov

GREENWOOD PRESS
Westport, Connecticut · London

Library of Congress Cataloging-in-Publication Data

Danilov, Victor J.
 Hall of fame museums : a reference guide / Victor J. Danilov.
 p. cm.
 Includes bibliographical references and index.
 ISBN: 0–313–30000–3 (alk. paper)
 1. Museums—United States—History. 2. Halls of fame—United
States—History. 3. Sports museums—United States—History.
4. Celebrities—Museums—United States—History. 5. Popular
culture—Museums—United States—History. 6. Museum exhibits—
United States—History. I. Title.
 AM11.D348 1997
 973'.074—dc21 97–16714

British Library Cataloguing in Publication Data is available.

Library of Congress Catalog Card Number: 97–16714
ISBN: 0–313–30000–3

First published in 1997

Greenwood Press, 88 Post Road West, Westport, CT 06881
An imprint of Greenwood Publishing Group, Inc.

Printed in the United States of America

The paper used in this book complies with the
Permanent Paper Standard issued by the National
Information Standards Organization (Z39.48–1984).

10 9 8 7 6 5 4 3 2 1

Dedicated to halls of fame,
which recognize and inspire
outstanding achievement
in a wide range of fields.

Contents

Preface		xi
Chapter 1	Recognizing Achievement	1
Chapter 2	A Historical Perspective	17
Chapter 3	Diversity of Operations	27
Chapter 4	Telling the Story	49
Chapter 5	An Expanding Movement	63
Directory of Hall of Fame Museums and Exhibits		73
	Sports and Games Halls of Fame	75
	All-Sports	75
	Baseball	93
	Basketball	99
	Beach Volleyball	100
	Bicycling	101
	Bowling	102
	Boxing	102
	Checkers	103
	Chess	104
	Collegiate Sports Halls of Fame	104
	Croquet	105
	Dog Racing	105
	Dog Sledding	106
	Equestrian	107
	Ethnic Sports Halls of Fame	108
	Field Hockey	109
	Field Trials	109
	Figure Skating	110

Fishing 111
Football 113
Frisbee 119
Golf 119
Gymnastics 121
Harness Racing 121
Ice Hockey 122
Jousting 123
Kiting 124
Lacrosse 124
Local Sports Halls of Fame 125
Marbles 126
Motorcycling 126
Motor Sports 127
Polo 133
Racquetball 133
Roller Skating 133
Sailing 134
Shuffleboard 136
Skeet Shooting 136
Skiing 137
Snowmobiling 138
Soap Box Racing 139
Soccer 139
Softball 140
Speed Skating 141
Sports Media 141
State Sports Halls of Fame 142
Surfing 143
Swimming 143
Tennis 144
Thoroughbred Racing 146
Track and Field 147
Trapshooting 147
Volleyball 148
Water Skiing 149
Weightlifting 149
Winter Olympics 150
Wrestling 151
Non-Sports Halls of Fame 153
Agriculture 153
Automobiles 154
Aviation and Space 156
Business and Industry 164

Camping 166
Cartoon Art 167
Circus 167
Clowns 168
Dance 169
Ethnicity 170
Firefighting 170
Invention 171
Labor 172
Law Enforcement 173
Mining 174
Mobile Homes/Recreational Vehicles 175
Music 176
Native Americans 181
Notable Americans 182
Paper 184
Petroleum 184
Photography 185
Plastics 186
Poultry 187
Quilting 187
Radio and Television 188
Regional History 189
River History 191
Space 191
State Non-Sports Halls of Fame 192
Teaching 193
Towing and Recovery 193
Western Heritage 194
Women 198
Unusual Halls of Fame 201
 Barbie Dolls 201
 Bulls 201
 Burlesque 202
 Cockroaches 202
 Crayons 203
 Hamburgers 203
 Medical Devices 204
 Presidential Losers 204
 Sneakers 205
Statuary Halls of Fame 207
Walks of Fame 209
Rings of Fame 215
Halls of Fame in Other Countries 217

Australia 217
Canada 217
France 228
Germany 228
Great Britain 231
Israel 232
Japan 233
Mexico 233
New Zealand 234
Singapore 235
Geographical Guide to Hall of Fame Museums and Exhibits 239
Selected Bibliography 257
Index 259

Preface

Nearly every community, state, association, and activity in the United States has one or more halls of fame—in sports, business, civic service, and other fields. They celebrate outstanding achievers in particular fields, usually on an annual basis. Most inductions into halls of fame are simply luncheon or dinner award programs at which certificates or plaques are presented to honorees, who display them in their homes and offices.

This book is devoted to a different type of hall of fame, one that is far less common. It has a physical presence, with museum-like exhibits that are open to the public regularly. Some are actually museums, while others are galleries in museums or permanent exhibits at other places, such as sports arenas, civic centers, association headquarters, and other unconventional sites.

The earliest versions of halls of fame were in Europe several centuries ago. They took the form of statuary tributes to national heroes in England, France, and Germany. The United States followed with a National Statuary Hall, which still exists in the Capitol building. However, it was not until the turn of the last century that the first statuary memorial called itself a "hall of fame." The modern hall of fame movement really began in the 1930s, accelerated in the 1950s and 1960s, and still is expanding rapidly today.

It is estimated that there are nearly 300 hall of fame museums and exhibits throughout the world, with over 90 percent in the United States. This book—based largely on the author's survey of the field—describes 274 such halls of fame for which reliable information could be obtained. It shows that hall of fame museums and exhibits—which represent approximately 3 percent of American museum-like facilities—are becoming an increasing important segment of the museum world.

It has been 20 years since the last studies of halls of fame were made. In

recent years, a number of articles and publications have described the growth and popularity of halls of fame. This book adds to the knowledge of the field by tracing the development of such institutions, examining their facilities and operations, and describing virtually all the hall of fame museums and exhibits available to the public. It provides an invaluable resource for founders, operators, and visitors of these enlightening and entertaining halls of achievement.

Chapter 1

Recognizing Achievement

Once relatively rare, "halls of fame" now can be found across the United States and even in some other countries. Nearly every field and many communities, states, and ethnic and other groups have some form of hall of fame recognition for outstanding achievement.

Some of the nation's best known figures have been enshrined in halls of fame, including George Washington, Babe Ruth, Benjamin Franklin, Clark Gable, Eli Whitney, Buffalo Bill Cody, Barney Oldfield, Red Grange, Will Rogers, Henry Ford, Sugar Ray Robinson, and Sally Ride. Many others whose names are not commonplace also have been inducted into halls of fame.

ABC-TV's *World News Tonight* has estimated that there are more than 3,000 halls of fame. Most of them consist simply of an annual luncheon or dinner at which those being honored are presented with a certificate or plaque. A much smaller number, several hundred, pay tribute to inductees with museum-like exhibits in such places as museums, galleries, display areas, or other public spaces. It is this latter group with public display facilities that is the focus of this book.

Halls of fame generally are defined as groups of individuals in particular categories who have been selected as especially noteworthy for their achievements. Those halls of fame that have a facility open to the public in which memorials to the honorees—and frequently other related materials—often are called hall of fame museums and exhibits, even though some are not "museums" in the conventional sense.

Halls of fame have been described many different ways. For example, Paul Soderberg, Helen Washington, and their coeditors in *The Big Book of Halls of Fame in the United States and Canada*, published in 1977, stated:

A Hall of Fame is any organization which calls itself a hall of fame, which has strict standards for election to membership, and which is designed to inspire future greatness in a field by any means of preserving and presenting the excellence of great individuals in that field.

William F. ''Buck'' Dawson, founding executive director of the International Swimming Hall of Fame, Fort Lauderdale, Florida, compared a hall of fame museum with a traditional museum in this way:

A hall of fame is a museum with a personality. Whereas an anthropological museum deals in the composite man, a hall of fame deals in specific men and women—personalities whose talent and achievement express biographically the dramatic episodes displayed in the hall of fame.

A further distinction has been presented by Jan Armstrong, former director of the International Tennis Hall of Fame in Newport, Rhode Island:

Generally, museums have been better collectors of the past, and halls of fame have been better collectors of the present. Museums have been better collectors of objects; halls of fame have been better collectors of personalities. Museums have been better at the immeasurable; halls of fame have been better at the measurable.

However halls of fame are defined or described, it is clear that many have become significant components of the museum world and among the nation's most popular cultural and educational attractions.

AN OVERVIEW

Hall of fame museums and exhibits encompass at least 274 halls of fame in categories located at 242 sites—some of which house more than one hall of fame. Approximately three-fourths are national or international in scope, with the others being locally or state oriented. Ninety percent of the halls and facilities are in the United States; only 30 are in other countries. Nearly all halls of fame are operated as nonprofits.

Sports and games halls of fame are the most numerous, best known, and most visited of the American halls. They account for two-thirds of the halls, sites, and categories of fields covered. Nearly everyone has heard of—and many have seen—such leading sports halls of fame as the National Baseball Hall of Fame and Museum in Cooperstown, New York; the Pro Football Hall of Fame in Canton, Ohio; the Naismith Memorial Basketball Hall of Fame in Springfield, Massachusetts; and the Indianapolis Motor Speedway Hall of Fame Museum in Indianapolis, Indiana.

Among the 60 categories of sports and games halls of fame are other such diverse halls as all-sports, bowling, chess, croquet, fishing, golf, lacrosse, rac-

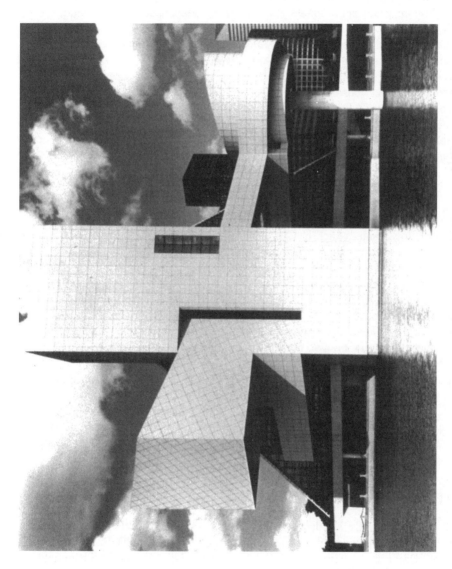

One of the newest and most popular halls of fame is the Rock and Roll Hall of Fame and Museum in Cleveland. The 150,000-square-foot facility, designed by I.M. Pei, already has an annual attendance of approximately 1 million and is planning a 30,000-square-foot addition. Courtesy Rock and Roll Hall of Fame and Museum and Peit Van Lier Photography, Cleveland.

quetball, roller skating, sailing, shuffleboard, skiing, soccer, softball, swimming, tennis, trapshooting, and thoroughbred racing.

Some non-sports halls of fame in the United States also have extensive facilities and large attendances, including the new Rock and Roll Hall of Fame and Museum (with approximately 1 million in attendance) in Cleveland, the National Cowboy Hall of Fame and Western Heritage Center in Oklahoma City, the Country Music Hall of Fame and Museum in Nashville, and Inventure Place, National Inventors Hall of Fame in Akron, Ohio.

The 46 categories of non-sports halls cover such other fields as agriculture, aviation and space, business and industry, cartoon art, dance, law enforcement, notable Americans, photography, radio and television, regional history, and women.

Hall of fame museums and exhibits are located in 42 states, the District of Columbia, and Puerto Rico. Florida has the most, with 19 halls of fame at 16 sites, followed by New York with 15 halls and sites; California and Michigan, 13 halls and sites; Texas, 13 halls at nine sites; and Wisconsin, 13 halls at eight sites.

The greatest number of hall of fame museums and exhibits outside the United States are in Canada, which has 18 such halls—12 museums and six galleries. The best known and attended are the Aquatic Hall of Fame and Museum of Canada in Winnipeg, Manitoba, and the Hockey Hall of Fame and Canada's Sports Hall of Fame, both in Toronto.

Among the most popular halls of fame elsewhere are two baseball halls—the Professional Baseball Hall of Fame of Mexico in Monterrey and the Japanese Baseball Hall of Fame and Museum in Tokyo. Seven other countries with halls of fame are Australia, France, Germany, Great Britain, Israel, New Zealand, and Singapore.

The earliest types of halls of fame were statuary memorials in Europe—at such places as Westminster Abbey in London and the Panthéon in Paris. But the first to call itself a hall of fame was the Hall of Fame for Great Americans in the Bronx, New York City, at the turn of the century. After a slow start, halls of fame proliferated in many fields and forms throughout the United States and an increasing number of other countries.

TYPES OF HALLS

A hall of fame can be many things, and take a variety of forms. Some are not really halls of fame honoring outstanding achievement; others are merely luncheon or dinner awards ceremonies. A number are only collections of materials and do not induct anyone or anything.

For example, the "Hamburger Hall of Fame" in Cooperstown, New York, is the name of a restaurant and not a hall of fame (but such a hall does exist in Wisconsin). The *Hallmark Hall of Fame* is the name of a television dramatic series, and the "Hall of Fame" and "Hall of Shame" selections on CNN's

Capital Gang program are simply ways of calling attention to laudatory and despicable acts by individuals, organizations, and government agencies.

The bulk of actual halls of fame do not have a physical presence with exhibits open to the public. Among such halls are the Pickle Packers Hall of Fame, the Accounting Hall of Fame, the International Best-Dressed Hall of Fame, the Broadcasting and Cable Hall of Fame, the Colorado Sports Hall of Fame, and many others.

Even some hall of fame museums are not truly what is generally considered a "hall of fame" but rather collections of specific types of objects; examples are the Barbie Doll Hall of Fame (Barbie dolls), Palo Alto, California; the Car Collectors Hall of Fame (country music stars' cars), Nashville; the Quackery Hall of Fame (questionable medical devices), Minneapolis; the Astronaut Hall of Fame (astronaut photos and space materials), Winslow, Arizona; and Legends and Superstars Hall of Fame (entertainers' photos, costumes, etc.), in Nashville and in Branson, Missouri.

Others are not "museums" in the usual sense. Rather, they are exhibits, statuary halls, walls of plaques, walks of fame, and rings of fame. But because they have some hall of fame and museum aspects, they often are included as "hall of fame museums." Among the facilities in this category are the Radio Hall of Fame (a gallery in a museum), Chicago; the National Statuary Hall (memorial statues), Washington, D.C.; the Hall of Fame for Great Americans (colonnade busts), the Bronx; the Greater Flint Area Sports Hall of Fame (wall plaques), Flint, Michigan; the Hollywood Walk of Fame (sidewalk tributes), Hollywood, California; and the Dallas Cowboys Ring of Honor (stadium signage), Irving, Texas.

A number of halls of fame go by other names, such as the Little League Baseball Hall of Excellence in Williamsport, Pennsylvania; the National Firefighting Hall of Heroes, Phoenix; the Shreveport–Bossier City Sports Museum of Champions, Shreveport, Louisiana; and the New York Yankees Memorial Park in the Bronx.

Approximately one-third of the American institutions in this book are self-contained hall of fame museums, consisting of exhibits celebrating displays pertaining to the nature, history, artifacts, or other materials of the field. Examples include the Alabama Sports Hall of Fame, Birmingham; the National Baseball Hall of Fame and Museum, Cooperstown; the Rock and Roll Hall of Fame and Museum, Cleveland; and the American Police Hall of Fame and Museum, Miami.

Some hall of fame museums do not use "museum" in their names although they are in fact comprehensive museums. Examples are the Pro Football Hall of Fame, Canton; the Greyhound Hall of Fame, Abilene, Kansas; the National Cowboy Hall of Fame and Western Heritage Center, Oklahoma City; and the Clown Hall of Fame and Research Center, Delavan, Wisconsin.

Another type of museum is the hall of fame devoted entirely to the honorees, with little or no additional materials or exhibits. Among such institutions are

the Collegiate Tennis Hall of Fame, Athens, Georgia; the Field Trial Hall of Fame, Grand Junction, Tennessee; and the Aiken Thoroughbred Racing Hall of Fame, Aiken, South Carolina.

DIVERSITY OF LOCATIONS

About one-fifth of the halls of fame are galleries in unaffiliated museums. Some are at community or county museums, such as the Muskegon Area Sports Hall of Fame in the Muskegon County Museum, Muskegon, Michigan; the Paper Industry Hall of Fame at the Neenah Historical Society, Neenah, Wisconsin; and the International Frisbee Hall of Fame in the Houghton County Historical Museum, Linden, Michigan. Others are at museums in related fields—like the Plastics Hall of Fame in the National Plastics Center and Museum, Leominster, Massachusetts, and the Virginia Aviation Hall of Fame in the Virginia Aviation Museum, Sandston. Also, a few are located at other types of museums with large attendances, such as the National Business Hall of Fame at the Museum of Science and Industry in Chicago with over 2 million visitors annually.

A number of halls of fame were started and are operated by museums, as in the case of the International Museum of Cartoon Art Hall of Fame, Boca Raton, Florida; the Petroleum Hall of Fame at the Permian Basin Petroleum Museum, Library, and Hall of Fame, Midland, Texas; and the Appalachian Hall of Fame at the Museum of Appalachia, Norris, Tennessee.

About the same proportion of halls of fame are found at non-museum locations, including civic centers, fieldhouses, sports arenas, libraries, parks, stadiums, mansions, race tracks, universities, gift shops, community and recreational centers, and even such places as airports, restaurants, gymnasiums, borough halls, retirement villages, country clubs, theme parks, farms, office buildings, banks, circus barns, rodeo stands, association headquarters, the U.S. Capitol, and homes for neglected, abused, or abandoned children. Many of these are merely exhibits or primarily displays of plaques.

Among those halls of fame at such non-museum sites are the North Dakota Sports Hall of Fame, at the Jamestown Civic Center; the Delaware County Athletes Hall of Fame, Brookhaven Borough Hall, Pennsylvania; the Family Camping Hall of Fame, Bear Brook State Park, Allenstown, New Hampshire; the International Circus Hall of Fame in a former circus barn, Peru, Indiana; the Senior Athletes Hall of Fame, Freedom Village Retirement Community, Bradenton, Florida; the International Checkers Hall of Fame, in the founder's mansion, Petal, Mississippi; the Show Jumping Hall of Fame and Museum, at the Busch Gardens theme park, Tampa, Florida; the Route 66 Hall of Fame in a truckers' restaurant, McLean, Illinois; and the Chicagoland Sports Hall of Fame at the Maryville Academy (for neglected, abused, and abandoned children), Des Plaines, Illinois.

Some halls of fame have several locations. They include the Bay Area Sports Hall of Fame, with exhibits and plaques at the San Francisco International

Airport and the Oakland Coliseum; the Greater Flint Afro-American Hall of Fame, which has plaques at the Flint Public Library and photographs and memorabilia at a neighborhood recreational center in Flint, Michigan; the Maine Sports Hall of Fame, with its main location in Portland and a display case in a restaurant in Bangor; and the Country Music Hall of Fame and Museum, which also operates two historic sites in Nashville.

Sometimes more than one hall of fame is located in a museum or other site. Six halls of fame—all related to aviation—are housed in the EAA Air Adventure Museum in Oshkosh, Wisconsin, while the International Motorsports Hall of Fame in Talladega, Alabama, has five smaller sports-related halls. Others include the Texas Sports Hall of Fame in Waco, which has five Texas halls of fame, covering all-sports, baseball, high school basketball, high school football, and tennis; and the International Bowling Museum and Hall of Fame in St. Louis, consisting of four halls—the American Bowling Congress Hall of Fame, Women's International Bowling Congress Hall of Fame, Women's International Hall of Fame, and Bowling Proprietors Association of America Hall of Fame. The latter also houses the St. Louis Cardinals Hall of Fame.

Several university museums do not call themselves halls of fame, but function like them by singling out the institution's outstanding athletes, coaches, and teams. They include the Paul W. Bryant Museum at the University of Alabama at Tuscaloosa and the Margaret Dow Towsley Sports Museum at the University of Michigan in Ann Arbor. The Penn State Football Hall of Fame at Pennsylvania State University in State College uses hall of fame in its name, but it does not elect individuals or teams. The University of Tennessee Football Hall of Fame in Knoxville, on the other hand, merely honors players who were consensus all-Americans or were elected to the National Football Foundation's College Football Hall of Fame.

In other countries, hall of fame museums and exhibits are usually self-contained museum-like facilities, galleries in related museums, or statuary tributes to national heroes. The latter came first, with statues, busts, or plaques at such historic sites as Westminster Abbey in Great Britain, the Panthéon in France, and Walhalla and Ruhmeshalle in Germany.

Among the self-contained halls are the Aquatic Hall of Fame and Museum of Canada, Winnipeg; the Canadian Football Hall of Fame and Museum, Hamilton, Ontario; the Hockey Hall of Fame, Toronto; the Naismith International Basketball Centre and Hall of Fame, Almonte, Ontario; the New South Wales Hall of Champions, Homebush Bay, Australia; the Japanese Baseball Hall of Fame and Museum, Tokyo; and the Professional Baseball Hall of Fame of Mexico, Monterrey.

Hall of fame galleries in museums include Canada's Aviation Hall of Fame in the Reynolds-Alberta Museum, Weaskiwin, Alberta; the Daredevil Hall of Fame in the Niagara Falls Museum, Niagara Falls, Ontario; the Ehrensaal in the Deutsches Museum, Munich, Germany; and the Singapore Sports Hall of Fame in the Singapore Sports Museum, Singapore.

SPORTS HALLS OF FAME

Sports and games halls of fame account for 160 of the 244 halls of fame and museum-like exhibits in the United States, with eight of the sites housing more than one hall of fame. The largest category is all-sports, which has 51 halls of fame. Most are state halls of fame, such as the Connecticut Sports Museum and Hall of Fame in Hartford; the Florida Sports Hall of Fame and Museum, Lake City; the Louisiana Sports Hall of Fame, Natchitoches; the Missouri Sports Hall of Fame, Springfield; and the Texas Sports Hall of Fame (which houses four other state halls of fame) in Waco.

Halls of fame covering all sports also can be found frequently at the local level. Among such halls are the Bay Area Sports Hall of Fame, San Francisco; the Muskegon Area Sports Hall of Fame, Muskegon, Michigan; and the Delaware County Athletes Hall of Fame, Brookhaven, Pennsylvania.

Another common type of all-sports hall of fame is the nationality, ethnic, or racial hall, such as the National Italian American Sports Hall of Fame in Chicago; the National Polish-American Sports Hall of Fame, Orchard Lake, Michigan; the National Jewish American Sports Hall of Fame, Washington, D.C.; and the International Afro-American Sports Hall of Fame and Gallery, Detroit. Seventeen other primarily local and state Jewish sports halls of fame (including one in Canada) are located largely in American community and recreational centers.

Three other large sports categories are baseball, football, and motor sports. Among the ten baseball hall of fame museums are the National Baseball Hall of Fame and Museum in Cooperstown; National Baseball Congress Hall of Fame in Wichita, Kansas; and the South Dakota Amateur Baseball Hall of Fame in Lake Norden. Football has eight halls of fame and motor sports seven. The football museums include the Pro Football Hall of Fame in Canton; the College Football Hall of Fame, South Bend, Indiana; and Green Bay Packer Hall of Fame, Green Bay, Wisconsin. Among the motor sports halls are the Indianapolis Motor Speedway Hall of Fame Museum in Indiana; the International Motorsports Hall of Fame in Alabama; and the NMPA Stock Car Hall of Fame/Joe Weatherly Museum in South Carolina.

The International Bowling Museum and Hall of Fame in St. Louis houses five halls of fame—four in bowling and one in baseball (the St. Louis Cardinals Hall of Fame, which recently moved from Busch Stadium across the street). Another hall of fame complex—the new World Golf Hall of Fame in Ponte Vedra Beach, Florida—includes four different golfing halls of fame. Fishing and tennis have four separate halls of fame, including the National Fresh Water Fishing Hall of Fame in Hayward, Wisconsin, and the International Tennis Hall of Fame in Newport, Rhode Island.

Two sports hall of fame categories with three facilities each are basketball, which includes the Naismith Memorial Basketball Hall of Fame in Springfield,

Massachusetts, and sailing, represented by the America's Cup Hall of Fame in Bristol, Rhode Island.

Most other American sports categories have a single hall of fame museum or exhibit. They include such facilities as the International Boxing Hall of Fame in Canastota, New York; the United States Hockey Hall of Fame, Eveleth, Minnesota; the National Museum of Polo and Hall of Fame, Lake Worth, Florida; the National Soccer Hall of Fame, Oneonta, New York; the International Swimming Hall of Fame, Fort Lauderdale, Florida; and Lacrosse Hall of Fame Museum, Baltimore.

A number of games also have halls of fame, museums, or exhibits, such as the International Checkers Hall of Fame in Petal, Mississippi; the United States Chess Hall of Fame, Washington, D.C.; National Croquet Hall of Fame, Newport, Rhode Island; and National Shuffleboard Hall of Fame, St. Petersburg, Florida.

Twenty-three of the 30 halls of fame in other countries are devoted to sports. Among the 18 in Canada are Canada's Sports Hall of Fame in Toronto; the Aquatic Hall of Fame and Museum of Canada, Winnipeg; the Canadian Football Hall of Fame and Museum, Hamilton; and the British Columbia Sports Hall of Fame Museum, Vancouver.

Sports halls of fame in other countries include the New South Wales Hall of Champions in Homebush Bay, Australia; the International Jewish Sports Hall of Fame, Netanya, Israel; the Japanese Baseball Hall of Fame and Museum, Tokyo; the Professional Baseball Hall of Fame of Mexico, Monterrey; the New Zealand Sports Hall of Fame, Wellington; and the Singapore Sports Hall of Fame, Singapore. The Wimbledon Lawn Tennis Museum near London is also frequently considered a hall of fame museum or exhibit, because of its emphasis on outstanding tennis players throughout the world.

NON-SPORTS HALLS OF FAME

Forty-three categories of non-sports activities account for 84 halls of fame at 73 sites in the United States. More than one-third fall in two categories—aviation/space and music.

In the aviation/space category, six of the 16 halls of fame—dealing with antique or classic planes, home-built aircraft, war planes, aerobatics, flight instruction, and Wisconsin aviation—occupy galleries at the EAA Air Adventure Museum in Oshkosh, Wisconsin. Among the other aviation and space halls are the National Aviation Hall of Fame at Wright-Patterson Air Force Base, Ohio; the U.S. Astronaut Hall of Fame, Titusville, Florida; the Georgia Aviation Hall of Fame, Warner Robins; the International Aerospace Hall of Fame, San Diego; the Alabama Aviation Hall of Fame, Birmingham; and the International Space Hall of Fame, Alamogordo, New Mexico.

The 11 music halls of fame are headed by the Country Music Hall of Fame and Museum in Nashville and the new Rock and Roll Hall of Fame and Museum in Cleveland—among the largest and most popular halls of fame. Other music halls include the Alabama Music Hall of Fame, Tuscumbia; the Oklahoma Jazz Hall of Fame, Tulsa; the National Oldtime Fiddlers' Hall of Fame, Weiser, Idaho; and the Legends and Superstars Hall of Fame, which has two locations— Nashville and Branson, Missouri.

The western heritage category contains five hall of fame museums, including the National Cowboy Hall of Fame and Western Heritage Center in Oklahoma City and the ProRodeo Hall of Fame and Museum of the American Cowboy in Colorado Springs.

The automobile and law enforcement categories each have three halls of fame. Among the facilities are the newly relocated Automotive Hall of Fame in Dearborn, Michigan; the American Police Hall of Fame and Museum, Miami; and the Texas Ranger Hall of Fame and Museum, Waco.

Only two halls of fame—the National Business Hall of Fame and the Merchandise Hall of Fame, both in Chicago—are listed in the business and industry category; 20 others, however, can be found in specialized business and industrial fields, such as agriculture, mining, mobile homes, paper, petroleum, photography, and plastics. The latter include the National Agricultural Center and Hall of Fame, Bonner Springs, Kansas; the National Mining Hall of Fame and Museum, Leadville, Colorado; and the Petroleum Hall of Fame, Midland, Texas.

The two oldest American halls of fame are statuary halls honoring great personages—the National Statuary Hall in Washington and the Hall of Fame for Great Americans in the Bronx. Two more specialized statuary tributes are the National Hall of Fame for Famous American Indians in Anadarko, Oklahoma, and the Television Academy Hall of Fame in North Hollywood, California.

Other well known halls of fame include the Radio Hall of Fame in Chicago; the National Women's Hall of Fame, Seneca Falls, New York; the Appalachian Hall of Fame, Norris, Tennessee; the South Dakota Hall of Fame, Chamberlain; and the Hollywood Walk of Fame in California.

Among the unusual—and sometimes frivolous—halls of fame are the Barbie Doll Hall of Fame in Palo Alto, California; Bull Hall of Fame, Plain City, Ohio; the Burlesque Hall of Fame and Museum, Hellendale, California; the Cockroach Hall of Fame, Plano, Texas; the Quackery Hall of Fame, Minneapolis; and the Hall of Fumes (featuring smelly sneakers) in Montpelier, Vermont.

A number of halls of fame in other countries are among the most historic and extensive—Westminster Abbey in Great Britain, the Panthéon in France, and the Walhalla, Ruhmeshalle, and Deutsches Museum Ehrensaal in Germany. They honor national heroes. Only two of Canada's 18 halls of fame are outside the sports field—Canada's Aviation Hall of Fame in Weaskiwin and Daredevil Hall of Fame in Niagara Falls.

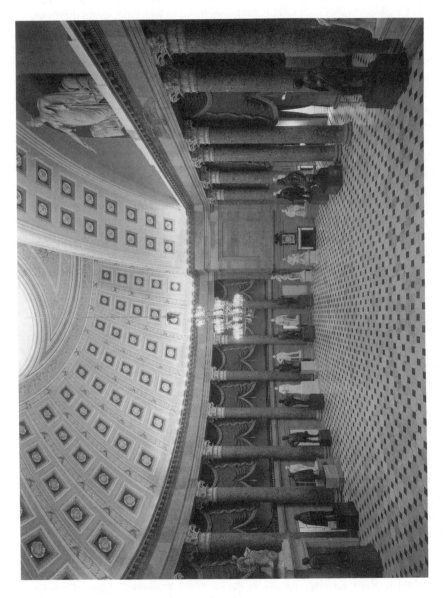

The National Statuary Hall located at the Capitol in Washington, D.C., was the nation's first hall of fame. It was established by Congress in 1864 to honor illustrious Americans. Each state can recognize two outstanding citizens. Ninety-five statues now can be seen in Statuary Hall. Courtesy Architect of the Capitol.

MISSION STATEMENTS

Most halls of fame have similar objectives—to honor outstanding individuals (and sometimes teams, animals, or objects) for their achievements. The museums, galleries, and other hall of fame sites enable the operators to celebrate the inductees and inform the public about their achievements and fields, through the use of plaques, photographs, memorabilia, artifacts, films, interactive exhibitry, or other such techniques.

Some mission statements are brief and direct, such as that of the International Bowling Museum and Hall of Fame in St. Louis, which seeks "to collect and preserve the history of bowling and its greatest heroes, and display that history to the visiting public."

The International Boxing Hall of Fame in Canastota, New York, says, "Our mission is to honor and preserve boxing's rich heritage, chronicle the achievements of those who excelled and provide an educational experience for our many visitors."

Some halls of fame museums place greater emphasis on inspiring the visiting public. For example, the mission of the San Diego Hall of Champions Sports Museum—which contains the Breitbard Hall of Fame—is "to promote, recognize and preserve athletic achievement for the purpose of inspiring individuals of all ages to reach their full potential."

Education also can be the focus, as with the National Football Foundation and its College Football Hall of Fame in South Bend: "The purpose . . . is to preserve and promote amateur football, its character-building attributes, and its vital role in education by honoring outstanding accomplishments on the athletic field, in the classroom, and in society."

Halls of fame sometimes go beyond the basic objectives in mission statements to include how they implement the purpose, as in the case of the National Museum of Racing and Hall of Fame in Saratoga Springs:

The mission of the National Museum of Racing and Hall of Fame is to interpret the history and convey the excitement of Thoroughbred racing in America to the broadest possible audience. The Museum fosters education and understanding of Thoroughbred racing by providing public access to equine art, artifacts, memorabilia, film, video, books and historical archives. The Museum collects, preserves, researches, interprets and exhibits the entire spectrum of Thoroughbred racing, enhanced by interactive displays. Further, the Museum is the official National Thoroughbred Racing Hall of Fame honoring Horses, Trainers, and Jockeys.

Non-sports halls of fame have similar mission statements. They often are concise and pointed, such as the one at the National Women's Hall of Fame in Seneca Falls, New York, which describes the institution's mission as "to honor in perpetuity those women, citizens of the United States of America, whose contributions to the arts, athletics, business, education, government, humanitar-

ianism, philosophy, or science have been of the greatest value for the development of their country.''

The National Agricultural Center and Hall of Fame in Kansas has a one-sentence mission: ''to educate the public on the history and importance of agriculture.'' But it is followed by a more extensive statement of purpose:

- To honor farmers, farm women, farm leaders, teachers, scientists, and others who have made outstanding contributions to the establishment, development, advancement, or improvement of agriculture in the United States.

- To foster, promote, and encourage a greater sense of appreciation of the dignity and importance of agriculture.

- To maintain a library and museum for the collection and preservation for posterity of agricultural tools, implements, machines, vehicles, pictures, paintings, books, papers, documents, and other artifacts relating to agriculture.

The Georgia Aviation Hall of Fame in Warner Robins, which is dedicated to paying tribute to those who have made outstanding contributions to aviation in Georgia, offers a more promotionally oriented statement of purpose:

- Honor those, living or dead, who by extraordinary achievement or service have made outstanding and lasting contributions to aviation in Georgia.

- Preserve, protect, and present the proud history of aviation in Georgia.

- Promote and encourage the growth and public support of aviation within the state of Georgia.

- Increase aerospace educational training opportunities within the state of Georgia.

- Increase public understanding of the roles and missions of aerospace power for national defense.

Most halls of fame in other countries have mission statements similar to those in the United States, as indicated in the objectives of the Canadian Football Hall of Fame and Museum in Hamilton. Its mission is ''to commemorate the names of players and others who have contributed to the development of Canadian Football and to collect, preserve, document, research, exhibit and interpret artifacts and other memorabilia that relate to the history of all levels of Canadian Football.''

The Saskatchewan Sports Hall of Fame and Museum in Regina focuses on its provincial role: it is ''dedicated to recognizing the contribution of sport to the lives of the people of Saskatchewan''; to celebrating ''individual and team achievements and traditions''; and to striving ''to collect, record, preserve, interpret and commemorate the sport heritage of this province.''

The form, length, and contents of hall of fame mission statements differ, but they all have the same basic objective—to state the purpose of the institution and provide direction to its operations.

THE HONOREES

The nature and numbers of honorees in halls of fame vary greatly. Most are individuals, but athletic teams, horses, dogs, bulls, automobiles, medical devices, hamburgers, dolls, cockroaches, and even smelly sneakers are subjects of halls of fame. The number of inductees ranges from a handful to several thousand.

In general, a designated committee makes the selections based on records of achievement in the field. In some cases, individuals do not qualify for election until they have been retired for a number of years, usually five or more. In the few privately operated halls of fame, the selections normally are made by the owners.

The typical hall of fame enshrines individuals. Because of the large number of sports halls of fame, honorees most often are athletes, and sometimes coaches, managers, trainers, officials, whole teams, owners, organizers, benefactors, writers, and others associated with sports.

The Singlehanded Sailors Hall of Fame in Newport, Rhode Island, honors only those who have sailed around the world by themselves, and the International Snowmobile Racing Hall of Fame and Museum in Saint Germain, Wisconsin, recognizes individuals for their racing achievements.

However, most sports halls of fame induct others in addition to athletes. For example, the Lacrosse Hall of Fame Museum in Baltimore cites players, coaches, and others who have contributed to the advancement of the sport, while inductees at the State of Oregon Sports Hall of Fame in Portland range from all-American athletes to individuals and companies that have furthered sports in the state through means other than athletic competition.

In non-sports fields, a similar pattern is usually followed. Most halls of fame honor individuals—generally pioneers, leaders, and innovators—for their contributions to the field. That occurs at the Automotive Hall of Fame in Michigan; the International Space Hall of Fame in New Mexico; the Dance Hall of Fame in New York; and the Plastics Hall of Fame in Massachusetts.

Both sports and non-sports halls of fame sometimes focus on subjects other than humans. Examples include the Canine Hall of Fame for Lead Dogs in Knik, Alaska; the Saratoga Harness Racing Museum and Hall of Fame, Saratoga Springs, New York; the Corvette Hall of Fame and Americana Museum, Cooperstown, New York; the Crayola Hall of Fame, Easton, Pennsylvania; the Hamburger Hall of Fame, Seymour, Wisconsin; the Bull Hall of Fame in Ohio; Cockroach Hall of Fame in Texas; the Quackery Hall of Fame in Minnesota; the Hall of Fumes in Vermont; and the Barbie Doll Hall of Fame in California.

Most European halls of fame—such as Westminster Abbey in Great Britain, the Panthéon in France, and Walhalla in Germany—honor only the nation's distinguished statesmen, military heroes, artists, writers, scientists, and other individuals of distinction. Foreign sports halls of fame are similar to those in the United States, honoring athletes, coaches, officials, teams, or other contributors, as illustrated by the Naismith International Basketball Centre and Hall of

Fame in Canada, the New Zealand Sports Hall of Fame, and the Singapore Sports Hall of Fame.

The number of honorees in a hall of fame vary greatly. For instance, the International Aerobatic Hall of Fame in Oshkosh, Wisconsin has only two inductees, while the American Police Hall of Fame and Museum in Miami has enshrined over 6,000 law enforcement officers, and the Hollywood Walk of Fame has honored more than 2,000 entertainment figures.

Among those with relatively few inductees are the Catskill Fly Fishing Museum Hall of Fame, Livingston Manor, New York (three honorees); the Pro Beach Volleyball Hall of Fame, Clearwater Beach, Florida (five); the Paper Industry Hall of Fame, Neenah, Wisconsin (six); the Merchandise Mart Hall of Fame, Chicago, and International Gymnastics Hall of Fame and Museum, Oklahoma City, (eight); and the Burlesque Hall of Fame and Museum, Hellendale, California, (eleven).

At the other extreme are halls of fame with hundreds or more inductees, such as the North Dakota Sports Hall of Fame, Jamestown (1,500); the Delaware County Athletes Hall of Fame, Brookhaven, Pennsylvania (900); the College Football Hall of Fame, South Bend (770); and the International Swimming Hall of Fame, Fort Lauderdale (432).

The number enshrined more often ranges between 25 and 200. It includes such halls of fame as the State of Kansas Sports Hall of Fame, Abilene (64); the International Circus Hall of Fame, Peru, Indiana (124); the United States Chess Hall of Fame, Washington, D.C. (26); the World Figure Skating Museum and Hall of Fame, Colorado Springs (66); the Aviation Hall of Fame and Museum of New Jersey, Teterboro (100); the National Fresh Water Fishing Hall of Fame, Hayward, Wisconsin (35); the Pro Football Hall of Fame, Canton (189); and the National Mining Hall of Fame and Museum, Leadville, Colorado (126).

INCREASING POPULARITY

Halls of fame are specialized museums or places to recognize achievement in a particular field. They are not replacements for traditional museums of art, history, science, or other fields. Rather, they are supplementary, pertaining to sports and other fields normally not covered to any degree in other museums.

Halls of fame are one of the fastest-growing segments of the museum world. In 1977, the authors of *The Big Book of Hall of Fame in the United States and Canada* stated, "New halls of fame have been created in North America at the rate of about one hall every month since 1936." This estimation covered all forms of halls of fame, not just museum-like halls. This rate of growth has accelerated since the 1970s; the number of new hall of fame museums and exhibits was established at from four to six times the earlier rate in the 1980s and 1990s.

The big surge in halls of fame museums and exhibits has occurred since the 1950s. This impetus can be attributed to a number of factors, especially the

tremendous growth of, and interest in, sports and other fields; the increasing desire to memorialize and know more about sports and other illustrious figures; and the greater educational and economic level, mobility, leisure time of the public, and its readiness to travel and visit scenic, historic, and cultural places, including halls of fame.

At the same time, halls of fame have become more than collections of photographs and a few objects. Some are full-blown museums, with interesting and colorful exhibits, extensive collections, professional staffs, and sizable buildings. In many instances, they have impressive induction ceremonies, major collateral activities, and aggressive marketing programs. They often are important elements of a community or field, and many are major tourist attractions. Above all, halls of fame fill a void in the museum world and bring recognition to thousands of achievers, and enjoyment to millions of their followers.

Some hall of fame museums and exhibits hardly can be called "halls of fame," while others have failed to live up to expectations. Overall, however, the hall of fame museum movement has made tremendous progress and continues to evolve as it strives to reach its potential.

Chapter 2

A Historical Perspective

The modern hall of fame museum movement began in the United States in this century, but its historical roots date back to Europe, much earlier, with the memorializing of illustrious national figures, often called "national heroes."

Westminster Abbey in London, England, was the first site of these national tributes. It is in this historic church, where kings and queens are crowned and many are buried, that noted statesmen and other distinguished persons have been entombed and honored with monuments since the fourteenth century.

A Poets' Corner began in 1556 with the tomb of Geoffrey Chaucer. It was followed by the tombs and memorials of other great names of letters, science, and other fields, figures such as Alfred Tennyson, Ben Johnson, and Charles Darwin. A number of monuments also have been installed to prominent persons who are buried elsewhere, including William Shakespeare, Charles Dickens, and Winston Churchill.

The Panthéon in Paris, France, followed in the eighteenth century. Originally a basilica, it was converted into a national shrine in 1791 during the French Revolution. The Panthéon's crypt holds the remains of many of France's distinguished statesmen, heroes, and thinkers, including Voltaire, Emile Zola, Jean-Jacques Rousseau, and Victor Hugo.

King Ludwig I of Bavaria was responsible for two memorial temples in Germany in the nineteenth century—Walhalla near Donaustauf and Ruhmeshalle in Munich. He built the Walhalla in 1830–42 to honor great German philosophers, soldiers, artists, and other notables; it now has 123 busts and 64 commemorative tablets citing distinguished national figures. It also was King Ludwig who constructed the Ruhmeshalle in 1843–53 to memorialize outstanding Bavarians who have made significant contributions to science, art, and their country. Originally

seventy-four busts were placed along a colonnade, and others have been added since for a total of 79.

The first comparable American memorial tribute was National Statuary Hall, established by an act of Congress in 1864 to honor those "illustrious for their historic renown or for distinguished civic or military services." It provided for each state to select and install statues of two notable citizens in the Capitol in Washington.

Statues of 96 outstanding Americans have been placed on display by the 50 states (four states had made only one selection). The first statue—of Nathanael Greene, a Revolutionary War general from Rhode Island—was installed in 1870. Among the others honored in the hall are such figures as Thomas Jefferson, Benjamin Franklin, Alexander Hamilton, Brigham Young, William Jennings Bryan, Robert E. Lee, and Will Rogers.

EARLY AMERICAN "HALLS OF FAME"

The modern era of halls of fame began with the founding of the Hall of Fame for Great Americans in 1900. Although similar to its European predecessors in form (featuring busts in a colonnade), it differed in name and operation. It was the first to use the term "hall of fame" and the first non-governmental body to start such a tribute and to select the honorees.

The Hall of Fame for Great Americans was initiated by New York University to encourage a deeper appreciation of noteworthy individuals who had made significant contributions to the American experience. Over the years, 102 distinguished American men and women have been elected to the hall of fame. Bronze busts of 98 individuals have been placed in the 630-foot open-air colonnade, with four busts still to be completed and installed. They represent such prominent Americans as George Washington, Abraham Lincoln, Thomas Edison, Harriet Beecher Stowe, Booker T. Washington, Mark Twain, and Franklin Delano Roosevelt. The Bronx, New York, campus at which the hall of fame is located was transferred in 1973 by NYU to Bronx Community College of the City University of New York.

It was not until the 1930s that halls of fame museums and exhibits as we know them today began to appear on the American scene. The first was a combination of the old and new approaches at another Bronx location—New York Yankees Memorial Park at Yankee Stadium. A number of monuments and plaques were placed in the outfield of the ballfield (they were later moved to a fenced area near the bullpen and bleachers because they became hazardous obstacles to players). They honored some of the greatest players, managers, and officials of the baseball team. The first monument was dedicated in 1932.

The 1932 Summer Olympic Games in Los Angeles led to the founding of the Helms Athletic Foundation in 1935 and a sports hall of fame museum in 1936. The Olympics left numerous photographs, equipment, memorabilia, artworks, and other sports-related materials that formed the core of the hall of fame

The first hall of fame to use the term was the Hall of Fame for Great Americans, founded in 1900 by New York University and now part of the Bronx Community College. The 630-foot colonnade contains bronze busts of 98 of the 102 distinguished men and women honored for their contributions to the American experience. Courtesy Hall of Fame for Great Americans.

museum established by the foundation, which also began an awards program. The prime movers felt that outstanding athletes deserved to be recognized like other great achievers in earlier halls.

Over its 34 years of operation, the Helms Foundation established halls of fame in nearly 30 sports fields—honoring athletes and others and displaying items from the collections under one roof. As independent halls of fame developed, the number of sports covered diminished. The Helms Athletic Foundation closed in 1970, and the hall of fame museum sponsorship was taken over by a series of savings and banking institutions—United Savings and Loan Association, Citizens Savings and Loan Association, and then First Interstate Bank.

In 1985, the First Interstate Bank gave the land, building, and contents to the Amateur Athletic Foundation of Los Angeles, founded after the city's 1984 Summer Olympics (which produced a $200 million surplus, of which 40 percent went to the new foundation and 60 percent to various Olympic groups and other activities).

The new foundation later discontinued the hall of fame museum and distributed some of the collections to specialized sports halls of fame. It still has an extensive collection of Olympic artifacts, artworks, memorabilia, and other materials, some dating to the first modern Olympic Games in 1896. It also makes awards and organizes temporary exhibitions. The emphasis, however, is on funding sports programming for children in southern California and serving as a major sports resource center.

In 1936, the first American hall of fame in single sport was founded—the National Baseball Hall of Fame and Museum. The museum opened in 1939 in Cooperstown, New York, and has grown to 80,000 square feet, featuring artifacts, memorabilia, films, and interactive exhibits. It became the model for many hall of fame museums that followed.

Another type of hall of fame founded in the 1930s was the Automotive Hall of Fame, the first industrially oriented hall. It was established in 1939, but it was not until 1975 that it had a permanent exhibit in Midland, Michigan; in 1997 it opened a new 25,000-square-foot museum in Dearborn, Michigan. The practice of founding a hall of fame and then taking years before opening a museum or exhibit became a common pattern for halls of fame.

A WARTIME LULL FOLLOWED BY RAPID GROWTH

The period during and immediately following World War II produced few new halls of fame, and no museums or exhibits in the field. The College Football Hall of Fame was founded by the National Football Foundation in 1947. However, it did not make its first inductions until 1951, and it was not until 1978 that it opened a museum-like facility at an amusement complex near Cincinnati. In 1995, the hall was relocated and opened as a museum in South Bend, Indiana.

It was in the 1950s that the hall of fame movement began its steady growth,

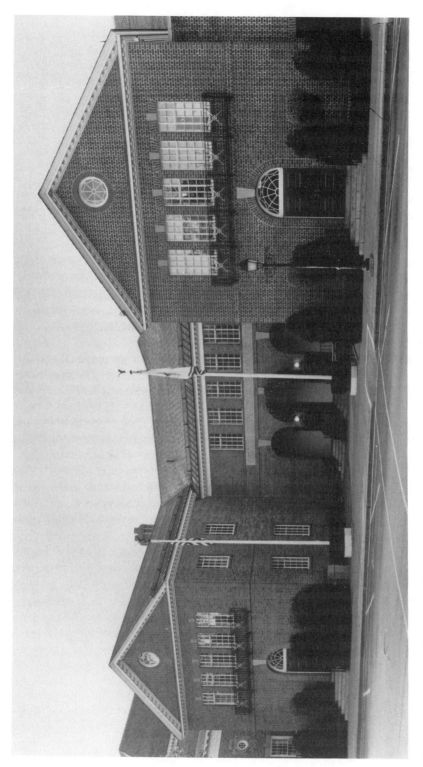

This is the entrance to the National Baseball Hall of Fame and Museum in Cooperstown, New York. Opened in 1939, the three-story structure contains thousands of artifacts, photographs, and other materials depicting the history of baseball and its greatest players and most memorable moments. It has an annual attendance of over 400,000. Courtesy National Baseball Hall of Fame and Museum.

with more than 25 halls being created that eventually developed into museums or exhibits (only ten—mostly in sports—made this transition in the same decade).

Hall of fame museums that were founded and opened during the decade included the United States National Ski Hall of Fame, Ishpening, Michigan (founded 1950, opened 1954); the National Museum of Racing and Hall of Fame, Saratoga Springs, New York (founded 1950, opened 1955); the National Hall of Fame for Famous American Indians, Onadarko, Oklahoma (founded 1952, first statue dedicated 1954); the Indianapolis Motor Speedway Hall of Fame Museum, Indianapolis (founded 1952, opened 1956); and the International Tennis Hall of Fame, Newport, Rhode Island (founded 1954, opened 1955). The Merchandise Mart Hall of Fame statuary tribute to retail merchants was opened in Chicago in 1953.

Among those halls of fame that were started but did not open during this period were the National Cowboy Hall of Fame and Western Heritage Center, Oklahoma City (founded 1954, opened 1965); the Breitbard Hall of Fame (founded 1953 and opened as part of the San Diego Hall of Champions Sports Museum in 1961); and the South Dakota Amateur Baseball Hall of Fame, Lake Norden (founded 1958, opened 1976).

In the 1960s, more than 30 hall of fame museums were founded, and approximately 20 were opened. A rapidly increasing number of non-sports halls of fame came into being, including the American Police Hall of Fame and Museum, Miami (founded and opened, 1960); the National Agricultural Center and Hall of Fame, Bonner Springs, Kansas (founded 1960, opened 1966); the Hollywood Walk of Fame, Hollywood, California (founded and opened, 1960); and the Country Music Hall of Fame and Museum, Nashville (founded 1961, opened 1967). Among the new sports halls of fame were the Pro Football Hall of Fame, Canton, Ohio (founded 1961, opened 1965); the International Swimming Hall of Fame, Fort Lauderdale, Florida (founded 1962, opened 1967); and the Naismith Memorial Basketball Hall of Fame, Springfield, Massachusetts (founded and opened 1968).

Many other halls of fame were created during the decade but did not open until later, such as the National Fresh Water Fishing Hall of Fame, Hayward, Wisconsin (founded 1960, opened 1976); the Indiana Basketball Hall of Fame, New Castle (founded 1962, opened 1970); the Greyhound Hall of Fame, Abilene, Kansas (founded 1963, opened 1973); the Green Bay Packer Hall of Fame, Green Bay, Wisconsin (founded 1969, opened 1976); and the National Women's Hall of Fame, Seneca Falls, New York (founded 1969, opened 1979).

FROM THE 1970s TO THE 1990s

The biggest increase in hall of fame museums and exhibits occurred in the next three decades, when approximately two-thirds of all American hall of fame museums and exhibits were established and opened.

In the 1970s, over 40 halls of fame were founded, and nearly the same number opened. Among the new facilities were the United States Hockey Hall of Fame, Eveleth, Minnesota (founded 1972, opened 1973); the Aviation Hall of Fame and Museum of New Jersey, Teterboro (founded and opened 1972); the National Polish-American Sports Hall of Fame, Orchard Lake, Michigan (founded 1973, opened 1978); the South Dakota Hall of Fame, Chamberlain (founded 1973, opened 1978); and the Dallas Cowboys Ring of Honor, Irving, Texas (founded and displayed 1975).

Halls of fame that were founded in the 1970s but not opened until later included the Maine Sports Hall of Fame, Portland (founded 1972, opened 1991); the International Motorsports Hall of Fame, Talladega, Alabama (founded 1975, opened 1983); the Lea County Cowboy Hall of Fame and Western Heritage Center, Hobbs, New Mexico (founded 1978, opened 1982); and the United States Slo-Pitch Softball Association Hall of Fame Museum, Petersburg, Virginia (founded 1979, opened 1984).

Approximately one-third of all American hall of fame museums and exhibits were created and opened in the 1980s. Among the more than 60 new halls founded and the nearly 70 opened were the Arizona Hall of Fame Museum, Tucson (founded 1981, opened 1987); the Barbie Doll Hall of Fame, Palo Alto, California (founded and opened 1984); the Dance Hall of Fame, Saratoga Springs, New York (founded and opened 1987); and the Labor Hall of Fame, Washington, D.C. (founded and opened 1988).

Other halls of fame established in the 1980s and opened during the following decade included the Alabama Music Hall of Fame, Tuscumbia (founded 1980, opened 1990); the Rock and Roll Hall of Fame and Museum, Cleveland (founded 1983, opened 1995); the Television Academy Hall of Fame, North Hollywood, California (founded 1984, opened 1991); the Clown Hall of Fame and Research Center, Delavan, Wisconsin (founded 1987, opened 1991); and the Radio Hall of Fame, Chicago (founded 1988, opened 1991).

Nearly 45 hall of fame museums and exhibits were founded, and almost 70 opened in the United States during the 1990s—and the decade still is not over. At its present growth rate, the decade could surpass the record-setting 1980s. Among the new halls were the Pro Beach Volleyball Hall of Fame, Clearwater Beach, Florida (founded and opened in 1990); the National Sprint Car Hall of Fame and Museum, Knoxville, Iowa (founded 1990, opened 1991); the Appalachian Hall of Fame, Norris, Tennessee (founded 1992, opened 1993); the Connecticut Sports Hall of Fame, Hartford (founded and opened 1992); the Paper Industry Hall of Fame, Neenah, Wisconsin (founded 1994, opened 1995); and the Mississippi Music Hall of Fame, Jackson (founded and opened 1996).

HALLS IN OTHER COUNTRIES

The development of hall of fame museums and exhibits in other countries has been relatively slow since the development of early memorials to illustrious

individuals in prior centuries. Although 30 halls of fame exist in ten other nations, the only country with a considerable number is Canada, which accounts for 18 of the facilities.

The first hall of fame in Europe since the nineteenth century was established at the Deutsches Museum in Munich, Germany, in 1925. Called Enrensaal, it is a gallery honoring principally early German scientists, engineers, inventors, and others for their contributions to the advancement of science or technology.

The second hall of fame in other countries was in Mexico, where the Professional Baseball Hall of Fame of Mexico was founded in 1939, but it was not until 1973 that the hall opened in a brewery in Monterrey. A similar Japanese Baseball Hall of Fame and Museum was started in Tokyo in 1959. It moved to its present location in the Tokyo Dome in 1988.

Nearly half of Canada's hall of fame museums, all in sports, were founded in the 1940s through the 1960s. The initial two were in hockey—the Hockey Hall of Fame, founded in 1943 and opened in 1961 in Toronto, and the International Hockey Hall of Fame, also established in 1943 but not opening until 1978, in Kingston, Ontario. They were followed by Canada's Sports Hall of Fame, which was founded and opened in 1955, making it Canada's oldest continuously operated hall of fame museum. It has been located in Toronto's Exhibition Place since 1967.

Five hall of fame museums, including two provincial halls, were started in the 1960s—the Canadian Football Hall of Fame and Museum, Hamilton, Ontario (founded 1962, opened 1972); the Saskatchewan Sports Hall of Fame and Museum, Regina (founded 1966, opened 1979); the British Columbia Sports Hall of Fame and Museum, Vancouver (founded and opened 1966); and the Aquatic Hall of Fame and Museum of Canada, Winnipeg (founded and opened 1967).

In the 1970s, four more Canadian sports hall of fame museums were launched—the New Brunswick Sports Hall of Fame, Fredericton (founded 1970, opened in its present site 1977); the Canadian Golf Hall of Fame, Oakville, Ontario (founded 1971, opened 1976); the Curling Hall of Fame and Museum of Canada, a former traveling exhibition now in Kitchener, Ontario (founded 1973, opened 1997); and the Northwestern Ontario Sports Hall of Fame, now in Thunder Bay, Ontario (founded 1976, opened 1978).

Among the Canadian sports hall of fame museums established in the 1980s and 1990s were the Olympic Hall of Fame and Museum, Calgary (founded and opened after the 1988 Winter Olympics there); the Naismith International Basketball Centre and Hall of Fame, Almonte, Ontario (founded 1989 and opened 1993 in a farmhouse near the birthplace of the founder of basketball); and the Canadian Figure Skating Hall of Fame, Gloucester, Ontario (founded and opened 1990 in the figure skating association's headquarters).

The two non-sports halls of fame in Canada are housed in galleries in related museums. The Daredevil Hall of Fame, which honors those who have challenged Niagara Falls, was founded and opened in the 1950s as part of the Niagara Falls

Museum, Niagara Falls, Ontario. Canada's Aviation Hall of Fame, founded in 1973, had been located since 1992 in a hanger at the Reynolds-Alberta Museum in Wetaskiwin, Alberta.

The hall of fame museums and exhibits in other countries pertain to sports and have evolved since the 1970s. They include the Wimbledon Lawn Tennis Museum, Wimbledon, England, which has a gallery devoted to outstanding tennis players (founded and opened 1977); the New South Wales Hall of Champions, Homebush Bay, Australia (founded and opened 1978); the International Jewish Sports Hall of Fame, a gallery in the Wingate Institute for Physical Education and Sports, near Netanya, Israel (founded 1979, opened 1981); the Singapore Sports Hall of Fame, a component of the Singapore Sports Museum, Singapore (founded and opened 1983); and the New Zealand Sports Hall of Fame, an office-based exhibit that will be expanded as part of the new Wellington Sports Stadium (founded and opened 1990).

AN EVOLVING MOVEMENT

Halls of fame have come a long way since the statuary national tributes of earlier centuries. They are far more numerous, diversified, and developed as museums and exhibits. They cover a much wider range of fields and honorees, and they can be found in unlikely locations as well as traditional sites.

It is difficult to describe a typical hall of fame museum or exhibit, because of the many differences in origin, selection process, form, content, operation, site, size, attendance, and other factors. Basically, halls of fame honor exceptional achievers in particular fields, although some are really only collections of objects. In addition to enshrining individuals, a number of halls of fame honor dogs, horses, bulls, dolls, cars, or other non-humans.

Today, a hall of fame can take many forms, such as a museum, exhibit, statuary plaza, wall of plaques, walk of fame, stadium ring of fame, or some other manifestation. It can be located almost anywhere. Many are museums or galleries in museums. Others are in civic centers, fieldhouses, sports arenas, libraries, stadiums, mansions, universities, parks, race tracks, or other unconventional sites.

The hall of fame movement continues to evolve. New halls are being established, better sites are being developed, new ways are being introduced to honor inductees, more effective techniques are being utilized in exhibits and programs, and increased public attention is being focused on halls of fame.

Halls of fame have multiplied greatly in the last half-century because they apparently fill a need to recognize outstanding achievement in sports and other fields—and for the public to be able to visit a place where it can relive memories and learn more about heroes and fields of interest.

Chapter 3

Diversity of Operations

Hall of fame museums and exhibits are founded, located, governed, staffed, funded, and operated in many different ways. Most are started by interested individuals or groups, while others are created by professional associations, city and state governments, and in other ways. They are generally nonprofit organizations with governing boards, but some are part of associations or governments, and a few are privately operated without such boards. Many have professional staffs; others depend largely upon volunteers. Nearly all rely upon earned income, contributions, or other funding sources to cover the cost of their operations.

The early statuary monuments in Europe were created by monarchs and national governments to honor illustrious statesmen, military leaders, scientists, writers, and other leading figures for their achievements. This is the same reason that contemporary halls of fame are founded in particular fields. However, the founding forces, contents, and operations differ considerably from the early memorials.

Today, relatively few halls of fame consist of statues and busts of those honored. Among the handful that still take this form are the Hall of Fame for Great Americans, the Bronx, New York; the National Hall of Fame for Famous American Indians, Anadarko, Oklahoma; and the Television Academy Hall of Fame, North Hollywood, California.

Nearly all halls of fame, except those that are merely luncheon or dinner awards programs, take the form of museums or exhibits that use displays of plaques, photographs, artifacts, memorabilia, or other materials to honor outstanding achievers, and frequently to tell about the history and nature of their fields.

FOUNDERS OF HALLS OF FAME

Hall of fame are most often started by individuals or groups of people interested in the subject matter. For example, the Alabama Jazz Hall of Fame Museum, Birmingham, was founded by J. L. Lowe, a jazz enthusiast, who became its director; the Muskegon Area Sports Hall of Fame, Muskegon, Michigan, resulted from the efforts of Dick Hedges, a retired local sports writer; the International Tennis Hall of Fame and Museum, Newport, Rhode Island, was initiated by tennis innovator James Van Alen; the International Motorsports Hall of Fame, Talladega, was the dream of William H. G. France, Sr.; the American Police Hall of Fame and Museum, Miami, was initiated by several injured law enforcement officers who wanted a memorial to officers killed in the line of duty and a museum containing police artifacts; and the National Mining Hall of Fame and Museum, Leadville, Colorado, was spearheaded by a group of former miners and mining officials.

Sometimes, halls of fame are created, entirely or partly, through major contributions from one or more individuals. This occurred with the Missouri Sports Hall of Fame in Springfield, where John Q. Hammons, developer and philanthropist, made a $2.5 million startup gift; the Dance Hall of Fame, Saratoga Springs, New York, which was established with the financial support of Mrs. Cornelius Vanderbilt Whitney; and the International Checkers Hall of Fame, Petal, Mississippi, where Charles C. Walker gave his mansion and funds to start the institution.

Halls of fame are frequently initiated by clubs and associations, especially in sports. Among those that started with clubs are the Automotive Hall of Fame, Dearborn, Michigan, which began with the Automobile Old Timers Club in New York City; the Harness Racing Museum and Hall of Fame, Goshen, New York, established by the Trotting Horse Club of America; and the Mississippi Sports Hall of Fame and Museum, Jackson, launched by the Jackson Touchdown Club. Halls founded by associations include the United States Skating Hall of Fame, Colorado Springs, established by the United States Figure Skating Association; the Lacrosse Hall of Fame Museum, Baltimore, started by the United States Lacrosse Coaches Association; the National Softball Hall of Fame and Museum, Oklahoma City, part of the Amateur Softball Association; and the Florida Sports Hall of Fame and Museum, Lake City, founded by the Florida Sports Writers Association and Florida Sportscasters Association.

A number of halls of fame were established or located on college and university campuses, including the Penn State Football Hall of Fame, State College; the Tom Kearns University of Miami Sports Hall of Fame, Miami; the University of Tennessee Football Hall of Fame, Knoxville; the National Wrestling Hall of Fame and Museum at Oklahoma State University, Stillwater; and the National Polish-American Sports Hall of Fame at St. Mary's College, Orchard Lake, Michigan.

A few halls of fame originated with companies, such as the Radio Hall of

Fame, Chicago, started by Emerson Radio Corporation and then assumed by the Museum of Broadcast Communications; the Weightlifting Hall of Fame, York, Pennsylvania, founded and still located at the York Barbell Company; and the St. Louis Cardinals Sports Hall of Fame, established by Anheuser-Busch, Inc., at Busch Stadium, but recently relocated to the International Bowling Museum and Hall of Fame building across the street from the ball field in St. Louis.

GOVERNMENT-INITIATED HALLS

City, state, and federal governments also have been instrumental in creating halls of fame. Among the halls initiated by governmental bodies are the Texas Ranger Hall of Fame and Museum, founded by and located in Waco, Texas; the State of Alabama Sports Hall of Fame, Birmingham, established by the state legislature; and the National Statuary Hall, created by Congress and located in the Capitol in Washington, D.C. Several halls of fame also have been chartered by Congress, although operated independently—such as the National Agricultural Center and Hall of Fame, Bonner Springs, Kansas, and the National Aviation Hall of Fame, Wright-Patterson Air Force Base, Ohio.

In some communities, chamber of commerce and tourism bureaus have worked to establish halls of fame, usually for economic development or because the hall's field began in the area. Among the halls resulting from chamber or tourism development are the Volleyball Hall of Fame, Holyoke, Massachusetts; the Green Bay Packer Hall of Fame, Green Bay, Wisconsin; the Pro Beach Volleyball Hall of Fame, Clearwater, Florida; and the National Cowgirl Hall of Fame and Western Heritage Center, Hereford, Texas (now relocating to Fort Worth).

The eagerness to attract a hall of fame—and the desire of founders to obtain financial assistance—sometimes results in a bidding battle among competing cities, chambers of commerce, and other local boosters. Perhaps the most heated and costly competition was for the Rock and Roll Hall of Fame and Museum, which eventually was lured to Cleveland when city leaders provided $65 million of the $92 million needed to build a lakefront home for the hall. Other bidding wars brought the Indiana Basketball Hall of Fame to New Castle; Inventure Place, National Inventors Hall of Fame, to Akron, Ohio; and the College Football Hall of Fame to South Bend, Indiana.

Some museums have established halls of fame as extensions of their operations. They include the Petroleum Hall of Fame, at the Permian Basin Petroleum Museum, Midland, Texas; the International Museum of Cartoon Art Hall of Fame, Boca Raton, Florida; the Appalachian Hall of Fame, Museum of Appalachia, Norris, Tennessee; and the National Firefighting Hall of Heroes, Hall of Flame Museum of Firefighting, Phoenix.

Then, there are the collectors and entrepreneurs who have started privately operated museums or exhibit spaces they call "halls of fame" but where the

contents do not fall within the usual definition. Among such places, basically collections of objects, are the Corvette Hall of Fame and Americana Museum, Cooperstown, New York; the Original Baseball Hall of Fame, Minneapolis; the Barbie Doll Hall of Fame, Palo Alto, California; and the Car Collectors Hall of Fame, Nashville.

The pattern of contemporary halls of fame in other countries has been similar to the establishment of halls of fame in the United States. In Canada, for instance, James T. Sutherland was largely responsible for launching both the Hockey Hall of Fame in Toronto and International Hockey Hall of Fame in Kingston, Ontario; Barbara Ryan advocated the founding of the Canadian Figure Skating Hall of Fame, Gloucester, Ontario; three Toronto businessmen led the campaign for Canada's Sports Hall of Fame, Toronto; and two curling associations created the Curling Hall of Fame and Museum in Canada, Kitchener, Ontario. Cities and provinces also have helped develop halls of fame, such as the Aquatic Hall of Fame and Museum of Canada in Winnipeg, and the New Brunswick Sports Hall of Fame in Fredericton.

Other nations have had comparable experiences in the founding of halls of fame. Alejandro Aguilar Reyes initiated the idea of, and the Professional Teams Association implemented, the Professional Baseball Hall of Fame of Mexico, Monterrey; and Joseph Siegman founded the International Jewish Sports Hall of Fame, located on a college campus, the Wingate Institute for Physical Education and Sport, near Netanya, Israel. The New Zealand Sports Hall of Fame in Wellington was a cooperative effort of the city and various sports groups; the Singapore Sports Council started the Singapore Sports Hall of Fame; and the Ehrensaal, a hall of fame in science and technology, was founded at the Deutsches Museum in Munich, Germany, in cooperation with scientific and industrial leaders.

HALL OF FAME FACILITIES

The facilities housing hall of fame museums and exhibits come in all sizes and types, ranging from a few hundred square feet to multibuilding complexes, and from a hallway exhibit to a comprehensive museum.

Most of the large hall of fame museums have buildings especially constructed for that purpose, such as the 80,000-square-foot National Baseball Hall of Fame and Museum in Cooperstown, New York; the 48,000-square-foot Naismith Memorial Basketball Hall of Fame, Springfield, Massachusetts; the 77,000-square-foot Inventure Place, National Inventors Hall of Fame, Akron; the 150,000-square-foot Rock and Roll Hall of Fame and Museum, Cleveland; and the 220,000-square-foot National Cowboy Hall of Fame and Western Heritage Center, Oklahoma City (including several expansions).

Some major hall of fame museums have a number of adjoining buildings. Among such complexes are the 83,000-square-foot Pro Football Hall of Fame, which consists of five interconnected buildings in Canton, Ohio; the 25,000-

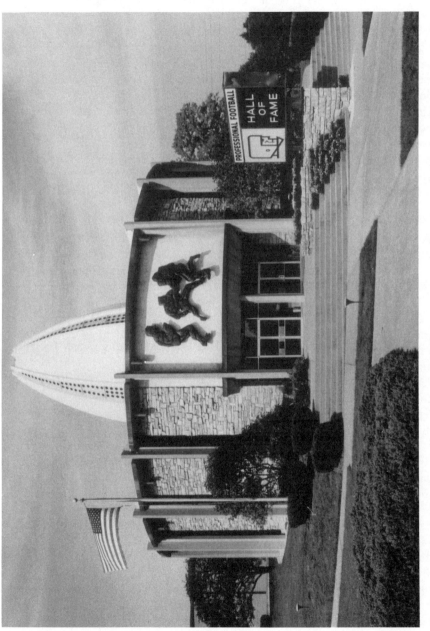

The Pro Football Hall of Fame consists of five interconnected buildings in Canton, Ohio. The 83,000-square-foot complex began with a single building in 1963 as a result of a community fundraising campaign in the city which had one of the early professional football teams. Courtesy Pro Football Hall of Fame.

square-foot National Fresh Water Fishing Hall of Fame, occupying seven buildings on a six-acre site in Hayward, Wisconsin; and the 80,000-square-foot International Motorsports Hall of Fame, with five buildings at the Talladega Superspeedway in Alabama.

At the other extreme are such hall of fame museums as the 650-square-foot United States Bicycling Hall of Fame, Sommerville, New Jersey; the 900-square-foot South Carolina Tennis Hall of Fame, Belton; the 600-square-foot Route 66 Hall of Fame, McLean, Illinois; and the 325-square-foot National Fish Culture Hall of Fame, Spearfish, South Dakota.

Halls of fame that occupy only a gallery in a museum or are located at unconventional sites tend to be smaller than those where the entire facility is devoted to a hall of fame. Among those that fall in this category are the Maine Sports Hall of Fame, which occupies 600 square feet in a restaurant building in Portland; the Mountain Bike Hall of Fame and Museum, with 300 square feet in the Crested Butte Heritage Museum in Colorado; and the Western America Ski Hall of Fame, primarily a wall of plaques at the Western SkiSport Museum, Soda Springs, California.

Among the other halls of fame in unusual locations are the Chicagoland Sports Hall of Fame at the Maryville Academy, a center for neglected, abused, and abandoned children in Des Plaines, Illinois; the Senior Athletes Hall of Fame at the Freedom Village Retirement Community in Bradenton, Florida; the National Croquet Hall of Fame in an art museum in Newport, Rhode Island; the Bay Area Sports Hall of Fame at two locations, San Francisco International Airport and Oakland Coliseum; the International Circus Hall of Fame in a 1920s circus barn in Peru, Indiana; and the American Poultry Hall of Fame in a federal library in Beltsville, Maryland.

Most hall of fame facilities are somewhere between the small and large facilities, usually in the 10,000 to 30,000-square-foot range. They include such places as the 10,000-square-foot National Wrestling Hall of Fame and Museum, Stillwater, Oklahoma; the 15,342-square-foot Texas Sports Hall of Fame, Waco; the 30,000-square-foot State of Alabama Sports Hall of Fame, Birmingham; the 20,000-square-foot Greyhound Hall of Fame, Abilene, Kansas; and the 15,000-square-foot Clown Hall of Fame and Research Center, Delavan, Wisconsin.

Some halls of fame are located in historic structures, such as the 9,400-square-foot International Tennis Hall of Fame and Museum, housed in an 1880 National Historic Landmark in Newport, Rhode Island, and the 24,000-square-foot Harness Racing Museum and Hall of Fame, located in a 1913 English Tudor-style former stable (that has been expanded twice) in Goshen, New York.

Other halls have facilities beyond the hall of fame building, including the 10,000-square-foot International Swimming Hall of Fame, which also has an art gallery, library and archives, two 50-meter Olympic-size pools, a diving pool, a teaching pool, and a swimming flume in Fort Lauderdale, Florida. There is also the 4,000-square-foot National Soccer Hall of Fame, home for a national soccer library and archives, four playing fields, and numerous soccer clinics,

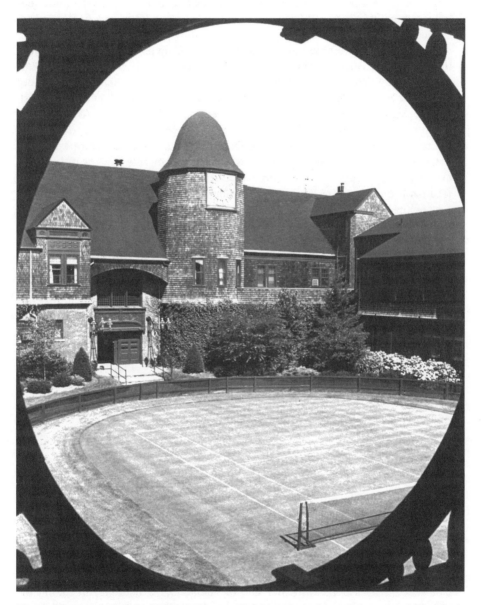

The International Tennis Hall of Fame and Museum is housed in one of America's architectural masterpieces—the Newport Casino, a historic Victorian structure built in 1880 as a social and recreational club for summer residents in Newport, Rhode Island. Courtesy International Tennis Hall of Fame and Museum, Newport, Rhode Island.

tournaments, symposia, and other activities in Oneonta, New York. (Plans are under way for a new 27,000-square-foot museum, a 10,000-seat stadium, and indoor arena, training facilities, and additional playing fields on a 61-acre site.)

Most hall of fame museum spaces typically are devoted to hall honorees and related exhibits in the field. Examples include the College Football Hall of Fame in South Bend, where 35,000 of the 58,000 square feet are exhibits; the United States Hockey Hall of Fame, Eveleth, Minnesota, 14,000 of 20,000 square feet; the Roller Skating Hall of Fame, Lincoln, Nebraska, 2,000 of 2,400 square feet; and the All-American Soap Box Derby Museum and Hall of Fame, Akron, Ohio, 3,500 of 3,900 square feet. The remaining space generally is used for offices, collections storage, maintenance, gift shop, restaurant, or other such purposes.

Contemporary halls of fame in other countries also vary greatly in location and size. Some are self-contained museums, such as the Hockey Hall of Fame, located in a former bank building in Toronto, with 35,000 of its 52,000 square feet being exhibits; the Naismith International Basketball Centre and Hall of Fame, which occupies a century-old farmhouse near Almonte, Ontario, Canada; and the Professional Baseball Hall of Fame of Mexico, housed in a 13,200-square-foot building at a brewery in Monterrey.

Other halls of fame are galleries in museums, including the Ehrensaal at the Deutsches Museum in Munich; the Singapore Sports Hall of Fame in the Singapore Sports Museum; and the Canada's Aviation Hall of Fame at the Reynolds-Alberta Museum in Wetaskiwin, Alberta. Some are in association offices, such as the Canadian Figure Skating Hall of Fame in Gloucester, or sports arenas and stadiums, like the New South Wales Hall of Champions in Homebush, Australia. The size of halls of fame also differs considerably, as indicated by the 500 square feet for the Daredevil Hall of Fame gallery at the Niagara Falls Museum in Canada, compared to 22,000 square feet (including 18,000 for exhibits) at Canada's Sports Hall of Fame in Toronto.

GOVERNING BODIES

Nearly all halls of fame have governing boards, usually called the board of trustees, directors, or governors. The exceptions are those that are part of associations, governments, or are privately owned and operated halls of fame. Governing boards are legally responsible for the operation of the halls of fame and museums. They normally set the objectives and policies, approve the budget and major initiatives, and hire the director to operate the hall and museum.

The size of governing boards varies widely, as can be seen by the following examples—Motorsports Hall of Fame of America, Novi, Michigan, 24 members; the International Snowmobile Racing Hall of Fame, Saint Germain, Wisconsin, 11 members; the Pro Football Hall of Fame, Canton, 17 members; and the National Museum of Racing and Hall of Fame, Saratoga Springs, New York, 25 members. The boards generally are self-perpetuating, with members being elected to three-year staggered terms.

Some boards are rather specific as to their composition. For instance, the board members of the National Cowboy Hall of Fame and Western Heritage Center in Oklahoma City represent 17 western states; the 18-member board of the Saints Hall of Fame Museum in Kenner, Louisiana, consists of representatives of various Saints football fan clubs, former Saints sportscasters, and elected officials; and the 13-member board of the Lea County Cowboy Hall of Fame and Western Heritage Center in Hobbs, New Mexico, requires that the 13-member board include the chairman of the New Mexico Junior College Board of Trustees (the hall is located on the campus) and that the other 12 directors be elected by the general membership.

Most boards have an executive committee that oversees the hall of fame or museum operations and works with the director on a continuous basis, as occurs at the International Tennis Hall of Fame in Newport and Florida Sports Hall of Fame and Museum in Lake City. A few facilities make use of advisory boards, as at the National Sprint Car Hall of Fame and Museum in Knoxville, Iowa, which has a nine-member board and a 21-member national advisory board. Some institutions also have non-voting honorary board members, who are long-serving former board members, major financial contributors, or outstanding people in the field.

A number of hall of fame museums are governed by a foundation board, including the Lacrosse Hall of Fame Museum, Baltimore; the Water Ski Hall of Fame and Museum, Winter Haven, Florida; the Country Music Hall of Fame and Museum, Nashville; the Mississippi Sports Hall of Fame and Museum, Jackson; and the Television Academy Hall of Fame, North Hollywood. Inventure Place, National Inventors Hall of Fame, Akron, has a National Inventors Hall of Fame Foundation Board, an Inventure Place Board, and a combination joint board. The Plastics Hall of Fame at the National Plastics Center and Museum, Leominster, Massachusetts, is operated by a plastics society–created Plastics Academy.

In some states, members of state-established halls of fame are appointed entirely or partly by the governor of the state, as occurs at the Georgia Aviation Hall of Fame, Warner Robins; the Alabama Music Hall of Fame, Tuscumbia; and the State of Alabama Sports Hall of Fame, Birmingham. The latter has 14 board members—one from each of seven congressional districts, appointed by the governor; four from the state at large, named by the governor; one appointed by the lieutenant governor (speaker of the House) and the chairman of the civic center where the hall of fame is located.

Some halls of fame do not have governing boards, because they are established by or report to city or state agencies. Examples are the Texas Ranger Hall of Fame and Museum, a city department in Waco; the Shreveport–Bossier City Sports Museum of Champions, operated by the City of Shreveport and a local sports foundation; the South Carolina Criminal Justice Hall of Fame, Columbia, a division of the Community Services Office of the State Department of Public Safety; and the International Space Hall of Fame at The Space Center,

Alamogordo, New Mexico, operated under the auspices of the New Mexico Office of Cultural Affairs.

Among the other halls of fame that operate without a separate governing board are the Hall of Fame for Great Americans at the Bronx Community College in New York, where the college president exercises a "stewardship" over the hall and appoints the director; the Dance Hall of Fame at the National Museum of Dance, Saratoga Springs, a program of the Saratoga Performing Arts Center; and All-American Soap Box Derby Museum and Hall of Fame, Akron, operated by International Soap Box Derby, Inc.

In other countries, most early statuary halls of fame are operated through government ministries, while others usually are part of museums or associations or have their own governing boards. Included among those Canadian halls of fame with their own boards are the Aquatic Hall of Fame and Museum of Canada, Winnipeg; the Hockey Hall of Fame, Toronto; and Canada's Sports Hall of Fame, Toronto, which has a 24-member board of governors. The Canadian Figure Skating Hall of Fame in Gloucester has a board of trustees appointed by the Canadian Figure Skating Association, while the Olympic Hall of Fame and Museum in Calgary is owned and operated by the Calgary Olympic Development Association.

CRITERIA FOR INDUCTION

The selection of hall of fame inductees is the most important function at virtually all hall of fame museums and exhibits. The criteria, eligibility, and selection process are similar, but yet somewhat different.

Inductees nearly always are chosen for making significant contributions in their fields or to their geographical, ethnic, or other areas. Sometimes the criteria are stated simply in a sentence or paragraph, while others are longer, especially if there are several or more categories of enshrinement.

The United States National Ski Hall of Fame and Museum in Ishpeming, Michigan, summarizes its criteria as merely "those women and men who have contributed to American skiing as outstanding athletes, or ski sport builders, or both." The Indiana Basketball Hall of Fame, New Castle, seeks "to recognize those deserving individuals for their accomplishments as a high school player or coach in the state of Indiana or for their contributions to Indiana high school basketball." The Maine Sports Hall of Fame, Portland, describes its criteria as a Maine native or person who has had significant ties to the state and "has brought distinction to Maine in any sport or made a major contribution to the development and advancement of sports in the state." The Quilters Hall of Fame, Marion, Indiana, honors "any person who has made outstanding contributions to the quilt world as a whole."

Sometimes, the criteria are more extensive, such as at the College Football Hall of Fame, South Bend, which lists seven points for criteria and eligibility. It states "First and foremost, a player must have received major first team all-American recognition" and then adds, "While each nominee's football achieve-

ments are of prime consideration, his post football record as a citizen is also weighted. He must have proved himself worthy as a citizen, carrying the ideas of football forward into his relations with his community and his fellow man along with love of his country.''

The Television Academy Hall of Fame, North Hollywood, has a general statement saying it will induct "individuals and television programs who/which have made outstanding contributions to television and who/which are deserving of the recognition of the industry and public at large for their contributions." It follows with separate criteria for individuals—"persons who have made outstanding contributions in the arts, sciences and management of television, based either on cumulative contributions and achievements or upon a singular and extraordinary contribution or achievement"—and programs—"a television program [which] constitutes an outstanding contribution to the arts and sciences of television."

The National Cowboy Hall of Fame and Western Heritage Center, Oklahoma City, has three different halls of fame and criteria for various types of contributions—the Rodeo Hall of Fame for outstanding cowboys and cowgirls; Great Westerners Hall of Fame for individuals and organizations in the development of the West; and the Great Western Performers Hall of Fame for actors, singers, and other entertainers for their contributions to the West in their performances and lives.

The criteria for being selected for a hall of fame sometimes depends solely or largely on a single act. For example, a boy or girl must win a national marbles championship to be inducted into the Marbles Hall of Fame, Wildwood, New Jersey, and an inventor is required to hold a United States patent that has enhanced our way of life in order to be enshrined at Inventure Place, National Inventors Hall of Fame, Akron. On a more somber note, the American Police Hall of Fame and Museum, Miami, honors only law enforcement officers who have been killed in the line of duty.

Halls of fame in other countries follow a similar path in their criteria for enshrinement, as indicated by examples from Canada. The Canadian Football Hall of Fame and Museum in Hamilton, Ontario, honors "players and others who have contributed to the development of Canadian Football"; the Aquatic Hall of Fame and Museum of Canada, Winnipeg, inducts individuals who have attained international recognition in aquatics by winning a gold medal in the Olympics or World games or two gold medals in Commonwealth or Pan American games—plus by making a contribution to aquatics over a number of years; and the Saskatchewan Sports Hall of Fame and Museum, Regina, strives "to recognize and preserve the memory of those people who have brought honour to Saskatchewan through their contribution to the world of sport."

ELIGIBILITY REQUIREMENTS

Most halls of fame have specific requirements for eligibility in the consideration of candidates. These ground rules must be met in addition to the merits

of the nomination. They include such requirements as being active in the field for a specified number of years; meeting an age requirement; being retired for a certain number of years; being deceased; or having been born, lived, or active in the hall of fame's geographical area.

The Trapshooting Hall of Fame and Museum in Vandalia, Ohio, will not consider candidates until after 25 years of participation in the sport; the Radio Hall of Fame, Chicago, requires at least ten years of significant contributions for consideration in two induction categories and 20 years in two other categories; and the Indianapolis Motor Speedway Hall of Fame Museum, Indianapolis, has a 20-year participation "waiting period" before consideration.

A player needs to be retired a minimum of five years to be eligible for the Pro Football Hall of Fame, Canton; five years at the International Motorsports Hall of Fame, Talladega; and three years at the National Softball Hall of Fame and Museum, Oklahoma City.

Candidates must have been deceased for at least ten years to be considered for the National Agricultural Center and Hall of Fame, Bonner Springs; five years for the Texas Ranger Hall of Fame and Museum, Waco; 15 years for the National Hall of Fame for Famous American Indians, Anadarko; and five years for the National Mining Hall of Fame and Museum, Leadville.

Nearly all halls of fame that require nominees to have been born, lived, or worked in the area are city or state halls, such as Chicagoland Sports Hall of Fame, Des Plaines; the Arizona Hall of Fame Museum, Phoenix; the Alabama Aviation Hall of Fame, Birmingham; the Florida Sports Hall of Fame and Museum, Lake City; and the Texas Golf Hall of Fame, The Woodlands.

Some halls of fame have multiple eligibility requirements, such as the National Baseball Hall of Fame and Museum, Cooperstown, which states that players must have been active in the major leagues at some time during a period beginning 20 years before and ending five years prior to election; they must have played in ten major league championship seasons; and they must have ceased to be an active player in the major leagues at least five years before consideration. At the Puerto Rico Sports Hall of Fame in San Juan, it is necessary for a candidate to have been born or developed in Puerto Rico, be 40 years of age or older, and have been retired from active participation for the last five years.

To be eligible for selection in the New South Wales Hall of Champions in Australia, the nominee either must have been born in the province or to have represented New South Wales for a substantial part of his or her career. Canada's Sports Hall of Fame in Toronto, on the other hand, requires that a candidate be a Canadian citizen and be either retired from active competition or three years beyond a significant achievement, such as an Olympic gold medal or World championship.

THE SELECTION PROCESS

Hall of fame selections usually are made by the governing board or a selection committee. Sometimes, nominees are voted into the hall of fame by the public or some special group—such as association or foundation members, media representatives, or past inductees. In a few instances, the owner of a privately operated hall of fame or museum makes the selections.

Nominations can come from the public, association or foundation members, board members, nominating committees, or other sources, depending upon a hall of fame's procedures. Among those halls of fame that invite public nominations are the Georgia Aviation Hall of Fame, Warner Robins; the United States National Ski Hall of Fame, Ishpeming; the Naismith Memorial Basketball Hall of Fame, Springfield; the Radio Hall of Fame, Chicago; and the Mountain Bike Hall of Fame and Museum, Crested Butte.

Among the halls of fame that use other nomination methods are the College Football Hall of Fame, South Bend, which accepts nominations only from dues-paying members of the National Football Foundation; at the United States Slo-Pitch Softball Association Hall of Fame Museum, Petersburg, Virginia, nominations and elections are made by state directors and Executive Committee members at the association's annual national meeting. The Harness Racing Museum and Hall of Fame, Goshen, receives nominations only from chapters of the United States Harness Writers Association. The National Aviation Hall of Fame, Wright-Patterson Air Force Base, relies on a board of nominations and its screening committee. The America's Cup Hall of Fame, Bristol, Rhode Island, makes use of a 22-member selection committee for nominations. The Rock and Roll Hall of Fame and Museum, Cleveland, has a small committee of rock and roll historians, critics, and industry professionals for nominations. The Alabama Jazz Hall of Fame Museum, Birmingham, asks current inductees to nominate new candidates.

The election of nominees to halls of fame is most often the responsibility of the governing board, or an appointed committee assigned the task. Among those halls of fame where the board makes such decisions are the Lacrosse Hall of Fame, Baltimore; the Georgia Sports Hall of Fame, Macon; the National Mining Hall of Fame and Museum, Leadville; the Trapshooting Hall of Fame and Museum, Vandalia; the National Cowboy Hall of Fame and Western Heritage Center, Oklahoma City; and the Puerto Rico Sports Hall of Fame, San Juan.

Board-created special committees to select inductees include a committee of board members at Missouri Sports Hall of Fame, Springfield; a committee of industry executives appointed by the board chairman at the RV/MH Hall of Fame, Elkhart, Indiana; a 13-member Honors and Selection Committee named by the board president at the Maine Sports Hall of Fame, Portland; and a board-appointed Hall of Fame Committee at the Roller Skating Hall of Fame, Lincoln.

Sometimes a hall of fame selection committee is part of the bylaws or procedures established for electing inductees. Such committees include the National

Honors Committee, National Women's Hall of Fame, Seneca Falls, New York; the National Induction Committee, National Sprint Car Hall of Fame and Museum, Knoxville; the Honors Court Committee, Virginia Sports Hall of Fame, Portsmouth; and the Hall of Fame Committee, National Softball Hall of Fame and Museum, Oklahoma City.

Inductees also are selected in many other ways. For example, the Texas Ranger Hall of Fame and Museum, Waco, uses a committee of retired Texas Rangers; Inventure Place, Inventors Hall of Fame, Akron, has a National Selection Committee consisting of representatives from national scientific and technical organizations; the Mississippi Sports Hall of Fame and Museum, Jackson, relies on a 10-member committee of the Jackson Touchdown Club. The State of Oregon Sports Hall of Fame Museum, Portland, takes a vote of its membership; the International Motorsports Hall of Fame, Talladega, polls 154 media representatives worldwide; and the International Space Hall of Fame, Alamogordo, depends upon an 11-member Governor's Space Center Commission for its selections.

In a few cases, a single individual makes the hall of fame selections, as occurs at the Appalachian Hall of Fame at the Museum of Appalachia, Norris, where the honorees are chosen by the founder and owner, John Rice Irwin. At the Ted Williams Museum and Hitters Hall of Fame, Hernando, Florida, Ted Williams himself selects inductees in the baseball hitters hall of fame.

A number of halls of fame do not make their own selections but merely pick up honorees from their area inducted into other halls of fame. They include the St. Louis Cardinals Hall of Fame Museum, which simply recognizes St. Louis players in the National Baseball Hall of Fame, Cooperstown, and the Western America Ski Hall of Fame, Soda Springs, California, which includes skiers from that region who have been inducted into the United States National Ski Hall of Fame and Museum, Ishpeming.

Halls of fame in other countries also have a mixture of nominating and electing procedures. Canada's Sports Hall of Fame, Toronto, has a 13-member selection committee that considers nominations from the public at large, while the Canadian Figure Skating Hall of Fame, Gloucester, has a board-appointed selection committee that reviews nominations by members of the figure skating association. A 200-member committee of sports writers nominates and elects inductees for the Professional Baseball Hall of Fame of Mexico in Monterrey, while a single person, Jacob Sherman, makes the selections for the Daredevil Hall of Fame, Niagara Falls, in Canada.

PAID AND VOLUNTEER STAFFS

Most hall of fame museums have small paid staffs and make extensive use of volunteers, while other hall of fame exhibits in larger facilities usually rely almost entirely on volunteers and the staffs associated with the sites—such as sports arenas, civic centers, and museums.

The 150,000-square-foot Rock and Roll Hall of Fame and Museum in Cleveland has the largest paid staff among hall of fame museums, 114 (63 professional and administrative, 28 visitor services, 12 loss-prevention, seven facilities, and four box office). It makes use of only six volunteers. The 220,000-square-foot National Cowboy Hall of Fame and Western Heritage Center, Oklahoma City, ranks next with a 75-member staff, covering curatorial, administration, publishing, store, security, and maintenance areas. It also utilizes approximately 200 volunteers.

Other hall of fame museums with sizable paid staffs include the National Baseball Hall of Fame and Museum, Cooperstown, with 70 full-time and 70 part-time employees (it does not make use of volunteers, but plans to do so); the Country Music Hall of Fame and Museum, Nashville, 50 to 70 employees—depending upon season—including curators, research historians, librarians, archivists, folklorists, and marketing, retail, host, and other personnel (75–80 volunteers); Inventure Place, National Inventors Hall of Fame, Akron, 60 full-time employees, divided into departments of exhibits, development, marketing, and operations (having an unusually high 850 volunteers); the Pro Football Hall of Fame, Canton, 20 full-time and 30 to 50 part-time employees, depending upon season (no volunteer program); the American Police Hall of Fame and Museum, Miami, 22 employees, including director, curator, assistant curator, visitors staff, publications personnel, and support people (nearly 120 volunteers); and the International Tennis Hall of Fame, 20 employees in Newport and New York City offices and 20 seasonal in Newport (125 volunteers).

Among those facilities in the middle range as to number of staff members are the Texas Ranger Hall of Fame and Museum, Waco, 13 employees, including director, curator, library/archivist, and support personnel (no volunteer program); the Lacrosse Hall of Fame Museum, Baltimore, 11 staff members (eight volunteers); the Harness Racing Museum and Hall of Fame, Goshen, 11 full-time employees (six volunteers); the Alabama Music Hall of Fame, Tuscumbia, 11 employees (30 volunteers); the National Museum of Racing and Hall of Fame, Saratoga Springs, ten full-time and five part-time employees (35 volunteers); the National Fresh Water Fishing Hall of Fame, Hayward, nine employees, including executive director, business manager, secretary, mail clerk, three sales clerks, and two maintenance persons (four volunteers); the College Football Hall of Fame, South Bend, seven employees, including executive director, marketing director, group sales and special events manager, publicity director, audiovisual coordinator, volunteer coordinator, and collections manager (70 volunteers); the International Swimming Hall of Fame, Fort Lauderdale, six full-time and five part-time employees (20 to 200 volunteers, depending upon the season); and the International Bowling Museum and Hall of Fame, St. Louis, five full-time and seven part-time employees (two volunteers).

A number of hall of fame museums have only one or a few paid staff members. They include the Clown Hall of Fame and Research Center, Delavan, one full-time employee (four volunteers); the South Carolina Criminal Justice Hall

of Fame, Columbia, one to two full-time and four part-time employees (no volunteer program); the Saratoga Harness Racing Museum and Hall of Fame, Saratoga Springs, two full-time employees, including a director and assistant (five volunteers); the Aviation Hall of Fame and Museum of New Jersey, Teterboro, two full-time and one part-time employee (30 volunteers); the Volleyball Hall of Fame, Holyoke, Massachusetts, two full-time and one part-time employee (40 volunteers); the Lea County Cowboy Hall of Fame and Western Heritage Center, Hobbs, two full-time employees, including a director and secretary (no volunteer program); United States Hockey Hall of Fame, Eveleth, three full-time and one part-time employee (25 volunteers); the National Sprint Car Hall of Fame and Museum, Knoxville, three full-time employees, including an executive director, marketing director, and executive assistant (15 regular and 25 seasonal volunteers); and the Saints Hall of Fame Museum, Kenner, four part-time employees (25 volunteers).

A considerable number of small halls of fame do not have any paid staff members. Among those that are staffed entirely by volunteers are the World Kite Museum and Hall of Fame, Long Beach, Washington (15 volunteers); the All-American Soap Box Derby Museum and Hall of Fame, Akron (10 volunteers); the International Snowmobile Racing Hall of Fame, Saint Germain (20 volunteers); the Pro Beach Volleyball Hall of Fame, Clearwater (eight volunteers); South Carolina Tennis Hall of Fame, Belton (20 volunteers); and National Hall of Fame for Famous American Indians, Anadarko (four volunteers).

The paid or volunteer staffs are minimal or nonexistent at some halls of fame located at museums or unconventional sites whose personnel provide assistance. Examples include the Senior Athletes Hall of Fame, with one employee and four volunteers, which is located at a retirement village in Bradenton, Florida; the National Agricultural Aviation Museum, without its own staff, is part of a 20-person museum complex in Jackson, Mississippi; and the National Fish Culture Hall of Fame, with no full-time staff and 20 part-time guides, is in a partnership with the D. C. Booth National Historic Fish Hatchery in Spearfish, South Dakota.

A number of halls of fame are galleries in parent museums that furnish whatever staff services are needed. They include the National Rivers Hall of Fame in the Mississippi River Museum, Dubuque, Iowa, which has ten full-time and 40 part-time employees, and 200 volunteers; the International Space Hall of Fame in The Space Center, Alamogordo, having 33 full-time and part-time employees and 50 volunteers; the Agricultural Hall of Fame in the National Agricultural Center and Hall of Fame, Bonner Springs, with 25 full-time and part-time employees and 200 volunteers; and the International Aerospace Hall of Fame in the San Diego Aerospace Museum, which has 15 full-time and 15 part-time employees, and 300 volunteers.

A wide range of staffing and uses of volunteers also can be found in halls of fame in other countries. In Canada, for instance, the Hockey Hall of Fame in

Toronto has 25 full-time and 50 part-time employees, and five volunteers; Canada's Sports Hall of Fame, Toronto, three full-time and six seasonal part-time employees (no volunteer program); the Olympic Hall of Fame and Museum, Calgary, three full-time professionals and 65 volunteers; the Naismith International Basketball Centre and Hall of Fame, Almonte, two part-time employees and 75 volunteers; the Canadian Figure Skating Hall of Fame, Gloucester, one part-time archivist/curator (no volunteer program); Canada's Aviation Hall of Fame, located in a hangar at the Reynolds-Alberta Museum, Wetaskiwin, one curator/director and 100 volunteers; and the Aquatic Hall of Fame and Museum of Canada, Winnipeg, one part-time curator and 15 volunteers, with the city providing the building maintenance.

COSTS AND FUNDING

It takes more money today to start, constuct, and operate hall of fame museums and exhibits than ever before. In earlier days, it was possible to launch a hall of fame with a few thousand dollars and even build a facility for less than a million dollars. That rarely is the case today.

The cost of a hall of fame building varies greatly, depending upon the size and contents. Among the costs of some recent homes for halls of fame are the National Aviation Hall of Fame, Wright-Patterson Air Force Base, $6 million; the Indiana Basketball Hall of Fame, New Castle, $2.1 million; the College Football Hall of Fame, South Bend, $14 million; the Mississippi Sports Hall of Fame and Museum, Jackson, $4.5 million; the Naismith Memorial Basketball Hall of Fame, Springfield, $11.5 million; Inventure Place, Inventors Hall of Fame, Akron, $38 million; the Rock and Roll Hall of Fame and Museum, $92 million; and the Hockey Hall of Fame, Toronto, $15 million.

The operating budgets of hall of fame museums and exhibits range from a few thousand dollars to over $5 million annually. Sources of operating funds also vary greatly, with individual and corporate contributions; association, foundation, and government support; special events; admissions and other earned income being the most common methods of funding.

The largest budgets are those of some of the biggest and most active hall of fame museums. Among the institutions with budgets of over $5 million are the Country Music Hall of Fame and Museum, Nashville; Inventure Place, National Inventors Hall of Fame, Akron; and the American Police Hall of Fame and Museum, Miami. Close behind is the National Cowboy Hall of Fame and Western Heritage Center, Oklahoma City, with a $4.5 million annual budget.

Other hall of fame museums with budgets in excess of $1 million include the International Tennis Hall of Fame, Newport, $3 million; the Pro Football Hall of Fame, Canton, $2.88 million; the National Museum of Racing and Hall of Fame, Saratoga Springs, $1.35 million; the College Football Hall of Fame, South Bend, $1.3 million; and the Lacrosse Hall of Fame Museum, Baltimore, $1.2 million.

Among the hall of fame museums in the $500,000–$600,000 budgetary tier are the National Soccer Hall of Fame, Oneonta; the Texas Ranger Hall of Fame and Museum, Waco; the International Motorsports Hall of Fame, Talladega; the International Swimming Hall of Fame, Fort Lauderdale; the National Sprint Car Hall of Fame and Museum, Knoxville; and the Alabama Music Hall of Fame, Tuscumbia.

Those facilities with annual budgets in the $200,000–$350,000 range include the National Mining Hall of Fame and Museum, Leadville, Colorado; the Missouri Sports Hall of Fame, Springfield; the Georgia Sports Hall of Fame, Macon; the Texas Sports Hall of Fame, Waco; the United States Hockey Hall of Fame, Eveleth; the National Fresh Water Fishing Hall of Fame, Hayward; the National Wrestling Hall of Fame, Stillwater; the National Women's Hall of Fame, Seneca Falls; the United States National Ski Hall of Fame and Museum, Ishpeming; the State of Alabama Sports Hall of Fame, Birmingham; and the Indiana Basketball Hall of Fame, New Castle.

Some of the hall of fame museums with $100,000 to $200,000 budgets are the Alabama Jazz Hall of Fame Museum, Birmingham; the Florida Sports Hall of Fame and Museum, Lake City; the Maine Sports Hall of Fame, Portland; the Aviation Hall of Fame and Museum, Oklahoma City; and the South Carolina Criminal Justice Hall of Fame, Columbia.

Many of the smaller hall of fame museums and exhibits have budgets of less than $100,000, including the Volleyball Hall of Fame, Holyoke, $80,000; the United States Bicycling Hall of Fame, Somerville, $65,000; the Marbles Hall of Fame, Wildwood, $25,000; the Pro Beach Volleyball Hall of Fame, Clearwater, $15,000; the National Fish Culture Hall of Fame, Spearfish, $7,000; and the Family Camping Hall of Fame, Allenstown, New Hampshire, $2,000.

The budgets of hall of fame museums and exhibits in other countries are modest in comparison to their American counterparts. In Canada, the Olympic Hall of Fame and Museum, Calgary, and Canada's Sports Hall of Fame, Toronto, have operating budgets of $300,000. Other budgets include $180,000 for the Naismith International Basketball Centre and Hall of Fame, Almonte; $90,000 for the Canadian Figure Skating Hall of Fame, Gloucester; and $25,000 for the Aquatic Hall of Fame and Museum of Canada, Winnipeg.

SOURCES OF FUNDS

Like nearly all museums, hall of fame museums depend upon a mixture of income and support. The basic earned income usually consists of admissions, membership dues, and gift shop sales. It sometimes is supplemented by programming fees, food sales, licensing, endowment, income, publishing, building rentals, or special events. However, it almost always requires additional support, such as contributions, grants, sponsorships, or appropriations, to balance the budget.

Among those hall of fame museums that have diverse funding resources are the Inventure Place, National Inventors Hall of Fame, Akron, which depends

upon individual and corporate contributions, foundation grants, admissions, memberships, sponsorships, building rentals, and special projects to meet its $5 million annual budget. The Country Music Hall of Fame and Museum, Nashville, with a similar-sized budget, relies on admission fees, gift shop sales, private and public support, and special products, such as records, books, and other museum-produced materials. The College Football Hall of Fame, South Bend, funds its $1.3 million budget through sponsorships, donations, admissions, special events, and hotel and motel tax funds. Even smaller halls of fame frequently find it necessary to have broad-based funding, such as the Florida Sports Hall of Fame and Museum, Lake City, with a $160,000 budget, which has a statewide televised auction, sponsorship, state support, and individual and business contributions, as well as admissions and gift shop income. '

Most hall of fame museums have fewer sources of funding. For example, the National Fresh Water Fishing Hall of Fame, Hayward, receives nearly all of its funds from admissions, memberships, and contributions; the National Baseball Hall of Fame and Museum, Cooperstown, admissions, gift shop sales, and donations; the Texas Sports Hall of Fame, Waco, contributions, admissions, and fundraising events; and the Naismith Memorial Basketball Hall of Fame, Springfield, memberships, admissions, and gift shop sales.

Some halls of fame depend largely upon only two principal funding sources, as with the Pro Football Hall of Fame, Canton, which relies on admissions and museum store sales; the National Women's Hall of Fame, Seneca Falls, memberships and contributions; the International Swimming Hall of Fame, Fort Lauderdale, memberships and sponsorships; and the South Carolina Tennis Hall of Fame, Belton, contributions and funding from the South Carolina Tennis Patrons Foundation.

A number of hall of fame museums have a single major funding source, including the National Softball Hall of Fame and Museum, Oklahoma City, admissions; the Hall of Fame for Great Americans, Bronx, grants; the Water Ski Hall of Fame and Museum, Winter Haven, contributions; the Pro Beach Volleyball Hall of Fame, Clearwater, memberships; and the Television Academy Hall of Fame, North Hollywood, funded by the Academy of Television Arts and Sciences.

Government funds provide all or most of the operating budgets for city, state, or federally initiated halls of fame. They include the city-funded Alabama Jazz Hall of Fame Museum, Birmingham; the state-supported Arizona Hall of Fame Museum, Phoenix; and the federally operated National Statuary Hall, Washington, D.C. In some cases, nongovernmental halls of fame also are helped financially, such as the Virginia Sports Hall of Fame, Portsmouth, supported by city and state appropriations, membership dues, and private contributions. The Rock and Roll Hall of Fame and Museum, Cleveland, gets funding from city, county, and state governments to supplement admission, merchandise, and licensing revenue, foundation grants, and individual and corporate contributions.

A few hall of fame museums have endowments that produce a portion of

their incomes. Among such rare institutions are the National Museum of Racing and Hall of Fame, Saratoga Springs, supported by admissions, gift shop sales, endowment income, and fundraising efforts; and the Harness Racing Museum and Hall of Fame, Goshen, funded largely through industry contributions, private support, and endowment income.

Many more halls of fame make use of fundraising events, such as silent auction and tournaments by the Trapshooting Hall of Fame and Museum, Vandalia; golf and basketball tournaments and induction banquets by the Indiana Basketball Hall of Fame, New Castle; raffles and special events at basketball, baseball, and football games by the Maine Sports Hall of Fame, Portland; golf outings and annual raffles by the RV/MH Hall of Fame, Elkhart; and hall of fame awards dinners and other special events, at the Radio Hall of Fame, Chicago.

ADMISSIONS, MEMBERSHIPS, ATTENDANCE

Most hall of fame museums and exhibits do not have an admission charge, but more than one-third depend upon admission fees for part of their funding. Admissions range from a nominal dollar or two at such places as the World Kite Museum and Hall of Fame, Long Beach, Washington, $1; the Harness Racing Museum and Hall of Fame, Goshen, $1.50; and the Indianapolis Motor Speedway Hall of Fame Museum, $2, to $9.95 at the U.S. Astronaut Hall of Fame, Titusville, Florida; $10 at the International Drag Racing Hall of Fame, Ocala, Florida; and $12.95 at the Rock and Roll Hall of Fame and Museum, Cleveland. More typically, admissions are in the $3 to $6 range, as at the National Women's Hall of Fame, Seneca Falls, $3; the Missouri Sports Hall of Fame, Springfield, $5; and the American Police Hall of Fame and Museum, Miami, $6.

Approximately one-fifth of the halls of fame have membership programs. The Rock and Roll Hall of Fame and Museum, Cleveland, has the largest number of members by far, with over 67,000. Ranking next is the National Cowboy Hall of Fame and Western Heritage Center, Oklahoma City, with 9,000; the Television Academy Hall of Fame, North Hollywood, 8,500; and the National Fresh Water Fishing Hall of Fame, Hayward, 6,500. Some memberships total less than 100, including the Alabama Jazz Hall of Fame Museum, Birmingham, at 25, and Texas Sports Hall of Fame, Waco, 42.

The attendance at halls of fame varies greatly, with the largest and best known receiving the most visitors. The most popular hall of fame museum is the Rock and Roll Hall of Fame and Museum, Cleveland, with an attendance of approximately 1 million, while the Business Hall of Fame has the highest potential exposure as an exhibit at Chicago's Museum of Science and Industry, having an annual attendance of over 2 million. Another place seen by many—perhaps a million or more, although no count is kept—is the Hollywood Walk of Fame, the sidewalk tribute to entertainment stars in Hollywood.

Among the other halls of fame with substantial attendances are the National Baseball Hall of Fame and Museum, Cooperstown, 400,000; the National Cowboy Hall of Fame and Western Heritage Center, Oklahoma City, more than 300,000; the Indianapolis Motor Speedway Hall of Fame Museum, 300,000; Inventure Place, National Inventors Hall of Fame, Akron, Ohio, 300,000; the Country Music Hall of Fame and Museum, Nashville, 250,000; the Pro Football Hall of Fame, Canton, 225,000. At least four halls are at 200,000: the International Aerospace Hall of Fame, San Diego; the International Space Hall of Fame, Alamogordo; the NMPA Stock Car Hall of Fame/Joe Weatherly Museum, Darlington, South Carolina; and the Radio Hall of Fame, Chicago.

Many of the smaller hall of fame museums and exhibits, especially those located some distance from populated areas, receive a few thousand or fewer visitors a year. They include the South Carolina Tennis Hall of Fame, Belton, 500; the New York Jewish Sports Hall of Fame, Commack, New York, 600; the Family Camping Hall of Fame, Allenstown, 1,000; the Trapshooting Hall of Fame and Museum, Vandalia, 1,200; the Singlehanded Sailors Hall of Fame, Newport, 1,500; and the United States Slo-Pitch Softball Association Hall of Fame Museum, Petersburg, 2,000.

Halls of fame in other countries have this same diversity in funding, admissions, and attendance. The main difference is in membership programs, which can be found at only a handful of Canadian museums—such as the Hockey Hall of Fame, Toronto, which has 500 members; the Naismith International Basketball Centre and Hall of Fame, Almonte, over 400; and Canada's Aviation Hall of Fame, Wetaskiwin, 200.

The national monuments in most European countries are funded by the national governments, but independent halls of fame on the Continent and elsewhere rely on various income and support sources. In Canada, the Hockey Hall of Fame is supported basically by the founding sponsoring organizations; the Naismith International Basketball Centre and Hall of Fame is funded largely by donations, programs, merchandising, and sponsorship; Canada's Aviation Hall of Fame, Wetaskiwin, donations and grants; Canada's Sports Hall of Fame, Toronto, receives 30 percent of its budget from the local government and must obtain 60 percent through fundraising; the Daredevil Hall of Fame, Niagara Falls, primarily admission fees; and the Canadian Figure Skating Hall of Fame, Gloucester, the Canadian Figure Skating Association.

Approximately half of the halls of fame in other countries have admission fees, such as $6.75 at the Daredevil Hall of Fame and $8.75 at the Hockey Hall of Fame in Canada; 400 yen at the Japanese Baseball Hall of Fame, Tokyo; 10 Deutsche marks at the Deutsches Museum (home of the Ehrensaal), Munich; and 4 pounds at Westminster Abbey, London.

The national halls of heroes in Europe attract the most visitors among halls in other countries, as well as the Ehrensaal at the Deutsches Museum, which has an annual attendance of 1.3 million. Other halls with considerable numbers of visitors include the Aquatic Hall of Fame and Museum of Canada, Winnipeg,

more than 400,000; the Hockey Hall of Fame, Toronto, 300,000; the Professional Baseball Hall of Fame of Mexico, Monterrey, 145,000; the Japanese Baseball Hall of Fame and Museum, Tokyo, 130,000; and Canada's Sports Hall of Fame, Toronto, 100,000.

NO SINGLE PATTERN

Halls of fame museums and exhibits differ widely in their founding, locations, governing, staffing, funding, attendance, and overall operations. Yet they basically have a common objective—to honor achievement in a particular field by perpetuating the memory of the inductees, and often to inform the visiting public about the nature, history, and importance of the field.

The pre-twentieth-century versions of halls of fame were started as tributes to a nation's outstanding figures. In this century, halls of fame became more individualized, being started by interested persons and groups, professional associations, local and state governments, chambers of commerce, and others. They are in popular sports fields like baseball, basketball, and football, and in such lesser-known fields as field hockey, racquetball, and skeet shooting. They honor exceptional achievement in many other fields, including agriculture, aviation and space, business and industry, invention, law enforcement, music, radio and television, and western heritage. Also, they are local, statewide, regional, ethnic, national, or international in scope.

The sites of hall of fame museums and exhibits range from a wall of plaques or photographs to a comprehensive museum containing collections of artifacts, memorabilia, dioramas, films, videos, and interactive exhibitry. They are funded by admissions, memberships, gift shop sales, contributions, grants, appropriations, programming fees, special events, building rentals, endowment income, and in many other ways; each hall of fame relies upon the mixture that works best for that field, location, and set of circumstances.

The number of visitors makes the difference between financial success or failure in some cases, but attendance may have less impact in other instances where the costs are largely covered by contributions, grants, appropriations, or subsidies and where supporters are more interested in the cause and having a place to tell the story.

Hall of fame museums and exhibits play a vital role in recognizing outstanding achievement and furthering the advancement of a field. They also set a standard, provide a goal for participants in the field, and make it possible for ardent followers and the general public to bring back memories, pay homage to heroes, learn more about honorees and the field, and spend an enjoyable hour or two in today's rapidly changing world.

Chapter 4

Telling the Story

People go to hall of fame museums and exhibits primarily to see the exhibits about those enshrined and the related field. Many visitors also participate in the public programming and special events offered by the halls of fame. It is these exhibits, programs, and events that are the core of how any hall of fame communicates its story.

The early versions of halls of fame consisted almost entirely of busts of national heroes, sometimes supplemented by plaques and statues. This was so at Westminster Abbey in England, the Panthéon in France, and Walhalla and Ruhmeshalle in Germany. The first two halls of fame in the United States followed this pattern of exhibitry—statues at the National Statuary Hall in Washington, D.C., and busts at the Hall of Fame for Great Americans in the Bronx, New York.

Today, some halls of fame, in addition to these forerunners, still consist almost entirely of busts, statues, or plaques. For example, the National Hall of Fame for Famous American Indians in Anadarko, Oklahoma, relies on busts, and the Television Academy Hall of Fame in North Hollywood, California, features busts and statues. Many other halls of fame are principally walls of plaques, such as the U.S. Racquetball Hall of Fame, Colorado Springs; the Western America Ski Hall of Fame, Soda Springs, California; and the Delaware County Athletes Hall of Fame, Brookhaven, Pennsylvania.

However, it is far more common for busts, statues, and plaques to be only part of contemporary hall of fame museums and exhibits. Busts of inductees are included among the exhibits at the Pro Football Hall of Fame, Canton, Ohio; the Motorsports Museum and Hall of Fame of America, Novi, Michigan; and the Saints Hall of Fame Museum, Kenner, Louisiana. A statue of Ted Williams dominates the Ted Williams Museum and Hitters Hall of Fame, Hernando, Flor-

Hall of fame inductees most often are recognized with plaques, as is the case at the National Softball Hall of Fame and Museum in Oklahoma City. The hall of fame was established in 1957, with the 10,114-square-foot museum opening in 1973. Courtesy National Softball Hall of Fame and Museum.

ida, and statuettes of drivers, breeders, and other honorees are featured at Harness Racing Museum and Hall of Fame, Goshen, New York. Plaques describe inductees at the North Carolina Sports Hall of Fame, Raleigh, the International Afro-American Sports Hall of Fame and Gallery, Detroit, and many other halls. Instead of bronze plaques, some halls of fame use photographs of honorees with biographical information, such as at the Trapshooting Hall of Fame and Museum, Vandalia, Ohio, or portraits, as does the South Carolina Tennis Hall of Fame, Belton.

EMPHASIS ON EXHIBITS

Nearly all hall of fame museums and exhibits devote most of their space to exhibits about those enshrined and often about the field. This is especially true of the smaller halls of fame that do not have large collections and staffs nor operate libraries, archives, restaurants, or other such services. The bigger hall of fame museums have more extensive exhibits, but the percentage of exhibit space usually is less because of other space needs.

Smaller halls of fame with much of their space going for exhibits include the Shreveport–Bossier City Sports Museum of Champions, Shreveport, Louisiana, all of its 800 square feet; the Water Ski Hall of Fame and Museum, Winter Haven, Florida, 3,500 of 4,000 square feet; and the Mississippi Music Hall of

Fame, Jackson, 9,000 of 10,000 square feet. Among the larger halls of fame, the Country Music Hall of Fame and Museum, Nashville, uses 17,000 of 35,000 square feet for exhibits; the National Baseball Hall of Fame, Cooperstown, New York, 50,000 of 80,000; and the College Football Hall of Fame, South Bend, Indiana, 35,000 of 58,000.

Exhibits range from modest panels with photographs and information about recipients to more elaborate displays of artifacts, memorabilia, artwork, replicas, and other historical materials—frequently with films, videos, multimedia presentations, dioramas, participatory games, interactive computers, and other such high-interest techniques. In general, the larger and more comprehensive the hall of fame, the more extensive and sophisticated the exhibitry. In some cases, the exhibits are produced internally, but more often they are designed and fabricated by contractors.

Among those halls of fame that rely largely on panel exhibits are the National Women's Hall of Fame, Seneca Falls, New York, which also displays artifacts; the United States National Ski Hall of Fame and Museum, Ishpeming, Michigan, supplemented with artifacts and trophies; and the Senior Athletes Hall of Fame, Bradenton, Florida, featuring poster-type exhibits.

Photographs are the most prevalent elements of hall of fame exhibits. Sometimes they are merely mounted on panels or walls, as occurs at the Route 66 Hall of Fame, McLean, Illinois; the Singlehanded Sailors Hall of Fame, Newport, Rhode Island; and the Gallery of Also Rans, Norton, Kansas. Enlarged or illuminated photos are utilized in other instances, such as at the National Baseball Hall of Fame and Museum, Cooperstown, and the Rock and Roll Hall of Fame and Museum, Cleveland.

Films, videos, and multimedia presentations also are offered by many halls of fame. At the ProRodeo Hall of Champions and Museum of the American Cowboy, Colorado Springs, a multimedia orientation program takes visitors on a historical trip through the early West, while the Mississippi River Museum (which includes the National Rivers Hall of Fame), Dubuque, Iowa, has a 15-minute, two-screen film featuring the sights and sounds of the Mississippi, with artifacts and special effects bringing the river to life. Theaters can be found at many other halls of fame, including the Naismith Basketball Hall of Fame, Springfield, Massachusetts, which features the multi-screen film *Hoopla* on the diversity and popularity of basketball; the Texas Golf Hall of Fame, The Woodlands, where the film *Share the Greatness* describes the history of Texas golf; and the Pro Football Hall of Fame, Canton, which projects its film *100-Yard Universe* on game-day action on a huge, 20-by-42-foot Cinemascope screen.

Among the many other audiovisual offerings are video clips of memorable moments in Alabama sports at the State of Alabama Sports Hall of Fame, Birmingham; hockey films that can be requested by visitors for showing, at the United States Hockey Hall of Fame, Eveleth, Minnesota; and filmed highlights of college and professional sports at the Texas Sports Hall of Fame, Waco.

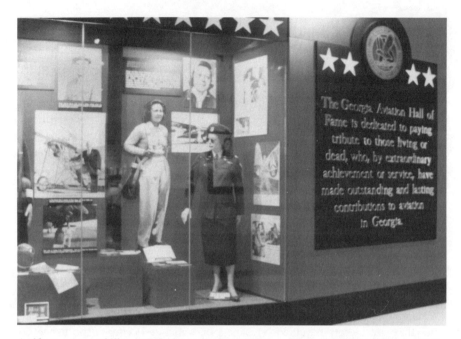

Artifacts, memorabilia, and photographs frequently are featured in hall of fame exhibits, as shown here at the Georgia Aviation Hall of Fame, located in the Museum of Aviation in Warner Robins. Courtesy Georgia Aviation Hall of Fame.

HISTORICAL STOREHOUSES

Many hall of fame museums and exhibits contain a wealth of personal memorabilia, artifacts, and other historical items pertaining to the inductees and the field. They often include uniforms, equipment, awards, vehicles, contracts, dairies, costumes, instruments, manuscripts, correspondence, or other such materials.

Sports and music halls of fame are especially strong in memorabilia. Among the halls with extensive memorabilia collections and exhibits are the National Baseball Hall of Fame and Museum, which makes use of over 1,000 memorabilia, photographs, and items of early equipment such as balls, bats, gloves, and catcher's gear in tracing the history of baseball; and the Country Music Hall of Fame and Museum, where more than 5,000 memorabilia, artifacts, and other historical materials, including costumes, instruments, and original song manuscripts, are exhibited.

Many of the smaller sports and music halls of fame also have considerable memorabilia and artifacts, including the International Boxing Hall of Fame, Canastota, New York, with boxing gloves, robes, and other belongings of famous fighters; the State of Alabama Sports Hall of Fame, Birmingham, which

has World Series baseball, Super Bowl football, U.S. Open golf, and other trophies and memorabilia; the National Freshwater Fishing Hall of Fame and Museum, Hayward, Wisconsin, with approximately 350 antique and classic outboard motors, 400 mounted fish, 6,000 dated lures, 1,000 reels, hundreds of rods, and numerous boats; and the Alabama Music Hall of Fame, Tuscumbia, with costumes, instruments, and even Elvis Presley's original recording contract.

Museums with halls of fame in other fields frequently have extensive collections and exhibits of artifacts, such as the National Agricultural Center and Hall of Fame (site of the National Farmers Memorial) Bonner Springs, Kansas, containing more than 30,000 agricultural and rural-living artifacts, including tractors, threshers, plows, wagons, and various farm implements; and the Museum of Appalachia (home for the Appalachian Hall of Fame), Norris, Tennessee, with over 250,000 relics of the past from the region.

Motor sports museums and halls of fame usually have a historical emphasis, with displays of racing cars driven by the enshrined and others in the field. They include the Indianapolis Motor Speedway Hall of Fame Museum, Indianapolis, which exhibits 75 Indy and other racing vehicles—one-third of its collection; the International Motorsports Hall of Fame, Talladega, Alabama, displaying over 100 racing cars; and Don Garlits Museum of Drag Racing (home of the International Drag Racing Hall of Fame), Ocala, Florida, with more than 90 racing cars and 50 other vehicles.

Some of the largest historical objects are found at aviation and space museums that are the sites of halls of fame, such as the EAA Air Adventure Museum (home for six aviation-related halls of fame), Oshkosh, Wisconsin, which has a collection of 267 planes, with over 90 on display at any time; the Museum of Aviation (site of the Georgia Aviation Hall of Fame), Warner Robins, with 85 aircraft from World War I to the present; and the San Diego Aerospace Museum, San Diego (where the International Aerospace Hall of Fame is located), with many restored planes and replicas of the *Wright Flyer*, Lindbergh's *Spirit of St. Louis*, and various World War I and II and other aircraft. Perhaps the largest historic craft at any hall of fame museum is the National Landmark steamboat *William M. Black* at the Mississippi River Museum (which includes the National Rivers Hall of Fame) in Iowa.

Some halls of fame or museums have actual or re-created historical settings. Such examples include FarmTown U.S.A., featuring a relocated one-room schoolhouse, a century-old train depot, and a four-generation blacksmith shop at the National Agricultural Center and Hall of Fame in Kansas; a re-created Old West town with a boardwalk, gunshop, general store, saddle shop, hotel, blacksmith shop, and marshal's office, as well as an authentic sod house, chuck wagon, sheepherder's wagon, and simulated gold mine at National Cowboy Hall of Fame and Western Heritage Center in Oklahoma; restored log cabins at the Museum of Appalachia (where the Appalachian Hall of Fame is located); and the restored oldest surviving recording studio in Nashville and one of the oldest

working letterpress poster print shops in America at the Country Music Hall of Fame and Museum in Tennessee.

RANGE OF EXHIBITRY

Exhibit techniques at halls of fame range from simple displays of memorabilia and artifacts to some of the most advanced exhibitry in the museum field. In addition to the plaques, panels, photographs, and audiovisual presentations mentioned earlier, halls of fame make use of cases, artworks, dioramas, models, replicas, walk-throughs, timelines, touch screens, computer games, participatory activities, and even virtual reality as exhibit techniques.

The most common form of exhibit is to place photographs, memorabilia, artifacts, and information about honorees in cases, as occurs at the Virginia Sports Hall of Fame, Portsmouth, which has a separate case for each of its 155 inductees; the Labor Hall of Fame, Washington, D.C., where several of the enshrined are highlights in each kiosk case; and the Tom Kearns University of Miami Sports Hall of Fame, Coral Gables, Florida, with 21 glass cases with memorabilia and trophies received or used by many of the inducted athletes.

Artworks pertaining to the sport or other field to which the hall of fame is dedicated are displayed in exhibit halls or art galleries in a surprising number of facilities. They include an extensive collection of Western artworks by such noted artists as Charles M. Russell, Frederic Remington, and Charles Schrey-vogel, and five of the world's largest Western landscape paintings at the National Cowboy Hall of Fame and Western Heritage Center, Oklahoma City; paintings depicting historical and oil industry subjects at the Permian Basin Petroleum Museum, Library, and Hall of Fame, Midland, Texas; portraits of Presidents George Washington and Andrew Jackson, who were involved in thoroughbred racing, and an entire gallery devoted to the works of Edward Troye, one of the leading equine artists, at the National Museum of Racing and Hall of Fame, Saratoga Springs, New York; and paintings in which croquet is an element at the National Croquet Hall of Fame, located in the Newport Art Museum in Rhode Island.

Miniature and full-scale dioramas are used at some halls of fame, including the National Mining Hall of Fame and Museum, Leadville, Colorado, which has 22 hand-carved miniature dioramas of gold mining scenes, and the State of Alabama Sports Hall of Fame, Birmingham, where six life-like dioramas depict sports figures and scenes.

Models and replicas sometimes are found in aviation and space museums, such as the San Diego Aerospace Museum (home of the International Aerospace Hall of Fame), which has both models and replicas of airplanes, and the Meteor Crater Museum of Astrogeology (where the Astronaut Hall of Fame is located), Winslow, Arizona, with models of spacecraft. It also is not unusual to replicate locker rooms in sports halls of fame, as is done at the College Football Hall of Fame in Indiana, the Naismith Memorial Basketball Hall of Fame in Massachu-

One of the features of the International Bowling Museum and Hall of Fame in St. Louis is four reproduced 1924 bowling lanes with human pinsetters where visitors can bowl for a nominal fee. The hall of fame/museum also has contemporary bowling lanes with automatic pinsetters for use by visitors. Courtesy International Bowling Museum and Hall of Fame, St. Louis, Mo.

setts, and the Green Bay Packer Hall of Fame, in Wisconsin. The National Mining Hall of Fame and Museum has walk-through replicas of underground coal and hard-rock mines in Colorado. The replicated Western town at the National Cowboy Hall of Fame and Western Heritage Center in Oklahoma is designed for visitors to pass through.

Timelines can be effective in tracing the development of a field and pointing out the historical milestones and often the significant achievements of honorees. Among the halls of fame using such an approach are the International Bowling Museum and Hall of Fame, St. Louis; the Texas Tennis Hall of Fame, Waco; and the Lea County Cowboy Hall of Fame and Western Heritage Center, Hobbs, New Mexico.

"HANDS-ON" EXHIBITS

The most popular exhibits at halls of fame are usually those where the visiting public can participate or interact—the so-called "hand-on" exhibits. Visitors seem to enjoy dynamic exhibits more than static ones, almost regardless of the subject matter. Among the more common exhibits of this type at halls of fame are participatory games, computerized access to information, touch-screen videos, and such new techniques as interactive-theater decision making and virtual reality.

Participatory exhibits take many forms, such as sitting in and pretending to drive a stock car at the Motorsports Museum and Hall of Fame of America, Novi; shooting basketballs and testing skills against hall of famers at the Naismith Memorial Basketball Hall of Fame, Springfield; trying to solve a crime at a simulated crime scene in the American Police Hall of Fame and Museum, Miami; bowling on old-time and contemporary lanes at the International Bowling Museum and Hall of Fame, St. Louis; and making up and acting as a clown at the Clown Hall of Fame and Research Center, Delavan, Wisconsin.

Inventure Place, National Inventors Hall of Fame in Akron, Ohio, has a 20,000-square-foot "Inventors Workshop" exhibit area with interactive exhibits ranging from lasers to strobe lights. It also enables visitors to experiment by building a sound system, taking apart a dishwasher, putting together a computer, constructing a dam and locks, and engaging in other such creative hands-on activities.

Computerized exhibits can be found at many halls of fame. They make it possible to retrieve information about inductees and other outstanding bowlers at the International Bowling Museum and Hall of Fame, St. Louis; learn about football's colorful traditions and to test one's football strategy at the College Football Hall of Fame, South Bend; play a basketball trivia game with a computer at the Indiana Basketball Hall of Fame, New Castle; and interact with a series of touch-screen information-delivery kiosks at the Mississippi Sports Hall of Fame and Museum, Jackson. Some halls of fame, including the State of Alabama Sports Hall of Fame, Birmingham, and the International Tennis Hall of Fame and Museum, Newport, Rhode Island, also make use of interactive videos.

The Pro Football Hall of Fame, Canton, has a "QB-1 Call-the-Play Theater" exhibit that will allow up to ten people to compete simultaneously in play calling, while the Naismith Memorial Basketball Hall of Fame, Springfield, and the U.S. Astronaut Hall of Fame, Titusville, Florida, have virtual reality exhibits where visitors can play a basketball hall of famer or float free of the Earth's gravity in the Skylab space station.

TYPES OF EXHIBITS

Halls of fame have two basic types of exhibitions—permanent and temporary. The permanent ones are long-term exhibits of more than two or three years duration, while temporary exhibitions are short-term, ranging from several months to a couple of years. Most exhibits in halls of fame are of the permanent variety, including the enshrinement hall and related exhibits on inductees and the history and development of the field. These exhibits usually are updated, refurbished, and even redesigned periodically and are the heart of hall of fame offerings. Temporary exhibitions are generally used to fill gaps or to supplement permanent exhibits and give the public a reason for visiting or making return visits to the hall of fame.

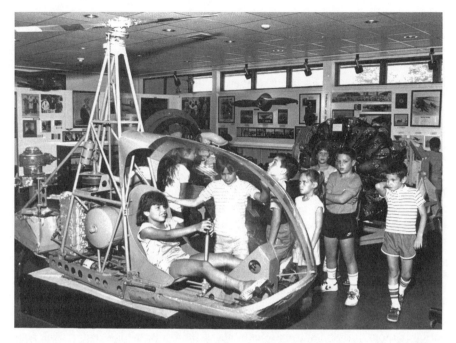

Hands-on experiences increasingly can be found at halls of fame. In this photo, children enjoy "flying" a cutaway helicopter in the educational center of the Aviation Hall of Fame and Museum of New Jersey at the Teterboro Airport. Courtesy Aviation Hall of Fame and Museum of New Jersey.

In addition to the plaques, busts, photographs, or portraits of inductees in the hall honoring the enshrined, most halls of fame have a number of related long-term exhibits using one or more of the preceding exhibit techniques. These include exhibits on the development of ropes, saddles, chaps, boots, and other cowboy gear over the last century at the ProRodeo Hall of Fame and Museum of the American Cowboy, Colorado Springs; more than 200 American racing colors at the National Museum of Racing and Hall of Fame, Saratoga Springs; a jazz band stage setting that honors Alabama musicians in famous bands at the Alabama Jazz Hall of Fame Museum, Birmingham; over 25 restored sprint cars at the National Sprint Car Hall of Fame and Museum, Knoxville; gold specimens, documents, photographs, and artifacts relating to the nation's 17 gold rushes at the National Mining Hall of Fame and Museum, Leadville; a locker room featuring a pep talk from a baseball manager at the Missouri Sports Hall of Fame, Springfield; a television studio where visitors can make videos of themselves as anchorpersons at the Radio Hall of Fame, Chicago; and the history of baseball at the National Baseball Hall of Fame and Museum, Cooperstown.

Some halls of fame have temporary display spaces for the showing of short-term special exhibitions that they develop or obtain on loan from others. In most

instances, temporary exhibitions are mixed with permanent exhibits. However, some places, such as the Texas Sports Hall of Fame, Waco, use their lobbies or some other stand-alone temporary exhibition spaces.

Among the diverse temporary exhibitions at halls of fame have been "Fred Harvey and the Harvey Girls in Arizona" at the Arizona Hall of Fame Museum, Phoenix; "Marce Cunningham: Points in Space" at the National Museum of Dance (home of the Dance Hall of Fame), Saratoga Springs, New York; science exhibits from another museum at the Inventure Place, National Inventors Hall of Fame, Akron, and loan exhibitions on croquet at the National Croquet Hall of Fame, Newport.

A few halls of fame even organize and circulate traveling exhibitions, as does the National Women's Hall of Fame, Seneca Falls, which has developed exhibitions on outstanding women and suffrage, and also the International Photography Hall of Fame and Museum, Oklahoma City, where loan exhibitions consist of photographs from its extensive collections.

Halls of fame in other countries have a similar wide range of exhibits and display techniques. Inductees are honored in various ways—busts, reliefs, photographs, and exhibit cases with historical documents at the Deutsches Museum's Ehrensaal in Munich; blowup photographs, memorabilia, and equipment at the Professional Baseball Hall of Fame of Mexico, Monterrey; and a wall of action photographs and showcase exhibits of uniforms, medals, equipment, certificates, and other materials pertaining to hall of famers and their sports at the New South Wales Hall of Champions, Homebush Bay, Australia.

Among the exhibits in Canadian halls of fame are photographs, memorabilia, artifacts, and touch-screen video kiosks at Canada's Sports Hall of Fame, Toronto; memorabilia, photographs, posters, sculpture, and original artworks, at the Aquatic Hall of Fame and Museum of Canada, Winnipeg; photographs, memorabilia, and historic aircraft, at Canada's Aviation Hall of Fame, Wetaskiwin, Alberta; portraits, photographs, trophies, memorabilia, equipment, films, and video, at the Hockey Hall of Fame, Toronto; and steel busts, memorabilia, artifacts, photographs, and interactive exhibits, at the Canadian Football Hall of Fame and Museum, Hamilton, Ontario, which also circulates traveling exhibitions on Canadian football.

PROGRAMMING AND SPECIAL EVENTS

In addition to honoring inductees and presenting exhibits, most halls of fame are involved in other types of activities, such as educational programs, special events, library and archival services, and other functions designed to serve their fields and often to attract publicity, funds, or visitors.

Education programs usually are aimed at school groups and teachers, although they sometimes include such public programming as tours, classes, lectures, films, workshops, seminars, and contests. The Country Music Hall of Fame and Museum, Nashville, has an education department that serves over 20,000 stu-

Among the halls of fame found in other countries is the Professional Baseball Hall of Fame of Mexico in Monterrey. It was first started as a result of a newspaper poll of fans in 1939. In 1973, a brewery was selected as the sponsor and home for the hall of fame. It now is housed in a 13,200-square-foot building on the brewery's premises and attracts 145,000 visitors each year. Courtesy Professional Baseball Hall of Fame of Mexico.

dents and teachers annually with learning activities and materials—including a
"Words and Music Program" that links school children with Nashville song-
writers and results in over 5,000 student-written songs each year. The National
Plastics Center and Museum (where the Plastics Hall of Fame is located), Leom-
inster, Massachusetts, has an education program that includes an interactive dis-
covery center for young children, live plastics demonstrations, guided tours, a
50-minute, hands-on laboratory experience, and a traveling van program.

Guided tours are available at many halls of fame. Examples are the National
Agricultural Center and Hall of Fame, Bonner Springs; the ProRodeo Hall of
Fame and Museum of the American Cowboy, Colorado Springs; the American
Police Hall of Fame and Museum, Miami; the Green Bay Packer Hall of Fame,
Green Bay (which includes a tour of the adjacent stadium); and the National
Skeet Shooting Hall of Fame Museum, San Antonio.

Educational activities also take many other forms, such as films that inform
the public about traffic, safety, danger from strangers, substance abuse, and other
such topics, at the South Carolina Criminal Justice Hall of Fame, Columbia;
workshops designed to acquaint individuals with the skills of songwriting, mu-
sicianship, and singing, at the Alabama Music Hall of Fame, Tuscumbia; sem-
inars that teach teens the art of clowning and the dangers of drug and alcohol
abuse, at the Clown Hall of Fame and Research Center, Delavan; and a poster
and essay contest for students during the National Women's History Month in
March, at the National Women's Hall of Fame, Seneca Falls.

Several halls of fame operate summer camps. Inventure Place, National In-
ventors Hall of Fame, Akron, which has an Inventors Workshop, honors college
and university students for inventive problem solving in the B.F. Goodrich Col-
legiate Inventors Program and sponsors summer inventive camps for students.
The U.S. Astronaut Hall of Fame, Titusville, is the home of the U.S. Space
Camp Florida, a space science camp where youngsters train like astronauts in a
hands-on learning environment. From January through April, the Museum of
Yachting (site of the Singlehanded Sailors Hall of Fame), Newport, operates a
weekend School for Yacht Restoration to teach basic skills required to repair,
maintain, and restore classic wooden yachts.

Libraries or archives are often an important part of halls of fame. Among
such facilities are the new McCaig-Wellborn International Motorsports Research
Library at the International Motorsports Hall of Fame, Talledaga; 9,000-volume
library at the National Cowboy Hall of Fame and Western Heritage Center,
Oklahoma City; the National Baseball Library, containing the world's largest
collection of baseball reference materials, photographs, and audiovisual re-
sources, at the National Baseball Hall of Fame and Museum, Cooperstown; an
archive of radio and television materials at the Museum of Broadcast Commu-
nications (home of the Radio Hall of Fame), Chicago; a 30,000-volume library
at the International Swimming Hall of Fame, Fort Lauderdale, Florida; and li-
brary and archives at the National Museum of Roller Skating (which houses the
Roller Skating Hall of Fame), Lincoln, Nebraska.

 Special events can be the highlight of the year for some halls of fame, especially when combined with enshrinement ceremonies. The National Baseball Hall of Fame and Museum, Cooperstown, and the Pro Football Hall of Fame, Canton, have an annual "Hall of Fame Game" as part of their induction festivities; the International Boxing Hall of Fame Museum, Canastota, holds an "Induction Weekend of Champions" that includes boxing matches, a golf tournament, a collectors' show of memorabilia, and an awards dinner. The National Sprint Car Hall of Fame and Museum, Knoxville, schedules a sprint car racing program at the time of its induction program.

 Tournaments are highly popular at some halls of fame. Examples include a Grand Prix tennis tournament at the International Tennis Hall of Fame and Museum, Newport; swimming tournaments at the International Swimming Hall of Fame, Fort Lauderdale; the Mississippi Open Tournament and other checkers tournaments at the International Checkers Hall of Fame, Petal, Mississippi; and softball tournaments, all-star games, and player camps at the National Softball Hall of Fame and Museum, Oklahoma City.

 A number of facilities have a series of special events to serve and draw the public. The National Agricultural Center and Hall of Fame in Kansas offers such events as Old Fashioned Days, highlighting early rural-life crafts, arts, and pastimes; Farm Heritage Days, featuring displays and demonstrations of classic farm machines; Draft Horse Power Days, with demonstrations of horse power; and Fall Farm Festival, a country food fair with demonstrations, hay rides, and other activities. The Museum of Appalachia (which includes the Appalachian Hall of Fame) in Tennessee holds a Fourth of July Celebration and Anvil Shoot, Tennessee Fall Homecoming, and Christmas in Old Appalachia programs.

 The biggest special event is at the EAA Air Adventure Museum (home for six aviation halls of fame) in Wisconsin, which holds an annual week-long fly-in that attracts from 12,000 to 15,000 planes and more than 800,000 people.

 In other countries, Canadian halls of fame are more active than others in educational activities, libraries and archives, and special events. The Canadian Football Hall of Fame and Museum, Hamilton, offers five educational programs for school groups; the Curling Hall of Fame and Museum of Canada, Kitchener, Ontario, has the largest curling reference library outside Scotland; the Hockey Hall of Fame, Toronto, operates a resource center with literature and reference material on the sport; and the Reynolds-Alberta Museum (where Canada's Aviation Hall of Fame is located), Wetaskiwin, has guided tours, live demonstrations, a resource center, and special events.

 However, it is the Deutsches Museum (site of Ehrensaal) in Germany that has the most extensive educational programming, largest library and archives, and most special events among foreign halls of fame. Other museums with special facilities include a baseball information system and a library at the Japanese Baseball Hall of Fame and Museum in Tokyo and the Kenneth Ritchie Wimbledon Library at the Wimbledon Lawn Tennis Museum in Great Britain.

CONTENT AND QUALITY

Although they are quite similar in objectives, hall of fame museums and exhibits differ widely in facilities, collections, exhibits, programs, and other aspects of their operations. Virtually all seek to honor outstanding achievement and to further public appreciation and understanding of their fields. The principal instruments are the exhibits and programs that tell their stories. But there are considerable differences in the levels of their offerings and public responses.

It is neither necessary nor possible for every hall of fame to be large, to offer an array of expensive exhibits and programs, or to be in a highly visible and popular field. But it is essential that the content and quality of what is available appropriately reflect and interpret the field and generate the interest and support needed to sustain the hall's operations.

Some halls of fame have large and exquisite collections of memorabilia, artifacts, photographs, artworks, or other materials. Others are strong in exhibitry and programs but less bountiful in meaningful collections. Those halls of fame that have the ''right'' combinations seem to be the most effective in communicating their messages—and attracting the public.

Many halls of fame have developed from mere tributes to outstanding individuals into comprehensive museums, some using the latest exhibit techniques and program innovations. Others have remained basically hall of fame shrines, appealing primarily to the converted.

It is clear, however, that the most popular and successful, from the standpoint of the visiting public, are those halls of fame that have relevant, high-interest collections, exhibits, and programs and that effectively market their offerings.

Chapter 5

An Expanding Movement

The hall of fame movement began slowly, then accelerated, and is now in the midst of major expansion. The 1990s have seen the startup of hall of fame museums and exhibits, the relocation of some existing halls, construction and planning of new facilities, increased and upgraded exhibits and programs, and greater public interest and attendance. Even more developments are under way as the twenty-first century approaches.

Numerous new halls of fame were founded and their museums opened during the first half of the decade, including such diverse facilities as the National Motorcycle Museum and Hall of Fame, Sturgis, South Dakota; the Missouri Sports Hall of Fame, Springfield; the Family Camping Hall of Fame, Allenstown, New Hampshire; the Ted Williams Museum and Hitters Hall of Fame, Herando, Florida; the National Teachers Hall of Fame, Emporia, Kansas; and the National Sprint Car Hall of Fame and Museum, Knoxville, Iowa.

Some halls of fame established earlier were successful in funding and opening museums in the 1990s. One of these institutions was the Rock and Roll Hall of Fame and Museum, which opened in Cleveland in 1995 and has become the largest and most popular hall of fame museum, with 150,000 square feet and approximately 1 million visitors annually. Among the others in this category were the Clown Hall of Fame and Research Center, Delavan, Wisconsin; the Motorsports Museum and Hall of Fame of America, Novi, Michigan; the Alabama Jazz Hall of Fame, Birmingham; the Florida Sports Hall of Fame and Museum, Lake City; and the Curling Hall of Fame and Museum in Kitchener, Ontario.

Another leading hall of fame museum—Inventure Place, National Inventors Hall of Fame—was one of a number relocated and expanded during the first half of the decade. The inventors hall began as a small display in the Patent

and Trademark Office in Arlington, Virginia, in 1973. It was moved to Akron, Ohio, and opened as a more comprehensive museum in 1995. The 77,000-square-foot facility now has an annual attendance of 300,000. Other hall of fame museums relocated during this period included the College Football Hall of Fame, from Cincinnati to South Bend, Indiana; the Texas Sports Hall of Fame, from Grand Prairie to Waco; the International Museum of Cartoon Art Hall of Fame, from Rye, New York, to Boca Raton, Florida; and the Indiana Basketball Hall of Fame, from Indianapolis to New Castle.

EXHIBITS AT OTHER SITES

Halls of fame also were started as exhibits in museums, sports arenas, and other sites during the early 1990s. Among these hall galleries were four of six aviation halls of fame at the EAA Air Adventure Museum, Oshkosh, Wisconsin; the Appalachian Hall of Fame at the Museum of Appalachia, Norris, Tennessee; the Sports Hall of Fame of New Jersey at the Meadowlands Sports Complex, East Rutherford; the Paper Industry Hall of Fame at the Neenah Historical Society, Neenah, Wisconsin; the National Baseball Congress Hall of Fame at Lawrence-Dumont Stadium, Wichita, Kansas; and the International Frisbee Hall of Fame at the Houghton County Historical Museum, Lake Linden, Michigan.

In addition some halls of fame created earlier found homes as galleries in museums, including the Plastics Hall of Fame in the National Plastics Center and Museum, Leominster, Massachusetts; the National Croquet Hall of Fame in the Newport Art Museum, Newport, Rhode Island; and the North Carolina Sports Hall of Fame in the North Carolina Museum of History, Raleigh.

Among the other types of halls of fame opened during this period were the Television Academy Hall of Fame, consisting of an outdoor plaza of busts and statues, North Hollywood, California; the Palm Springs Walk of Stars and Gallery Without Walls, a sidewalk plaque and sculpture program, Palm Springs, California; and the Surfing Walk of Fame, a sidewalk tribute near a surfing museum, Huntington Beach, California.

A number of hall of fame museums also were opened or relocated in Canada in the early 1990s. They included the Naismith International Basketball Centre and Hall of Fame, which opened near Almonte, Ontario, and two that moved to new sites—British Columbia Sports Hall of Fame and Museum, B.C. Place Stadium, Vancouver, and Canada's Aviation Hall of Fame, Reynolds-Alberta Museum, Wetaskiwin, Alberta.

CONTINUING GROWTH

The second half of the decade should be even more active for halls of fame, if 1996 and 1997 developments are any indication. New hall of fame museums and exhibits continue to be founded and opened, and existing halls are being

expanded and improved. Many other halls of fame are seeking funds and sites for new museums.

Among the museums opened in the two-year span were the Mississippi Music Hall of Fame, Jackson; the National Museum of Polo and Hall of Fame, Lake Worth, Florida; the Mississippi Sports Hall of Fame and Museum, Jackson; and the Puerto Rico Sports Hall of Fame, San Juan. New exhibit galleries included the Senior Athletes Hall of Fame, housed in a retirement village in Bradenton, Florida; the National Jewish American Sports Hall of Fame, a gallery in a museum in Washington, D.C.; and the National Firefighting Hall of Fame, an addition to the Hall of Flame of Firefighting in Phoenix.

Hall of fame museums that have just completed expansions and new exhibits include the National Cowboy Hall of Fame and Western Heritage Center, Oklahoma City, a $9 million expansion to increase the square footage to 220,000—the largest among halls of fame; the Harness Racing Museum and Hall of Fame, Goshen, New York, which renovated and expanded its home in a 1913 English Tudor–style stable; and ProRodeo Hall of Fame and Museum of the American Cowboy, Colorado Springs, where 20,000 square feet and new exhibits were added.

In other developments among established hall of fame museums and exhibits, the Automotive Hall of Fame moved from Midland, Michigan, into a new building in Dearborn; the Penn State Football Hall of Fame will be incorporated into a new $5 million Penn State All-Sports Hall of Fame under construction in State College; the Business Hall of Fame is being redesigned at Chicago's Museum of Science and Industry; the Tennessee Sports Hall of Fame is moving from Knoxville to a new indoor arena being built in Nashville; the Quilters Hall of Fame in Marion, Indiana, is restoring a historic house for its new site; the International Museum of Cartoon Art is completing a $15 million expansion, including the tripling of space for its Cartoon Art Hall of Fame in Boca Raton, Florida; and the National Italian American Sports Hall of Fame in Elmwood Park, Illinois, is moving to a new building being constructed near downtown Chicago.

PLANNED OPENINGS AND EXPANSIONS

A number of new hall of fame museums are preparing to open before the end of the decade, including the Georgia Sports Hall of Fame, Macon; the National Sportscasters and Sportswriters Hall of Fame, Salisbury, North Carolina; the Pro Beach Volleyball Hall of Fame, Clearwater Beach, Florida; the National Aviation Hall of Fame, Wright-Patterson Air Force Base, Ohio; the International Fishing Hall of Fame, Dania, Florida; and possibly the World Golf Hall of Fame, Ponte Verde Beach, Florida.

The National Aviation Hall of Fame, which was established in 1962, finally is getting a home of its own—a $6 million, 15,000-square-foot building being

constructed adjacent to the United States Air Force Museum. The International Fishing Hall of Fame is being developed as part of the $25 million International Game Fish Association complex, occupying 10,000 of the center's 59,000 square feet. The World Golf Hall of Fame is the centerpiece of a 6,300-acre World Golf Village. It will consist of a 75,000-square-foot facility and will house three other professional golf halls of fame.

Some existing hall of fame museums also are planning new buildings and major expansions. They include the Country Music Hall of Fame and Museum, Nashville, a new 100,000-square-foot building; the Volleyball Hall of Fame, Holyoke, Massachusetts, a building with indoor and outdoor volleyball courts; National Soccer Hall of Fame, Oneonta, New York, a $30 million soccer complex with a 27,000-square-foot museum building and other facilities on a 61-acre site; and the San Diego Hall of Champions Sports Museum, moving to a larger building. The National Cowgirl Hall of Fame and Western Heritage Center, which relocated from Hereford, Texas, to Fort Worth, is planning a new facility; the newly opened Rock and Roll Hall of Fame and Museum already plans a $10 million, 30,000-square-foot addition to its Cleveland home; and the International Gymnastics Hall of Fame and Museum, which recently relocated from Oceanside, California, to temporary quarters in Oklahoma City, is developing plans for a new building.

Among the other hall of fame museums and galleries that have new buildings in their long-range plans are the National Skeet Shooting Hall of Fame Museum, San Antonio; the Georgia Aviation Hall of Fame, Warner Robins; Paper Industry Hall of Fame, Neenah, Wisconsin; and the Virginia Sports Hall of Fame, Portsmouth. Expansion also is in the future plans of such halls as the State of Oregon Sports Hall of Fame Museum, Portland; the Alabama Music Hall of Fame, Tuscumbia; the Florida Sports Hall of Fame and Museum, Lake City; and the American Police Hall of Fame and Museum, Miami.

Many other halls of fame without facilities are involved in raising funds or finding a site. It now appears that the National High School Football Hall of Fame will locate in Valdosta, Georgia; the Delaware Sports Museum and Hall of Fame will find a home in a state-owned stadium in Wilmington; and the North Dakota Cowboy Hall of Fame will select a site from among four finalists—Mandan, Medora, Towner, and Watford City. Other organizations engaged in fundraising and site selection include the International Women's Sports Hall of Fame, the South Carolina Athletic Hall of Fame, the National High School Band Directors Hall of Fame, the Hellenic Athletic Hall of Fame, the World Sports Humanitarian Hall of Fame, and the British Columbia Hockey Hall of Fame.

SIGNS OF PROGRESS

The growth in the number of sports museums and halls of fame resulted in the formation of the International Association of Sports Museums and Halls of

Fame in 1971. The organization was founded to exchange information of mutual interest and to provide a forum for the discussion of common problems and ideas. It now also presents a distinguished service award and publishes a newsletter and directory.

The idea for such an association came from William F. "Buck" Dawson, founding executive director of the International Swimming Hall of Fame in Fort Lauderdale, Florida. He invited a dozen or more fellow directors to come to his hall to discuss the possibility of creating a loosely knit organization for sports museums and halls of fame. Only two directors besides Dawson showed up, both Canadians—M. H. "Lefty" Reid, director-curator of the Hockey Hall of Fame and curator of Canada's Sports Hall of Fame in Toronto, and Vaughn L. Baird, chairman of the Aquatic Hall of Fame and Museum in Winnipeg. They elected themselves officers and delegated President Dawson to continue efforts to form the association.

A second meeting was held in 1972 at the Naismith Memorial Basketball Hall of Fame in Springfield, Massachusetts, when the association was formalized and 19 sports museums and halls of fame became charter members. Since then, the membership has climbed rapidly, reaching 124 in 1993 and 143 in 1997, with member organizations now in 12 other countries.

Another more recent development was the staging, from November 26, 1996 to February 23, 1997, of "The Hall of Fame Hall of Fame" special exhibition, featuring materials from over 50 halls of fame at the Center for the Arts at Yerba Buena Gardens in San Francisco. It was the first exhibition of its type, exhibiting photographs, artifacts, equipment, trophies, statuettes, uniforms, portraits, and other items from halls of fame—some with facilities and others only with collections.

In the exhibition catalog, Renny Pritikin, artistic director for visual arts at the center, wrote:

The hall of fame has an ideology parallel to the American myth that anyone can grow up to be President. The meritocracy is primary—with hard work to maximize talent, and a little luck, most anyone can be a Hall of Fame contender at some unnamed skill. Fame as a value, as a way of documenting success underlies the entire network of halls.

She called halls of fame "walk-in textbooks," narrating an alternate cultural history "based on values and interests rarely considered in the exhibitions in other kinds of museums."

NOT ALL SUCCESSES

Unfortunately, not all halls of fame thrive. Some never get off the ground, while others fail for lack of funds, attendance, or other reasons. Among those facilities that have closed are the International Palace of Sports Hall of Fame, North Webster, Indiana; the Hall of Fame of Boxing, New York City; the Amer-

ican Bicycle Hall of Fame, Staten Island, New York; the Negro Baseball Hall of History, Ashland, Kentucky; the Poker Hall of Fame, Las Vegas, Nevada; the Hall of Fame of Great Billiard Players, Johnston City, Illinois; and the Canadian Country Music Hall of Fame, Swift Current, Saskatchewan.

The Helms Foundation Hall of Fame in Los Angeles was discontinued because of a change in direction of the foundation. The International Museum of Surgical Science and Hall of Fame in Chicago decided to drop the hall of fame aspect of its museum operations. The Hot Dog Hall of Fame in Fairfield, California, continues its ceremonial duties although its collections were placed in storage after closing. (It plans to reopen as a combined museum, restaurant, gallery, and gift shop.)

Some hall of fame museums have been more fortunate, restructuring and reopening successfully after closing primarily for lack of attendance. This occurred at the College Football Hall of Fame, which failed at an amusement park near Cincinnati and relocated in a new, city-funded building in South Bend, Indiana. The Texas Sports Hall of Fame closed for lack of attendance in Grand Prairie and reopened as the umbrella organization for five halls of fame in Waco. The Circus Hall of Fame closed in Sarasota, Florida, when its leased land was sold but then resurfaced as the International Circus Hall of Fame in Peru, Indiana, once the home of many circuses. Finally, the Chicago Sports Hall of Fame was located at Soldier Field and then Mike Ditka's Restaurant before closing, only to be relocated at a children's academy in Des Plaines, Illinois, and renamed the Chicagoland Sports Hall of Fame.

IMPROVEMENTS AND EXPANSIONS

Nearly all current hall of fame museums and exhibits appear to be doing well and making improvements in their collections, exhibits, and programs or expanding their offerings and facilities. In most cases, the principal needs are more space, funds, or attendance—the same as other types of museums.

Among halls focusing on additions to their collections are the South Carolina Tennis Hall of Fame, Belton, which is working on enlarging its tennis artifact collection; the National Agricultural Aviation Museum (and its hall of fame), Jackson, Mississippi, where the vintage plane collection is being expanded; and the RV/MH Hall of Fame, Elkhart, Indiana, which is planning collection and library expansions.

In the exhibit area, the Lacrosse Hall of Fame Museum, Baltimore, will be expanding to double its exhibit space; the Indiana Basketball Hall of Fame, New Castle, plans to add space to accommodate girls and women's basketball exhibits (females are not now inducted); the American Police Hall of Fame and Museum, Miami, will increase space for its memorial exhibit honoring an increasing number of slain officers; and the National Fresh Water Fishing Hall of Fame,

Hayward, Wisconsin, plans an eighth building to house its motor and boat exhibits, which will allow space in existing buildings for interactive and other displays.

The Museum of Broadcast Communications (which includes the Radio Hall of Fame), Chicago, is developing a new comprehensive exhibit plan that will be implemented over the next three years, while the International Swimming Hall of Fame, Fort Lauderdale, is updating its exhibit offerings. In other exhibit improvements, the Television Academy Hall of Fame will be installing new artwork and adding a "Wall of Fame" to its statuary plaza in California; the National Mining Hall of Fame and Museum, Leadville, is working on new coal, industrial minerals, and model train exhibits; and the Colorado Ski Museum-Ski Hall of Fame, Vail, is planning to add exhibits on ski equipment and ski patrol, as well as a theater area.

Among the various theater, library, archives, and educational programming improvements planned are a research library on southern music and a 1,200-seat auditorium at the Alabama Music Hall of Fame, Tuscumbia; expansion of the library, archives, and educational facilities at the San Diego Aerospace Museum (home of the International Aerospace Hall of Fame); major expansion of the educational center of the Aviation Hall of Fame and Museum of New Jersey, Teterboro; and creation of a River Discovery Center for the Mississippi River Museum and its National Rivers Hall of Fame, Dubuque, Iowa.

Some halls of fame are in various stages of major renovation, such as the International Tennis Hall of Fame, Newport, Rhode Island, which is completing a five-phase, $6 million renovation; the National Softball Hall of Fame and Museum, Oklahoma City, where an extensive renovation of the museum building and exhibits is planned; and the Texas Ranger Hall of Fame and Museum, Waco, which intends to remodel and renovate its facility, with new exhibits, library, and education programs by the turn of the century.

Many others are planning to expand their facilities, including the International Motorsports Hall of Fame, Talladega, Alabama; the Country Music Hall of Fame and Museum, Nashville; the International Snowmobile Racing Hall of Fame, Saint Germain, Wisconsin; the Texas Sports Hall of Fame, Waco; and the National Sprint Car Hall of Fame and Museum, Knoxville. The Hall of Fame for Great Americans, the Bronx, New York, also is making plans for a biographical library, study-media center, and lifestyle museum adjacent to its open-air colonnade of busts of distinguished Americans.

A number of hall of fame museums are considering relocating to other sites to obtain more adequate facilities, including the National Women's Hall of Fame, Seneca Falls, New York; the Water Ski Hall of Fame and Museum, Winter Haven, Florida; and the Museum of Family Camping, Allenstown, New Hampshire.

Similar developments are taking place in other countries. In Canada, the Ca-

nadian Figure Skating Hall of Fame, Gloucester, Ontario, is expanding its collections and planning to start volunteer and membership programs; the Aquatic Hall of Fame and Museum of Canada plans an expansion and embellishment of the museum in Winnipeg by 1999; the Olympic Hall of Fame and Museum, Calgary, intends to double its 10,500-square-foot facility; Canada's Sports Hall of Fame, Toronto, has major reorganization, refinancing, and relocation in its plans; and the Naismith International Basketball Centre and Hall of Fame's plans call for a $4 million multifunctional complex on the Naismith farm near Almonte.

Elsewhere, the International Jewish Sports Hall of Fame, Netanya, Israel, is raising funds for an Israel Sport Museum to which it will relocate. The Professional Baseball Hall of Fame of Mexico, Monterrey, is planning a major renovation of its building and exhibits for its 25th anniversary in 1998; and the New Zealand Sports Hall of Fame, Wellington, plans to move to the new Wellington Sports Stadium when completed in 2000.

LOOKING AHEAD

Funding and marketing are essential to the success of hall of fame museums. That is why the National Soccer Hall of Fame, Oneonta, is working to increase its contributions, memberships, grants, and sponsorship. The Florida Sports Hall of Fame and Museum, Lake City, is planning to improve its educational outreach programs and marketing efforts to increase attendance and financial support throughout the state. The National Museum of Racing and Hall of Fame, Saratoga Springs, New York, has plans to enhance its endowment and national outreach programs, as well as expand its physical plant; and the Missouri Sports Hall of Fame, Springfield, intends to pursue state support while operating on a fiscally sound basis, offering more services and programs and involving high schools and colleges to a greater degree.

Operating a hall of fame facility can be costly, and it requires a reliable stream of income and support beyond startup funding. Finding ways to increase revenues and contributions is a never-ending job. Failure to do so is the most common cause for hall of fame failures.

Most hall of fame museums are becoming more professional and accountable in operations, getting larger, and developing better collections, exhibits, and programs. In the process, they have become more interesting and enjoyable, with greater appeal to the visiting public. This is the primary reason for the growing attendances and support that many halls of fame are receiving from within and outside their respective fields.

The future looks even brighter for hall of fame museums and exhibits, especially in the United States. An increasing number of halls of fame are being founded, opened, upgraded, or expanded to honor outstanding achievers and to tell stories and display objects pertaining to the inductees and their fields. The

quality of exhibits and programs keeps improving, and the funding becomes more dependable. At the same time, the public is recognizing, to an increasing degree, the historical value of halls of fame and their importance as cultural, educational, and social centers.

Directory of
Hall of Fame Museums
and Exhibits

Sports and Games
Halls of Fame

ALL-SPORTS

BAY AREA SPORTS HALL OF FAME, San Francisco and Oakland, California. The San Francisco Chamber of Commerce sponsors a Bay Area Sports Hall of Fame with exhibits of plaques and information about honorees at two locations, the San Francisco International Airport and the Oakland Coliseum. Since being started in 1980, the hall of fame has inducted 72 outstanding athletes from the area.

Among the sports figures in the hall of fame are Joe DiMaggio and Willie Mays in baseball; Ernie Nevers and Y. A. Tittle, football; Hank Luisetti and Bill Russell, basketball; Helen Willis Moody and Helen Jacobs, tennis; and Ann Curtis, swimming. The exhibits are located in the United Airlines wing of the San Francisco airport and near the main entrance to the Oakland Coliseum.

Proceeds from an annual enshrinement banquet are used to buy equipment for youth sports programs in the San Francisco area.

Bay Area Sports Hall of Fame, San Francisco Chamber of Commerce, 465 California St., San Francisco, CA 94104. Phone: 415/392–4520. Hours: San Francisco International Airport—open 24 hours; Oakland Coliseum—whenever events scheduled. Admission: free.

BREITBARD HALL OF FAME, San Diego, California. The Breitbard Hall of Fame, which honors San Diego's most outstanding athletes and coaches for their career accomplishments, is the featured attraction at the San Diego Hall of Champions Sports Museum in this California city. It all started with the formation of the Breitbard Athletic Foundation, which began in 1946 by recognizing primarily local high school and college athletes. In 1953, the foundation

established the Breitbard Hall of Fame, followed by the opening of the Hall of Champions museum in 1961. The Hall of Champions moved to its present 16,000-square-foot quarters in Balboa Park in 1983 and now is preparing to occupy the renovated, historic Federal Building in the park, which will provide three times more space.

The founding of the foundation, hall of fame, and museum was spearheaded by Bob Breitbard, former San Diego State University football coach and later businessman. Over the last century, more than 50,000 athletes in 46 sports have been presented awards in six categories, ranging from stars of the month to disabled athletes of the year.

The Breitbard Hall of Fame has inducted 84 athletes and coaches, including Ted Williams, Don Larsen, and Randy Jones, baseball; Kellen Winslow, Ron Mix, and Dan Fouts, football; Bill Walton and Milton Phelps, basketball; Arnie Robinson, Billy Mills, and Willie Banks, track and field; Craig Stadler, Billy Casper, and Mary Kathryn Wright, golf; Maureen Connolly and Karen Hantze Susman, tennis; Florence Chadwick, Charles Fletcher, and Florence Chambers Newkirk, aquatics; Archie Moore and Lee Ramage, boxing; Jim Londos, wrestling; Bud Muehleisen, racquetball; Dave Freeman and Joe Alston, badminton; Gerry Driscoll and Dennis Conner, sailing; Bill Muncey, hydroplane racing; Rube Powell, archery; Charlie Whittingham, thoroughbred racing; and Sid Gillman and Don Coryell, football coaches.

A statue from life of Ted Williams is the centerpiece of the hall of fame, which features plaques of those enshrined. Among the many artifacts, memorabilia, and photographs in the Hall of Champions are Ted Williams's bat, Dan Fouts's jersey, Bill Muncey's thunderboat, Archie Moore's robe, Maureen Connolly's trophies, and three of horseracing's most celebrated trophies—the Kentucky Derby, Preakness, and Horse of the Year. The museum has an annual attendance of approximately 75,000.

Breitbard Hall of Fame, San Diego Hall of Champions Sports Museum, 1649 E. Prado, Balboa Park, San Diego, CA 92101. Phone: 619/234–2544. Hours: 10–4:30 daily; closed New Year's Day, Thanksgiving, and Christmas. Admission: adults, $3; seniors, military, and students, $2; children 6–17, $1.

CHICAGOLAND SPORTS HALL OF FAME, Des Plaines, Illinois. The Chicagoland Sports Hall of Fame, formerly the Chicago Sports Hall of Fame located at Soldier Field, opened in 1996 at the Maryville Academy in suburban Des Plaines. It now occupies 10,000 square feet and honors 220 athletes, coaches, owners, writers, and other sports figures from the Chicago metropolitan area.

The hall of fame came to the academy, one of 16 Catholic-operated centers for neglected, abused, and abandoned children, largely through the efforts of the Rev. John P. Smith, who heads the academy and was a former all-American basketball player at the University of Notre Dame.

The Chicago Sports Hall of Fame started in 1979 as a trailer owned by the Olympic Beer Company. In 1983, the Chicago Park District assumed sponsorship of the hall of fame and installed banners, photographs, and memorabilia of

the inductees near the main entrance to Soldier Field, site of Chicago Bears football games and many other athletic and special events. In 1988 the hall of fame materials were moved to Mike Ditka's Restaurant, which closed in 1991. All the exhibits and collections were then placed in storage until the hall of fame was relocated and renamed at the Maryville Academy.

Four rooms in the academy's Villa building contain photographs, memorabilia, interactive computers, and other materials associated with the hall of fame honorees. Among those enshrined are such luminaries as Red Grange, Bronko Nagurski, Sid Luckman, Mike Ditka, George Connor, Dick Butkus, and Walter Payton, of the Chicago Bears; Paddy Driscoll, Marshall Goldberg, Charlie Trippi, and Elmer Angsman, former Chicago Cardinals; Gabby Hartnett, Phil Cavarretta, Andy Pafko, Billy Williams, Ernie Banks, and Ron Santo, of the Chicago Cubs; Minnie Minoso, Billy Pierce, Luke Appling, Ted Lyons, Luis Aparicio, and Nellie Fox, Chicago White Sox; Chet Walker, Chicago Bulls; Bobby Hull, Stan Mikita, and Keith Magnuson, Chicago Blackhawks; Tony Zale, Barney Ross, and Muhammad Ali, boxing; Ralph Metcalfe and Willye White, track; football coaches Amos Alonzo Stagg, Knute Rockne, and George Halas; basketball coaches Ray Meyer, George Ireland, and John Kerr; and baseball owners Charles Comiskey, Bill Veeck, and Charles Finley.

Chicagoland Sports Hall of Fame, Maryville Academy, 1150 N. River Rd., Des Plaines, IL 60016. Phone: 847/294–1799. Hours: 10–4 daily; closed major holidays. Admission: free.

CONNECTICUT SPORTS MUSEUM AND HALL OF FAME, Hartford, Connecticut.

Outstanding athletes and sports figures in the state are enshrined in the Connecticut Sports Museum and Hall of Fame, located in the Hartford Civic Center. The hall of fame originally opened in the Aetna Gallery in 1992, moving to the civic center later that year.

Twenty-eight persons are honored in the hall of fame, which features plaques, photographs, equipment, and artworks pertaining to the inductees. They include Walter Camp, Floyd Little, and Andy Robustelli in football; Bruce Jenner, Jan Merrill-Morin, and Lindy Remigino, in track and field; Willie Pep, Marlon Starling, and Bob Steele, boxing; Walt Drop and Fay Vincent, Jr., baseball; Calvin Murphy, basketball; Dorothy Hamill, figure skating; and Juliu Boros, golf.

Among the changing exhibitions that have been presented since 1992 are exhibits on mountain climber John Helenek; whiffle ball, which was invented in Connecticut; University of Connecticut basketball; baseball umpire Terry Tata; Hartford Whalers and New Haven Nighthawks hockey teams; women in sports; and 1987 Trumbull Little League world champions.

Connecticut Sports Museum and Hall of Fame, Hartford Civic Center, 1 Civic Center Plaza, Hartford, CT 06103. Phone: 860/724–4918. Hours: 10:30–2:30 Mon., Wed., Fri.; closed holidays. Admission: free.

DELAWARE COUNTY ATHLETES HALL OF FAME, Brookhaven, Pennsylvania.

More than 900 athletes, coaches, officials, and other sports figures have

been elected to the Delaware County Athletes Hall of Fame in southeastern Pennsylvania. Plaques honoring those enshrined are displayed in the lobby of the Brookhaven Borough Hall. Twenty-four persons are inducted annually at two awards dinners.

The hall of fame was created in 1956, with the plaques first being displayed in Schwartz Center at Widener University in Chester, in 1983. In 1996, the hall of fame exhibit was moved to Brookhaven. Among the inductees are baseball players Hack Wilson and Mickey Vernon; World Series manager Danny Murtaugh; football back John Cappelletti; and horse trainer Samuel Riddle.

Delaware County Athletes Hall of Fame, Brookhaven Borough Hall, 2 Cambridge Rd., Brookhaven, PA 19015. Phone: 610/586–8074. Hours: 9–5 Mon.–Fri.; other times by appointment. Admission: free.

FLORIDA SPORTS HALL OF FAME AND MUSEUM, Lake City, Florida. The Florida Sports Hall of Fame and Museum in Lake City is dedicated to preserving, honoring, and promoting knowledge of excellence manifested by inducted individuals and in the history and conduct of sports in Florida. The hall of fame was founded in 1958 by the Florida Sports Writers Association and Florida Sportscasters Association. It moved into its present 9,800-square-foot semicircular building in 1990.

The 146 hall of fame inductees include such sports luminaries as football stars Pat Summerall, Larry Csonka, Bob Griese, and Steve Spurrier; baseball greats Don Sutton and Lou Pinella; golf legend Jack Nicklaus; motor racing champion Bobby Allison; all-around woman athlete Babe Didrickson Zaharias; boxing manager Angelo Dundee; sports team owners George Steinbrenner and Wayne Huizenga; sportscaster Red Barber; and football coaches Don Shula and Bobby Bowden.

Among the exhibits are individual cubicles for each hall of famer; video presentations; interactive displays; a wide array of national awards, such as the Thorpe, Groza, Sullivan, and Butkus awards; and exhibits relating to the national football championships won by Florida State University and the University of Miami.

Florida Sports Hall of Fame and Museum, 601 Hall of Fame Dr., Lake City, FL 32055. Phone: 904/758–1310. Hours: 9–5 daily. Admission: adults, $6; seniors, $3; children under 12 with paying adult and school and church groups, free.

GEORGIA SPORTS HALL OF FAME, Macon, Georgia. The Georgia Sports Hall of Fame is scheduled to move into a new $6.6 million, 43,000-square-foot home in Macon in 1998. The organization began as the Georgia Prep Sports Hall of Fame in 1956, merged with the State Athletic Hall to encompass all sports in 1963, and became the Georgia Sports Hall of Fame by act of the state legislature in 1978. All previous inductees became automatic members of the state hall of fame.

The hall of fame, which honors athletes who have excelled in sports in Geor-

gia, now has 241 honorees. They include such sports notables as Ty Cobb, Hank Aaron, and Luke Appling in baseball; Frank Sinkwich, Fran Tarkenton, and Mel Blount, football; Walt Frazier, basketball; Bobby Jones, golf; and John Heisman, Vince Dooley, and Dan Reeves, football coaches.

In addition to displays on the hall of famers, the new facility will have exhibits on the 1996 Olympics held in Atlanta, University of Georgia and Georgia Tech sports, and the Atlanta Hawks and Braves professional basketball and baseball teams.

Georgia Sports Hall of Fame, PO Box 4644, Macon, GA 31208. Phone: 912/752–1585. Hours and admission: to be determined.

GREATER FLINT AFRO-AMERICAN HALL OF FAME, Flint, Michigan. The Greater Flint Afro-American Hall of Fame honors outstanding local black athletes in two locations in Flint, Michigan. Plaques for approximately 60 inductees are displayed on the lower level of the Flint Public Library, while photographs and memorabilia can be seen at the Berston Fieldhouse, a community recreational center. The hall of fame was founded in 1984.

Greater Flint Afro-American Hall of Fame, Flint Public Library, 1026 E. Kearsley St., Flint, MI 48503. Phone: 810/232–7111. Hours: 8 A.M.–9 P.M. daily. Admission: free. Also Berston Fieldhouse, 3300 N. Saginaw St., Flint, MI 48505. Phone: 810/787–6531. Hours: by appointment. Admission: free.

GREATER FLINT AREA SPORTS HALL OF FAME, Flint, Michigan. Outstanding high school, collegiate, and professional athletes, and teams and other sports figures from the Flint, Michigan, area are recognized in the Greater Flint Area Sports Hall of Fame, located in the lobby of the city's IMA Sports Arena.

Started in 1980, the hall of fame now has plaques citing 118 individuals and nine teams. Among the honorees are Lynn Chandnois, Don Coleman, Lloyd Brazil, Andy MacDonald, Brad Van Pelt, Leroy Bolden, and Dennis Johnson, football all-Americans; Paul Krause, Clarence Peaks, Bob Rowe, Leo Sugar, Jesse Thomas, Leon Burton, Reggie Williams, and Booker Moore, professional football players; Justus Thigpen and Terry Furlow, professional basketball players; Mike Menosky, Dave Hoskins, Steve Boros, and Ron Pruitt, professional baseball players; and such other stars as Sue Novara-Reber in cycling, Roger Bernard in boxing, Pam Stockton Brady in badminton, Jim Doyle in softball, Howard Gilroy and Jeanette Robinson in bowling, Herb Washington in track,Ken Morrow in hockey, Mike Secrest in motor racing, Sophie Kurys in baseball and softball, and Anne McLogan-Herman in swimming.

Greater Flint Area Sports Hall of Fame, IMA Sports Arena, 3501 Lapeer Rd., Flint, MI 48503. Phone: 810/744–2872. Hours: whenever sports center is open. Admission: free.

INTERNATIONAL AFRO-AMERICAN SPORTS HALL OF FAME AND GALLERY, Detroit, Michigan. Many of the nation's most outstanding athletes are enshrined in the International Afro-American Sports Hall of Fame and Gal-

lery in the Old Wayne County Building in Detroit. The idea was first proposed in 1977 to respond to concern that the early history and achievements of black athletes might be lost. In 1982, a place was found to honor them on the fourth floor of the historic building.

Among the approximately 70 athletes inducted into the hall of fame are champion boxers Joe Louis and Sugar Ray Robinson; Hank Aaron, baseball legend; Wilma Rudolph, Olympic track gold medalist; Althea Gibson, tennis standout; and Dave Bing and Oscar Robertson, basketball all-stars, as well as such lesser-known athletes as Lafayette Allen, Jr., in bowling and Thelma Cowans in golf.

In addition to plaques, photographs, and memorabilia pertaining to the honorees, the hall of fame contains various sports equipment and a life-size sculpture, made largely of car bumpers, of Muhammad Ali.

International Afro-American Sports Hall of Fame and Gallery, Old Wayne County Bldg., 600 Randolph St., PO Box 27615, Detroit, MI 48227. Phone: 313/862–5034. Hours: 9–5 Mon.–Fri.; closed holidays. Admission: free.

LOUISIANA SPORTS HALL OF FAME, Natchitoches, Louisiana. The Louisiana Sports Hall of Fame recognizes the state's outstanding athletes, coaches, athletic directors, and officials. Founded in 1958 by the Louisiana Sports Writers Association, the hall of fame is located in the concourse and foyer of the Northwestern State University's Coliseum in Natchitoches. It is seen by approximately 150,000 persons who attend events in the multipurpose arena each year.

Among the 172 inductees in the hall of fame are Y. A. Tittle, Steve Van Buren, Terry Bradshaw, Billy Cannon, John David Crow, and Willie Davis in football; Bob Pettit, Willis Reed, Pete Maravich, and James Silas, basketball; Mel Ott, Ted Lyons, Bill Dickey, and Lou Brock, baseball; Glenn Hardin, Don Styron, and Johnny Morriss, track and field; Tony Canzoneri, Willie Pastrano, and Joe Brown, boxing; Eric Guerin and J. D. Mooney, horse racing; Tommy Bolt, Jay Herbert, and Clifford Ann Creed, golf; Ham Richardson, tennis; Kathy Johnson Clarke, gymnastics; and football coaches Eddie Robinson, Clark Shaughnessy, and Alvin McMillin. Portraits, photographs, biographical information, memorabilia, uniforms, and other items are displayed.

Louisiana Sports Hall of Fame, Coliseum, Northwestern State University, S. Jefferson St., Natchitoches, LA 71497. Phone: 318/357–6467. Hours: 8–4:30 Mon.–Fri.; during events; closed holidays. Admission: free.

MAINE SPORTS HALL OF FAME, Portland, Maine. Outstanding Maine athletes and sports figures are honored in the Maine Sports Hall of Fame, housed in a 600-square-foot room at the corner of the TGI Friday's Restaurant building in Portland. Organized in 1972, the hall of fame moved into its present quarters in 1991 and is planning to expand into a larger facility in the near future.

The hall of fame has enshrined 159 individuals, including Joan Benoit Samuelson, winner of the first women's Olympic marathon; Joey Gamache, Jr., World Boxing Association lightweight and junior welterweight champion; Bill

Swift, San Francisco Giants pitcher who was the first Maine native to win more than 20 games in the major leagues; Dick MacPherson, former Syracuse University and New England Patriots football coach; Shirley Povich, *Washington Post* sports editor; and Bob Woolf, pioneer sports agent.

The hall contains biographical information and photographs of inductees, as well as other displays, artifacts, and memorabilia. It also has a display case in the Legends Restaurant in Bangor, which honors inductees from the greater Bangor area.

In addition to those enshrined, the hall of fame presents a President's Award to exceptional athletes who are still active but not yet eligible for induction, and Outstanding Achievement Awards to individuals and teams.

Maine Sports Hall of Fame, 295 Fore St., Portland, MA 04101. Phone: 207/799–4555. Hours: May 1–Nov. 1, 12:30–3 Wed.–Fri. Admission: free.

MARGARET DOW TOWSLEY SPORTS MUSEUM, Ann Arbor, Michigan. The Margaret Dow Towsley Sports Museum at the University of Michigan in Ann Arbor functions like a hall of fame for the university's sports program. Named for the benefactor and opened in 1991, it honors athletes and teams in 21 varsity sports.

Located in Schembechler Hall, the museum features photographs, memorabilia, trophies, murals, films, and interactive exhibits on the history, teams, players, games, and other aspects of sports at the University of Michigan.

Margaret Dow Towsley Sports Museum, Schembechler Hall, 1200 S. State St., Ann Arbor, MI 48109–2201. Phone: 313/763–4422. Hours: 11–4 Mon.–Fri.; also 6–8 P.M. Fri. for home hockey games and 11–4 Sat. for home football games. Admission: free.

MISSISSIPPI SPORTS HALL OF FAME AND MUSEUM, Jackson, Mississippi. Although founded in 1961, the Mississippi Sports Hall of Fame and Museum had to wait until 1996 before its museum opened in Jackson. The $4.5 million sports complex was made possible by $1 million and $2.5 million bond issues approved by the Mississippi legislature and a $1 million contribution from the Coca-Cola bottling company in Jackson.

The hall of fame idea began with the Jackson Touchdown Club, which started inducting honorees in 1961, but there was no effort to collect or house memorabilia or personal recollections. The museum concept took shape when the Mississippi Sports Foundation was chartered in 1992.

The 21,542-square-foot hall of fame and museum building is surrounded by 17 exterior 24-foot columns, each topped by a five-foot ball representing a different sport (such as baseball, football, basketball, tennis, soccer, bowling, volleyball, etc.).

The hall has 171 inductees, including such stellar athletes as Walter Payton, football; Ralph Boston, track and field; Archie Manning, football; and Dizzy Dean, baseball (a special section is devoted to him). There are also individuals like Margaret Wade, heralded Delta State basketball coach, and Stew Hester,

noted for moving the U.S. Open from private Forest Hills to the public U.S. Tennis Center while president of the U.S. Tennis Association.

In addition to the exhibits on hall of famers, the museum offers participatory experiences in golf, soccer, baseball, and broadcasting and has a series of interactive touch-screen information delivery kiosks.

Mississippi Sports Hall of Fame and Museum, 1152 Lakeland Dr., Jackson, MS 39216. Phone: 601/982–8264. Hours: 10–4 Tues.–Sat.; closed major holidays. Admission: adults, $5; seniors and children 6–17, $3.50; children 5 and under, free; groups of 12 or more, $3 each.

MISSOURI SPORTS HALL OF FAME, Springfield, Missouri. The Missouri Basketball Hall of Fame and an earlier all-sports hall of fame evolved into the Missouri Sports Hall of Fame in 1993 when the latter opened its museum in Springfield—thanks to a $2.5-million gift from John Q. Hammons, developer and philanthropist.

Bronze statues of basketball, baseball, and football players welcome visitors to the 30,000-square-foot facility. The hall of fame features the history of Missouri sports; honors exemplary athletes, coaches, teams, officials, contributors, and media; and seeks to promote sports throughout the state—especially among youth.

Forty-four persons have been inducted into the all-sports hall of fame since its founding (and over 300 if those enshrined in prior basketball and sports halls are included). Among the honorees are Stan Musial and George Brett in baseball; Len Dawson and coach Dan Devine in football; Ed MacCauley in basketball; Hale Irwin in golf; and Bob Costas and Jack Buck in sports broadcasting.

The exhibits include a simulated basketball court, with photographs, memorabilia, and artifacts of hall of famers; an interactive touch-screen football exhibit featuring many of the inductees; a pitching cage in which 100-mph pitches are demonstrated; a locker room in which visitors receive a pep talk from baseball manager Whitey Herzog; a Harold Ensley fishing display; a Ford Bronco that conquered the Baja circuit; and a Ford Thunderbird that raced at championship speeds in several NASCAR events.

Missouri Sports Hall of Fame, 5051 Highland Springs Blvd., Springfield, MO 65809. Phone: 417/887–3100. Hours: 10–4 Mon.–Sat., 12–4 Sun.; closed Easter and Christmas. Admission: adults, $5; seniors, $4; children 6–15, $3; children 5 and under, free; families, $10.

MUSKEGON AREA SPORTS HALL OF FAME, Muskegon, Michigan. The Muskegon Area Sports Hall of Fame is dedicated to outstanding athletes, coaches, officials, and other sports figures from the eastern Lake Michigan shoreline area around Muskegon, Michigan. Organized in 1987 by Dick Hedges, a retired sports writer, the hall of fame contains plaques, photographs, artifacts, and memorabilia in a room at the Muskegon County Museum.

Among the 65 individuals enshrined in the hall of fame are Bennie Ooster-

baan, all-American football end at the University of Michigan; Earl Morrall, who played 21 years as quarterback in the National Football League; Bob Zuppke, legendary football coach at the University of Illinois; Paul Griffin, who played for the San Antonio Spurs in professional basketball; Kenny Lane, former lightweight boxing contender; and Frank Secory, longtime baseball umpire in the National League.

Muskegon Area Sports Hall of Fame, Muskegon County Museum, 430 W. Clay Ave., Muskegon, MI 49440. Phone: 616/722–0278. Hours: 9:30–4:30 Mon.–Fri.; 12:30–4: 30 Sat.–Sun.; closed major holidays. Admission: free.

NATIONAL HIGH SCHOOL SPORTS HALL OF FAME, Kansas City, Missouri. The National Federation of State High School Associations in Kansas City, Missouri, has been inducting outstanding athletes, coaches, officials, administrators, and others into its National High School Sports Hall of Fame since 1982. The honorees, who must be at least 35 years old, are nominated by the various state high school associations.

The inductees, which now number 207, are cited for their achievements and impact on high school athletics. Plaques of those enshrined are exhibited in the national headquarters for a year and then sent to the nominating state associations for permanent display. Among those who have been honored are Byron ''Whizzer'' White, Merlin Olsen, and Earl Campbell in football; Oscar Robertson, Bill Bradley, and Larry Bird in basketball; Johnny Bench in baseball; Jesse Owens in track; Arnold Palmer in golf; and coaches Tom Landry in football and Phil Jackson in basketball.

National High School Sports Hall of Fame, 11724 N.W. Plaze Circle, Kansas City, MO 64195. Phone: 816/464–5400. Hours: 8–4:30 Mon.–Fri.; closed holidays. Admission: free.

NATIONAL ITALIAN AMERICAN SPORTS HALL OF FAME, Chicago, Illinois. The National Italian American Sports Hall of Fame is on the move again. Founded in Elmwood Park, Illinois, in 1978, it moved to Arlington Heights, Illinois, in 1987, and now is constructing a new 9,000-square-foot facility near downtown Chicago, scheduled to open in late 1997.

Many of the great American athletes of Italian descent are honored in the hall of fame. Among the 127 Italian-Americans inducted are such sports figures as Joe DiMaggio and Phil Rizzuto in baseball; Hank Luisetti, basketball; Phil and Tony Esposito, hockey; Rocky Marciano, boxing; Brian Boitano, figure skating; Carmen Salvino, bowling; Mario Andretti, motor racing; Vince Lombardi and Alan Ameche, football; Eddie Arcaro, horse racing; Mary Lou Retton, gymnastics; Randy Savage, wrestling; Willie Mosconi, billiards; Jennifer Capriati, tennis; and Matt Biondi, swimming.

Tributes to honorees are grouped according to the sports, in some 22 categories. The hall of fame has one of the most extensive collections of artifacts and memorabilia among such facilities. It includes such objects as Biondi's 11

Olympic gold medals; hockey sticks of the Esposito brothers; silks, boots, and other riding gear of jockey Arcaro; a suede costume worn by Boitano when he won the Olympic figure skating gold in 1988; Ameche's Heisman Trophy; shoes and warm-up jacket of Olympic gold-medalist Retton; Salvino's bowling ball and shoes; and the STP No. 1 car driven by Andretti in the 1970 Indianapolis 500.

National Italian American Sports Hall of Fame, 2625 Clearbrook Dr., Arlington Heights, IL 60005. Phone: 706/437–3077. Hours: closed until new facility opens in Chicago. Admission: adults, $2; seniors and children, $1.

NATIONAL JEWISH AMERICAN SPORTS HALL OF FAME, Washington, D.C. A permanent gallery opened in 1997 to house the National Jewish American Sports Hall of Fame at the B'nai B'rith Klutznick National Jewish Museum in Washington, D.C. The hall of fame, which honors American athletes, coaches, and other sports figures of Jewish descent, was founded in 1991; it was previously a temporary exhibition.

Among the 30 inductees are boxers Benny Leonard and Barney Ross; football stars Sid Luckman and Marshall Goldberg; baseball legends Hank Greenberg and Sandy Koufax; Olympic swimmer Mark Spitz; basketball standout Dolph Schayes; and tennis player Dick Savitt.

The 600-square-foot hall of fame gallery consists of lockers, photographs, equipment, memorabilia, and videos pertaining to the inductees. In addition, it has an Honor Roll of 40 additional persons cited for their contributions to sports.

National Jewish American Sports Hall of Fame, B'nai B'rith Klutznick National Jewish Museum, 1640 Rhode Island Ave., N.W., Washington, DC 20036. Phone: 202/857-6583. Hours: 10–5 Sun.–Fri.; closed national and Jewish holidays. Admission: free.

NATIONAL POLISH-AMERICAN SPORTS HALL OF FAME, Orchard Lake, Michigan.The National Polish-American Sports Hall of Fame has enshrined 62 outstanding American athletes, coaches, and others of Polish descent since being founded in 1973. The hall of fame has been located on the second floor of the Dombrowski Fieldhouse at St. Mary's College in Orchard Lake, Michigan, since 1978.

Centerpiece of the hall of fame is an exhibit on the first inductee, Stan Musial of the St. Louis Cardinals baseball team. Among the others honored are baseball stars Carl Yastrzemski, Phil Niekro, and Tony Kubeck; football quarterback Johnny Lujack; and Duke University basketball coach Mike Krzysewski. The hall contains plaques with photographs and information about inductees, as well as a collection of memorabilia.

National Polish-American Sports Hall of Fame, Dombrowski Fieldhouse, St. Mary's College, Orchard Lake, MI 48324. Phone: 810/683–0401. Hours: by appointment. Admission: free.

NEW YORK JEWISH SPORTS HALL OF FAME, Commack, New York. The New York Jewish Sports Hall of Fame was founded in 1993 at the Suffolk

Y Jewish Community Center in Commack as a result of members' interest in educating Jewish youth as to their heritage. The community center now features—in a hallway—the uniforms, lockers, photographs, memorabilia, and panels of enshrined Jewish athletes and others who have contributed to sports in the State of New York.

Among the 27 inductees are such Jewish athletes, coaches, and sports figures as Sandy Koufax, Hank Greenberg, and Art Shamsky, for baseball; Sid Luckman, Gary Wood, and Dick Steinberg, football; Dolph Schayes, Art Heyman, Sid Tanenbaum, and Red Auerbach, basketball; Benny Leonard, boxing; Henry Wittenberg, wrestling; Shep Messing, soccer; and Mel Allen, Marv Albert, and Marty Glickman, sports announcers.

The New York Jewish Sports Hall of Fame is one of 17 mostly local, but also state and regional, Jewish sports halls of fame in the United States and Canada. Most consist of photographs or plaques on the walls of Jewish community and recreational centers. Some also have artifacts or exhibits. In addition, an International Jewish Sports Hall of Fame is located in Israel.

These community and recreational center halls of fame include: the National Jewish American Sports Hall of Fame, Washington, D.C.; the Canton Jewish Community Center Hall of Fame, Canton, Ohio; Chicago's Jewish Sports Hall of Fame, Northbrook, Illinois; the Columbus Jewish Community Center Hall of Fame, Columbus, Ohio; the Greater Washington Jewish Sports Hall of Fame, Rockville, Maryland; the JCC Sports Hall of Fame, Cleveland Heights, Ohio; the Michigan Jewish Sports Hall of Fame, West Bloomfield; the Milwaukee Jewish Community Center Sports Hall of Fame, Milwaukee; the Montreal YM/YWHA Sports Hall of Fame, Montreal, Canada; the Philadelphia Jewish Sports Hall of Fame, Philadelphia; the Rhode Island Jewish Athletes Hall of Fame, Providence; Rochester Jewish Athletes Hall of Fame, Rochester; the St. Louis Jewish Sports Hall of Fame, St. Louis; the Southern California Jewish Sports Hall of Fame, Los Angeles; the Western Pennsylvania Jewish Sports Hall of Fame, Pittsburgh; and the YM/YWHA of Northern Jersey Sports Hall of Fame, Wayne.

New York Jewish Sports Hall of Fame, Suffolk Y Jewish Community Center, 74 Hauppauge Rd., Commack, NY 11725. Phone: 526/462–9800. Hours: whenever Y is open. Admission: free.

NORTH CAROLINA SPORTS HALL OF FAME, Raleigh, North Carolina. The North Carolina Sports Hall of Fame honors the state's leading sports achievers in a 4,000-square-foot gallery at the North Carolina Museum of History in Raleigh. Originally initiated by the Charlotte Chamber of Commerce, the hall of fame held its first induction ceremonies in 1963. As the program and collections grew, memorabilia and other objects were placed in storage at the state history museum. In 1980–82, the museum presented a temporary exhibition on the hall of famers; when the museum moved into its new building in 1994, a permanent gallery was devoted to the North Carolina Sports Hall of Fame. It now is seen by many of the nearly 300,000 visitors to the museum annually.

The hall of fame has enshrined 173 players, coaches, administrators, and others for their outstanding accomplishments and services. They include such sports figures as Charlie Justice, Ace Parker, and Sonny Jourgensen in football; Enos Slaughter and ''Catfish'' Hunter in baseball; Sam Jones, Walter Davis, and David Thompson in basketball; Arnold Palmer, Raymond Floyd, and Estelle Lawson Page in golf; Jim Beatty and Dr. LeRoy Walker in track and field; Richard Petty and Dale Earnhardt in stock car racing; and coaches Dean Smith and Kay Yow in basketball and Wallace Wade in football.

The gallery contains plaques, photographs, banners, and various memorabilia and artifacts of the inductees.

North Carolina Sports Hall of Fame, North Carolina Museum of History, 5 E. Edenton St., Raleigh, NC 27601–1011. Phone: 919/715–0200. Hours: 9–5 Tues.–Sat.; 1–6 Sun.; closed New Year's Day, Thanksgiving, and Christmas. Admission: free.

NORTH DAKOTA SPORTS HALL OF FAME, Jamestown, North Dakota. The North Dakota Sports Hall of Fame in Jamestown evolved out of a hall of fame devoted to amateur baseball in the state. The Association of North Dakota Amateur Baseball Leagues Hall of Fame was founded in 1963; it was succeeded by an all-sports hall of fame in 1988, when it was decided to broaden the scope.

The hall of fame now honors nearly 1,500 athletes, coaches, administrators, officials, and others in four divisions at the Jamestown Civic Center. Ten individuals who have brought national recognition to North Dakota by their actions on the national level constitute Division 1, the highest honor. They include Roger Maris, New York Yankees outfielder and home run king; Phil Jackson, Chicago Bulls coach and former New York Knicks standout; Virgil Hill, light heavyweight boxing champion; Dave Osborn, Minnesota Vikings running back; Cliff Purpur, first American to play in the National Hockey League; and Ron Erhardt, New York Giants offensive coordinator and former New England Patriots coach.

In the other three divisions, approximately 60 persons are enshrined in the North Dakota Sports Hall of Honor for being recognized at the national level in a particular sport or sports; 719 are in the Sports Association Hall of Fame for being inducted into their respective sports association's hall of fame; and over 700 are cited in the sports hall of fame at one of North Dakota's 13 colleges and universities.

The Division 1 inductees are honored at a dinner and their photographs are displayed at the civic center, while those in the state hall of honor and association hall of fame are recognized with plaques and panels at the center. Photographs, memorabilia, trophies, and other such materials also are displayed at the center. Those individuals in college and university halls of fame are honored primarily at their respective institutions.

North Dakota Sports Hall of Fame, Jamestown Civic Center, 212 Third Ave., N.E., Jamestown, ND 58401. Phone: 701/252–8088. Hours: 8–5 Mon.–Fri.; closed major holidays. Admission: free.

ORANGE COUNTY SPORTS HALL OF FAME, Anaheim, California. The Orange County Sports Hall of Fame makes its home on the second floor of Anaheim Stadium, home of the Anaheim Angels baseball team. Among the diverse sports stars inducted into the hall of fame are Walter Johnson and Rod Carew in baseball; Ann Meyers, basketball; and Cathy Rigby, gymnastics.

The hall of fame was started in 1980 by a group of sportswriters. In 1983, it merged with the Orange County Sports Association and later that year opened exhibits in a 7,500-square-foot space.

Orange County Sports Hall of Fame, Anaheim Stadium, Anaheim, CA 92806. Phone: 714/254–3100. Hours: whenever stadium has events. Admission: free.

PAUL W. BRYANT MUSEUM, Tuscaloosa, Alabama. The Paul W. Bryant Museum at the University of Alabama in Tuscaloosa is named for "Bear" Bryant, the late legendary football coach of the Crimson Tide. It is not called a "hall of fame," but it functions like one—focusing on the university's sports history and its outstanding athletes and coaches, with an emphasis on football.

Founded in 1985, the 16,000-square-foot museum traces the history of football and other sports at the university. It contains artifacts, memorabilia, photographs, films, videos, radio recordings, and other materials on great moments in Alabama football and other sports, as well as displays on exceptional players and coaches. It features a film on the life, career, and philosophy of Coach Bryant, and it also has an exhibit on the Southeastern Conference, of which the university is a member. The annual attendance is approximately 35,000.

Paul W. Bryant Museum, University of Alabama, 300 Bryant Dr., PO Box 870385, Tuscaloosa, AL 35487. Phone: 205/348–4668. Hours: 9–4 daily, closed major holidays. Admission: adults, $2; seniors and children 6–17, $1; children under 5, free.

PUERTO RICO SPORTS HALL OF FAME, San Juan, Puerto Rico. The Puerto Rico Sports Hall of Fame in San Juan has been inducting outstanding Puerto Rican athletes, coaches, and promoters since 1958, but it was not until 1997 that it had a place to honor the sports stars. The original space under the grandstand of the Sixto Escobar Stadium was converted that year into an 11,000-square-foot museum and library facility.

The original hall of fame organization was started by the island's newspaper association, but it operated for only one year. It then was taken over by a private group, which worked for years to find a home for the hall.

Approximately 190 persons have been inducted into the hall of fame. They include such stars as Roberto Clemente, Luis Arroyo, Sandy Alomar, Sr., and Amilo Navarro in baseball; Sixto Escobar, Carlos Ortiz, Wilfredo Gomez, and Wilfredo Benitez, boxing; Chi Chi Rodriquez, golf; Charles and Stanley Pasarell and Welby Van Horn, tennis; Victor Mario Perez, Juan Vicens, Pedro I. Pradoes, and Teo Cruz, basketball; Jesus Vasallo, Anita Lallande, and Fernando Canales, swimming; and Juan Luyandak, Rebekah Colberg, Rolando Cruz, and Juan R. Palmer, track and field.

Puerto Rico Sports Hall of Fame, PO Box 361899, San Juan, Puerto Rico 00936–1899. Phone: 809/756–5306. Hours: 9–5 Mon.–Fri.; 9–12 Sat.; closed major holidays. Admission: to be determined.

SENIOR ATHLETES HALL OF FAME, Bradenton, Florida. Elderly amateur athletes who have performed extraordinary feats of speed, strength, accuracy, or endurance are honored in the Senior Athletes Hall of Fame in Bradenton, Florida. The hall was founded in 1992 to recognize men and women athletes over 50 years of age who consistently set national or world records in their fields.

The hall of fame—which was relocated to the Freedom Village Retirement Community in 1996—has panel exhibits on recipients in a central complex building called The Landings. Among the first 18 inductees are Melvin C. Buschman, pentathlon; Dorothy Bundy Cheney, tennis; Helen Mary Darnell, track and field; Clive Davies, distance running; Dorothy Leonard Donnelly, swimming; Theodore Epstein, untraendurance triathlon; and Joseph John Norris, bowling.

Senior Athletes Hall of Fame, The Landings, Freedom Village Retirement Community, Bradenton, FL 34210. Phone: 941/756–8808. Hours: 9–5 Mon.–Fri.; 10–2 Sat. Admission: free.

SHREVEPORT–BOSSIER CITY SPORTS MUSEUM OF CHAMPIONS, Shreveport, Louisiana. The Shreveport-Bossier City Sports Museum of Champions in Shreveport, Louisana, honors athletes from the area who have won conference, national, or world championships or have been selected as all-Americans in their fields. Established in 1992, it is a joint venture of the two cities in cooperation with the local Sports Foundation.

Eighty-three individuals have been inducted into the hall of fame and museum, including such stars as Terry Bradshaw, Joe Ferguson, Stan Humphries, and David Woodley in football; Robert Parish, basketball; Freddie Spencer, motorcross; John Frank, horse racing; and Hal Sutton, Miller Barber, and Tommy Bolt, golf.

The 800-square-foot exhibit area contains information about the inductees and various memorabilia from the enshrined athletes.

Shreveport-Bossier City Sports Museum of Champions, 700 Clyde Fant Pkwy., Shreveport, LA 71101. Phone: 318/221–0712. Hours: 9–4:30 Mon.–Fri.; 12–4 Sat.–Sun.; closed major holidays. Admission: adults, $2; students, $1.

SPORTS HALL OF FAME OF NEW JERSEY, East Rutherford, New Jersey. New Jersey's outstanding athletes are honored in the Sports Hall of Fame of New Jersey, located in the box office lobby of the Continental Airlines Arena at the Meadowlands Sports Complex in East Rutherford.

Founded in 1993, the hall of fame has recognized with plaques 37 inductees, including Yogi Berra and Phil Rizzuto, baseball; Vince Lombardi and Joe Theisman, football; Bill Bradley and Rick Barry, basketball; and Althea Gibson, tennis.

Sports Hall of Fame of New Jersey, Sports and Exposition Authority, Continental Air-
lines Arena, Meadowlands Sports Complex, East Rutherford, NJ 07073. Phone: 201/
507–8134. Hours: whenever box office is open. Admission: free.

STATE OF ALABAMA SPORTS HALL OF FAME, Birmingham, Alabama.
Created by an act of the Alabama Legislature in 1967, the State of Alabama
Sports Hall of Fame is dedicated to preserving and honoring the state's sports
heritage. Its first museum was opened in 1969. It moved into the present three-
story, 30,000-square-foot building in Birmingham in 1992.

The museum features more than 4,000 pieces of memorabilia and artifacts,
six life-size dioramas, interactive touch-screen exhibitry, and bronze plaques to
tell Alabama's sports story and the achievements of the state's greatest sports
figures.

The hall of fame has 183 inductees. They include such athletes as Jesse
Owens, Olympic track champion; Bart Starr, quarterback of the Green Bay Pack-
ers Super Bowl champions; Joe Louis, world boxing champion; Willie Mays,
Hank Aaron, and Satchel Paige, baseball greats; Bo Jackson, football and base-
ball star; Davey Allison, motor racing champion; Jerry Pate, U.S. Open golf
champion; and famed football coaches Paul "Bear" Bryant, Bobby Bowden,
Gene Stallings, and John W. Heisman, for whom the Heisman Trophy is named.

Among the exhibit highlights are three baseball World Series trophies; two
Heisman trophies; football's Super Bowl XXV trophy; a U.S. Open golf trophy;
quarterback Ken Stabler's Hickok Belt; and gold medals, Super Bowl rings,
football players' contracts, and oil paintings of sports figures.

The hall of fame also has special programs to select distinguished Alabama
and American sportsmen and confer Bryant-Jordan scholar-athlete achievement
awards.

State of Alabama Sports Hall of Fame, 2150 Civic Center Blvd., Birmingham, AL 35203.
Phone: 205/323–6665. Hours: 9–5 Mon.–Sat.; 1–5 Sun. Admission: adults, $5; seniors,
$4; students, $3; families, $13; groups of 10 or more, $1 less.

STATE OF KANSAS SPORTS HALL OF FAME, Abilene, Kansas. The
State of Kansas Sports Hall of Fame has had three homes since it was founded
in 1961. Started as a centennial project, it first opened in Topeka, then moved
to the basement level of the Watkins Community Museum of History in
Lawrence, and finally relocated to a 7,000-square-foot remodeled bank building
in Abilene in 1991.

Among the 64 players, coaches, and officials in the hall of fame are such
outstanding athletes and coaches as Gene Cunningham and Jim Ryun in track
and field; Gale Sayers and John Hadl in football; Danny Manning and Dean
Smith in basketball; and Ralph Houk in baseball. The exhibits include portraits
of inductees, biographical information, photographs, memorabilia, sports equip-
ment, and a ten-minute video.

State of Kansas Sports Hall of Fame, 213 N. Broadway, Abilene, KS 67410. Phone: 913/263-7403. Hours: 10-4 Mon.-Sat.; 1-4 Sun.; closed major holidays. Admission: free.

STATE OF MICHIGAN SPORTS HALL OF FAME, Detroit, Michigan. Detroit's Cobo Center is the site of the State of Michigan Sports Hall of Fame, which recognizes outstanding individuals and teams in amateur and professional sports for bringing distinction to the state and its communities. The exhibit features bronze picture-plaques of the honorees.

The hall of fame, founded in 1954 and opened in Cobo Center in 1966, has inducted 189 individuals and teams. They include Gordie Howe and Alex Delvecchio, of the Detroit Red Wings, hockey; Denny McLain, Willie Horton, and manager George "Sparky" Anderson, of the Detroit Tigers, baseball; David DeBusschere and Bob Lanier, of the Detroit Pistons, basketball; Billy Sims and Alex Karras, of the Detroit Lions, football; Tom Harmon and coach Bo Schembechler, University of Michigan football; coach Hugh "Duffy" Daugherty, Michigan State University football; auto pioneer Henry Ford; power-boat racer William Muncey; and sportscasters Van Patrick and Ernie Harwell.

State of Michigan Sports Hall of Fame, Cobo Center, 1 Washington Blvd., Detroit, MI 48226. Phone: 313/259-4333. Hours: whenever Cobo Center is open. Admission: free.

STATE OF OREGON SPORTS HALL OF FAME MUSEUM, Portland, Oregon. More than 245 athletes and others who have contributed to the advancement of sports in Oregon are honored in the State of Oregon Sports Hall of Fame Museum in Portland. They range from all-American athletes to individuals and companies that have furthered sports in the state through means other than athletic competition.

Founded in 1978, the nonprofit hall of fame/museum has occupied 3,300 square feet in the Standard Insurance Center building in downtown Portland since 1986. It now is planning to expand to 9,000 square feet in another facility.

The hall of fame exhibits contain photographs, uniforms, equipment, sporting event programs, memorabilia, and other materials of inductees. Among the displays is Terry Baker's 1962 Heisman Trophy in football. There are also the uniforms of such sports stars as Mel Counts, Oregon State University basketball Olympian; Ahmad Rashad, University of Oregon football great; Art Jones, Portland Buckaroo hockey standout; Steve Prefontaine, University of Oregon track star; and Bill Walton, the Portland Trailblazers most valuable player in the 1977 professional basketball championships.

The museum also displays personal artifacts from such athletes as Mary Decker-Slaney, track; Norm Van Brocklin, football; Don Schollander, swimming; Mickey Lolich, baseball; Rick Sanders, wrestling; Andy Aitkenhead, hockey; and Larry Mahan, rodeo.

Among the hall of fame's activities is the awarding of college scholarships to high school senior athletes on the basis of their academic and sports achievements and financial need.

State of Oregon Sports Hall of Fame Museum, 900 S.W. Fifth Ave., Suite C-80, PO Box 4381, Portland, OR 97208. Phone: 503/227–7466. Hours: 10–3 Mon.–Sat. Admission: free.

TENNESSEE SPORTS HALL OF FAME, Nashville, Tennessee. The Tennessee Sports Hall of Fame—which has been housed in the Thompson-Boling Assembly Center at the University of Tennessee in Knoxville—will be moving into the Nashville Arena when it is completed in 1998. It has inducted 249 athletes, coaches, and other sports figures since being founded in 1966. Originally started by the Middle Tennessee Sportswriters and Broadcasters Association, the hall of fame now is operated by the State of Tennessee.

The hall of fame has consisted largely of photographs of honorees, but it will be expanded to include artifacts, memorabilia, films, videos, interactive exhibits, and other materials when opened as part of the new indoor area being built in Nashville.

Among those enshrined in the hall of fame are such stars as A.F. "Bud" Dudley, Ed "Too Tall" Jones, and Doug Akins in football; Wilma Rudolph and Ralph Boston in track; Cary Middlecoff in golf; and Bob Neyland, Herman Hickman, and Johnny Majors, football coaches.

Tennessee Sports Hall of Fame, Nashville Arena, Nashville, TN 37201. Phone: 423/974-1224. Hours and admission: to be determined.

TEXAS SPORTS HALL OF FAME, Waco, Texas.
TEXAS BASEBALL HALL OF FAME
TEXAS HIGH SCHOOL BASKETBALL HALL OF FAME
TEXAS HIGH SCHOOL FOOTBALL HALL OF FAME
TEXAS SPORTS HALL OF FAME
TEXAS TENNIS HALL OF FAME

The Texas Sports Hall of Fame actually is five different halls of fame—Texas Sports Hall of Fame, Texas Tennis Hall of Fame, Texas Baseball Hall of Fame, Texas High School Football Hall of Fame, and Texas High School Basketball Hall of Fame. The various halls of fame joined forces to celebrate and preserve Texas sports history after a 15,342-square-foot facility was built to accommodate them in 1993 near Baylor University in Waco.

Each hall of fame has its own exhibit gallery, which recognizes individuals who have excelled in their representative fields. The total number of honorees now exceeds 600. The building also has a lobby that shows special and traveling exhibitions, and the Tom Landry Theater that features films of college and professional sports highlights.

The Texas Sports Hall of Fame began as the Texas Sports Hall of Champions in 1951. It was located in Grand Prairie for many years before closing in 1986 because of poor attendance resulting from its remote location. The new facility now has an annual attendance of approximately 25,000. Over 200 inductees have been cited for their sports accomplishments.

Among the inductees, and their items on display, are golfers Jimmy Demaret and Jack Burke, Jr., Augusta National green master's blazers; quarterback Davey O'Brien, 1938 Heisman Trophy; auto racers A. J. Foyt and Johnny Rutherford, racing uniforms; jockey Willie Shoemaker, racing silks, crop, and saddle blanket; ballplayer Rogers Hornsby, 1926 uniform; shotputter Randy Mattson, 16-pound ball; and game jerseys of many football, baseball, and other stars, such as Bob Lilly, Joe Greene, Roger Staubach, and Nolan Ryan.

The Texas Tennis Hall of Fame, founded in 1981, was the first to get together with the Texas Sports Hall of Champions in the new complex. It now has more than 60 honorees, including Davis Cup and Wrightman Cup stars Wilmer Allison and Nancy Richey and "the father of tennis in Texas," Daniel A. Penick. The hall also has a *Tennis Time Tunnel* that features the evolution of rackets and the Arthur Ashe Future Champions trophy.

The Texas Baseball Hall of Fame, established in 1978, had 97 inductees in 1996, while the Texas High School Football Hall of Fame, started in 1968, had 144, and the Texas High School Basketball Hall of Fame, founded in 1971, had 121.

Many of the nation's greatest athletes and coaches went to Texas high schools and now are in the school halls of fame. They include ballplayer Jackie Robinson, basketball star Shaquille O'Neal, and football coach Jack Pardee. The exhibits contain photographs, memorabilia, news clippings, and artifacts of many of the inductees.

Texas Sports Hall of Fame, 1108 S. University Parks Dr., Waco, TX 76706. Phone: 817/ 756–1633. Hours: 10–5 Mon.–Sat.; 12–5 Sun. Admission: adults, $4; seniors, $3.50; students, $2; and children 5 and under, free.

TOM KEARNS UNIVERSITY OF MIAMI SPORTS HALL OF FAME, Coral Gables, Florida. The Tom Kearns Sports Hall of Fame at the University of Miami in Coral Gables, Florida, honors more than 100 of the university's outstanding athletes, coaches, and other sports figures. Founded in 1989, the hall of fame is named for its major benefactor, a leading businessman and university hall of famer in football and boxing.

Among those who have been inducted into the hall of fame are such star athletes as Bernie Kosar, Ted Hendricks, Jim Otto, and Vinny Testaverde, football; Rick Barry, basketball; Greg Vaughn, baseball; and Greg Louganis, swimming.

The facility has five viewing areas, including a Hall of Honor that pays homage to the university's outstanding amateur and professional athletes as well as all-Americans and Olympians—with their names inscribed on respective plaques. Hall of famers are honored in a lobby atrium, which contains photographs and 21 glass cases with trophies and memorabilia received or used by many of those enshrined. Another gallery traces the history of University of Miami sports and features video highlights, while championship teams and athletic directors are spotlighted in a conference center.

Tom Kearns University of Miami Sports Hall of Fame, University of Miami, 1 Hurricane
 Dr., Coral Gables, FL 33146. Phone: 305/284–2775. Hours: 11–3 Mon., Wed., Fri.;
 closed holidays. Admission: free.

VIRGINIA SPORTS HALL OF FAME, Portsmouth, Virginia. Individuals
who have made lasting contributions to sports in Virginia, the nation, and the
world are enshrined in the Virginia Sports Hall of Fame in Portsmouth. The
hall of fame program was started in 1966 and opened in its present home in the
city's "old town" in 1972.

The hall of fame, which consists of three large rooms, features individual
display cases for each of the 155 inductees. The cases contain information about
the honorees and articles that were used in their playing, coaching, or admin-
istrative careers.

Among the sports figures in the hall of fame are such stars as Ace Parker,
Bill Dudley, and Willie Lanier in football; Eppa Rixey, Gene Alley, and Hank
Foiles, baseball; Robert Spessard, Bill Chambers, and Nancy Lieberman-Cline,
basketball; Sam Snead, Lew Worsham, and Lily Harper Martin, golf; Arthur
Ashe, C. Alphonso Smith, and Harold W. Burrows, Jr., tennis; Harrison Flippin,
Scrap Chandler, and Archie Hahn, track; Jean McLean Davis, equestrian;
Charles Vail, sailboat racing; Doris Leigh, bowling; Joe Weatherly, auto racing;
Frank B. Havens, canoeing; Bill Martin, Sr., wrestling; Shelly Mann, swimming;
Bob Rowland, speedboat racing; Chris Chanery, horse racing; Leigh Williams,
Francis Lee Summers, and Paul W. Rice, four sports each; Meb Davis, Bill
Thomas, Herbert Bryant, and Pappy Gooch, all major sports; and C. P. Miles,
James B. Bryan, Bobby Dandridge, Rosie Thomas, and Dave Twantzik, coaches
or administrators.

Virginia Sports Hall of Fame, 420 High St., PO Box 370, Portsmouth, VA 23705. Phone:
 804/393–8031. Hours: 10–5 Tues.–Sat.; 1–5 Sun. Admission: free.

BASEBALL

COMISKEY PARK HALL OF FAME, Chicago, Illinois. Chicago White Sox
players whose numbers have been retired are honored in the Comiskey Park
Hall of Fame in Chicago. The hall of fame, located adjacent to the gift shop
along the main concourse of the baseball park, was founded in 1991 with the
opening of the new Comiskey Park, home field of the White Sox.

Seven former White Sox star players—including outfielder Minnie Minoso,
shortstop Luis Aparicio, and second baseman Nellie Fox—have been inducted
into the hall of fame. In addition to featuring photographs, memorabilia, and
other materials pertaining to the hall of famers, the facility also has displays on
the White Sox, professional women's baseball, the Negro leagues, and other
baseball played at Comiskey Park; current all-star first baseman Frank Thomas;
and such objects as an 1888 American Baseball Association trophy; "Shoeless

Joe'' Jackson's 1919 contract, and a 1991 time capsule with items from the old Comiskey Park (was replaced by the new stadium).

Comiskey Park Hall of Fame, Comiskey Park, 333 W. 35th St., Chicago, IL 60616. Phone: 312/924–1000. Hours: baseball season—during games; Thanksgiving– Christmas and March—10–4 Mon.–Sat. Admission: free.

LITTLE LEAGUE BASEBALL HALL OF EXCELLENCE, Williamsport, Pennsylvania. One of the galleries at the Peter J. McGovern Little League Baseball Museum in Williamport, Pennsylvania, is devoted to the Little League Baseball Hall of Excellence. Started in 1988, the hall honors former Little League players who have achieved success in the major leagues and other fields.

Sixteen notables—such as pitchers Jim Palmer and Tom Seaver, actor Tom Selleck, and columnist George Will—have been inducted into the hall of excellence. The gallery features illuminated panels of the honorees, as well as photographs, memorabilia, equipment, and trophies. Nearly 500 major league players are former little leaguers. The induction ceremonies are held each year before the Little League World Series championship game in August.

The museum is devoted to the nature, history, growth, and highlights of Little League baseball, which began in 1939 in Williamsport and now involves 2.5 million youngsters in more than 80 countries. The exhibits focus on the development, players, equipment, and rules of Little League baseball. Among the displays are interactive quizzes on baseball and Little League regulations; production of equipment; batting and pitching cages; highlights of championship games; and issues facing youngsters today, ranging from proper nutrition to drugs.

Little League Baseball Hall of Excellence, Peter J. McGovern Little League Baseball Museum, Rte. 15, PO Box 3485, Williamsport, PA 17701. Phone: 717/326–3607. Hours: Memorial Day–Labor Day—9–7 Mon.–Sat.; 12 noon–7 Sun.; Labor Day–Memorial Day—9–5 Mon.–Sat.; 12 noon–5 Sun. Admission: adults, $5; seniors, $3; children 5–13, $1.50; children under 5, free; families, $13.

NATIONAL BASEBALL CONGRESS HALL OF FAME, Wichita, Kansas. The National Baseball Congress, which sanctions many of the nation's leading amateur summer leagues and hosts a world series every August, established a hall of fame in 1991 to honor players from the series who have achieved stardom in the major leagues, and other outstanding players.

The hall of fame, located in the gift shop at Lawrence-Dumont Stadium in Wichita, Kansas, has inducted 29 players, including such luminaries as Bob Boon, Roger Clemens, Rick Monday, Ossie Smith, and Don Sutton. They are honored with plaques, photographs, and memorabilia. In addition, photos and mementos of other players, coaches, and teams are displayed.

National Baseball Congress Hall of Fame, Lawrence-Dumont Stadium, 300 S. Sycamore, Wichita, KS 67213. Phone: 316/267–3372. Hours: 9–5 Mon.–Fri.; also open during Wranglers home games and during National Baseball Congress world series. Admission: free.

NATIONAL BASEBALL HALL OF FAME AND MUSEUM, Cooperstown, New York. The National Baseball Hall of Fame and Museum opened in Cooperstown, New York, in 1939 on the 100th anniversary of baseball, which is said to have been devised by Abner Doubleday and first played in the small upstate community. Today, it is one of the nation's largest and most popular halls of fame, with an annual attendance of more than 400,000.

The first election to the hall of fame was held in 1936, several years before the museum was built (it has since been expanded to 80,000 square feet). Among the honorees were such baseball greats as Ty Cobb, Walter Johnson, Christy Mathewson, Babe Ruth, and Honus Wagner.

The initial step in organizing a baseball museum and hall of fame was the building of Doubleday Field on the farm lot where youths played the game in 1839. The dedication ceremonies for the first game in the stadium in 1920 were attended by many prominent baseball figures and dignitaries. The field, the discovery of a number of baseball artifacts nearby, and the desire to call attention to Cooperstown's role in baseball history stimulated philanthropist Stephen C. Clark of Cooperstown to open a one-room exhibit featuring one of the first baseballs, and other objects in a village club. The exhibit attracted considerable attention and prompted Alexander Cleland, who had been associated with Clark in business affairs, and others to suggest the establishment of a national baseball museum.

Ford Frick, then president of baseball's National League, became enthusiastic about the museum idea and obtained the support of Kenesaw Mountain Landis, baseball's first commissioner, and William Harridge, president of the American League. Contributions and baseball memorabilia from all parts of the country soon followed.

When planning began in 1935 for baseball's centennial celebration in 1939, Frick proposed that a hall of fame also be included in plans for the baseball museum in Cooperstown. The cooperation of the Baseball Writers Association of America was enlisted to select the honorees. The first election followed in 1936, and they have continued annually since, with one modification: a veterans committee was created recently to enshrine baseball greats from the nineteenth century and the old Negro leagues.

A total of 232 players, managers, umpires, owners, and executives have been inducted into the hall of fame during its 60 years of operation. Among the outstanding players recognized are Tris Speaker, Cy Young, Frank Chance, Joe Tinker, Rogers Hornsby, Dizzy Dean, Lou Gehrig, Bob Feller, Ted Williams, Ralph Kiner, Joe DiMaggio, Hank Greenberg, Satchel Paige, Stan Musial, William Mays, Sandy Koufax, Hank Aaron, and Brooks Robinson. Other hall of famers include such individuals as managers Connie Mack, Joe McCarthy, and Casey Stengel; umpires Cal Hubbard, Jocko Conlan, and Bill Klem; owners Charles Comiskey and Clark Griffith; and executives Ed Barrow, Branch Rickey, and Larry MacPhail.

The museum honors inductees with plaques and uses many of their photo-

graphs, artifacts, and memorabilia in three floors of exhibits. More than 1,000 photographs and artifacts are used to trace the history of baseball. Among the other exhibits are displays on uniforms, manufacture of equipment, the World Series, the All-Star game, ball parks, Cooperstown history, world tours, the minor leagues, records, great moments, today's players, baseball cards, and such stars as Babe Ruth and Casey Stengel.

Visitors also can see the world's largest collection of baseball reference materials in the National Baseball Library, baseball films shown periodically, and Doubleday Field, nearby site of the annual Hall of Fame Game, which matches two major league teams each summer.

National Baseball Hall of Fame and Museum, 25 Main St., PO Box 590, Cooperstown, NY 13326–0590. Phone: 607/547–7200. Hours: May–Sept. 9–9 daily; Oct.–Apr. 9–5 daily; closed New Year's Day, Thanksgiving, and Christmas. Admission: adults, $9.50; seniors, $8; children 7–12, $4; children 6 and under, free.

NEW YORK YANKEES MEMORIAL PARK, the Bronx, New York. Twenty of the greatest players, managers, and officials of the New York Yankees baseball team are honored with monuments and plaques in Memorial Park in the outfield section of Yankee Stadium in the Bronx. The novel "hall of fame"—located near the bullpen and bleachers—also has a special walk as a tribute to ballplayers whose uniform numbers have been retired.

The first monument was dedicated in 1932 to the memory of Miller Huggins, long-time manager who guided the Yankees to six American League pennants and three world championships. It was followed by monuments for Lou Gehrig, the outstanding first baseman who played 2,130 consecutive games; Babe Ruth, the home run king; and slugger Mickey Mantle, who was added in 1996. The monuments originally were a part of the playing field in center field but were later moved to a fenced area, because they became obstacles for outfielders trying to retrieve long drives.

The first plaque was installed in 1940 as a tribute to Jacob Ruppert, a former team owner who built Yankee Stadium. Plaques later were added for two all-star center fielders, Joe DiMaggio and Mickey Mantle; general manager Edward Barrow; and two winning managers, Joe McCarthy and Casey Stengel.

In the 1980s, plaques honored such Yankee greats as Thurman Munson, Roger Maris, Elston Howard, Phil Rizzuto, Billy Martin, Lefty Gomez, Whitey Ford, Yogi Berra, Bill Dickey, and Allie Reynolds.

Monument Park also has two plaques not related to baseball. One commemorates the visit of Pope Paul VI to Yankee Stadium in 1965, and a second refers to Pope John Paul II's visit in 1979. Both were placed by the Knights of Columbus.

The walkway features the retired uniform numbers of 13 players and managers, all but one (Reggie Jackson) already honored with monuments or plaques. Monument Park, located on the first level in Section 36 of Yankee Stadium, is open from the time the gates open until 45 minutes before game time.

New York Yankees Monument Park, Yankee Stadium, 161st St. and River Ave., the Bronx, NY 10451. Phone: 718/293–4300. Hours: prior to the start of Yankee games. Admission: free with game tickets.

ORIGINAL BASEBALL HALL OF FAME OF MINNESOTA, Minneapolis, Minnesota. The Original Baseball Hall of Fame of Minnesota is located in a souvenir shop across from the Gate A entrance to the Hubert H. Humphrey Metrodome in Minneapolis. It was founded in 1986 on the other side of the Metrodome and moved to its present location in 1991.

The hall of fame is actually an exhibit of photographs, memorabilia, and equipment pertaining to baseball greats, such as Babe Ruth, Mickey Mantle, and Hank Aaron. Much of it is a store devoted to the sale of baseball souvenirs.

Original Baseball Hall of Fame of Minnesota, 910 Third St., Minneapolis, MN 55415. Phone: 612/375–5707. Hours: 8–4 Mon.–Fri.; 11–3 Sat.; during and after events in Metrodome. Admission: free.

ST. LOUIS CARDINALS HALL OF FAME MUSEUM, St. Louis, Missouri. The St. Louis Cardinals Hall of Fame Museum does not induct baseball players into its own hall of fame but serves as a repository for St. Louis baseball history and recognizes St. Louis players who have been enshrined in the National Baseball Hall of Fame in Cooperstown, New York.

The 4,500-square-foot hall, which formerly was located on the second-level concourse of Busch Stadium and moved into the International Bowling Museum and Hall of Fame building across the street in 1997, was opened in 1968 and became an all-baseball museum in 1992. Founded by Anheuser Busch, Inc., it features the history and memorabilia of the St. Louis Cardinals from 1892 (when the St. Louis Brown Stockings began playing in the National League) until the present, as well as the early St. Louis Negro leagues and the St. Louis Browns that played in the American League.

The Hall of Fame Room contains plaques of over 40 hall of famers who played for St. Louis baseball teams. The ''Cooperstown Heroes'' exhibit uses memorabilia from the National Baseball Hall of Fame to highlight their careers. The rich heritage of St. Louis baseball is presented, with a chronological perspective. Among the stars celebrated are Rogers Hornsby, George Sisler, Joe Medwick, Dizzy Dean, Stan Musial, Johnny Mize, Frankie Frisch, Jesse Haines, Ken Boyer, Lou Brock, Bob Forsch, Red Schoendienst, Bob Gibson, Enos Slaughter, and ''Cool Papa'' Bell.

Admission covers both the bowling and baseball halls of fame. For an additional charge, visitors can tour Busch Stadium, walk on the ball field, and see the players' view from the Cardinals' dugout.

St. Louis Cardinals Hall of Fame Museum, International Bowling Museum and Hall of Fame, 111 Stadium Plaza, St. Louis, MO 63102. Phone: 314/231–6340. Hours: 9–5 Mon.–Sat.; 12–5 Sun.; closed New Year's Eve and Day, Thanksgiving, and Christmas

Eve and Day. Admission: included in bowling museum's admission—adults, $5; children, $3; stadium tour, $2.50; groups of 20 or more, special rates.

SOUTH DAKOTA AMATEUR BASEBALL HALL OF FAME, Lake Norden, South Dakota. South Dakota's amateur baseball history and outstanding players and coaches are the focus of the South Dakota Amateur Baseball Hall of Fame in Lake Norden. The first inductions were in 1958, but a permanent 1,500-square-foot home for the hall was not built until 1976.

The hall of fame has honored 110 players and coaches. The exhibits include inductee plaques, photographs, and information and a pictorial history of amateur baseball in South Dakota, with artifacts, memorabilia, equipment, and historical documents.

South Dakota Amateur Baseball Hall of Fame, 519 Main Ave., PO Box 80, Lake Norden, SD 57248. Phone: 605/785–3553. Hours: mid-May–mid-Oct. 9 A.M.–7 P.M. daily; other times by appointment. Admission: free.

TED WILLIAMS MUSEUM AND HITTERS HALL OF FAME, Hernando, Florida. The Ted Williams Museum and Hitters Hall of Fame in Hernando, Florida, is a tribute to the former Boston Red Sox first baseman and other great baseball sluggers. The 10,000-square-foot museum—founded in 1994, with a hall of fame being added in 1995—seeks to further public understanding and appreciation of the history and importance of baseball as a national pastime.

A larger-than-life statue of Ted Williams dominates the museum entrance. His long career is told, from his first Red Sox contract to the final at-bat in Boston, largely through photographs, memorabilia, and artifacts. In addition, television monitors show actual game footage and interviews with such celebrated players as Stan Musial, Joe DiMaggio, and Bob Feller, as well as baseball fans like former President George Bush.

The Hitters Hall of Fame recognizes 25 of baseball's greatest hitters, as selected by Williams. They include such stars as Ty Cobb, Rogers Hornsby, Tris Speaker, Joe Jackson, Josh Gibson, Babe Ruth, Lou Gehrig, Jimmie Foxx, Mel Ott, Hank Greenberg, Johnny Mize, Joe DiMaggio, Stan Musial, Ralph Kiner, Willie Mays, Mickey Mantle, Hank Aaron, Frank Robinson, Duke Snider, Harmon Killebrew, and Mike Schmidt.

The museum and hall of fame also provides a retrospective of the most significant achievements in hitting, from Babe Ruth's fabled "called shot" home run in the 1932 World Series to George Brett's 1980 bid to become the first player since Ted Williams to hit .400 in a season.

Ted Williams Museum and Hitters Hall of Fame, 2455 N. Citrus Hills Blvd., Hernando, FL 34442. Phone: 904/527–6566. Hours: 10–4 Tues.–Sun. Admission: adults, $3; children 12 and under, $1.

TEXAS BASEBALL HALL OF FAME. (See All-Sports category.)

BASKETBALL

BLACKHAWKS/BULLS HALL OF FAME. (See Ice Hockey category.)

INDIANA BASKETBALL HALL OF FAME, New Castle, Indiana. The Indiana Basketball Hall of Fame in New Castle celebrates "Hoosier hysteria" and honors the state's high school basketball stars and coaches. Founded in 1962, it was the first in the nation to cite high school players and coaches for their basketball accomplishments.

The hall of fame started as an awards function in conjunction with the Downtown Lions Club of Indianapolis, followed by the opening of a museum in an office building in the capital city in 1970. When the building was sold in 1986, the museum closed, its contents were placed in storage, and a site committee began to look for a new location. Thirteen communities expressed interest in having the hall of fame and museum; New Castle and Henry County won the bidding with an offer to construct a 14,000-square-foot building on a five-acre site adjacent to the world's largest high school gym (seating 9,300). The $2.1 million new home opened in 1990.

More than 300 players, coaches, and other individuals who have contributed to Indiana's high school basketball tradition have been inducted into the hall of fame. The first five honorees were Homer Stonebraker, Ernest Wagner, Ward Lambert, Robert Vandivier, and John Wooden. Some of the more recent inductees are such players as Oscar Robertson, George McGinnis, Larry Bird, and Steve Alford. Photographs, memorabilia, artifacts, and videos are used primarily to trace their careers in high school, and often into college and professional basketball.

Much of the museum is devoted to the nature and history of basketball in Indiana. A courtyard at the entrance features 21 flags of current state and regional champions and a 70-by-36-foot map of the state composed of thousands of paving blocks honoring a school, team, coach, or donor. Exhibits include a chronological history of basketball; films of championship games; interactive games like trying to outwit a computer and shooting a basketball; and a gallery devoted to hometowns and high schools throughout the state, containing team photographs, uniforms, mascots, banners, school spirit buttons, and other such materials.

Indiana Basketball Hall of Fame, 1 Hall of Fame Court, New Castle, IN 47362. Phone: 317/529–1891. Hours: 10–5 Tues.–Sat.; 12–5 Sun.; closed New Year's Day, Easter, Thanksgiving, and Christmas. Admission: adults, $3; seniors, $2; students, $1; preschoolers, free.

NAISMITH MEMORIAL BASKETBALL HALL OF FAME, Springfield, Massachusetts. The Naismith Memorial Basketball Hall of Fame in Springfield, Massachusetts, is named for Dr. James Naismith, the Springfield College faculty member who invented the game as part of a physical education program in 1891.

The hall of fame was founded in 1968 and located at Springfield College for 17 years. In 1985, it moved into a $11.5 million, 48,000-square-foot, three-level new home adjacent to Interstate 91, and it substantially increased its annual attendance, which now exceeds 170,000 annually.

The basketball shrine honors the game's great players, teams, coaches, officials, and contributors at virtually every level—men and women, amateur, collegiate, professional, international, and wheelchair. Among the 215 individuals and four teams inducted are such players as Kareem Abdul-Jabbar, Rick Barry, Elgin Baylor, Dave Bing, Bill Bradley, Wilt Chamberlain, Bob Cousy, Julius Erving, Walt Frazier, John Havlicek, Bob Kurland, Nancy Lieberman-Cline, Pete Maravich, George Mikan, Cheryl Miller, Oscar Robertson, Bill Russell, Bill Walton, and Jerry West; coaches like Phog Allen, Red Auerbach, Chuck Daley, Hank Iba, Bob Knight, Al McGuire, Jack Ramsay, Adolph Rupp, Dean Smith, Margaret Wade, and John Wooden; and such teams as the original Boston Celtics, the Buffalo Germans, and the Renaissance.

The three levels of exhibits include basketball memorabilia, photographs, videos, interactive displays, multiscreen films, and tributes to hall of famers. Visitors can see exciting basketball game footage on video monitors, interact with past and present stars in the Wilson Imagymnation Theater, engage in a virtual reality game, test their shooting skills, watch basketball's hoopla in the multiscreen Converse Theater, and learn more about their favorite players in the Honors Court.

Naismith Memorial Basketball Hall of Fame, 1150 W. Columbus Ave., Springfield, MA 01101. Phone: 413/781–6500. Hours: 9–5 daily, but 9–6 July–Labor Day; closed New Year's Day, Thanksgiving, and Christmas. Admission: adults, $8; seniors and students 7–15, $5; children 6 and under, free; discounts for groups and military.

TEXAS HIGH SCHOOL BASKETBALL HALL OF FAME. (See All-Sports category.)

BEACH VOLLEYBALL

PRO BEACH VOLLEYBALL HALL OF FAME, Clearwater, Florida. The Pro Beach Volleyball Hall of Fame was founded as the International Beach Volleyball of Fame in Clearwater Beach, Florida, in 1990. The name was changed several years later the better to reflect its focus, and as planning and fundraising accelerated for a permanent site.

The hall of fame—housed temporarily in the lobby of the Clearwater Beach Memorial Civic Center since 1996—honors players, officials, supporters, and pioneers for their accomplishments in professional beach volleyball. The five individuals inducted thus far include star players Ron Von Hagen, Matt George, Jon Stevenson, and Jim Menges, as well as Jose Cuervo Tequila, sponsor of the Cuervo Gold Crown and other volleyball tournaments since 1976.

The exhibits describe the achievements of the inductees and display photos, videos, posters, tournament programs, newspaper articles, and volleyball equipment, clothing, and trophies. Plans call for the hall of fame's permanent home to be constructed by 1998.

Pro Beach Volleyball Hall of Fame, 40 Causeway Blvd., PO Box 3672, Clearwater, FL 34630–8672. Phone: 813/461–0011. Hours: 9 A.M.–10 P.M. daily. Admission: free.

BICYCLING

MOUNTAIN BIKE HALL OF FAME AND MUSEUM, Crested Butte, Colorado. The history and leading figures in mountain biking are featured at the Mountain Bike Hall of Fame and Museum in Crested Butte, Colorado. Founded in 1988, the tiny hall of fame and museum is located in a 300-square-foot room in the Crested Butte Heritage Museum in the mountain and skiing resort community.

Among the 42 persons inducted into the hall of fame are Charles Kelly, early Repack race promoter, MountainBikes partner, and mountain bike magazine editor; Gary Fisher, Repack course record holder, mountain bike designer, and principal in MountainBikes; Chris Chance, East Coast frame builder who was first to recognize the potential of mountain bikes and was primarily responsible for introducing the sport to that region; and Mike Sinyard, owner of the Specialized firm, which is among the leaders in developing new mountain bike products.

The exhibits include classic mountain bike photographs and a number of the early mountain bikes, including Breezer 2, Stumjumper 56, and Mountain Goat 1. The hall of fame/museum also participates in Crested Butte's annual Fat Tire Bike Week, which features races, tours, clinics, and inductions into the hall of fame.

Mountain Bike Hall of Fame and Museum, 126 Elk Ave., PO Box 845, Crested Butte, CO 81224. Phone: 970/349–6817. Hours: 11–4 daily. Admission: free.

UNITED STATES BICYCLING HALL OF FAME, Somerville, New Jersey. The United States Bicycling Hall of Fame in Somerville, New Jersey, recognizes those who have contributed to the long history of bicycling. It also is considered the primary source of historical bicycling information and artifacts in the nation.

The hall of fame was founded in 1986 and opened its museum in 1988. It moved into new quarters, with the aid of a state grant, in 1995. Somerville is known as the "Bicycling Capital of America" because it is the site of the 50-mile "Criterium," the nation's longest running road race, which began in 1940.

Among the 45 hall of famers are Pop Kugler, who founded the "Criterium" and was the first inductee, and such cycling favorites as Ted Smith, Sue Novara Reber, Jack Disney, and Sheila Young Ochowicz.

U.S. Bicycling Hall of Fame, 166 W. Main St., Somerville, NJ 08876. Phone: 908/722-3620. Hours: 10–3 Mon.–Fri.; closed most major holidays, but open Memorial Day weekend when "Criterium" race is held. Admission: free.

BOWLING

INTERNATIONAL BOWLING MUSEUM AND HALL OF FAME, St. Louis, Missouri.
AMERICAN BOWLING CONGRESS HALL OF FAME
WOMEN'S INTERNATIONAL BOWLING CONGRESS HALL OF FAME
PROFESSIONAL BOWLERS ASSOCIATION HALL OF FAME
BOWLING PROPRIETORS ASSOCIATION OF AMERICA HALL OF
 FAME
More than 150 bowlers and bowling proprietors are honored in four halls of fame housed in the 50,000-square-foot International Bowling Museum and Hall of Fame in St. Louis. The facility, which opened in 1984 as the Bowling Hall of Fame and Museum, is the home for halls of fame of the American Bowling Congress, the Women's International Bowling Congress, the Professional Bowlers Association, and the Bowling Proprietors Association of America.
Such great bowlers as Dick Weber, Don Carter, Earl Anthony, Marion Ladewig, and Floretta McCutcheon are among the bowling stars enshrined in the halls of fame. The men inductees are shown in sculpted bronze tablets, while the women are presented in oil portraits. Some of their trophies and memorabilia also are on display.
In addition to the halls of fame, the museum has seven other exhibit areas—a time tunnel of bowling history; large paintings depicting special moments in the careers of leading bowlers; a circular display of bowling shirts, equipment, and related materials; computer terminals where visitors can retrieve historical and other information; a theater featuring a film on bowling; and old-time and modern computerized lanes where visitors can try their hand at bowling.
The St. Louis Cardinals Hall of Fame Museum, fomerly located at Busch Stadium across the street, now is housed in the bowling museum's building and can be seen for the same admission price.

International Bowling Museum and Hall of Fame, 111 Stadium Plaza, St. Louis, MO 63102. Phone: 314/231–6340. Hours: 9–5 Mon.–Sat.; 12–5 Sun.; closed New Year's Eve and Day, Thanksgiving, and Christmas Eve and Day. Admission: adults, $5; children, $3; groups of 20 or more, special rates.

BOXING

INTERNATIONAL BOXING HALL OF FAME, Canastota, New York. The International Boxing Hall of Fame in Canastota, New York, began in 1984, inspired by two local world titlists—middleweight Carmen Basilio and welter-

weight Billy Backus—who were celebrated in a showcase. This led to the opening of a 2,500-square-foot museum in 1989 on ten acres donated by the New York Thruway Authority.

In this small upstate New York community, boxing bouts were staged during the building of Erie Canal in the nineteenth century, gym and club fights flourished in the 1920s, high schools featured boxing as a major sport until the late 1940s, and several world champions later evolved.

The International Boxing Hall of Fame pays tribute to boxing's heritage and to 178 boxing greats, managers, trainers, and others who have made contributions to the sport. The boxers include such champions as John L. Sullivan, Jack Dempsey, Benny Leonard, Jack Johnson, Barney Ross, Gene Tunney, Joe Louis, Max Schmeling, Rocky Marciano, Sugar Ray Robinson, Tony Zale, Jake LaMotta, Rocky Graziano, Henry Armstrong, Billy Conn, Floyd Patterson, and Muhammad Ali. Among the other boxing figures cited are Angelo Dundee, Jack Kearns, A. J. Liebling, George "Tex" Rickard, and the Marquess of Queensberry.

In addition to plaques on a Wall of Honor, the museum has exhibits of boxing gloves, hand wraps, fist casts, and robes; life-size statues of famous fighters; displays of posters, tickets, and photographs; videos of historic fights; and other such materials.

International Boxing Hall of Fame, 1 Hall of Fame Dr., PO Box 425, Canastota, NY 13032. Phone: 315/697–7095. Hours: 9–5 daily; closed Thanksgiving and Christmas. Admission: adults, $4; seniors and children, 9–15, $3; children 8 and under, free.

CHECKERS

INTERNATIONAL CHECKERS HALL OF FAME, Petal, Mississippi. The International Checkers Hall of Fame came about as a result of the interest and generosity of Charles C. Walker, an insurance executive and checkers champion. He spearheaded the organizational efforts and incorporated the hall into the Tudor-style, grand home he was building in Petal, Mississippi. The hall of fame opened in 1970; with additions, it now occupies 35,000 square feet in the mansion.

The core of the hall of fame comprises two areas, called Hall I and Hall II, connected by an international walkway containing flags of 175 countries having checkers federations. Hall I is a large checkerboard room with pictures of world and local champions from checkers federations throughout the world, a collection of antique boards and other artifacts, trophies, historical documents, and books. Championship matches also are played in the hall. Hall II is the world's largest checkerboard. In addition to being used for tournament play, it sometimes is utilized to feed and house visiting players.

The Mississippi Open Tournament is held every Memorial Day weekend, and other world-class, adult, and youth competitions are scheduled at the hall of

fame from time to time. The hall of fame also has a program for school groups that teaches checkers using a human board, and provides lunch.

Among the outstanding checkers players in the hall of fame are world champion Dr. Marion Kinsley, Andrew Anderson, James Willye, Asa Long, Robert D. Yates, James Jerrie, and Richard Jordan.

International Checkers Hall of Fame, 220 Lynn Ray Rd., PO Box 365, Petal, MS 39465. Phone: 601/582–7090. Hours: 9–5 daily by appointment; closed holidays. Admission: adults, $3; children, $1; seniors and school groups, free.

CHESS

UNITED STATES CHESS HALL OF FAME, Washington, D.C. The nation's outstanding chess players are honored in the United States Chess Hall of Fame in Washington, D.C. Founded in New Windsor, New York, in 1986, the hall of fame moved to the U.S. Chess Center in Washington in 1992.

The hall of fame, which occupies a large room within the chess center, features plaques, photographs, and information of 26 inductees, including America's "big four"—Paul Morphy, Bobby Fischer, Frank Marshall, and Sammy Reshevsky.

The hall also contains exhibits on the history of American chess since 1492; chess boards, pieces, and memorabilia; the first commericial chess computer; the World Chess Championship trophy won by the U.S. team in 1993; a collection of chess books; and the opportunity for visitors to match wits with a chess computer.

United States Chess Hall of Fame, U.S. Chess Center, 1501 M. St., N.W., Washington, DC 20005. Phone: 202/857–4922. Hours: 5:30–11 P.M. Mon.–Thurs.; 12 noon–10 P.M. Sat.; 12 noon–6 Sun. Admission: free.

COLLEGIATE SPORTS HALLS OF FAME

COLLEGE FOOTBALL HALL OF FAME. (See Football category.)

COLLEGIATE TENNIS HALL OF FAME. (See Tennis category.)

INTERCOLLEGIATE SAILING HALL OF FAME. (See Sailing category.)

LACROSSE HALL OF FAME MUSEUM. (See Lacrosse category.)

MARGARET DOW TOWSLEY SPORTS MUSEUM. (See All-Sports category.)

PAUL W. BRYANT MUSEUM. (See All-Sports category.)

PENN STATE FOOTBALL HALL OF FAME. (See Football category.)

ROSE BOWL HALL OF FAME. (See Football category.)

TOM KEARNS UNIVERSITY OF MIAMI SPORTS HALL OF FAME. (See All-Sports category.)

UNITED STATES FIELD HOCKEY ASSOCIATION HALL OF FAME. (See Field Hockey category.)

UNIVERSITY OF TENNESSEE FOOTBALL HALL OF FAME. (See Football category.)

CROQUET

NATIONAL CROQUET HALL OF FAME, Newport, Rhode Island. The National Croquet Hall of Fame occupies a gallery in the Newport Art Museum in Newport, Rhode Island. Founded in 1979, the hall of fame was located at the Croquet Foundation of America headquarters in West Palm Beach, Florida, until 1992, when it was moved to the Art Museum.

Fifty-seven persons have been inducted into the hall of fame. Among those enshrined—their names are enscribed on a seven-foot trophy in the hall—are statesman W. Averell Harriman and such Broadway and Hollywood figures as Sam Goldwyn, Moss Hart, Louis Jourdan, Harpo Marx, Richard Rogers, George Sanders, and Darryl Zanuck.

The hall of fame gallery features a range of historic croquet equipment and artworks pertaining to croquet, a popular subject for artists. The emphasis is on temporary exhibitions relating to croquet. The museum also houses a croquet archive.

National Croquet Hall of Fame, Newport Art Museum, 76 Bellevue Ave., Newport, RI 02840. Phone: 401/848–8200. Hours: 1–4 Tues.–Sat.; 12–4 Sun.; closed major holidays. Admission: adults, $5; seniors and children 13 and older, $4; children 12 and under, free.

DOG RACING

**DOG MUSHERS' HALL OF FAME
CANINE HALL OF FAME FOR LEAD DOGS**
(See Dog Sledding category.)

GREYHOUND HALL OF FAME, Abilene, Kansas. The Greyhound Hall of Fame in Abilene, Kansas, pays tribute to the swiftest of the canine breeds.

Founded in 1963, the hall of fame opened in its present home in the heart of America's greyhound country in 1973, with the assistance of the National Greyhound Association and Greyhound Track Operators Association.

Forty-nine greyhounds and 23 individuals have been inducted into the Greyhound Hall of Fame, and 138 owners, trainers, officials, and others have been named to the Greyhound Hall of Fame "Pioneers" for their contributions to the development of greyhounds and greyhound racing in America, Australia, Great Britain, and Ireland.

The first greyhounds enshrined were R. B. Carroll's Rural Rube, Merrill Blair's Flashy Sir, and Gene Randle's Real Huntsman, while the most recent were Ruth Stagg's J.R.'s Ripper and Wayne Strong's and Warren J. Wegert's Miss Gorgeous. Two of the most victorious racers also are in the hall of fame—Ed Willard's Indy Ann, with 137 career victories in 1954–57, and George and Lora Nihart's Westy Whizzer, 107 wins in 1964–67.

Among the persons honored are Owen P. Smith, who invented the mechanical lure in 1919 and is considered the "father" of greyhound track racing, and Dennis Callaghan, first president of the National Greyhound Association. Among the newest inductees honored for their work in the greyhound field are Walt Collins, Isadore Hecht, and C. N. Lambert.

In addition to hall of fame plaques and related displays, the museum has an exhibit on the history of greyhounds from 5000 B.C. to its racing development in America; displays on the nation's major greyhound tracks; video presentations on how greyhounds are raised, trained, and raced; and interactive units that enable visitors to select and breed winning greyhounds and to watch major races from the past to the present. The annual attendance is approximately 40,000.

Greyhound Hall of Fame, 407 S. Buckeye, Abilene, KS 67410. Phone: 913/263–3000. Hours: Apr–Oct. 9 A.M.–8 P.M. daily; Nov.–Mar. 9–5 daily; closed New Year's Day, Thanksgiving, and Christmas. Admission: free.

DOG SLEDDING

DOG MUSHERS' HALL OF FAME
CANINE HALL OF FAME FOR LEAD DOGS

Two halls of fame related to dog sledding are located in the Knik Museum, a historic building from the gold rush era along the Iditarod Trail in Knik, Alaska. They are the Dog Mushers' Hall of Fame and the Canine Hall of Fame for Lead Dogs, both founded in 1967 as part of the 100th anniversary celebration of the purchase of Alaska from Russia. Sled dog teams played an important part in the settlement of Alaska during its first century, and they annually take part in the 1,049-mile Iditarod Race from Anchorage to Nome.

Twenty-four persons are enshrined in the dog mushers' hall, ranging from early pioneers to race winners. Among the inductees are Clyde Williams, Leonard Seppla, Scotty Allen, Joe Bedington, Sr., Norman Vaughn, Ron Wendt, and

Earl and Natalie Norris. Ten dogs—including highly regarded Togo, Balto, Andy, and Baldy—are in the lead dogs' hall of fame.

The halls of fame are on the second floor of a 1910 building that was formerly a pool hall in the gold mining town of Knik, near Palmer. They contain photographs, biographical information, and sledding equipment.

The Knik Museum and its halls of fame—which are open only in the summer—were administered by the Dorothy G. Page Museum in Wasilla until recently. The Wasilla-Knik-Willow Creek Historical Society is now responsible for their operation.

Dog Mushers' Hall of Fame and Canine Hall of Fame for Lead Dogs, Knik Museum, Goose Bay Rd., PO Box 3467, Palmer, AK 99645. Phone: summer, 907/376–7755; winter, 907/376–2005. Hours: June–Aug. 12–6 daily; closed remainder of year. Admission: adults, $2; seniors, $1.50; children 18 and under, free.

EQUESTRIAN

AIKEN THOROUGHBRED RACING HALL OF FAME. (See Thoroughbred Racing category.)

HARNESS RACING MUSEUM AND HALL OF FAME. (See Harness Racing category.)

NATIONAL JOUSTING HALL OF FAME. (See Jousting category.)

NATIONAL MUSEUM OF POLO AND HALL OF FAME. (See Polo category.)

NATIONAL MUSEUM OF RACING AND HALL OF FAME. (See Thoroughbred Racing category.)

SARATOGA HARNESS RACING MUSEUM AND HALL OF FAME. (See Harness Racing category.)

SHOW JUMPING HALL OF FAME AND MUSEUM, Tampa, Florida. The Show Jumping Hall of Fame and Museum, located at the Busch Gardens theme park in Tampa, Florida, is dedicated to the men, women, and horses who have made great contributions to the equestrian sport of show jumping and to encouraging broader interest and participation in the sport.

The hall of fame began in 1987 and became a part of Busch Gardens in 1989. Twenty-three people and four horses have been inducted into the hall. They include riders William Steinkraus, Bertalan de Nemethy, Frank Chapot, Kathy Kusner, Morton W. Smith, Mary Mairs Chapot, Harry D. Chamberlin, and Arthur McCashin; owners August A. Busch, Jr., and Patrick Butler; trainers Jimmy

Williams, Frances Rowe, and Barbara Worth Oakford; show manager and course designer Dr. Robert C. Rost; horse show official Whitney Stone; and horses Idle Dice, San Lucas, and Snowman.

The exhibits consist of plaques honoring the hall of famers, historical and Olympic memorabilia, a history of show jumping, and listings of U.S. medals in the Olympics, Pan American Games, and World Championships.

Show Jumping Hall of Fame and Museum, Busch Gardens, 3000 Busch Blvd., Tampa, FL 33612. Phone: 508/698–6810. Hours: 9–5 daily. Admission: free with paid admission to Busch Gardens.

UNITED PROFESSIONAL HORSEMEN'S ASSOCIATION HALL OF FAME, Lexington, Kentucky. The United Professional Horsemen's Association Hall of Fame consists of plaques in the foyer and a scrapbook with information and photographs of inductees in the library of the American Saddle Horse Museum in Lexington, Kentucky. The hall of fame honors professional horse trainers for their contributions to the saddlebred industry.

The association—which has its offices in the museum—has inducted 39 persons into the hall of fame. They include such leading horsemen as Fritz Jordan, Earl Teater, Garland Bradshaw, Tom Moore, Charles and Helen Crabtree, Max Parkinson, Rex Parkinson, Don Harris, and Dick Waller.

The 18,000-square-foot American Saddle Horse Museum, which operates independently, is devoted to the history and current uses of the American saddlebred horse. Visitors are greeted by a life-size statue of Supreme Sultan, one of the breed's most notable stallions, and they walk across "Saddlebred Sidewalk," featuring bricks with names of exceptional horses. Exhibits include a multimedia presentation, dioramas and paintings of leading saddlebreds, artifacts, memorabilia, and other displays.

United Professional Horsemen's Association Hall of Fame, American Saddle Horse Museum, 4093 Iron Works Pike, Lexington, KY 40511–8401. Phone: 606/259–2746. Hours: Memorial Day–Labor Day, 9–6 daily; remainder of year, 9–5 daily, but closed Mon.–Tues. Nov. 1–mid-March and at Thanksgiving, Christmas, and New Year's. Admission: adults, $3; seniors, $2.50; children 7–12, $2; children 6 and under, free; families, $6.

ETHNIC SPORTS HALLS OF FAME

GREATER FLINT AFRO-AMERICAN HALL OF FAME. (See All-Sports category.)

INTERNATIONAL AFRO-AMERICAN SPORTS HALL OF FAME AND GALLERY. (See All-Sports category.)

NATIONAL ITALIAN AMERICAN SPORTS HALL OF FAME. (See All-Sports category.)

NATIONAL JEWISH AMERICAN SPORTS HALL OF FAME. (See All-Sports category.)

NATIONAL POLISH-AMERICAN SPORTS HALL OF FAME. (See All-Sports category.)

NEW YORK JEWISH SPORTS HALL OF FAME. (See All-Sports category.)

FIELD HOCKEY

UNITED STATES FIELD HOCKEY ASSOCIATION HALL OF FAME, Collegeville, Pennsylvania. Thirty-four women are enshrined in the United States Field Hockey Association Hall of Fame in Helfferich Hall at Ursinus College in Collegeville, Pennsylvania. The hall of fame was founded in 1986, with the first inductions in 1988, when hall exhibits opened in the Ursinus fieldhouse.

Field hockey was introduced in the United States from England in 1901; field hockey clubs were established that year in Poughkeepsie, New York, and at Philadelphia's Merion Cricket Club. Vonnie Gros, coach of the 1984 U.S. Olympic field hockey team, which placed third and was the first American team to win an Olympic medal, is among the hall of fame honorees. Photographs and information on inductees, as well as artifacts and memorabilia and the history of field hockey in the United States, can be seen in the hall of fame.

U.S. Field Hockey Assn. Hall of Fame, Ursinus College, Helfferich Hall, Collegeville, PA 19428. Phone: 610/409–3612. Hours: 8:30–5 Mon.–Fri.; closed holidays. Admission: free.

FIELD TRIALS

FIELD TRIAL HALL OF FAME, Grand Junction, Tennessee. The Field Trial Hall of Fame is one of three buildings at a complex in Grand Junction, Tennessee, that also includes the National Bird Dog Museum and the National Wildlife Heritage Center. The National Field Trial Championships also have been held in the area since 1900. The hall of fame that honors people and field trial dogs was founded in 1954; it was located in a gallery in the bird dog museum from 1991 to 1994, when an adjacent building was constructed to house it.

More than 300 dogs and individuals—owners, trainers, handlers, breeders, and supporters—are honored in the hall of fame, which features portraits, photographs, and memorabilia of those inducted. Honorees are selected each year by readers of *American Field* and *Retriever Field Trial News.*

The National Bird Dog Museum contains a major collection of art and memorabilia pertaining to bird dogs, as well as exhibits and multimedia presentations on the history, breeding, and talents of different bird dogs. The National Wildlife Heritage Center contains an extensive library and educational program pertaining to bird dogs and hunting.

Field Trial Hall of Fame, 505 Hwy. 57 West, Grand Junction, TN 38039. Phone: 901/ 764–2058. Hours: 10–2 Tues–Fri.; 10–4 Sat.; 1–4 Sun.; closed major holidays. Admission: free.

FIGURE SKATING

LAKE PLACID HALL OF FAME. (See Winter Olympics category.)

WORLD FIGURE SKATING MUSEUM AND HALL OF FAME
UNITED STATES FIGURE SKATING HALL OF FAME

Two figure skating halls of fame are located under one roof in Colorado Springs, Colorado—the World Figure Skating Hall of Fame and the United States Skating Hall of Fame. The ice skating complex evolved from a modest American museum in 1965 in Boston, where the U.S. Figure Skating Association had its headquarters at the time.

The association and its museum and hall of fame moved to Colorado Springs in 1980. Four years later, the International Skating Union, governing body of figure skating throughout the world, voted to have its hall of fame at the same site. Both halls of fame began in 1976, inducting outstanding amateur and professional skaters, professional coaches, and others who have made significant contributions to the sport.

Today, the joint complex is known as the World Figure Skating Museum and Hall of Fame, with the United States Figure Skating Hall of Fame occupying a portion of the 10,000-square-foot building. Sixty-six persons have been inducted into the world hall of fame and 48 into the U.S. hall of fame.

Among those enshrined in the world hall of fame are Sonja Henie of Norway, Barbara Ann Scott of Canada, Katarina Witt of Germany, James Koch of Switzerland, Dianne Towler and Bernard Ford of Great Britain, and Richard Button, Peggy Fleming, and Scott Hamilton of the United States. The U.S. hall of fame inductees include Dorothy Hamill, Janet Lynn, Jojo Starbuck, and Kenneth Shelley.

Each hall of famer has a plaque with a photograph and skating accomplishments. Among the other exhibits in the museum are hundreds of ice skates, some dating from the eighth century; costumes, posters, programs, photographs, and films; and other materials depicting the history of ice skating. In addition, the museum has a collection of Sonja Henie dolls; more than 20 versions of the classic children's book *Hans Brinker and the Silver Skates*; and an extensive collection of artworks pertaining to figure skating; special displays on American

Olympic gold medalists Brian Boitano and Scott Hamilton; an exhibit that pays tribute to the U.S. figure skating team killed in a plane crash in Brussels in 1961 on the way to the World Championships in Prague; and audio and video presentations of the world's great figure skaters.

World Figure Skating Museum and Hall of Fame, 20 First St., Colorado Springs, CO 80906. Phone: 719/635–5200. Hours: June–Aug. 10–4 Mon.–Fri., 10–4 Sat.; Sept.–May 10–4 first Sat.; closed major holidays. Admission: free.

FISHING

CATSKILL FLY FISHING MUSEUM HALL OF FAME, Livingston Manor, New York. The Catskill Fly Fishing Center and Museum in Livingston Manor, New York, has a hall of fame that honors innovators in the fly fishing field. The organization was founded in 1981, with the first hall of fame induction in 1985. Initially located in Roscoe, New York, the center and museum moved to a converted farmhouse and barn on its present 35-acre site in Livingston Manor in 1988. A new museum building was added in 1995 to house the hall of fame and other exhibits.

Three persons have been inducted into the hall of fame and are honored with plaques, photographs, and biographical information. They are Theodore Gordon, writer, conservationist, and angling authority, known as the "father" of American dry fly fishing; Art Flick, conservation activist, an amateur entomologist who created many dry flies, and author of the popular *Streamside Guide to Naturals and Their Imitations*; and Leon Chandler, educator, former president of Trout Unlimited, and longtime head of the Cortland Line Company, which was responsible for the development of the modern fly line.

The 2,000-square-foot museum traces the lives and contributions of many of the great names associated with the Catskill area, as well as others from the world of fly fishing. It also offers interpretive exhibits on the evolution of fly fishing and displays hundreds of exceptional rods, reels, and flies.

Catskill Fly Fishing Museum Hall of Fame, Catskill Fly Fishing Center and Museum, 5447 Old Rte. 17, PO Box 1295, Livingston Manor, NY 12758. Phone: 914/439–4810. Hours: Apr.–Oct. 10–4 daily; Nov.–Mar.–10–1 Tues.–Fri., 10–4 Sat. Admission: adults, $3; seniors and children under 12, $1.

INTERNATIONAL FISHING HALL OF FAME, Dania, Florida. A new International Fishing Hall of Fame is being developed as part of a $25 million International Game Fish Association complex being constructed in Dania, Florida. The hall of fame, which will honor anglers, captains, and business leaders, will occupy approximately 10,000 square feet of the 59,000-square-foot fishing center, which is scheduled to open in late 1998.

Two-thirds of the complex, to be known as IGFA World Fishing Center, will be devoted to museum-like exhibits, including the hall of fame. Six other gal-

leries will be devoted to salt and fresh water fishing history, records and record holders, equipment, boats, and other such topics. The facility also will have a library, archives, and outdoor exhibit areas on boats and wetlands. The first inductions into the hall of fame will be in 1997.

International Fishing Hall of Fame (to be located in Dania, FL.) International Game Fish Assn., 1301 E. Atlantic Blvd., Pompano Beach, FL 33060. Phone: 454/941–3474. Hours and admission: to be determined.

NATIONAL FISH CULTURE HALL OF FAME, Spearfish, South Dakota. The National Fish Culture Hall of Fame, founded in 1985 by the Fish Culture Section of the American Fisheries Society, is located at the D. C. Booth Historic Fish Hatchery in Spearfish, South Dakota. It honors persons who have contributed to the advancement of fish culture and the propagation of fish and other aquatic organisms.

The hall of fame, housed in a replica of the 1899 hatchery ice house, is near the hatchery's Visitor Center and Museum, which contains one of the largest collections of fish-culture artifacts. Operated by the U.S. Fish and Wildlife Service, the Booth hatchery was established in 1896 and is one of the oldest in the American West.

Plaques and mementoes of the 35 inductees can be seen at the hall of fame. Among the honorees are Spencer Baird, first U.S. Fish Commissioner, appointed in 1871; Charles G. Atkins, who conducted early work on Atlantic salmon culture and propagation; Seth Green, considered the "father" of American fish culture; Abram V. Tunison, early fish nutrition and training specialist; Lauren Donaldson, developer of Donaldson trout strains; and Seth L. Way, who designed and constructed the first practical catfish incubators.

National Fish Culture Hall of Fame, Fish Culture Section, D.C. Booth Historic Fish Hatchery, 423 Hatchery Cir., Spearfish, SD 57783. Phone: 605/642–7730. Hours: May–Sept. 10–6 daily; other times by appointment. Admission: free.

NATIONAL FRESH WATER FISHING HALL OF FAME, Hayward, Wisconsin. The National Fresh Water Fishing Hall of Fame, dedicated to the portrayal and conservation of the historical and contemporary aspects of fresh water sport-fishing and its participants, attracts approximately 100,000 visitors annually in the fishing resort community of Hayward, Wisconsin.

The hall of fame, which occupies 25,000 square feet in seven buildings on a six-acre site, was founded in 1960, and the first structure of its complex opened in 1976. It is known for one of its museum buildings—a huge, hand-sculpted likeness of a leaping fish (muskie), 143 feet long with an observation platform in its gaping jaw.

The hall of fame recognizes individuals and organizations for their achievements in seven areas—conservation, organization, science, education, communications, technology, and guiding. The awards are presented in four categories: the Enshrinement Program, for accomplishments with national or world impact in the field, which has 65 inductees; Legendary Anglers, honoring achievement

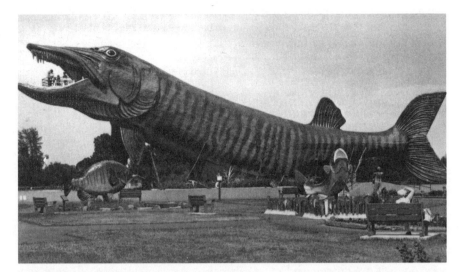

A 143-foot-long likeness of a leaping muskie houses one of the museum buildings of the national Fresh Water Fishing Hall of Fame in Hayward, Wisconsin. The hall of fame has seven buildings on a six-acre site. Courtesy National Fresh Water Fishing Hall of Fame.

with at least regional impact in fresh water fishing, 78 honorees; Fishing Guide Recognition, for outstanding work in guiding, 15 persons; and Organization Recognition, citing fishing industry organizations and businesses and government agencies for their contributions to fresh water fishing, 24 recipients.

Among those enshrined are Izaak Walton, 1600s conservationist, angler, and author; Dame Juliana Berners, an English nun who compiled writings on fishing in 1496; Ole Evinrude, outboard motor inventor; Lori Rapala, developer of the Rapala lure; and Ted Williams, baseball great also known for his fishing prowess.

The museum's exhibits include approximately 400 mounted fish, 350 antique and classic outboard motors, 6,000 dated lures, 1,000 reels, and fishing accessories, boats, films, and other materials. It also maintains records of the largest fish caught and serves as historical center and clearinghouse for information about the fishing industry.

National Fresh Water Fishing Hall of Fame, 1 Hall of Fame Dr., PO Box 33, Hayward, WI 54843. Phone: 715/634–4440. Hours: Apr. 15–Nov. 1 10–5 daily; closed remainder of year (although offices and library open 9–4 Mon.–Fri., except Christmas to New Year's Day). Admission: adults, $4; seniors, $3.50; children 10–18, $2.50; children under 10, $1.

FOOTBALL

COLLEGE FOOTBALL HALL OF FAME, South Bend, Indiana. The College Football Hall of Fame, now located in South Bend, Indiana, has a half-

century history that began with the establishment of the National Football Foundation in 1947. The foundation and hall of fame idea came from noted sports writer Grantland Rice, who advocated honoring the nation's outstanding collegiate football players and coaches.

The foundation made its first hall of fame selections in 1951. In 1978, a museum-like hall of fame facility was opened at the Kings Island entertainment complex near Cincinnati, Ohio. However, the hall of fame building closed in 1992 because of poor attendance. A number of cities sought the hall of fame before it was relocated and reopened in 1995 in South Bend. The city built a $7 million, 35,000-square-foot structure for the hall across from the downtown convention complex, and spent $7 million on the exhibitry. The football shrine now attracts more than 170,000 visitors annually.

The College Football Hall of Fame has inducted 770 players and coaches, and it pays tribute to them in the Hall of Champions at its new facility. Among the college football greats honored are such all-American players as Red Grange, George Gipp, Tom Harmon, Gale Sayers, Joe Namath, Roger Staubach, Terry Bradshaw, O. J. Simpson, and Walter Payton, and successful coaches like Walter Camp, Amos Alonzo Stagg, Knute Rockne, Pop Warner, Woody Hayes, Bear Bryant, Darrell Royal, and Ara Parseghian.

The hall of fame has plaques, photographs, and memorabilia of those enshrined; historical, video, and interactive exhibits; a 360-degree theater with college football highlights; and a 43-foot-high sculpture in the entrance lobby of the building composed of life-like cast figures, football artifacts, and audiovisual elements.

College Football Hall of Fame, 111 S. St. Joseph St., South Bend, IN 46601. Phone: 219/235–9999. Hours: 9–7 daily; closed major holidays. Admission: adults, $6; seniors, $5; children 6–14, $4; children 5 and under, free.

GREEN BAY PACKER HALL OF FAME, Green Bay, Wisconsin. The Green Bay Packer Hall of Fame—which honors the stars in the professional football team's history in Green Bay, Wisconsin—had a humble beginning. In 1964, the Green Bay Area Visitor and Convention Bureau placed a portable information center in the Lambeau Field parking lot. Approximately 10,000 visitors requested information on the area, and almost all wanted to know more about the Green Bay Packers. This resulted in an early attempt, in 1967, at a hall of fame exhibit, in the lower concourse of the Brown County Veterans Memorial Area. Although the small exhibit was open only during the summer, it was seen by 60,000 people that year.

Almost immediately, the visitor and convention bureau set out to build a permanent home for an expanded hall of fame, which was formally established in 1969. After a successful community fundraising campaign, the building was opened across the street from Lambeau Field in 1976. President Gerald Ford even presided at the cornerstone laying. The building was doubled in size to its

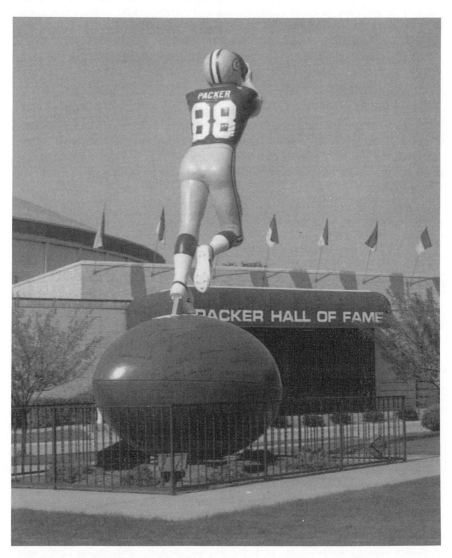

A 25-foot-high statue of a Packer receiver atop the world's largest autographed football greets visitors to the Green Bay Packer Hall of Fame, established in 1969 in Green Bay, Wisconsin. Courtesy Green Bay Packer Hall of Fame.

present 17,000 square feet in 1981, and more recently renovated with new exhibits. The hall of fame now attracts approximately 100,000 visitors each year. A 25-foot-high statue of a Packer receiver atop the world's largest autographed football welcomes visitors at the entrance.

The hall of fame honors 115 players, coaches, and others who have contributed significantly to the Packers. Among the inductees are coaches Curly Lambeau and Vince Lombardi, quarterbacks Cecil Isbell and Bart Starr, receivers Don Hutson and Boyd Dowler, linebacker Ray Nitschke, defensive end Willie Davis, guards Forrest Gregg and Fuzzy Thurston, cornerback Herb Adderley, defensive back Willie Woods, and running backs Paul Hornung and Jim Taylor.

The exhibits consist of plaques for the honorees, as well as photographs, memorabilia, trophies, jerseys, helmets, videos, participatory games, and other such materials.

Green Bay Packer Hall of Fame, 855 Lombardi Ave., PO Box 10567, Green Bay, WI 54307. Phone: 414/499–4281. Hours: Sept.–May 10–5 daily; June–Aug. 9–6 daily; closed Christmas. Admission: adults, $6; seniors, $5; children 6–15, $3.50; families, $17; groups—adults, $3; children, $2.

PAUL W. BRYANT MUSEUM. (See All-Sports category.)

PENN STATE FOOTBALL HALL OF FAME, State College, Pennsylvania. Pennsylvania State University's football heritage and stars are featured in the Penn State Football Hall of Fame in State College. Founded in 1981, the football hall of fame will be incorporated into the new $5 million Penn State All-Sports Hall of Fame, under construction on the campus.

The football hall of fame, located in the Greenberg Indoor Sports Complex, contains photographs, memorabilia, and trophies of outstanding players, teams, and coaches. Among the trophies are those for national championships and winners of the Heisman Trophy.

Penn State Football Hall of Fame, Pennsylvania State University, Greenberg Indoor Sports Complex, McKean and Pollock Rd., State College, PA 16802. Phone: 814/865-0411. Hours: 8–4:30 Mon.–Fri.; 11–3 Sat.–Sun., except on Sat. home football game days, when hours vary. Admission: free.

PRO FOOTBALL HALL OF FAME, Canton, Ohio. One of the oldest, largest, and most popular halls of fame is the Pro Football Hall of Fame in Canton, Ohio, home of the early professional football powerhouse, the Canton Bulldogs. The hall of fame was established in 1961; the museum opened in 1963 as a result of a community campaign to honor outstanding players, coaches, and other personnel. It now has an annual attendance of 225,000.

The 83,000-square-foot complex consists of five interconnected buildings, with 50,000 square feet devoted to exhibits. The facility has two enshrinement halls, six exhibit galleries, two theaters, and a research center. The contents are

a mixture of the old and the new in pro football. A seven-foot bronze statue of football great Jim Thorpe, who once played for the Canton team, greets visitors at the entrance.

Each of the hall's 189 inductees is honored with a bronze bust, an action mural, and a brief biography. Other exhibits pertain to the history of professional football, early and contemporary equipment; there are also such other exhibits as scenes from ABC's *Monday Night Football* games, the history of black players in professional football, filmed football highlights on a 20-by-42-foot screen in a 180-degree turnabout theater, and interactive video and other games.

Among those enshrined are football players Red Grange, Jim Thorpe, Earl "Dutch" Clark, Ernie Nevers, Sammy Baugh, Terry Bradshaw, Dick Butkus, Tony Dorsett, Jim Brown, Otto Graham, Bob Lilly, Mike Ditka, George Blanda, Paul Hornung, Alan Page, Walter Payton, Joe Greene, Bart Starr, Clyde "Bulldog" Turner, Forrest Gregg, Joe Namath, Roger Staubach, and Bronko Nagurski; coaches Vince Lombardi, Paul Brown, George Halas, Earl "Curly" Lambeau, Steven Owen, Chuck Noll, and Bill Walsh; owners or general managers Art Rooney, Tex Schramm, Jim Finks, Lamar Hunt, Tim Mara, and Al Davis.

The highlight of the year is the enshrinement ceremony and the annual American Football League–National Football Conference Hall of Fame preconference football game in late July or early August.

Pro Football Hall of Fame, 2121 George Halas Dr., NW, Canton, OH 44708. Phone: 330/456–8207. Hours: Memorial Day–Labor Day 9 A.M.–8 P.M. daily; Labor Day–Memorial Day 9–5; closed Christmas. Admission: adults, $9; seniors, $6; students, $4; families, $22.

ROSE BOWL HALL OF FAME, Pasadena, California. The Rose Bowl Hall of Fame honors players, coaches, administrators, athletic directors, officials, and others who have made significant contributions to the success of the nation's oldest football bowl game. Founded in 1989, it occupies two adjoining rooms—known collectively as "The Rose Bowl Room"—in the Tournament of Roses headquarters in Pasadena, California.

Fifty-eight persons have been inducted into the hall of fame. They include such outstanding Rose Bowl players as Archie Griffin, Ohio State back; Dick Butkus, Illinois linebacker; Frankie Albert, Stanford quarterback; Charley Trippi, Georgia tailback; Don Hutson, Alabama end; O. J. Simpson, Southern California running back; and Bob Griese, Purdue quarterback. They also include coaches Woody Hayes (Ohio State), John McKay (Southern California), Bob Schembechler (Michigan), and Don James (Washington); athletic director Bump Elliott, Michigan; and Stan Hahn and Lay Leishman, Tournament of Roses officials.

A photo plaque of each inductee is mounted in the Rose Bowl Room, which

also contains trophies, memorabilia, photographs, and information on Rose Bowl history and games.

Induction ceremonies are held in the "Court of Champions," at the south end of the Rose Bowl Stadium; it features a life-size bronze statue of a 1920s football player with the names of the honorees attached to the base. The court also has a plaque on the wall listing the participating universities, coaches, player of the games, and the game scores.

Rose Bowl Hall of Fame, Pasadena Tournament of Roses Assn., 391 S. Orange Grove Blvd., Pasadena, CA 91184. Phone: 818/449–4100. Hours: Feb.–Aug. 2–4 Thurs.; closed major holidays. Admission: free.

SAINTS HALL OF FAME, Kenner, Louisiana. Exceptional players, coaches, and officers of the New Orleans professional football team are enshrined in the Saints Hall of Fame, in the suburb of Kenner, Louisiana. The 7,500-square-foot museum, founded and opened in 1988, attracts over 75,000 visitors annually.

Seventeen former Saints are honored in the hall of fame. They include such greats as place-kicker Tom Dempsey, quarterback Archie Manning, wide receiver Danny Abramowicz, defensive back Tommy Meyers, and president and general manager Jim Finks.

The hall of fame exhibits feature busts and oil paintings of the inductees, as well as team memorabilia, a historical timeline, statistics, video highlights, field-goal kicking, a locker room, interactive quizzes, and tailgate parties.

Saints Hall of Fame, New Orleans Saints, 409 Williams Blvd., Kenner, LA 70062. Phone: 504/468–6617. Hours: 9–5 Tues.–Sat.; 1–5 Sun.; closed gamedays. Admission: adults, $3; seniors and students, $2.

TEXAS HIGH SCHOOL FOOTBALL HALL OF FAME. (See All-Sports category.)

UNIVERSITY OF TENNESSEE FOOTBALL HALL OF FAME, Knoxville, Tennessee. University of Tennessee all-American football players and outstanding coaches are honored in the university's Football Hall of Fame exhibit in the Neyland-Thompson Sports Center on the campus in Knoxville. Players automatically become members of the hall of fame after being made consensus all-Americans or being elected to the National Football Foundation's College Football Hall of Fame.

Founded in 1990, the hall of fame includes 56 players and coaches, including center Bob Johnson, tackle Doug Atkins, guard Steve DeLong, quarterback Bobby Dodd, and coaches Robert P. Neyland and John Majors. The exhibit includes photographs, biographical information, memorabilia, and other materials about the honorees and the university's football history.

University of Tennessee Football Hall of Fame, Neyland-Thompson Sports Center, University of Tennessee, PO Box 15016, Knoxville, TN 37901. Phone: 423/974–1266. Hours: 10–5 Mon.–Fri. and three hours before game on Sat. Admission: free.

FRISBEE

INTERNATIONAL FRISBEE HALL OF FAME, Lake Linden, Michigan. The International Frisbee Hall of Fame is located in the Michigan upper peninsula area, where the sport began in the 1950s. It opened in 1995 in a gallery in the Houghton County Historical Museum in Lake Linden, not far from Eagle Harbor, where frisbee was first developed.

Approximately 20 outstanding Frisbee players have been inducted into the hall of fame. They are largely winners of the International Frisbee Tournament and the World Frisbee Disc Championships. Among the honorees are Fred Morrison, who invented frisbee; the Healy brothers, who created the International Frisbee Tournament in 1958; and Victor Malafronte, winner of the first World Frisbee Disc Championship. The gallery contains photographs, memorabilia, trophies, videos, and other such materials.

International Frisbee Hall of Fame, Houghton County Historical Museum, 5500 Hwy. M-26, PO Box 127, Lake Linden, MI 49945. Phone: 906/296–4121. Hours: June–Aug. 10–4:30 daily; May, Sept., and Oct. 1–5 Sat.–Sun; other times by appointment. Admission: adults, $2.50; seniors and students, $2; families, $5.

GOLF

AMERICAN GOLF HALL OF FAME, Foxburg, Pennsylvania. The Foxburg Country Club, founded in 1887 in Foxburg, Pennsylvania, and now the nation's oldest golf course in continuous operation, is the site of the American Golf Hall of Fame. Started in 1965, the hall of fame has exhibits on 48 inductees on the second and third floors of the log cabin clubhouse.

Originally established to honor golfing greats, such as Gene Sarazen, Walter Hagen, Ben Hogan, and Byron Nelson, the hall of fame's emphasis has changed; now it primarily inducts outstanding golfers in the tri-state area.

The hall of fame has an exceptional collection of golfing artifacts and equipment, including golf clubs dating back to 1770.

American Golf Hall of Fame, Foxburg Country Club, Foxburg, PA 16036. Phone: 412/ 659–3196. Hours: Apr.–Oct. 8 to dusk daily; closed remainder of year. Admission: free.

TEXAS GOLF HALL OF FAME, The Woodlands, Texas. Portraits and information about the achievements of 25 outstanding golfers and other Texans who have contributed to the popular sport grace the Texas Golf Hall of Fame. Founded in 1992, the hall of fame is located near the 18th green of the Tournament Players Course in The Woodlands.

Among the inductees are such golfing legends as Ben Hogan, Byron Nelson, Tom Kite, Kathy Whitworth, Betty James, and Babe Didrikson Zaharias. The 10,000-square-foot hall of fame also contains exhibits of early golfing equipment, the development of golf carts, golf course construction, and tournament history; artifacts and memorabilia associated with such Texans as Willie Nelson

and former President George Bush; and a 15-minute film on the history of Texas golf.

Texas Golf Hall of Fame, Tournament Players Course, 18090 S. Millbend Rd., The Woodlands, TX 77380. Phone: 713/364–7270. Hours: 10–3 daily; closed holidays. Admission: free.

WORLD GOLF HALL OF FAME, Ponte Vedra Beach, Florida.
PROFESSIONAL GOLFERS' ASSOCIATION OF AMERICA HALL OF FAME
LADIES PROFESSIONAL GOLF ASSOCIATION HALL OF FAME
PGA TOUR HALL OF FAME

A new World Golf Hall of Fame is the centerpiece of an ambitious 6,300-acre World Golf Village being developed in Ponte Vedra Beach, Florida. The 75,000-square-foot facility will include: two existing halls of fame, the Professional Golfers' Association of America Hall of Fame (formerly in Pinehurst, North Carolina) and the Ladies Professional Golf Association Hall of Fame; the newly created PGA Tour Hall of Fame; and it will have provisions for an international ballot and special distinction category.

All the major golf organizations from throughout the world have joined in support of this all-inclusive hall of fame. Other elements of the planned multi-million-dollar World Golf Village include an international golf library and resource center, a resort hotel and conference center, a championship golf course, a clubhouse and two satellite courses, vacation villas, a shopping center, a golf academy, a spa and medical clinic, a PGA Tour Productions television studio, and a "Walk of Champions," which will link all the components of the village and honor all members of the hall of fame. Parts of the development will be phased in over a number of years.

Among the 72 members of the two existing halls of fame are such golf champions as Walter Hagen, Ben Hogan, Patty Berg, Bobby Jones, Byron Nelson, Julius Boros, Gene Sarazen, Tommy Armour, Jimmy Demaret, Arnold Palmer, Betty Jameson, Jack Nicklaus, Lee Trevino, Betsy Rawls, Tom Watson, Hale Irwin, Peter Thomson, Bobby Locke, Nancy Lopez, Gary Player, Sam Sneed, Babe Didrikson Zaharias, Billy Casper, Ray Floyd, Chi Chi Rodriguez, and Louise Suggs, as well as such celebrities as Bing Crosby, Bob Hope, and Dinah Shore. Johnny Miller will be the first to be inducted in the new World Golf Hall of Fame.

Exhibits will cover approximately 36,000 square feet of the World Golf Hall of Fame building. In addition to tributes to those enshrined, the exhibits will feature photographs, artifacts, trophies, memorabilia, films, videos, and interactive units. Other features will include a 300-seat big-screen theater, an outdoor par-three island challenge hole, and an outdoor 18-hole grass putting course.

World Golf Hall of Fame, World Golf Village, 100 TPC Blvd., Ponte Vedra Beach, FL 32082. Phone: 804/273–3350. Hours and admission: to be determined.

GYMNASTICS

INTERNATIONAL GYMNASTICS HALL OF FAME AND MUSEUM,
Oklahoma City, Oklahoma. The International Gymnastics Hall of Fame and Museum was started in 1987 by Glenn M. Sundby, publisher of *The International Gymnast*, in the magazine's building in Oceanside, California, shortly after relocating there. Finding the building larger than the publication needed, he conceived of the hall of fame and museum as a means to preserve historical objects in the field and to honor outstanding individuals from the global gymnastics community. In 1997, the hall of fame was moved to Oklahoma City. It now is housed temporarily in an underground downtown mall (below the First National Center building). Plans are underway to build a new permanent home.

The first two inductees were gymnasts Olga Korbut of Russia in 1987 and Nadia Comaneci of Romania in 1992. Six others were added in 1997—gymnasts Mary Lou Retton and Bart Conner of the United States and Masao Takemoto of Japan and coaches Bela Karolyi of Romania and Arthur Gander and Jack Gunthard of Switzerland.

The 2,000-square-foot facility is primarily a repository of gymnastic historical materials such as memorabilia, medals, uniforms, equipment, records, videos, and photographs.

International Gymnastics Hall of Fame and Museum, 120 N. Robinson St., E Concourse, Oklahoma City, OK 73102. Phone: 405/235–5600. Hours: 9–5 Mon.–Fri.; closed major holidays. Admission: free.

HARNESS RACING

HARNESS RACING MUSEUM AND HALL OF FAME, Goshen, New York. The Harness Racing Museum and Hall of Fame—formerly the Trotting Horse Museum, Home of the Hall of Fame—began in a 1913 English Tudor-style stable in Goshen, New York, in 1951. It was later expanded, and recently it was renovated and expanded again. It reopened in the summer of 1997 after being closed for improvements for a year. The name change took place in 1995.

Unlike most halls of fame, the museum came first; the hall of fame was added in 1958 to immortalize the great owners, trainers, drivers, innovators, and officials of harness racing. The hall of fame, which has 68 inductees, also is unusual in that it is divided into a Living Hall of Fame, with 41 members, and a Room of Immortals, which honors 27 deceased hall of famers.

Among the inductees have been John D. Campbell, all-time money-winning driver; Delvin Miller, driver, trainer, and breeder who won more than 2,400 races over his 60-year racing career; Norman Woolworth, a major owner, breeder, and amateur driver for more than 30 years; and Stephen G. Phillips, inventor of the starting gate. Life-like statuettes honor those who have been enshrined in the hall of fame.

The museum also has more than 100 exhibits of famous trotters, high-wheelers and modified sulkies, the sport's first starting gate, Currier and Ives trotting prints, equine paintings, and other artifacts, equipment, and memorabilia pertaining to the history of harness racing. Visitors also can see live horse training at neighboring Historic Track, the first sporting site in America designated as as National Historic Landmark.

Harness Racing Museum and Hall of Fame, 240 Main St., PO Box 590, Goshen, NY 10924. Phone: 914/294–6330. Hours: 10–5 Mon.–Sat.; 12–5 Sun.; closed New Year's Day, Thanksgiving, and Christmas. Admission: adults, $1.50; children, 50¢; guided tours, $2. Changes in hours and admissions being considered.

SARATOGA HARNESS RACING MUSEUM AND HALL OF FAME, Saratoga Springs, New York. The Saratoga Harness Racing Museum and Hall of Fame celebrates the rich past of harness racing in Saratoga Springs, New York. Established in 1983, the museum and hall of fame is located at historic Saratoga Raceway. Harness racing began in Saratoga Springs at least as early as 1847, when Lady Suffolk of the song ''The Old Gray Mare'' raced there—16 years before thoroughbred racing began.

Enshrined in the hall of fame are 27 persons and 25 horses. Among the individuals are Howard Parker, longtime driver and trainer at Saratoga Raceway; Del Miller, world-famous driver-trainer; and Ernest B. Morris, former owner and president of Saratoga Raceway.

The exhibits include tributes to hall of fame honorees and displays of high-wheel sulkies, antique horseshoes, harnesses, a blacksmith shop, paintings, and sculpture.

Saratoga Harness Racing Museum and Hall of Fame, 352 Jefferson St., PO Box 356, Saratoga Springs, NY 12866. Phone: 518/587–4210. Hours: May–June 10–4 Thurs.–Sat.; July–Aug. 10–4 Tues.–Sat.; Sept.–Nov. 10–4 Thurs.–Sat.; other times by appointment. Admission: free.

ICE HOCKEY

BLACKHAWKS/BULLS HALL OF FAME, Chicago, Illinois. The Chicago Blackhawks hockey and Chicago Bulls basketball players and teams are featured in the Blackhawks/Bulls Hall of Fame in the new United Center in Chicago. The exhibit area, which is an adjunct to the Fandomania gift shop near Gate 3-½, opened in 1994 upon completion of the arena.

The hall of fame does not induct anyone, but it has exhibits on star players—like Michael Jordan and Scottie Pippen of the Bulls—as well as team photographs, trophies, memorabilia, and lockers. Also, a statue of Jordan greets the public at the entrance to the United Center.

Blackhawks/Bulls Hall of Fame, United Center, 1001 W. Madison St., Chicago, IL 60612. Phone: 312/455–7600. Hours: 11–4 Tues.–Sun. and during sports events and

most concerts. Admission: free to public when events are not being held, only to ticketholders during events.

LAKE PLACID HALL OF FAME. (See Winter Olympics category.)

UNITED STATES HOCKEY HALL OF FAME, Eveleth, Minnesota. The legends of American hockey are enshrined in the United States Hockey Hall of Fame in Eveleth, Minnesota, a community with a hockey tradition that goes back to the turn of the century. The hall was founded in 1972 and had its first inductions in 1973, when it moved into its present three-story, 20,000-square-foot home.

Among the 90 American-born or American-developed hockey figures honored on pylons in the Great Hall are: Herb Brooks, who coached the United States to the Olympic gold medal in hockey in 1980; Hobey Baker, an outstanding player for whom the collegiate player of the year award is named; and such other American hockey greats as Bob Johnson, Ken Morrow, Jack Kelley, Bill Cleary, Walter Bush, Bill and Roger Christian, John Mariucci, Frank Brimsek, and John Mayasich. An unexpected honoree is cartoonist Charles Schultz, whose "Snoopy" creation inherited his love of hockey.

In addition to tributes to inductees, the hall of fame has an Olympic display featuring the 1960 and 1980 U.S. gold medal teams; a historical time tunnel; exhibits on the playing of hockey at various levels in America; a hockey art gallery; and a theater for showing videos.

U.S. Hockey Hall of Fame, 801 Hat Trick Ave., PO Box 657, Eveleth, MN 55734–0657. Phone: 218/744–5167. Hours: 9–5 Mon.–Sat.; 11–5 Sun. Admission: adults, $3; seniors, $2; students, $1.75; children under 6, free.

JOUSTING

NATIONAL JOUSTING HALL OF FAME, Mount Solon, Virginia. Started in 1821 in Virginia, jousting claims to be the oldest continuously held sporting event in America. Unlike the original killing contests of medieval Europe, in the American version two men mounted on horses use their lances to catch small rings attached to strings.

The hall of fame is in the Natural Chimneys Park near Mount Solon, Virginia, site of early and current jousting contests, and which has limestone formations resembling turrets of castles. The hall contains plaques, photographs, and information of inductees, as well as trophies, jousting rings, lances, and depictions of early jousting matches.

National Jousting Hall of Fame, Natural Chimneys Park, Rt. 1, Box 286. Mount Solon, VA 22843. Phone: 540/350–2510. Hours: daily during park hours. Admission: free.

KITING

WORLD KITE MUSEUM AND HALL OF FAME, Long Beach, Washington. The World Kite Museum and Hall of Fame in Long Beach, Washington, is a spin-off of the Washington State International Kite Festival held in the community. Its purpose is to tell the story of kites by preserving their past, recording the present, and honoring the people involved. The museum/hall of fame seeks to accomplish this mission through exhibits, educational programs, live demonstrations, and hands-on workshops.

The hall of fame was started in 1988, and the museum opened in 1990. Eighteen persons have been elected to the hall of fame, including Laurence Hargrave, who invented the box kite, and Masaaki Modegi, president of the Japanese Kite Association and a promoter and preserver of heritage Japanese kites.

Inductees are represented in the hall of fame gallery by framed certificates and miniature kites representing their work. They also are included in the museum's theme exhibits and sometimes in special exhibitions revolving around them.

The museum has a collection of over 1,200 kites from around the world. In 1989, the museum received a gift of the David Checkley Asian kite collection of approximately 700 Japanese, Chinese, and Malaysian kites.

World Kite Museum and Hall of Fame, PO Box 964, Long Beach, WA 98631. Phone: 360/642–4020. Hours: June 11–5 daily; weekends only during remainder of the year. Admission: adults, $1; seniors and students, 50¢; families, $3.

LACROSSE

LACROSSE HALL OF FAME MUSEUM, Baltimore, Maryland. One of the nation's oldest sports—having over 350 years of lacrosse history—is the focus of the Lacrosse Hall of Fame Museum in Baltimore, Maryland. The hall of fame was founded in 1959, became a museum in 1966, and moved into a new facility with its parent organization, the Lacrosse Foundation, in 1991.

The hall of fame has inducted 244 outstanding lacrosse players, coaches, and other individuals who have contributed to the advancement of the game. Among those enshrined in the hall are Douglas Turnbull, first player to be first-team all-American for four years straight; William H. Moore II, former U.S. Naval Academy lacrosse coach and first president of the Lacrosse Foundation; William Moore, who won more national championships (ten) than any other coach; and Claxton O'Connor, lacrosse enthusiast largely responsible for creating the Foundation.

The hall of fame exhibits include tributes to honorees; a 50-foot timeline of the game's greatest moments; vintage equipment and uniforms; rare photographs and art; a multimedia show; and trophies, memorabilia, and artifacts.

Lacrosse Hall of Fame Museum, 113 W. University Pkwy., Baltimore, MD 21210. Phone: 410/235–6882. Hours: 9–5 Mon.–Fri.; also 10–3 Sat., Mar.–May. Admission: adults, $2; students, $1.

LOCAL SPORTS HALLS OF FAME

AIKEN THOROUGHBRED RACING HALL OF FAME. (See Thorough-bred Racing category.)

BAY AREA SPORTS HALL OF FAME. (See All-Sports category.)

BLACKHAWKS/BULLS HALL OF FAME. (See Basketball category.)

BREITBARD HALL OF FAME. (See All-Sports category.)

CHICAGOLAND SPORTS HALL OF FAME. (See All-Sports category.)

COMISKEY PARK HALL OF FAME. (See Baseball category.)

DELAWARE COUNTY ATHLETES HALL OF FAME. (See All-Sports category.)

GREATER FLINT AFRO-AMERICAN HALL OF FAME. (See All-Sports category.)

GREATER FLINT AREA SPORTS HALL OF FAME. (See All-Sports category.)

GREEN BAY PACKER HALL OF FAME. (See Football category.)

LAKE PLACID HALL OF FAME. (See Winter Olympics category.)

MARGARET DOW TOWSLEY SPORTS MUSEUM. (See All-Sports category.)

MUSKEGON AREA SPORTS HALL OF FAME. (See All-Sports category.)

NEW YORK YANKEES MEMORIAL PARK. (See Baseball category.)

ORANGE COUNTY SPORTS HALL OF FAME. (See All-Sports category.)

PAUL W. BRYANT MUSEUM. (See All-Sports category.)

PENN STATE FOOTBALL HALL OF FAME. (See Football category.)

ST. LOUIS CARDINALS HALL OF FAME MUSEUM. (See Baseball category.)

SAINTS HALL OF FAME. (See Football category.)

SARATOGA HARNESS RACING MUSEUM AND HALL OF FAME. (See Harness Racing category.)

SHREVEPORT-BOSSIER CITY SPORTS MUSEUM OF CHAMPIONS. (See All-Sports category.)

TOM KEARNS UNIVERSITY OF MIAMI SPORTS HALL OF FAME. (See All-Sports category.)

UNIVERSITY OF TENNESSEE FOOTBALL HALL OF FAME. (See Football category.)

MARBLES

MARBLES HALL OF FAME, Wildwood, New Jersey. The annual National Marbles Tournament has been held since 1922 in Wildwood, New Jersey—which also is the home of the Marbles Hall of Fame, established in 1992 and opened in 1993 at the George F. Boyer Historical Museum.

Winners of the boys and girls championships are enshrined in the hall of fame, which occupies a 500-square-foot room in the local historical museum. Originally only for boys 8 to 14 years of age, the tournament was extended to girls in 1948. Among the 122 champions inducted are Bud McQuade, winner of the first tourney; Arron Butash, 1933; Bill Kloss, 1937; Benjamin Ryabik, 1946; Jerry Roy and Arlene Ridette, 1953; Doug Hager and Debra Stanley, 1973; and Bong Duong and Kim Shuttleworth, 1994. Trophies, photographs, and marbles of the tournament winners are displayed in the museum.

Marbles Hall of Fame, George F. Boyer Historical Museum, 3907 Pacific Ave., Wildwood, NJ 08260. Phone: 609/523–0277. Hours: May–Oct. 10–2 daily; Nov.–Apr. 10–2 Thurs.–Sun. Admission: free.

MOTORCYCLING

NATIONAL MOTORCYCLING MUSEUM AND HALL OF FAME, Sturgis, South Dakota. The National Motorcycle Museum and Hall of Fame is located in Sturgis, South Dakota—home of the annual Sturgis Rally and Races, formerly the Black Hills Motor Classic and Rally, the nation's oldest and largest motorcycle rally, started in 1938. The rally, held the first full week in August, now attracts nearly a quarter of a million people annually.

The 10,000-square-foot museum and hall of fame, founded in 1990, has in-

ducted 24 motorcycle racers, promoters, industry leaders, and others for their contributions in the field. They include racers Pete Hill, Bill Tuman, and Jim Davis; rally founder J. C. "Pappy" Hoel; and promoter Dot Robinson, known as "the first lady of motorcycling."

Plaques, photographs, information, memorabilia, trophies, and other materials concerning the hall of famers can be seen in the museum, as well as more than 100 motorcycles and displays tracing the history of motorcycling. Two of the prized motorcycles on display are a 1907 Harley-Davidson known as the "Mona Lisa of Motorcycles" and a 1915 Cyclone from actor Steve McQueen's collection. Among the other historic machines at the museum are early Ariel, BSA, Excelstor, Harley-Davidson, Indian, Norton, Royal Enfield, and Triumph motorcycles. The annual attendance is approximately 80,000.

National Motorcycle Museum and Hall of Fame, 2438 S. Junction Ave., Sturgis, SD 57785. Phone: 605/347–4875. Hours: 9–5 daily; closed New Year's Day, Thanksgiving, and Christmas. Admission: adults and children over 12, $3; seniors, $2; children 12 and under, free.

MOTOR SPORTS

D.I.R.T. HALL OF FAME AND CLASSIC CAR MUSEUM, Weedsport, New York. Legendary dirt race drivers are enshrined in the D.I.R.T. Hall of Fame and Classic Car Museum at the Cayuga County Fair Speedway in Weedsport, New York. The hall of fame and museum was founded in 1991 by the Drivers Independent Race Tracks (D.I.R.T.), recently renamed Dirt Motor Sports Inc., the nation's second-largest race-sanctioning body.

Forty drivers are honored in the hall of fame, including Frankie Schneider, Will Kagle, Donald Hoag, and Cliff Kotary. The museum also has a collection of over 50 classic cars and historic race cars, as well as racing photographs, films, memorabilia, and art. Among the racing cars are Buzzie Reutimann's "00" coupe and Gary Balough's "Batmobile 112," while classic cars include a 1929 Duesenberg straight-8, a 1929 Dodge Roadster with dual side-mounts, a 1957 Chevy two-door HT, and a 1969 Dodge Charger Hemi 4-speed.

D.I.R.T. Hall of Fame and Classic Car Museum, Dirt Motor Sports Inc., Cayuga County Fairgrounds, 1 Speedway Dr., Weedsport, NY 13166. Phone: 315/834–6667. Hours: mid-Apr.–Labor Day 10–5 Mon.–Sat., 12–7 Sun.; Sept.–Dec. 10–5 Mon. Fri., 11–4 Sat.–Sun.; closed Jan.–mid-Apr. Admission: adults, $4; seniors, students, and children over 5, $3; children 5 and under, free.

INDIANAPOLIS MOTOR SPEEDWAY HALL OF FAME MUSEUM, Indianapolis, Indiana. The Indianapolis Motor Speedway Hall of Fame Museum— located on the grounds of America's premier auto racing event, the Indianapolis 500—celebrates the outstanding individuals, vehicles, and events associated with automobile racing. The hall of fame was started in 1952, and the museum was

The Indianapolis Motor Speedway Hall of Fame Museum honors the outstanding individuals, vehicles, and events associated with automobile racing. The hall of fame was founded in 1952 and the museum was added in 1956. It now has an annual attendance of nearly 300,000. Courtesy Indianapolis Motor Speedway Hall of Fame Museum.

established in 1956; today nearly 300,000 visitors come to see the tributes and extensive collections annually.

The race track was built in 1909 and held its first Indy 500 race in 1911. The hall of fame was founded by the American Automobile Association, in cooperation with the Edison Institute of the Ford Foundation, to honor drivers, mechanics, car owners, promoters, officials, and manufacturers; to demonstrate racing's contributions to the development of the automobile industry; and to portray the impact of these contributions on the American way of life. After three years, however, the AAA withdrew its support, and the hall of fame was discontinued in 1955.

In 1956, Indianapolis Speedway President Tony Hulman created a foundation to operate a museum for auto racing at the track. In 1961 the hall of fame was reorganized, reactivated, and made as part of the museum. A new 43,346-square-foot building was opened in 1976 and later expanded to its present 90,000 square feet, of which 30,000 are devoted to exhibits.

The hall of fame has 102 inductees, including such Indy 500 winners as Wilbur Shaw, Mauri Rose, Bill Vukovich, A. J. Foyt, Jr., Parnelli Jones, Mario Andretti, Al Unser, Johnny Rutherford, and Rick Mears; Barney Oldfield and Eddie Rickenbacker, early racers; Gaston Chevrolet, racer and later manufacturer; Henry Ford, automobile pioneer and manufacturer; and Harvey Firestone, tire manufacturer.

The names of those enshrined are inscribed on a trophy, and portraits of living inductees are displayed, as well as over 30 of their winning Indy 500 cars. The latter are among the more than 75 racing vehicles on exhibit, which themselves represent only one-third of the museum's auto collection. Among the cars on display are Ray Harroun's historic "Marmon Wasp," winner of the first Indy 500 race in 1911; cars driven by Wilbur Shaw, Mauri Rose, A. J. Foyt, Jr., and other Indianapolis victors; and Le Mans race winners, Grand Prix cars, NASCAR stock cars, sprint cars, midget cars, and land speed cars.

Other exhibits include engines, helmets, tires, hubcaps, gloves, posters, artworks, photographs, and other such materials. A 30-minute film of great Indy races also is shown in the Tony Hulman Theater.

Indianapolis Motor Speedway Hall of Fame Museum, 4790 W. 16th St., Indianapolis, IN. (PO Box 24152, Speedway, IN 46224) Phone: 317/481–8500. Hours: 9–5 daily; May 9–6; closed Christmas. Admission: adults, $2; children under 16, free; bus ride around track when not in use, $2.

INTERNATIONAL DRAG RACING HALL OF FAME, Ocala, Florida. The International Drag Racing Hall of Fame is located at the Don Garlits Museum of Drag Racing in Ocala, Florida. The hall of fame was founded in 1984 by "Big Daddy" Garlits, regarded as the "king of drag racing," because of his many speed records and titles during 25 years in the sport. The first inductions were in 1990.

Ninety-seven drivers, track owners, and others related to drag racing are hon-

ored in the hall of fame, including Art Arfons, Sidney Allard, Zora Arkus-Duntov, Ray Godman, and Raymond Beadle. Their names are engraved on a large monument at the entrance to the museum, and their photographs and achievements are featured in the Drag Racing Building—one of two buildings that constitute the museum.

More than 90 racing cars, many used by hall of famers, can be seen in the Drag Racing Building, and over 50 vehicles in the Antique Car Building. The annual attendance is approximately 100,000.

International Drag Racing Hall of Fame, Don Garlits Museum of Drag Racing, 13700 S.W. 16th Ave., Ocala, FL 34473. Phone: 352/245–8661. Hours: 9–5:30 daily; closed Christmas. Admission: adults, $10; children 3–12, $3; children under 3, free.

INTERNATIONAL MOTORSPORTS HALL OF FAME, Talladega, Alabama.
ALABAMA SPORTS WRITERS HALL OF FAME
AUTOMOBILE RACING CLUB OF AMERICA HALL OF NATIONAL CHAMPIONS
QUARTER MIDGETS OF AMERICA HALL OF FAME
WESTERN AUTO MECHANICS HALL OF FAME
WORLD KARTING HALL OF FAME

The International Motorsports Hall of Fame has one of the nation's largest and most comprehensive hall of fame complexes, covering 80,000 square feet in five buildings, at the Talladega Superspeedway in Talladega, Alabama. It also incorporates five smaller sports halls of fame—Alabama Sports Writers Champions, the Western Auto Mechanics Hall of Fame, the Quarter Midgets of America Hall of Fame, the World Karting Hall of Fame, and the Automobile Racing Club of America Hall of National Champions.

The International Motorsports Hall of Fame was founded in 1975 to honor the leading figures in motor racing and to preserve the history of the sport on a worldwide basis. The present museum complex began to take shape in 1983; it now contains over 100 vehicles valued at more than $20 million, memorabilia, equipment and other materials related to motor racing. The annual attendance is approximately 100,000.

The hall of fame has enshrined 69 drivers, owners, mechanics, carmakers, innovators, and officials who have contributed to the development and growth of motor sports. The inductees include such racing champions as Bobby Allison, Mauri Rose, Wilbur Shaw, Bobby Unser, Graham Hill, Tony Bettenhausen Sr., Dan Gurney, Andy Granatelli, Cale Yarborough, Parnelli Jones, Joe Weatherly, Richard Petty, Rick Mears, and Bill Vukovich, Sr.; pioneer racers like Barney Oldfield, Louis Chevrolet, Ralph DePalma, and Sir Malcolm Campbell; auto executives and racing car innovators such as Henry Ford, Enzo Ferrari, Colin Chapman, and Ferdinand Porsche; and racing officials like Eddie Rickenbacker, John Marcum, William H. G. France, Sr., and Wally Parks.

Three of the five buildings are exhibition halls, with extensive collections of racing vehicles and other items pertaining to motor sports. They are the Daytona

Building, which features muscle cars; the Enoch Staley Building, containing racers and racing wrecks; and the Unocal 76 Building, with numerous race cars, displays, and the hall of fame. Other buildings are the main rotunda, which houses the offices and gift shop, and the McCaig-Wellborn International Motorsports Research Library, with books, periodicals, and other materials. In addition, there is the Mark II Pavilion, a covered courtyard used for temporary displays and car shows.

Among the vehicles on display are Richard Petty's STP Dodge Charger, with a career record of 31 wins and 16 pole positions; the Pontiac #22 stock car of Glenn "Fireball" Roberts; the champion drag racer of "Big Daddy" Don Garlits; Bill Elliott's 1985 Ford Thunderbird, which holds the record for the fastest 500-mile stock car race ever run; Porsche #962, driven by John Andretti, Bob Wollek, and Derek Bell, which dominated the 24 hours of Daytona in 1989; a 1919 Indianapolis racer; and the Budweiser Rocket Car, which could accelerate from 1 to 140 miles per hour in one second, and broke the speed of sound with a record run of 739.666 mph in 1979.

International Motorsports Hall of Fame, 3198 Speedway Blvd., PO Box 1018, Talladega, AL 35161. Phone: 205/362–5002. Hours: 9–5 daily; closed Easter morning, Thanksgiving, and Christmas. Admission: adults, $8; seniors, $7.50; children 7–17, $7; children 6 and under, free: groups of 25 or more, $1 off.

MOTORSPORTS MUSEUM AND HALL OF FAME OF AMERICA, Novi, Michigan. The Motorsports Museum and Hall of Fame of America, better known as simply the Motorsports Hall of Fame, is the only such facility dedicated to all forms of motorsports—cars, trucks, motorcycles, aircraft, snowmobiles, and water craft. Its hall of fame honors "Heroes of Horsepower" from the early part of the century to today's champions, in ten motor sports categories.

The 19,200-square-foot museum and hall of fame was founded in 1989, and it opened in 1993 in the Novi Expo Center in Novi, Michigan. Among the 75 persons inducted in the hall of fame are Henry Ford, who built some of the first racing cars; Roscoe Turner, for air racing; Barney Oldfield, auto racing; Gar Wood, powerboat racing; Cannon Ball Baker, motorcycle racing; Cale Yarborough, stock car racing; Don Prudhomme, drag racing; Al Unser, open wheel racing; and Phil Hill, sports car racing.

Busts of the inductees are featured in the exhibits, as well as biographical information and many photographs, uniforms, cars, artifacts, and memorabilia. The museum contains more than 75 vehicles, including Indy cars, sports cars, stock cars, sprint cars, dragsters, motorcycles, and boats. Among those on display is the legendary "Novi" Indy racer, namesake of the City of Novi.

Motorsports Museum and Hall of Fame of America, Novi Expo Center, PO Box 194, Novi, MI 48376–0194. Phone: 810/349–7223. Hours: 10–5 daily; closed major holidays. Admission: adults, $5; seniors and children under 12, $3.

NATIONAL SPRINT CAR HALL OF FAME AND MUSEUM, Knoxville, Iowa. The history and legends of sprint car and big car racing are featured at

the National Sprint Car Hall of Fame and Museum, located at the second turn of the Knoxville Raceway in Knoxville, Iowa.

The hall of fame was founded in 1990, and the museum opened in 1991. The facility, housed in a four-story, 36,000-square-foot building, also has 20 skybox-level suites overlooking the raceway at the Marion County Fairgrounds.

National Sprint Car Hall of Fame, sponsored by the Pella Corporation, honors outstanding drivers, owners, mechanics, promoters, sanctioning officials, and media in sprint and big car racing. Among the 104 inductees are such leading racing figures as Barney Oldfield, Eddie Rickenbacker, Arthur and Louis Chevrolet, A. J. Foyt, Jr., Johnny Rutherford, Mario Andretti, Parnelli Jones, Rex Mays, Fred Offenhauser, Joie Chitwood, Ralph DePalma, and August and Fred Duesenberg.

The National Sprint Car Museum (named for Donald Lamberti) contains more than 25 restored sprint cars—from vintage open-wheel racers to today's 800-horsepower machines, as well as engines, tires, tools, helmets, uniforms, trophies, photographs, paintings, plaques, and memorabilia of the sport. Among the cars on display are George Nesler/Earl Halaquist #2, Grant King/Sheldon Kinser #20, Maxium/Steve Kinser #11, Wally Meskowski/Johnny Rutherford #9, KurtisKraft/A. J. Foyt #83 midget, Dick Berggren/Don Edmunds #80, and the A. J. Watson/LeaderCards #2 champion car.

National Sprint Car Hall of Fame and Museum, 1 Sprint Capital Pl., PO Box 542, Knoxville, IA 50138. Phone: 515/842–6176. Hours: 10–6 Mon.–Fri.; 10–5 Sat.; 12–5 Sun. Admission: adults, $3; seniors and students, $2; children under 5, free.

NMPA STOCK CAR HALL OF FAME/JOE WEATHERLY MUSEUM, Darlington, South Carolina. The NMPA Stock Car Hall of Fame/Joe Weatherly Museum in Darlington, South Carolina, is a shrine to those who have made stock car racing one of the nation's fastest-growing sports. The hall of fame was founded in 1965 by the National Motorsports Press of America (NMPA) as part of a museum named for champion driver Joe Weatherly, who sought before his death in 1964 to have such a museum located at the Darlington Raceway. It now attracts approximately 200,000 visitors annually.

Fifty-one drivers and other figures in stock car racing have been inducted into the hall of fame, which occupies 2,500 of the museum's 6,500 square feet. Among those enshrined are Buck Baker, Junior Johnson, Fred Lorenzen, David Pearson, Fireball Roberts, Herb Thomas, Bob Welborn, and Cale Yarborough.

A separate exhibit case is devoted to each hall of famer, as well as videos on their achievements. The museum displays 15 cars, including Johnny Mantz's 1950 Plymouth that won the first Southern 500 at Darlington in 1950; Welborn's 1957 Chevrolet that took two National Association for Stock Car Auto Racing (NASCAR) convertible titles in 1957–58; Pearson's Mercury that won ten races in 1973; and cars driven by Roberts, Johnson, Yarborough, and others. Other exhibits pertain to engines, illegal parts removed from cars before races, and the history of stock car racing.

NMPA Stock Car Hall of Fame/Joe Weatherly Museum, 1301 Harry Byrd Hwy. (Rte. 151–34), PO Box 500, Darlington, SC 29532. Phone: 803/393–2103. Hours: 8:30–5 daily; closed Thanksgiving and Christmas. Admission: adults, $3; children 12 and under, free.

POLO

NATIONAL MUSEUM OF POLO AND HALL OF FAME, Lake Worth, Florida. The National Museum of Polo and Hall of Fame, which was founded in 1984, opened in 1997 in its new building in Lake Worth, Florida. The first inductions were in 1990, but there was at the time only a brief display at the Kentucky Horse Park in Lexington, Kentucky.

Thirty-four polo players and others who have contributed to the advancement of the sport have been inducted into the hall of fame. They include such leading figures as Thomas Hitchcock, Jr., Stewart Iglehart, Harry Payne Whitney, James Gordon Bennett, Michael G. Phipps, Robert E. Strawbridge, Jr., J. Watson Webb, Lawrence Waterbury, Louise Eustis Hitchcock, and Paul Butler. The exhibits honor the hall of famers and interpret the history and nature of polo.

National Museum of Polo and Hall of Fame, 9011 Lake Worth Rd., Lake Worth, FL 33467. Phone: 407/969–3210. Hours and admission: to be determined.

RACQUETBALL

U. S. RACQUETBALL HALL OF FAME, Colorado Springs, Colorado. U.S. Racquetball, formerly the American Amateur Racquetball Association, has inducted 94 outstanding players and others in eight categories into its hall of fame. They are honored with plaques, photographs, and memorabilia at the organization's headquarters in Colorado Springs, Colorado.

Approximately 8 million persons play racquetball in the United States. It got its start in the 1950s and had become extremely popular by the 1970s.

U.S. Racquetball Hall of Fame, U.S. Racquetball, 1685 W. Unitah, Colorado Springs, CO 80904. Phone: 719/635–5396. Hours: 9–5 Mon.–Fri.; closed holidays. Admission: free.

ROLLER SKATING

ROLLER SKATING HALL OF FAME, Lincoln, Nebraska. The United States Amateur Confederation of Roller Skating Hall of Fame, located in the National Museum of Roller Skating in Lincoln, Nebraska, has three categories of enshrinement that honor outstanding amateur athletes and teams, competitive coaches, and other individuals who have made exceptional contributions to the sport of roller skating.

The museum, which operates separately as a nonprofit organization, was founded in 1980 and opened in 1982. The hall of fame began in 1983 by citing athletes and teams for their skating performances. This was followed by the establishment of the coaches category in 1990 and the individual distinguished service awards in 1993.

More than 140 inductions have been made into the hall of fame—62 amateur and teams, 54 competitive coaches, and 24 individuals for distinguished service. They include Laurene Anselmi, who won 17 national titles; Dickie Thibodeaux, a star on the 1966–69 national hockey championship teams; Sylvia Hoffke, four-time winner of the senior women's singles title; Bettie Jennings, coach of national champions in dance, figure, and free skating in the 1950s–1970s era; Bert Anslemi, who helped develop the Girl Scout merit badge and coached many U.S. world teams; Perry Rawson, who introduced ballroom dancing on roller skates in America in the 1930s; Tony and Caroline Mirelli, stars of the only professional roller skating touring show for 12 years and who then turned to competitive teaching; and George Pickard, longtime executive director of the roller skating association and founding trustee of the National Museum of Roller Skating.

The 2,400-square-foot museum—which shares the building with the governing body of roller skating—has the largest collection of historical roller skates in the world, with some dating to 1819. The exhibits include skates, costumes, photographs, artworks, videos, and other materials, as well as displays recognizing hall of famers.

Roller Skating Hall of Fame, National Museum of Roller Skating, 4730 South St., Lincoln, NE 68506. Phone: 402/483–7551. Hours: 9–5 Mon.–Fri.; closed major holidays. Admission: free.

SAILING

AMERICA'S CUP HALL OF FAME, Bristol, Rhode Island. The America's Cup Hall of Fame is located in the Herreshoff Marine Museum, founded in 1971 in the original waterfront facility of the Herreshoff Manufacturing Company— once the nation's premier builder of power vessels and sailing yachts—in Bristol, Rhode Island. The hall of fame was established in 1992, and exhibits pertaining to the honorees were added two years later.

The Herreshoff company, which began in 1863, designed and built some of the nation's greatest racing and cruising yachts, including eight consecutive America's Cup defenders. Its other achievements included design and construction of the first naval torpedo ships, the hull for the first transatlantic airplane, and the first patented catamaran.

The museum interprets and demonstrates the ingenuity of the company's design and craftsmanship, through a collection of more than 45 vintage Herreshoff

yachts and boats, including the 1859 *Sprite*, the 25-foot Buzzards Bay *Aria*, and the 56-foot *Belisarius* yawl, which is anchored in front of the museum.

The America's Cup Hall of Fame exhibits include models, photographs, artifacts, the 1992 America's Cup yacht *Defiant*, and tributes to the 35 persons enshrined in the hall. A new building is planned to house the hall of fame.

Among those who have been inducted into the hall of fame are Dennis Conner, winner of the America's Cup in 1980, 1987, and 1988; Ted Turner, winner of the 1977 America's Cup; and Olin and Rod Stephens, considered the most prominent yacht designers in the modern era.

America's Cup Hall of Fame, Herreshoff Marine Museum, 7 Burnside St., PO Box 450, Bristol, RI 02809. Phone: 401/253–5000. Hours: 1–4 Mon.–Fri.; 11–4 Sat.–Sun.; closed Fourth of July. Admission: adults, $3; seniors, $2; students, $1; children, free; families, $5.

SINGLEHANDED SAILORS HALL OF FAME, Newport, Rhode Island. The hardy souls who have sailed the oceans of the world alone are honored in the Singlehanded Sailors Hall of Fame, a part of the Museum of Yachting at Fort Adams State Park in Newport, Rhode Island.

The museum was founded in 1980 to preserve and promote the history of international yachting and to recognize those individuals who have made major contributions. The hall of fame for solo sailors was added in 1986; it now has 29 inductees.

The hall of fame—which occupies 1,000 square feet of the museum's 2,500 square feet in a former Army mule barn at the fort—pays tribute to Joshua Slocum, the first person to sail around the world by himself, and to such other solo sailors as Francis Chichester, Robin Knox-Johnson, and H. G. "Blondie" Hasler. The hall contains artifacts, memorabilia, and photographs of the honorees.

Among the other museum exhibits are displays on the times when the Vanderbilts, Morgans, and Astors vied for the biggest mansions and the best yachts; classic one-design sail and power boats; America's Cup races and their contenders in Newport during the 1930s; and boats restored by the museum's Restoration School (which can be seen in the boat basin or at moorings near the museum building).

Singlehanded Sailors Hall of Fame, Museum of Yachting, Fort Adams State Park, PO Box 129, Newport, RI 02840. Phone: 401/847–1018. Hours: May 11–Oct. 31 10–5; other times by appointment. Admission: adults, $3; seniors and students, $2.50; children under 12, free; families, $6.

INTERCOLLEGIATE SAILING HALL OF FAME, Annapolis, Maryland. The names of winners of major collegiate sailing races are engraved on trophies and plaques at the Intercollegiate Sailing Hall of Fame in the Robert Crown Center at the United States Naval Academy in Annapolis, Maryland.

The hall of fame has over 80 perpetual trophies and plaques in various sailing

categories, with information on the history of each regatta and the person for which it is named. Other exhibit materials include photographs and model sailboats. Many of the sailing races are held on the nearby Severn River and Chesapeake Bay.

Intercollegiate Sailing Hall of Fame, U.S. Naval Academy, Robert Crown Center, 601 Brownson Rd., Annapolis, MD 21402–5043. Phone: 410/293–5605. Hours: 8–4 Mon.–Fri.; also 8–4 Sat.–Sun. during the racing season from Mar. through mid-Oct. Admission: free.

SHUFFLEBOARD

NATIONAL SHUFFLEBOARD HALL OF FAME, St. Petersburg, Florida. The nation's best shuffleboard players are enshrined in the National Shuffleboard Hall of Fame, housed in the St. Petersburg Shuffleboard Club in St. Petersburg, Florida.

Established in 1959, the hall of fame has honored 72 players and 52 others for service, including such early standout players as Mary Scalise, Webster H. Smith, Amy Close, Carl Spillman, Henry Badum, and Janet Smith, as well as contemporaries like Larry Faris, Mae Hall, Howard Rayle, James Snoddy, and Lou Tansky.

In addition to plaques, the hall has photographs, trophies, and memorabilia pertaining to shuffleboard. States with extensive shuffleboard activities, such as Florida, Ohio, California, Texas, and Arizona, also have plaques listing their officers in the hall.

National Shuffleboard Hall of Fame, St. Petersburg Shuffleboard Club, 559 Mirror Lake Dr., North, St. Petersburg, FL 33701. Phone: 813/822–2083. Hours: 8–4 Mon.–Fri. Admission: free.

SKEET SHOOTING

NATIONAL SKEET SHOOTING HALL OF FAME MUSEUM, San Antonio, Texas. Outstanding skeet shooters are enshrined in the National Skeet Shooting Hall of Fame Museum, located adjacent to the National Skeet Shooting Association headquarters in San Antonio, Texas. The hall of fame program began in 1970, and the hall of fame and museum building opened in 1988.

Among the more than 70 persons inducted into the hall of fame are John Dickey Boardman, Darrell L. Cool, Francis E. Ellis, Eveylen Jones, George W. Leishear, Wayne Mayes, Philip F. Murray, and Robert Paxton. Photographs, biographical information, memorabilia, artifacts, trophies, and other such materials are displayed. Because of the increasing number of the hall of fame honorees and the expanding collections, planning is under way for a larger facility.

National Skeet Shooting Hall of Fame Museum, National Skeet Shooting Assn., 5931 Roft Rd., San Antonio, TX 78253. Phone: 210/688–3371. Hours: open during the World Skeet Championships in October and other tournaments; other times by appointment. Admission: free.

SKIING

COLORADO SKI MUSEUM-SKI HALL OF FAME, Vail, Colorado. The Colorado Ski Museum-Ski Hall of Fame in Vail is devoted to preserving and interpreting the history of skiing in Colorado and to honoring the pioneers, skiers, industry leaders, and others who have made significant contributions to the development of skiing in the state.

The museum was founded during the state's centennial and the nation's bicentennial celebrations in 1976; the hall of fame was initiated the following year. It started in an old, log telephone company building and moved into its present location in the Vail Associates Transportation Center building in 1991.

The museum galleries include photographs, artifacts, equipment, and clothing portraying over 130 years of Colorado skiing. In addition to the hall of fame, the exhibits deal with the 1860s–1990s historical timeline, the U.S. Army 10th Mountain Division (which was based and trained in Colorado), the U.S. Forest Service, the world alpine championship, development of Colorado ski areas, and Colorado's Olympians.

Among the 104 in the hall of fame are William Brown, Charles Dole, Crosby Perry-Smith, and Peter Seibert, Sr., of the 10th Mountain Division; Marvin Crawford, Michael Elliot, Ted Farwell, James Harsh, Jimmie Heuga, Billy Kidd, Steve Knowlton, Bill Marolt, Andy Mill, Keith Wegeman, and Wallace "Buddy" Werner, Olympic racers; Hank Kashiwa, world professional champion; Howard Head and Marcellus Merrill, skiing equipment inventors; Warren Miller, skiing filmmaker; Bob Beattie, Anders Haugen, and John McMurtry, Olympic skiing coaches; Hugh Nevins, associated with the blind skier program; and Walter Paepke, Aspen skiing resort developer.

Colorado Ski Museum-Ski Hall of Fame, 231 S. Frontage Rd., PO Box 1976, Vail, CO 81658. Phone: 970/476–1876. Hours: 10–5 Tues.–Sun.; closed mid-April to mid-October, New Year's Day, Easter, Thanksgiving, and Christmas. Admission: free.

LAKE PLACID HALL OF FAME. (See Winter Olympics category.)

UNITED STATES NATIONAL SKI HALL OF FAME AND MUSEUM, Ishpeming, Michigan. The United States National Ski Hall of Fame was established in 1950 by the United States Ski Association—and a museum was opened oin 1954 in Ishpeming, Michigan—to honor men and women who have contributed to American skiing as outstanding athletes or ski sport builders. A new 20,000-square-foot facility replaced the original building in 1992.

Approximately 300 individuals have been enshrined in the hall of fame, including Lowell Thomas, Phil Mahre, Stein Eriksen, Gloria Chadwick, and John Fry. A plaque with the honoree's photograph and biographical summary is displayed in the hall.

Other exhibits feature skiing pioneers, modern Olympic medalists, the U.S. Army 10th Mountain Division, skiing trophies, or trace the evolution of skis, bindings, clothing, equipment, and activities.

The hall of fame and museum also has the Roland Palmedo National Ski Library, with over 1,000 books and other materials on skiing.

United States National Ski Hall of Fame and Museum, 610 Palms Ave., PO Box 191, Ishpeming, MI 49849. Hours: Oct.–mid-May 10–5; mid-May–Sept. 10–6; closed New Year's Day, Easter, Thanksgiving, and Christmas. Admission: adults, $3; seniors, $2.50; students 10 and over, $1; children under 10; free; groups of 10 or more, $2 per person.

WESTERN AMERICA SKI HALL OF FAME, Soda Springs, California. Outstanding athletes, sport builders, and inspirational leaders in skiing in the American West are honored in the Western America Ski Hall of Fame, located in the Western Skisport Museum at the Boreal Ski Area on historic Donnor Summit near Soda Springs, California. Members of the hall of fame are those persons from the West who have been inducted into the United States National Ski Hall of Fame in Ishpeming, Michigan.

More than 100 westerners are featured in the hall of fame, including "Snowshoe" Thompson, who delivered mail in the snowy Sierra Nevada Mountains in the 1860s; Lowell Thomas, noted broadcaster and skiing promoter; Dick Buek, Olympic downhill standout; and Wayne Poulsen, founder of Squaw Valley ski area.

In addition to the hall of fame wall, the 5,000-square-foot Western Skisport Museum contains exhibits on the U.S. ski team and its accomplishments since 1924; early skiing in the gold fields of northern California; evolution of skiing equipment; and development of western ski areas and snow surveying.

Western America Ski Hall of Fame, Western Skisport Museum, Boreal Ski Area, PO Box 729, Soda Springs, CA 95728. Phone: 916/426–3313. Hours: 10–4 Wed.–Sun. Admission: free.

SNOWMOBILING

INTERNATIONAL SNOWMOBILE RACING HALL OF FAME AND MUSEUM, Saint Germain, Wisconsin. The International Snowmobile Racing Hall of Fame and Museum in Saint Germain, Wisconsin, honors snowmobile racing greats and interprets the nature and history of the field. The idea for such a facility was born in 1983, but it was not until 1988 that the first inductees were enshrined, and 1989 that the hall of fame/museum was opened.

Thirty-one individuals have been recognized in the hall of fame for their racing achievements. They include such outstanding racers as two-time world champion Mike Trapp, Bob Eastman, Duane Frandsen, Jerry Bunke, J. Armand Bombardier, Edgar Hetten, and Yon Duhamel.

The exhibits range from plaques, memorabilia, and photographs of hall of famers to historical equipment and other displays, in the 4,000-square-foot building. The hall of fame/museum is supported largely through the proceeds of an annual ''Ride with the Champs''—a snowmobile celebrity ride initiated in 1984 in nearby Eagle River.

International Snowmobile Racing Hall of Fame, 6035 Hwy. 70 E., St. Germain, WI 54558 (office at 4302 Lakeshore Dr., Wausau, WI 54401). Phone: 715/359–9917. Hours: 9–5 Mon.–Sat. Admission: free.

SOAP BOX RACING

ALL-AMERICAN SOAP BOX DERBY MUSEUM AND HALL OF FAME,
Akron, Ohio. Winners of the annual All-American Soap Box Derby are honored in a museum and hall of fame at Derby Downs in Akron, Ohio. A wide assortment of championship cars, helmets, trophies, wheels, rule books, scrapbooks, photographs, and related materials can be seen at the museum's 3,900-square-foot, remodeled lodge home.

The Soap Box Derby had its beginning in 1933, when photographer Myron Scott organized the first race after taking pictures of three boys coasting down a hill in crude, box-like racers in Dayton, Ohio. He then invited others to a race, in which 19 participated. This was followed by regional races, with the winners going to Akron to compete for national titles.

The hall of fame was started in 1974, and the museum opened in 1979. Among those honored are Bob Turner, first world champion; Joe Lunn, the 1952 champion, who wrecked his car but still won; and Dick Kemp, 1954 world champion, who is the brother of Jack Kemp, former professional quarterback and congressman.

The all-volunteer facility is open during race week and by appointment during the year, with the annual attendance being approximately 10,000. Plans are under way for a new and larger building.

All-American Soap Box Derby Museum and Hall of Fame, 789 Derby Downs Dr., PO Box 7233, Akron, OH 44306. Phone: 330/733–8723. Hours: 10–4 race week; other times by appointment. Admission: free.

SOCCER

NATIONAL SOCCER HALL OF FAME, Oneonta, New York. The National
Soccer Hall of Fame in Oneonta, New York, serves as a center for many soccer-related activities and as a tribute to outstanding players, coaches, officials, and

other figures in the field. It was founded in 1981 and moved into its interim 4,000-square-foot building in 1982. Since then it has become the home for the national soccer library and archives, added four playing fields, and has hosted soccer clinics, tournaments, symposia, and other activities.

Plans are under way for $30 million Wright National Soccer Campus, which will include a 27,000-square-foot museum, a 10,000-seat stadium, an indoor arena, training facilities, and additional playing fields on a 61-acre site—with a target date of 1999. Oneonta is a hotbed of soccer, being the home of power-houses Hartwick College and Oneonta State, and having a youth program that involves 1,400 players.

The National Soccer Hall of Fame inductees are selected by four soccer organizations: the United States Soccer Federation, the National Soccer Coaches Association of America, the National Intercollegiate Soccer Officials Association, and the American Youth Soccer Organization. Among the 289 persons honored are such notable players as Pelé, Walter Bahr, Arnie Oliver, Werner Fricker, Efrain ''Chico'' Chacurian, and others.

Exhibits include photographs and biographical information on hall of fame honorees, trophies, uniforms, films, videos, memorabilia, and other materials related to the history and highlights of soccer. Among the subjects covered are origins of American soccer, the World Cup, collegiate champions, professional soccer, women players, families in American soccer, and centers of soccer activities.

National Soccer Hall of Fame, 5–11 Ford Ave., Oneonta, NY 13820. Phone: 607/432-3351. Hours: June–Aug. 9 A.M.–7:30 P.M. daily; Sept.–May 10–3 daily; Admission: adults, $4; seniors, $3.50; children under 16, $2.

SOFTBALL

NATIONAL SOFTBALL HALL OF FAME AND MUSEUM, Oklahoma City, Oklahoma. The National Softball Hall of Fame and Museum in Oklahoma City, Oklahoma, came about because the Amateur Softball Association needed a central location for a national headquarters and wanted a hall of fame and museum to honor those who have excelled in the sport or played a major role in its development. The hall of fame was established in 1957, and the museum opened in 1973.

Approximately 100,000 visitors annually now come to the 10,114-square-foot museum to see the hall of fame and other exhibits, such as the Olympic Gallery and a miniature softball diamond with bleachers (to view a softball championship video), and to learn how softballs and bats are manufactured.

Among the 134 softball greats enshrined in the hall of fame are Harold ''Shifty'' Gears, a legendary pitcher who struck out 13,244 batters, hurled 61 no-hitters, won 866 games, and lost 115; Joan Joyce, 18-time all-American who pitched 105 no-hitters and won 507 games while losing only 33 in a 21-year

career; Herb Dudley, fast-pitch all-American who holds the record for the most strikeouts in one game (55) and whose career spanned five decades; and Bertha Ragan Tickey, who was an all-American 18 times, pitched 162 no-hit games, won 757 games while losing 88, was a member of 11 national championship teams, and was named tourney most valuable player eight times.

National Softball Hall of Fame and Museum, 2801 N.E. 50th St., Oklahoma City, OK 73111. Phone: 405/424–5266. Hours: 9–4:30 Mon.–Fri; 10–4 Sat. and 1–4 Sun. in Mar.–Oct. Admission: adults, $2; children 12 and under, 50¢; groups, special rates.

UNITED STATES SLO-PITCH SOFTBALL ASSOCIATION HALL OF FAME MUSEUM, Petersburg, Virginia. The United States Slo-Pitch Softball Association Hall of Fame Museum, located in the association's headquarters building in Petersburg, Virginia, honors a wide range of softball standouts— male and female players, umpires, managers, executives, and others—for longevity and service. The association is one of two governing bodies in the softball field, the other being the Amateur Softball Association.

Sixty-three persons have been inducted into the hall of fame since it was founded in 1979, including such softball figures as Rick Wheeler, Edgar Allan Ramsey III, Rick Scherr, Floyd Salter, Pam Patrus, Laura Fillipp, Buddy Slater, and Bruce Meade. The museum opened in 1984.

Approximately 9,000 square feet of the association's 24,000-square-foot building are devoted to the museum, which honors hall of fame individuals with plaques and photographs, and great teams with championship jerseys. It also has artifacts, memorabilia, and other exhibits, including one on how softballs are made.

United States Slo-Pitch Softball Association Hall of Fame Museum, 3935 S. Crater Rd., Petersburg, VA 23803. Phone: 804/733–1005. Hours: 9–4 Mon.–Fri.; 10–4 Sat.; 12– 4 Sunday; closed holidays. Admission: adults, $1.50; seniors and students, $1; children under 12, free; groups, $1 per person.

SPEED SKATING

LAKE PLACID HALL OF FAME. (See Winter Olympics category.)

SPORTS MEDIA

ALABAMA SPORTS WRITERS HALL OF FAME. (See Motor Sports Category.)

NATIONAL SPORTSCASTERS AND SPORTSWRITERS HALL OF FAME, Salisbury, North Carolina. The National Sportscasters and Sportswriters Hall of Fame, founded in 1960 by the National Sportscasters and Sportswriters Association, is finally getting a home in which to honor its inductees. A former savings and loan building in Salisbury, North Carolina, has been acquired and

is undergoing renovation and exhibit development while a fundraising campaign is being completed.

Fifty-four persons have been inducted into the hall of fame, in three categories. They include sportswriters like Grantland Rice, Red Smith, Shirley Povich, Arthur Daley, and Edwin Pope, and such sportscasters as Bill Stern, Mel Allen, Chris Schenkel, Howard Cosell, and Keith Jackson. Among those in the two special categories are coach Knute Rockne, and athletes Jesse Owens, Dizzy Dean, and Lou Gehrig, for their inspirational quality, and President Ronald Reagan and actor John Wayne for having made a mark in sports and gone on to significant contributions in other fields.

The 11,500-square-foot facility will contain busts, information, photographs, and other materials about those enshrined, as well as interactive videos of game highlights and other information about various sports.

National Sportscasters and Sportswriters Hall of Fame, 322 E. Innes St., PO Box 559, Salisbury, NC 28145–0559. Phone: 704/633–4275. Hours and admission: to be determined.

STATE SPORTS HALLS OF FAME

COLORADO SKI MUSEUM-SKI HALL OF FAME. (See Skiing category.)

CONNECTICUT SPORTS MUSEUM AND HALL OF FAME. (See All-Sports category.)

FLORIDA SPORTS HALL OF FAME AND MUSEUM. (See All-Sports category.)

GEORGIA SPORTS HALL OF FAME. (See All-Sports category.)

INDIANA BASKETBALL HALL OF FAME. (See Basketball category.)

LOUISIANA SPORTS HALL OF FAME. (See All-Sports category.)

MAINE SPORTS HALL OF FAME. (See All-Sports category.)

MISSISSIPPI SPORTS HALL OF FAME AND MUSEUM. (See AllSports category.)

MISSOURI SPORTS HALL OF FAME. (See All-Sports category.)

NORTH CAROLINA SPORTS HALL OF FAME. (See All-Sports category.)

NORTH DAKOTA SPORTS HALL OF FAME. (See All-Sports category.)

SOUTH CAROLINA TENNIS HALL OF FAME. (See Tennis category.)

SOUTH DAKOTA AMATEUR BASEBALL HALL OF FAME. (See Baseball category.)

SPORTS HALL OF FAME OF NEW JERSEY. (See All-Sports category.)

STATE OF ALABAMA SPORTS HALL OF FAME. (See All-Sports category.)

STATE OF KANSAS SPORTS HALL OF FAME. (See All-Sports category.)

STATE OF MICHIGAN SPORTS HALL OF FAME. (See All-Sports category.)

STATE OF OREGON SPORTS HALL OF FAME MUSEUM. (See All-Sports category.)

TENNESSEE SPORTS HALL OF FAME. (See All-Sports category.)

TEXAS GOLF HALL OF FAME. (See Golf category.)

TEXAS SPORTS HALL OF FAME

TEXAS BASEBALL HALL OF FAME
TEXAS HIGH SCHOOL BASKETBALL HALL OF FAME
TEXAS HIGH SCHOOL FOOTBALL HALL OF FAME
TEXAS SPORTS HALL OF FAME
TEXAS TENNIS HALL OF FAME
(See All-Sports category.)

VIRGINIA SPORTS HALL OF FAME. (See All-Sports category.)

SURFING (See Walks of Fame section.)

SWIMMING

INTERNATIONAL SWIMMING HALL OF FAME, Fort Lauderdale, Florida. The International Swimming Hall of Fame in Fort Lauderdale, Florida, has one of the world's most comprehensive and popular hall of fame and museum complexes. It also has become the leading information center on all aquatic sports. The facilities include a 10,000-square-foot museum, an art gallery, a

library and archives, two 50-meter (Olympic-size) pools, a diving pool, a teaching pool, and a swimming flume.

Because of its history as a swimming center, Fort Lauderdale was selected as the site for the hall of fame and museum by the Amateur Athletic Union in 1962. It was in 1965 that the first swimming pool was opened and the first inductions were made. The museum opened in 1967, and the Federation Internationale de Natation Amateur designated it as the official International Swimming Hall of Fame in 1968.

By 1996 the hall had enshrined 432 aquatic greats, including Johnny Weissmuller, Buster Crabbe, Duke Kahanamoku, Don Schollander, Katherine Rawls, Pat McCormich, Esther Williams, Murray Rose, Eleanor Holm, Mark Spitz, Dawn Fraser, Adolph Kiefer, and Kusuo Kitamura.

The facility has two buildings covering 17,000 square feet, one for the hall of fame and museum and another for aquatic art, the library and archives, and offices. The exhibits include photographs, trophies, medals, films, videos, and memorabilia of hall of famers, as well as displays on the history, highlights, and excitement of swimming. The pools are used for training, enjoyment, and a wide range of competitions. The annual attendance is 10,000, but approximately 200,000 attend events at the facility each year.

International Swimming Hall of Fame, 1 Hall of Fame Dr., Fort Lauderdale, FL 33316. Phone: 954/462–6536. Hours: 9–7 daily. Admission: adults, $3; seniors, military, and children, $1; families, $5.

TENNIS

COLLEGIATE TENNIS HALL OF FAME, Athens, Georgia. The Intercollegiate Tennis Association founded the Collegiate Tennis Hall of Fame in 1983 to honor outstanding college and university players and coaches. The first inductions were the following year at the Henry Feild Tennis Complex, which houses the hall of fame on the University of Georgia campus in Athens.

Over 130 tennis players and coaches have been enshrined in the hall of fame, including such well-known stars as Arthur Ashe, Jimmy Connors, John McEnroy, Dennis Ralston, Ham Richardson, Stan Smith, and Roscoe Tanner. The hall contains plaques, photographs, and memorabilia of the inductees, as well as photographs of National Collegiate Athletic Association (NCAA) championship and Davis Cup teams, Grand Slam winners, and other outstanding players with collegiate backgrounds; mementos; and a collection of more than 100 tennis racquets.

The hall of fame facility was made possible largely through a major contribution by country music stars Kenny and Marianne Rogers, enthusiastic tennis supporters who lived nearby.

Collegiate Tennis Hall of Fame, University of Georgia, Henry Feild Tennis Complex, PO Box 1472, Athens, GA 30613. Phone: 706/542–8064. Hours: 10–2 Mon.–Fri. and during tennis tournaments; closed holidays. Admission: free.

INTERNATIONAL TENNIS HALL OF FAME AND MUSEUM, Newport, Rhode Island. The International Tennis Hall of Fame and Museum in Newport, Rhode Island, is housed in one of America's architectural masterpieces—the Newport Casino, a National Historic Landmark built in 1880 as a social and recreational club for summer residents. The historic Victorian building, designed by noted architect Stanford White of the McKim, Mead, and White firm, is known for its horseshoe piazza, turreted porches, and breezy veranda.

The Newport Casino was the site of the first U.S. National Lawn Tennis Championships, now known as the U.S. Open, in 1881. Today it is the home of the world's largest collection of tennis memorabilia. The six-acre complex also has 13 grass tennis courts—the world's oldest continuously used competition grass courts—where major professional tournaments are held each summer. They are open to the public from May to October.

The hall of fame was founded by tennis innovator James Van Alen in 1954 as ''a shrine to the ideals of the game.'' The museum opened the following year and now features tributes to 163 tennis legends in the hall of fame and exhibits of trophies, equipment, photographs, art, videos, and memorabilia. The newest exhibits include a simulated tennis gallery, displays on the modern game, and interactive videos to allow visitors to test their knowledge of tennis.

Among the tennis stars enshrined in the hall of fame are such early standouts as Bill Tilden, Helen Wills Moody Roark, Tony Trabert, Fred Perry, Don Budge, Alice Marble, Bobby Riggs, and Jack Kramer, and contemporaries like Chris Evert, Arthur Ashe, Billie Jean King, Bjorn Borg, and Hana Mandlikova.

International Tennis Hall of Fame and Museum, Newport Casino, 194 Bellevue Ave., Newport, RI 02840. Phone: 401/849–3990. Hours: 10–5 daily; closed Thanksgiving and Christmas. Admission: adults, $6; seniors, $4; children 5–15, $3; children under 5, free; families, $13; groups of 10 or more, discounted rates.

SOUTH CAROLINA TENNIS HALL OF FAME, Belton, South Carolina. An old Southern Railroad depot in Belton, South Carolina, serves as the home for the South Carolina Tennis Hall of Fame, as well as for the Ruth Drake Museum and the Belton Library. The hall of fame was founded in 1982; it opened the museum in 1984 to honor the state's leading amateur and professional tennis players, coaches, and officials, and to preserve historic tennis materials.

Twenty-four persons have been inducted into the hall of fame. They include Stan Smith, U.S. Open and Wimbledon champion; Dennis Van der Meer, world-renowned tennis instructor; Paul Searpa, Furman University men's tennis coach, who has more wins than any other coach; and Jack Mills, former Southern Tennis Association president and current vice president of the United States Tennis Association.

The focal point of the hall of fame is a portrait gallery featuring portraits of each inductee by prominent artist Wayland Moore. Racquets, trophies, clothing,

books, photographs, and other materials pertaining to the honorees and tennis in the state are among the other exhibits.

South Carolina Tennis Hall of Fame, Belton Depot, Main St., PO Box 843, Belton, SC 29627. Phone: 864/338–7751. Hours: 11–1 and 2–8 Mon.–Tues., Thurs.; 9–1 and 2– 3:30 Wed., Sat.; 11–1 Fri.; 2–4 Sun.; closed major holidays. Admission: free.

TEXAS TENNIS HALL OF FAME. (See All-Sports category.)

THOROUGHBRED RACING

AIKEN THOROUGHBRED RACING HALL OF FAME, Aiken, South Carolina. Horses bred and trained in the area that have achieved international distinction in racing are honored in the Aiken Thoroughbred Racing Hall of Fame in Aiken, South Carolina. Founded in 1979, the hall of fame features photographs, memorabilia, trophies, and other materials pertaining to the horses and their trainers.

Thirty-nine thoroughbreds are recognized in the 1,500-square-foot hall of fame, located in a restored carriage house on the grounds of Hopeland Gardens, which is within a mile of the heralded Aiken training track.

Aiken Thoroughbred Racing Hall of Fame, Whiskey Rd. and Dupree Pl., PO Box 1177, Aiken, SC 29802. Phone: 803/649–7700. Hours: Oct.–Mar. 2–4:30 Tues.–Sun. Admission: free.

NATIONAL MUSEUM OF RACING AND HALL OF FAME, Saratoga Springs, New York. The National Thoroughbred Racing Hall of Fame, which honors outstanding horses, jockeys, and trainers, is part of the National Museum of Racing and Hall of Fame in Saratoga Springs, New York. The museum was founded in 1950, and the hall of fame was established in 1955, when the museum opened in its building across from the historic Saratoga Race Course, America's oldest thoroughbred racing center. From 1951 to 1955, the museum had displayed temporary exhibitions at the nearby Canfield Casino.

The hall of fame now has 290 enshrines—148 thoroughbreds, 75 jockeys, and 67 trainers. Among the famous horses in the hall are Affirmed, Citation, Kelso, Lexington, Man o' War, Seabiscuit, Secretariat, and Whirlaway. Inducted jockeys range from nineteenth-century greats as Gil Patrick and Isaac Murphy to such contemporary stars as Angel Cordero, Willie Shoemaker, Chris Mc-Carron, and Laffit Pincay. Such highly regarded trainers as MacKenzie Miller, James Fitzsimmons, and Ben and Jimmy Jones are among those cited.

The museum/hall of fame, which occupies a 36,000-square-foot Georgian-Colonial design structure that has been expanded several times, features an exceptional collection of paintings, drawings, bronzes, trophies, silks, saddles, boots, whips, and other materials related to thoroughbred racing. Among the artwork are portraits of Presidents George Washington, who officiated at race

meets, and Andrew Jackson, who raced horses when he was in the White House. An entire gallery also is devoted to the works of Edward Troye, one of the leading equine artists of the nineteenth century.

National Museum of Racing and Hall of Fame, 191 Union Ave., Saratoga Springs, NY 12866–3566. Phone: 518/584–0400. Hours: racing season, 9–5 daily; non-racing season, 10–4:30 Mon.–Sat.; 12–4:30 Sun.; closed New Year's Day, Easter, Thanksgiving, and Christmas. Admission: adults, $3; seniors and students, $2; children under 5, free.

TRACK AND FIELD

NATIONAL TRACK AND FIELD HALL OF FAME, Indianapolis, Indiana. The National Track and Field Hall of Fame was founded in Charleston, West Virginia, in 1974, but has been located in Indianapolis, Indiana, since 1985, when it came under the aegis of USA Track & Field. It now occupies 3,500 square feet adjacent to the association's national headquarters in the Hoosier Dome.

The hall of fame was closed temporarily in 1996, when many of the exhibits were moved to Atlanta for the 1996 Summer Olympics and then shown in Los Angeles. Before they were reinstalled, plans were being made for a possible new location.

Most of the nation's top track and field stars and officials are among the 167 inductees, including sprinters Jesse Owens and Wilma Rudolph; broad jumper Ralph Boston; discus thrower Al Oerter; shot-putter Parry O'Brien; track star and golfer Babe Didrikson Zaharias; miler Glenn Cunningham; all-around athlete Jim Thorpe; decathlon champions Rafer Johnson and Bob Mathias; and Avery Brundage, long-time president of the U.S. Olympic Association and International Olympic Committee.

In addition to photographs and information about the hall of famers, the exhibits include many of their uniforms, equipment, and mementos, such as the first shots, prototype starting blocks, and parade uniforms.

National Track & Field Hall of Fame, 1 Hoosier Dome, Indianapolis, IN 46225. Phone: 317/261–0500. Hours: 11–5 daily; closed major holidays (now closed temporarily). Admission: free.

TRAPSHOOTING

TRAPSHOOTING HALL OF FAME AND MUSEUM, Vandalia, Ohio. The Trapshooting Hall of Fame and Museum is located at the national headquarters and tournament grounds of the Amateur Trapshooting Association in Vandalia, Ohio. The hall of fame was established in 1968; a wing was added to the association's clubhouse in 1969 to house the museum.

The hall of fame honorees are selected for significant contributions to the growth and betterment of trapshooting or for impressive records in trapshooting.

Among the 102 inductees are Annie Oakley, the legendary western sharpshooter, and John Philip Sousa, world-famous band leader and composer, who was a trapshooter and an administrator in the field.

The museum contains plaques and photographs of the hall of famers, as well as one of the largest collections of target-shooting memorabilia and artifacts. The exhibits tell the story of trapshooting from the days of live pigeon–shooting in the early 1800s to today's clay target. Among the items on display are shotguns, traps, targets, photographs, posters, programs, paintings, pins, emblems, clothing, and other such materials.

The facility also has an extensive library on the sport and sponsors a Youth Trapshooting Program involving training, special events, and scholarship awards.

Trapshooting Hall of Fame and Museum, 601 W. National Rd., Vandalia, OH 45377. Phone: 513/898–1945. Hours: 9–4 Mon.–Fri. Admission: free.

VOLLEYBALL

PRO BEACH VOLLEYBALL HALL OF FAME. (See Beach Volleyball category.)

VOLLEYBALL HALL OF FAME, Holyoke, Massachusetts. The Volleyball Hall of Fame was founded in 1978 in the city where volleyball was first played in 1895. Started by the local Chamber of Commerce, the hall of fame has been located in the Heritage State Park complex in Holyoke, Massachusetts, since 1987.

The hall of fame occupies 2,200 square feet on the second floor of an exhibit building at the multifaceted, eight-acre urban state park, which also includes a children's museum, craft center, visitors' center, merry-go-round, and a railroad with 1920s-style passenger cars that provides tours of Holyoke in the summer.

Thirty-two volleyball players, coaches, officials, and leaders have been inducted into the hall of fame, including Dr. William G. Morgan, a Holyoke YMCA physical director, who invented the sport. Among the other honorees are Flo Hyman, volleyball's first superstar, whose bronze sculpture is the centerpiece of the main gallery; Douglas Beal, coach of the 1984 U.S. gold-medal men's Olympic team; and Arie Selinger, coach of the 1984 U.S. silver-medal women's Olympic team.

The hall has plaques and memorabilia of those enshrined, a Court of Honor for outstanding teams and organizations, and exhibits on the nature and development of volleyball. Among the teams and organizations cited are the 1980 U.S. women's Olympic team, 1984 U.S. men's Olympic team, the Young Men's Christian Association, the United States Volleyball Association, the International Federation of Volleyball, and Special Olympics International.

The hall of fame plans to begin construction of its own building, with indoor and outdoor courts, in 1997.

Volleyball Hall of Fame, Heritage State Park, 444 Dwight St., PO Box 1895. Holyoke, MA 01041. Phone: 413/536–0926. Hours: 10–4 Tues.–Sat.; 12–5 Sun. Admission: free.

WATER SKIING

WATER SKI HALL OF FAME, Winter Haven, Florida. Outstanding skiers, pioneers, and officials in the water skiing field nationally and internationally are honored in the Water Ski Hall of Fame, operated by the American Water Ski Educational Foundation in Winter Haven, Florida. The hall of fame was founded, and its 4,000-square-foot facility was opened, in 1982.

Thirty-five persons have been inducted into the hall of fame since it was established as an extension of the water ski foundation, which also has extensive scholarship and financial aid programs. They include such skiers as Willa McGuire, Chuck Stearns, Liz Allan, and George "Banana" Blair; Ralph Samuelson, the "father" of water skiing; Dick Pope, Sr., founder of Cypress Gardens; and Dan Hains, founder of the American Water Ski Association.

The exhibits feature memorabilia and photographs of the hall of famers, as well as displays on the first water skis, the evolution of water skiing equipment, pioneers in the field, disabled skiers, barefoot skiers, show skiing, and world champions.

The water ski foundation and the hall of fame are planning to relocate to Interstate 4, between Orlando and Tampa. Eighty-two acres have been purchased for a 15,000-square-foot building and ski lake.

Water Ski Hall of Fame, American Water Ski Educational Foundation, 799 Overlook Dr., S.E., Winter Haven, FL 33884. Phone: 941/324–2472. Hours: 10–5 Mon.–Fri.; closed national holidays. Admission: free.

WEIGHTLIFTING

WEIGHTLIFTING HALL OF FAME, York, Pennsylvania. The Weightlifting Hall of Fame—affiliated with the United States Weightlifting Federation and the American Amateur Union's Physique bodybuilding division—is located on the first floor of the York Barbell Company's administrative building in York, Pennsylvania. Originally named the Bob Hoffman Weightlifting Hall of Fame when it opened in 1958, it changed to its present name and location in 1980.

The 7,500-square-foot hall of fame is devoted to Olympic lifting, powerlifting, bodybuilding, strongmanism, and American achievements in those areas. The Olympic lifting section focuses on the nature of international competitions, re-

cent outstanding weightlifters and their achievements, and many of the actual trophies and awards received since 1923.

Other exhibits look at strongmen of old, powerlifting since the first national competition in 1964, the development of bodybuilding, current fitness equipment, historical artifacts and memorabilia, and the life of Bob Hoffman, weightlifting pioneer and founder of York Barbell, a manufacturer of free weight products.

Weightlifting Hall of Fame, York Barbell Co., 3300 Board Rd., PO Box 1707, York, PA 17402. Phone: 717/767–6481. Hours: 10–3 Mon.–Sat.; closed major holidays. Admission: free.

WINTER OLYMPICS

COLORADO SKI MUSEUM-SKI HALL OF FAME. (See Skiing category.)

LAKE PLACID HALL OF FAME, Lake Placid, New York. Lake Placid, New York—host to the 1932 and 1980 Winter Olympics—has both a hall of fame and a museum. Until recently, the Lake Placid Hall of Fame was housed in a gallery at the 1932 and 1980 Lake Placid Winter Olympic Museum. In 1996, however, the hall of fame was relocated to a corridor in the Olympic Center.

Approximately 70 persons who have made significant contributions to the Lake Placid region have been inducted into the hall of fame. About half are outstanding winter sports athletes, while the remainder are persons who have made civic and other contributions to the area. Among those inducted are speedskater Jack Shea, winner of two gold medals in the 1932 Winter Olympics; figure skater Dick Button, double gold medalist in the 1948 Winter Olympics; figure skater Gordon McKellen, three-time national champion; speed skater Eric Heiden, winner of five gold medals in the 1980 Winter Olympics; and the 1980 U.S. Hockey Team, which defeated the Soviets for the gold medal.

The hall of fame, which was started in 1981, opened as a special exhibition and then became part of an early version of the museum. The present Lake Placid museum, which opened at Olympic Center in 1994, has an extensive collection of skis, skates, bobsleds, hockey helmets, clothing, medals, trophies, and certificates. It also has flags of competing nations, patches, pins, programs, the torch that carried the Olympic flame to Lake Placid, and the life-size raccoon mascot of the 1980 Winter Olympics.

Lake Placid Hall of Fame, Olympic Center, Main St., Lake Placid, NY 12964. Phone: 518/523–1655. Hours: whenever Olympic Center is open. Admission: free.

UNITED STATES HOCKEY HALL OF FAME. (See Ice Hockey category.)

UNITED STATES NATIONAL SKI HALL OF FAME AND MUSEUM. (See Skiing category.)

WESTERN AMERICA SKI HALL OF FAME. (See Skiing category.)

WRESTLING

NATIONAL WRESTLING HALL OF FAME AND MUSEUM, Stillwater, Oklahoma. The National Wrestling Hall of Fame and Museum, on the campus of Oklahoma State University in Stillwater, serves a triple function—to preserve the heritage of one of the world's oldest sports, celebrate the achievements of outstanding wrestlers, and encourage youth to aspire to lofty goals in the field.

The hall of fame/museum was founded in 1972 and moved into its present 10,000-square-foot home in 1976. Fourteen communities made bids for the facility before it was awarded to Stillwater, home of the wrestling collegiate powerhouse Oklahoma State.

The main exhibit components include the Honors Court, with granite plaques of 104 hall of famers and an audio system outlining their achievements and contributions; the Wall of Champions, containing 117 feet of plaques listing more than 5,000 names of wrestlers, teams, and coaches who have won national championships or have represented the United States in Olympic, Pan American, or World competition; and the Hall of Outstanding Americans, which highlights the careers of persons who have wrestled and later achieved success in other fields, such as business, government, the military, writing, or acting. Other exhibits focus on the history of wrestling, international competition, founders, and wrestling officials.

Among those honored in the hall of fame are such figures as champion wrestlers Dan Allen Hodge of the University of Oklahoma and Dan Gable of Iowa State University; coaches Raymond Clapp of the University of Nebraska and Charles M. Speidel of Pennsylvania State University; and a wide range of contributors. Individuals who once wrestled and are cited in the outstanding Americans hall include Presidents George Washington, Abraham Lincoln, and Theodore Roosevelt; General H. Norman Schwarzkopf; former Congressman and Secretary of Defense Donald Rumsfield; astronaut Michael Collins; actor Kirk Douglas; Nobel laureate Norman E. Borlaug; author John W. Irving; and businessmen Henry R. Kravis, Stephen Friedman, James M. Biggar, and Hiraoki Aoki.

A three-quarter-ton green marble replica of the 2,000-square-foot sculpture "The Wrestlers" by Cephisodotus greets visitors in the entrance hall. The exhibits feature banners, photographs, plaques, medals, trophies, uniforms, scrapbooks, and other memorabilia, as well as books, films, and videotapes pertaining to wrestling and its prime movers.

National Wrestling Hall of Fame and Museum, 405 W. Hall of Fame Ave., Stillwater, OK 74074. Phone: 405/377–5243. Hours: 9–4 Mon.–Fri.; weekends by appointment; closed holidays. Admission: free.

Non-Sports
Halls of Fame

AGRICULTURE

BULL HALL OF FAME. (See Unusual Halls of Fame section.)

NATIONAL AGRICULTURAL AVIATION MUSEUM AND HALL OF FAME. (See Aviation and Space category.)

NATIONAL AGRICULTURAL CENTER AND HALL OF FAME, Bonner Springs, Kansas. The National Agricultural Center and Hall of Fame was chartered by Congress in 1960 and was opened to the public in 1965 in Bonner Springs, Kansas. It honors farmers and others who have made outstanding contributions to agriculture and seeks to further appreciation of agriculture.

The 172-acre complex near Kansas City includes the Agricultural Hall of Fame, the Museum of Farming, the National Farmers Memorial, FarmTown U.S.A., and the National Agricultural Center headquarters building, as well as a narrow-gauge railroad and a nature trail. It attracts 25,000 visitors annually.

Thirty-two persons are enshrined in the hall of fame, including John Deere, developer of the first effective steel plow; Eli Whitney, inventor of the cotton gin; Cyrus McCormick, inventor of the first successful reaping machine; Luther Burbank, noted horticulturist and developer of new and improved varieties of cultivated plants; George Washington Carver, who promoted crop diversification and developed hundreds of derivative products from peanuts and potatoes; Squanto, the Pawtuxet Indian who aided colonists by teaching them Indian methods of planting and fertilizing corn; and Thomas Jefferson, third president of the United States, naturalist, scholar, architect, and plantation owner.

The hall of fame exhibits are in the 11,500-square-foot National Agricultural

Center main building, which also houses farming and rural-life exhibits and a gallery of rural art. A second building, called the Museum of Farming, covers 20,400 square feet and is devoted to classic tractors, threshers, and other large farm equipment. The entire complex has more than 50,000 square feet of indoor facilities and over 30,000 agricultural and rural artifacts, including a 1781 Indian plow, an 1827 covered wagon, an 1831 McCormick reaper, an 1881 steam thresher, a 1903 Dart truck, and over 800 varieties of barbed wire.

FarmTown U.S.A. is an outdoor replica of an early 1900s rural village; it includes a general store, blacksmith shop, schoolhouse, railroad depot, and a poultry hatchery, while the National Farmers Memorial features three massive, high-relief bronze panels that depict farming of the past, present, and future. The latter is the nation's only memorial dedicated to America's food producers.

A wide range of special events are presented at the agricultural complex, such as National Trails Day, featuring displays of animals and plant life in their natural habitats; Old Fashioned Days, highlighting early rural crafts, arts, and pastimes; Farm Heritage Days, with displays and demonstrations of classic farm machines; Draft Horse Power Days, offering demonstrations of horse power before the introduction of the diesel; and the Fall Farm Festival, a country food fair with demonstrations, hay rides, and more.

National Agricultural Center and Hall of Fame, 630 Hall Dr. (N. 126th St.), Bonner Springs, KS 66012. Phone: 913/721–1075. Hours: mid-Mar.–Nov. 9–5 Mon.–Sat.; 1–5 Sun.; closed major holidays and Dec.–mid-Mar. Admission: adults, $5; seniors, $4; children 5–12, $2.50; children under 5, free.

AUTOMOBILES

AUTOMOTIVE HALL OF FAME, Dearborn, Michigan. The Automotive Hall of Fame in Dearborn, Michigan, is the only industry-wide hall of fame in the motor vehicle field. It is dedicated to preserving the history of the industry through commemorating the contributions of its pioneers and leaders. The hall was established in 1939, and its museum was first opened in 1975. It moved to Dearborn in mid-1997.

The hall of fame began in New York City, as "Automobile Old Timers," moved to Washington, D.C., to Virginia in the 1960s, to Midland in 1971, and finally opened recently in a new, 25,000-square-foot, permanent facility adjacent to the Henry Ford Museum and Greenfield Village in Dearborn.

The hall honors individuals who have made a dramatic impact on the development of the automobile or the automotive industry by introducing or assisting in historically significant changes in products, processes, or concepts.

The photographs, biographies, and memorabilia of 150 inductees are displayed in the hall of fame. Among those who have been honored are such pioneer carmakers and innovators as Carl Benz, Henry Ford, William Durant,

Charles F. Kettering, Eiji Toyoda, Walter P. Chrysler, Siochiro Honda, and Lee A. Iacocca.

In addition to honoring such hall of famers, the Automotive Hall of Fame presents three other types of awards: a Distinguished Service Citation, for contributions through outstanding leadership in the industry or a specific important achievement; the Automotive Industry Leader of the Year Award, for contributing the most important advancement in the motor vehicle industry in the last year; and the Young Leadership and Excellence Award, which recognizes individuals between the ages of 25 and 35 who have demonstrated significant potential as future industry leaders.

Automotive Hall of Fame, 21400 Oakwood Blvd., Dearborn, MI 48121. Phone: 313/ 240–4000. Hours: Memorial Day–Halloween 10 A.M.–7 P.M. daily; Halloween–Memorial Day 10–5, Tues.–Sun.; closed New Year's Day, Thanksgiving, and Christmas. Admission: to be determined.

CAR COLLECTORS HALL OF FAME, Nashville, Tennessee. The prized automobiles of country music stars are featured at the Car Collectors Hall of Fame, a privately operated tourist attraction across the street from the Country Music Hall of Fame in Nashville, Tennessee.

Founded and opened by E. Howard Brandon in 1979, the museum-like facility contains approximately 45 cars, including Elvis Presley's 1976 Cadillac Eldorado, Barbara Mandrell's 1972 Rolls Royce, Tammy Wynette's 1982 Buick Riviera, Roy Acuff's 1975 Chrysler Imperial, Hank Williams, Jr.'s 1959 Cadillac Eldorado, Louise Mandrell's 1953 MG, and Marty Robbins's 1934 Packard limousine.

Among the other vehicles are a number used in motion pictures or on television programs, such as the Batmobile and Batcycle, the 1981 Delorean from the *Back to the Future* films, and the 1950 Studebaker adapted as a Tucker in a movie about its developer. The annual attendance is 45,000.

Car Collectors Hall of Fame, 1534 Demonbreun St., Nashville, TN 37203. Phone: 615/ 255–6804. Hours: Sept.–Mar. 9–5; Apr.–Aug. 8 A.M.–9 P.M. Admission: adults, $4.95; children 6–11, $3.25; group rates available.

CORVETTE HALL OF FAME AND AMERICANA MUSEUM, Cooperstown, New York. The Corvette Hall of Fame and American Museum in Cooperstown, New York, is a car museum unlike any other. Corvettes are used as a timeline to show the cultural history of the nation since the cars were introduced in 1953. Corvettes are displayed in separate rooms—in front of 12-by-30-foot photomurals of such American landmarks as Mount Rushmore, the Brooklyn Bridge, the Grand Canyon, and the Alamo—with a multimedia show, period objects, hit songs, slides of news events, and other such reminders of the year the car model debuted.

Some rooms also feature memorabilia of pop culture figures, like Marilyn Monroe for the 1953 room, James Dean for 1955, Elvis Presley in 1957, the

Beatles in 1965, Bruce Springsteen in 1984, and Madonna in 1988. Others feature actual objects from scenes in photomurals, such as cobblestones from the base of the Brooklyn Bridge and earth from landscapes depicted in the blowups.

A room replicating an old-time movie theater contains special Corvettes from the motion pictures *Corvette Summer* and *Death Race 2000* and the *Route 66* television series. There also is a re-creation of the Indianapolis 500 brickyard, with photomurals of Corvettes at the Indy races, as well as the actual pace cars of 1978 and 1986 and the Indy Festival car of 1990. Another room features a wide variety of objects relating to Corvettes, such as toy cars, Corvette engines, postcards, whiskey bottles shaped like Corvettes, and virtually every Corvette brochure, owner's manual, advertisement, etc., ever published.

The hall of fame/museum, which opened in 1992, was the brainchild of Allen Schery, a cultural anthropologist and archaeologist, who sought to put the Corvette back in the cultural milieu from which it emerged. It is planning to start a hall of fame for prominent persons in Corvette history.

Corvette Hall of Fame and Americana Museum, Route 28, PO Box 167, Cooperstown, NY 13326. Phone: 607/547–4135. Hours: July–Aug. 10–8 daily; Mar.–June and Sept.–Dec. 10–6 daily. Admission: adults, $8.95; seniors, $7.95; children, $5.95.

D.I.R.T. HALL OF FAME AND CLASSIC CAR MUSEUM. (See Motor Sports category.)

INTERNATIONAL TOWING AND RECOVERY HALL OF FAME. (See Towing and Recovery category.)

AVIATION AND SPACE

ALABAMA AVIATION HALL OF FAME, Birmingham, Alabama. The Alabama Aviation Hall of Fame, which honors outstanding men and women who have made significant contributions to aviation in the state and the field, was established by the Alabama Legislature in 1979. It made its first inductions in 1981, when it became a featured gallery at the Southern Museum of Flight in Birmingham.

Forty-four individuals have been enshrined in the hall of fame. They include such aviation pioneers and achievers as Orville and Wilbur Wright, Octave Chanute, Wernher von Braun, Glenn E. Messer, William C. McDonald, Jr., John Donalson, Benjamin O. Davis, Jr., Daniel "Chappie" James, and Charles "Chief" Anderson.

The Southern Museum of Flight traces more than eight decades of aviation history through historic aircraft, engines, models, and memorabilia of many aviation pioneers. Among the aircraft are a Huff Daland cropduster, a Republic Seabee amphibian, a T-6 World War II trainer, the first Delta Air Lines plane,

an F-4 jet fighter, a replica of the 1912 Curtiss Pusher, and various sailplanes and homebuilts. The memorabilia feature artifacts and other materials from Manfred ''Red Baron'' von Richthofen of World War I, Tuskegee airmen from World War II, women in aviation, and other early and more recent figures in aviation.

Alabama Aviation Hall of Fame, Southern Museum of Flight, 4343 73rd St., N., Birmingham, AL 35206–3642. Phone: 205/833–8226. Hours: 9:30–4:30 Tues.–Sat.; 1–4:30 Sun. Admission: adults, $3; seniors, $2.50; students, $2; preschoolers, free; groups— adults, $1.50; students, $1.

ASTRONAUT HALL OF FAME, Winslow, Arizona. The Meteor Crater Museum of Astrogeology in Winslow, Arizona, has an exhibit gallery devoted to the nation's astronauts and space program. Opened in 1986, the hall of fame gallery contains photographs of all the astronauts, space equipment, models of spacecraft, memorabilia, videos, a film, and an interactive computer on the space program, meteorites, and the solar system.

The museum is located near a huge meteorite hole—nearly a mile wide and 570 feet deep—caused by the impact of an enormous meteorite weighing millions of tons that crashed in the Arizona desert approximately 49,500 years ago. Apollo astronauts trained at the site, the best-preserved meteorite impact in the world, in preparation for their trip to the moon.

Astronaut Hall of Fame, Meteor Crater Museum of Astrogeology, Meteor Crater Rd., Winslow, AZ 86047. Phone: 520/289–2362. Hours: May 15–Sept. 15, 6–6 daily; Sept. 16–May 14, 8–5 daily. Admission: adults, $8; seniors, $7; children 6–17, $2; children under 6, free.

AVIATION HALL OF FAME AND MUSEUM OF NEW JERSEY, Teterboro, New Jersey. More than 100 men and women whose aeronautical achievements have brought recognition to the State of New Jersey are enshrined in the Aviation Hall of Fame and Museum of New Jersey at the Teterboro Airport.

Founded in 1972, the hall of fame/museum is a two-part facility, being located in the old Teterboro control tower on the west side of the airport and in an aeronautical educational center on the east side. Recognized as the official state aviation museum in 1979, it is dedicated to the preservation of New Jersey's distinguished aeronautical history, which began with the first balloon flight in America in 1793.

Among those in the hall of fame are aviators Charles Lindbergh, Amelia Earhart, Clarence Chamberlain, Floyd Bennett, and Richard Byrd, and astronauts Edwin Aldrin and Walter Schirra. In addition to the bronze plaques of inductees and various memorabilia, visitors can see Curtiss Wright piston engines, X-1 and X-15 rocket engines, the Arthur Godfrey aviation collection, and a glove Aldrin wore on the moon. They also can view aircraft activity at the busy airport from the control tower, sit in a helicopter cockpit and handle the controls, and walk through a 40-passenger Martin 202 plane of the 1950s outside the edu-

cational center. Plans call for a major expansion of the center during the coming year.

Aviation Hall of Fame and Museum of New Jersey, Teterboro Airport, Teterboro, NJ 07608. Phone: 201/288–6345. Hours: 10–4 Tues.–Sun.; closed New Year's Day, Easter, and Christmas. Admission: adults, $3; seniors and students, $2.

EAA AIR ADVENTURE MUSEUM HALLS OF FAME, Oshkosh, Wisconsin.
EAA AIRCRAFT HOMEBUILDERS HALL OF FAME
EAA ANTIQUE/CLASSICS HALL OF FAME
EAA WARBIRDS HALL OF FAME
FLIGHT INSTRUCTION HALL OF FAME
INTERNATIONAL AEROBATIC HALL OF FAME
WISCONSIN AVIATION HALL OF FAME

The EAA Air Adventure Museum in Oshkosh, Wisconsin, the home of six halls of fame, is tied with the International Motorsports Hall of Fame for housing the most halls of fame. All are related to aviation, with four being founded and operated by the museum and two merely being housed in the museum at the EAA (Experimental Aircraft Association) Aviation Center at Wittman Field.

The Wisconsin Aviation Hall of Fame, operated independently, was the first to be established. Starting in 1986, the hall has inducted 34 Wisconsin individuals for making substantial contributions to aviation progress. They include Brig. Gen. Billy Mitchell, astronauts Deke Slayton and James Lovell, and Gen. Hoyt S. Vandenberg.

The newest hall of fame is the Flight Instruction Hall of Fame, founded by the National Association of Flight Instructors in 1996. It will make its first inductions in 1997.

Both of these halls of fame are located in the Goldwater Room and adjoining Fergus Plaza. The four EAA-sponsored halls of fame—the EAA Aircraft Homebuilders Hall of Fame, the EAA Antique/Classics Hall of Fame, the EAA Warbirds Hall of Fame, and the International Aerobatic Hall of Fame—are housed in the Doolittle Gallery.

The first three EAA halls of fame began inductions in 1993, while the aerobatics hall started in 1995. The antique/classics hall has five inductees, George York, E. E. Hilbert, Cole Palen, Joe Juptner, and Kelly Viets; the aircraft homebuilders hall has 13 honorees, including George Bogardus, Paul H. Poberezny, and Steve Wittman; the warbirds hall has seven inductees, such as Walter E. Ohlrich, Jr., William E. Harrison, Jr., and Jerry Walbum; and the aerobatics hall has two honorees, Clint McHenry and Neil Williams.

The halls of fame pay homage to inductees with plaques and photographs. The 100,000-square-foot museum surrounds the halls, with memorabilia, photos, artworks, equipment, films, videos, interactive exhibits, and restored airplanes. The exhibits trace the history of aviation and focus on such topics as air races, precision aerobatics, and home-built planes (known here as experimental aircraft).

The museum has a collection of 267 planes, with over 90 aircraft on display at any time. They include antiques, classics, aerobatic planes, military trainers, fighters, gliders, ultralights, rotorcraft, and experimental aircraft. Approximately 50 of the planes are in six 1930s-style hangars at adjoining Pioneer Airport.

The aircraft collection includes a 1911 Curtiss Pusher, a 1929 Ford Tri-Motor, a Lockheed P-38 Lightning, a North American F-86 Sabre, a Boeing B-17 Flying Fortress, a Douglas A-26 Invader, a Grumman F8F Bearcat, a Chance-Vought F4U Corsair, a Messerschmitt/Hispano HA1112-MIL, a Mikoyan-Gurevich MiG-15, a Supermarine/Storo Spitfire Mk IXE, and scale replicas of the Wright brothers' *Flyer* and Charles Lindbergh's *Spirit of St. Louis*. On weekends in May through October, visitors even can go for a ride in the Ford Tri-Motor or a vintage, open-cockpit biplane.

The museum has an annual attendance of approximately 160,000. The highlight of the year is the annual week-long EAA Fly-In Convention, with 12,000 to 15,000 planes participating and more than 800,000 people attending, during the first week in August.

The EAA Air Adventure Museum was founded in 1963 by Paul H. Poberezny in West Allis, Wisconsin; it was later relocated to Oshkosh. It grew out of the Experimental Aircraft Association, started by Poberezny in his basement a decade earlier. The association now has over 750 chapters and more than 150,000 members worldwide.

EAA Halls of Fame, EAA Air Adventure Museum, 3000 Poberezny Dr., PO Box 3065, Oshkosh, WI 54903–3065. Phone: 414/426–4818. Hours: 8:30–5 Mon.–Sat.; 11–5 Sun.; closed New Year's Day, Easter, Thanksgiving, and Christmas. Admission: adults, $7; seniors, $6; students 8–17, $5.50; children under 8, free; families, $19.

GEORGIA AVIATION HALL OF FAME, Warner Robins, Georgia. The Georgia Aviation Hall of Fame, established by the Georgia Legislature in 1989, is dedicated to those who have made outstanding contributions to aviation in Georgia. It is located in the Museum of Aviation at the Robins Air Force Base in Warner Robins.

Thirty-one pilots, aircraft designers, aviation executives, astronauts, and others in the aviation field are enshrined in the hall of fame. They include Ben T. Epps, Georgia's pioneer aviator, aircraft designer, and builder; Maj. Gen. Frank O'Driscoll Hunter, the state's only World War I ace; Col. Eugene Jacques Bullard, the world's first black military pilot; Jacqueline Cochran, considered one of the greatest woman pilots in history; Daniel J. Haughton, former president and chairman of Lockheed Aircraft Corporation; Belford D. Maule, early pilot, inventor, designer, and manufacturer; Cmdr. Hamilton McWhorter III, the first naval carrier double ace (World War II); Capt. Manley L. Carter, Jr., fighter pilot, flight surgeon, and astronaut; C. E. Wollman, whose vision built Delta Air Lines; and Vice Adm. Richard H. Truly, pilot, astronaut, and administrator of the National Aeronautics and Space Administration.

The hall of fame, which occupies the second floor of the south wing of the

Museum of Aviation, tells the story of flight through the accomplishments of Georgia's inductees. The museum, which was established in 1984, features over 85 aircraft and aviation memorabilia from World War I to the present.

Among the aircraft and missles on display are a Boeing KC-971 Stratofreighter, a De Havilland C-7A Caribou, a Douglas C-124C Globemaster, a Lockheed SR-71 Blackbird, a McDonnell-Douglas F-4C Phantom, a North American F-100C Super Sabre, a Republic P-47D Thunderbolt, a Sikorsky CH-3E "Jolly Green," and a Martin TM-61C Matador missile.

Georgia Aviation Hall of Fame, Museum of Aviation, Hwy. 247 and Russell Pkwy., PO Box 2469, Warner Robins, GA 31099. Phone: 912/926–6870 or 912/926–4242. Hours: 10–5 daily; closed New Year's Day, Thanksgiving, and Christmas. Admission: free.

INTERNATIONAL AEROSPACE HALL OF FAME, San Diego, California. The San Diego Aerospace Museum and the International Aerospace Hall of Fame in California were founded separately (the museum in 1961 and the hall of fame in 1963), but they were housed under one roof for many years. They merged in 1993 and are now known collectively as the San Diego Aerospace Historical Center.

The hall of fame—which honors men and women who have made significant contributions to aviation or space history—occupies 5,400 square feet of the 105,406-square-foot aerospace center, which has an annual attendance of 200,000.

Among the 112 individuals enshrined in the hall of fame are pilots, aircraft designers, industrialists, explorers, astronauts, and others from throughout the world. They include Glenn H. Curtis, aviation pioneer and inventor; Charles Lindbergh, who made the first solo transatlantic flight; Sir Geoffrey de Havilland, noted British aircraft designer; Amelia Earhart, who pioneered transcontinental and transoceanic flying; Yuri Gagarin, a Soviet cosmonaut, who was the first human in space; and Neil Armstrong, astronaut, who was the first to set foot on the moon. The hall contains their portraits and various artifacts and memorabilia.

The museum has an impressive array of historical aircraft, engines, models, books, magazines, manuals, documents, photographs, and other aerospace materials. Among the historic planes on display are a Curtiss Robin, a Piper J-3 Cub, an American Eagle, an Aeronca C-3, a F-6F Hellcat, a Curtiss P-40, a British Spitfire, a Japanese Zero, a Ryan X-13 Vertiget, an A-4 Skyhawk, an F-86 Sabre, and a Soviet MiG-15, as well as replicas of the *Wright Flyer*, Lindbergh's *Spirit of St. Louis*, and various World War I and II and other aircraft. Three planes—an F-14 Phantom, a North Korean MiG-17, and a PBY Catalina—are displayed in a courtyard.

International Aerospace Hall of Fame of the San Diego Aerospace Museum, 2001 Pan American Plaza, Balboa Park, San Diego, CA 92101. Phone: 619/234–8291. Hours: 10–4:30 daily; closed New Year's Day, Thanksgiving, and Christmas. Admission: adults, $5; seniors, $4.50; children 6–17, $1.

INTERNATIONAL SPACE HALL OF FAME, Alamagordo, New Mexico. The International Space Hall of Fame, a part of The Space Center in Alamogordo, New Mexico, honors astronauts, space visionaries, pioneers, and facilitators. Founded in 1976 near White Sands, site of early space efforts, the museum and hall of fame are operated by the New Mexico Office of Cultural Affairs to tell the public about the history, science, and technology of space and to recognize those who have advanced knowledge of the universe.

The 60,000-square-foot Space Center collects, preserves, researches, and interprets objects and documents related to space exploration and presents exhibits, programs, and publications to further public understanding in the field. It has an annual attendance of approximately 200,000.

The International Space Hall of Fame has 130 inductees from throughout the world. They include Nicolaus Copernicus, the sixteenth-century Polish astronomer who first theorized that the earth moved around the sun; Robert Goddard, pioneer American rocket experimenter; Wernher von Braun, developer of the Saturn V rocket used in the Apollo flights to the moon; Chuck Yeager, high-altitude test pilot; John Glenn, Neil Armstrong, and Sally Ride, American astronauts; and Yuri Gagarin, the Soviet cosmonaut who was the first person to travel in space.

In addition to exhibits relating to those enshrined in the hall of fame, the museum has a wide range of space artifacts—from moon rocks to satellites—and facilities. Components include the Clyde W. Tombaugh Space Theater, consisting of a planetarium and an Omnimax large-screen theater; the John P. Stapp Air and Space Park, featuring the Sonic Wind No. 1 rocket sled, a Little Joe II rocket, a Mercury capsule mockup, and a full-scale replica of Sputnik; and an Astronaut Memorial Garden.

International Space Hall of Fame, The Space Center, Hwy. 2001, PO Box 533, Alamogordo, NM 88310. Phone: 505/437–2840. Hours: Memorial Day–Labor Day 9–6 daily; remainder of year 9–5 daily; closed Christmas. Admission: adults, $6; seniors, students, and military, $4.

NATIONAL AGRICULTURAL AVIATION MUSEUM AND HALL OF FAME, Jackson, Misissippi. Agricultural aviation pilots, operators, scientists, engineers, inventors, and others who have contributed to the progress of the field are honored in the National Agricultural Aviation Hall of Fame in Jackson, Mississippi.

Founded in 1983, the hall of fame is located in the National Agricultural Aviation Museum, which is part of the Jim Buck Ross Mississippi Agriculture and Forestry Museum living history complex. Approximately 250,000 visit the complex annually.

Among the 29 hall of famers are John A. McReady, the first cropduster; Jesse Orval Dockery, who began organized agricultural flying in the 1920s; Farrell Higbee, first executive director of the National Agricultural Aviation Association; and Richard Reade, first president of the association.

The museum has an extensive collection of vintage cropdusting airplanes, spray systems, hoppers, engines, and other artifacts, as well as photographs, paintings, and other materials. Among the aircraft are a 1940 Boeing-Stearman E75, converted to cropdusting in 1950; a 1945 Piper JE, converted to a ''cutback duster'' in 1957; a 1957 Grumman Ag-Cat Serial X-1 prototype; and a 1963 Piper Pawnee that operated from a half-mile dirt strip and logged over 4,600 hours cropdusting in Texas.

National Agricultural Aviation Museum and Hall of Fame, 1150 Lakeland Dr., Jackson, MS 39216. Phone: 601/354–6113. Hours: 9–5 Mon.–Sat.; 1–5 Sun.; closed New Year's Day, Thanksgiving, and Christmas Eve and Day. Admission: adults, $3; seniors, $2.75; students, $1.

NATIONAL AVIATION HALL OF FAME, Dayton, Ohio. The National Aviation Hall of Fame, established in 1962 and chartered by Congress two years later, finally is getting a home of its own. In 1996 groundbreaking ceremonies were held for a 15,000-square-foot building adjacent to the United States Air Force Museum at Wright-Patterson Air Force Base, Ohio. Completion is scheduled for the summer of 1998.

The hall of fame, which currently consists of a display of plaques on the third floor of the Dayton Convention and Exhibition Center, will be connected to the Air Force Museum but operated independently. The new $6 million facility will have exhibits, research activities, and offices, and it will be open free to the public.

The National Aviation Hall of Fame has honored 155 aviation and space leaders—pilots, scientists, engineers, inventors, teachers, and others in the aerospace field. Among the inductees have been aviation pioneers Orville and Wilbur Wright, Amelia Earhart, and Charles Lindbergh; Benjamin Davis, Jr., leader of the Tuskegee airmen in World War II; Collett Everman Woolman, founder of Delta Air Lines; Carl Norden, developer of gyroscopic instruments used in flight control and weapons systems; Robert Gilruth, former director of NASA's Manned Spacecraft Center; and astronauts John Glenn and Neil Armstrong.

National Aviation Hall of Fame, Dayton Convention and Exhibition Center, 1 Chamber Plaza, Dayton, OH 45402–2400 (after summer of 1998: Wright-Patterson Air Force Base, OH 45433). Phone: 513/226–0800. Hours: when center is open (to be determined at new site). Admission: free.

U.S. ASTRONAUT HALL OF FAME, Titusville, Florida. The U.S. Astronaut Hall of Fame, which opened in 1990 in Titusville, Florida, near the Kennedy Space Center, is dedicated to the nation's astronauts and the space program. It also is the home of the U.S. Space Camp, a space science camp where children undergo astronaut-like training in a hands-on learning environment.

Both the hall of fame and space camp are a joint venture of the U.S. Space Camp Foundation and the Astronaut Scholarship Foundation. The latter was

established by the Mercury flight astronauts and currently comprises the five surviving Mercury astronauts (Alan Shepard, John Glenn, Scott Carpenter, Wally Schirra, and Gordon Cooper) and the families of two deceased members (Gus Grissom and Deke Slayton).

The 21 Mercury and Gemini astronauts currently are honored in the hall of fame. Plans call for the 18 Apollo astronauts to be inducted in late 1997 and other astronauts to be added in the future.

The hall of fame focuses on America's entrance into the space race, with a look at the selection, training, and experiences of the nation's first space astronauts—the seven Mercury astronauts. The astronauts are featured in exhibits tracing their lives and space exploits, with the aid of photographs, films, artifacts, and memorabilia. Visitors can see the Sigma 7 spaceship that Wally Schirra flew into space, climb into a replica of that space capsule, and hear John Glenn explain the intricacies of the flying machine.

Another section looks at the 13 Gemini astronauts, who paved the way to the moon. It includes things ranging from Buzz Aldrin's grade-school report card and Gus Grissom's space suit to the equipment used during explorations on the moon.

Visitors also can enjoy a variety of hands-on aerospace experiences, such as spinning in the cockpit of a centrifuge G-force jet trainer (as the first astronauts did as test pilots); soar, bank, and barrel-roll in a simulator as their plane engages in dogfights over the desert; try to pilot the Space Shuttle to a safe landing at the Kennedy Space Center; and float free of the Earth's gravity in America's Skylab space station (via virtual reality). A film on America's space explorations, *Reach for the Stars*, also can be seen in the hall of fame's theater.

U.S. Astronaut Hall of Fame, 6225 Vectorspace Blvd., Titusville, FL 32780–8040. Phone: 407/269–6100. Hours: 9–5 daily, with extended summer hours; closed Christmas. Admission: adults, $9.95; children 4–12, $5.95; children 3 and under, free.

VIRGINIA AVIATION HALL OF FAME, Sandston, Virginia. Virginians who have made contributions to aviation are honored in the Virginia Aviation Hall of Fame, founded in 1978 by the Virginia Aviation Historical Society and housed in the Virginia Aviation Museum—a branch of the Science Museum of Virginia located at the Richmond International Airport in Sandston.

Among the 65 inductees in the hall of fame are such Virginia aviation figures as Brig. Gen. William E. Haymes, H. T. "Dick" Merrill, Sidney L. Shannon, and Chauncey E. Spenser. A photograph and biographical information of each honoree can be seen in the museum.

The Virginia Aviation Museum focuses on aviation history from World War I through World War II. It has a collection of 22 planes in flying condition, including one of the few remaining Spad VIIs from the first World War.

Virginia Aviation Hall of Fame, Virginia Aviation Museum, Richmond International Airport, 5701 Huntsman Rd., Sandston, VA 23150–1946. Phone: 804/236–3622.

Hours: 9:30–5 daily; closed Thanksgiving and Christmas. Admission: adults, $5; seniors, $4; children 4–12, $3; children under 4, free.

BUSINESS AND INDUSTRY

AMERICAN POULTRY HALL OF FAME. (See Poultry category.)

AUTOMOTIVE HALL OF FAME. (See Automobiles category.)

COUNTRY MUSIC HALL OF FAME AND MUSEUM. (See Music category.)

CRAYOLA HALL OF FAME. (See Unusual Halls of Fame section.)

GALLERY OF ALSO RANS. (See Unusual Halls of Fame section.)

HALL OF FUMES. (See Unusual Halls of Fame section.)

HAMBURGER HALL OF FAME. (See Unusual Halls of Fame section.)

INTERNATIONAL AEROSPACE HALL OF FAME. (See Aviation and Space category.)

INTERNATIONAL TOWING AND RECOVERY HALL OF FAME. (See Towing and Recovery category.)

MERCHANDISE MART HALL OF FAME, Chigago, Illinois. The Merchandise Mart Hall of Fame in Chicago was established in 1953 to immortalize outstanding American retail merchants whose contributions to merchandising have had far-reaching impact on the nation's economy. Massive bronze busts— four times life-size—of the eight business leaders honored are mounted on large pillars outside the Merchandise Mart's entrance, along the Chicago River.

The honorees include Marshall Field, founder of Marshall Field & Company; Edward A. Filene, president, William Filene & Sons; George Huntington Hartford, founder of the Great Atlantic & Pacific Tea Company; Julius Rosenwald, president and chairman, Sears, Roebuck & Company; John R. Wanamaker, founder of John Wanamaker, Inc.; Aaron Montgomery Ward, founder of Montgomery Ward & Company; Gen. Robert E. Wood, president and chairman, Sears, Roebuck & Company; and Frank Winfield Woolworth, founder of F. W. Woolworth Company.

The eight merchants were cited for making significant contributions to the American system of distribution through merchandising innovations, civic and community leadership, enlightened human relations, and financial success.

Among their pioneering ideas were the one-price store (which replaced barter), free delivery, 30 to 60-day time payment, customer returns for refund, counter merchandising (which let consumers see and touch merchandise), testing laboratories to improve the quality of merchandise, and sales by mail.

Merchandise Mart Hall of Fame, Merchandise Mart, Chicago, IL 60654. Phone: 312/ 527–4141. Hours: open 24 hours. Admission: free.

NATIONAL AGRICULTURAL CENTER AND HALL OF FAME. (See Agriculture category.)

NATIONAL AVIATION HALL OF FAME. (See Aviation and Space category.)

NATIONAL BUSINESS HALL OF FAME, Chicago, Illinois. The National Business Hall of Fame was founded in 1975 by Junior Achievement, Inc., to honor the nation's past and present business and industrial leaders. Since 1986 the hall of fame has been in an exhibit hall at one of the largest and most popular science and technology museums—the Museum of Science and Industry in Chicago, which has an annual attendance of over 2 million.

Among the 168 business and industrial leaders enshrined in the hall of fame are such company founders as Levi Strauss, Levi Strauss and Company; Leon L. Bean, L. L. Bean, Inc.; George Eastman, Eastman Kodak Company; Thomas J. Watson, Sr., IBM Corporation; John Rockefeller, Standard Oil Company; and Henry Ford, Ford Motor Company; such innovators as Eli Whitney, inventor of the cotton gin; John Deere, the steel plow; Igor Sikorsky, the helicopter; Richard W. Sears, mail-order retailing; Cyrus H. McCormick, the reaper; Edwin H. Land, instant photography, and Charles F. Kettering, automotive electric self-starter. Others include Amory Houghton, Corning Glass Works; Katharine Graham, the *Washington Post*; Lee Iacocca, Chrysler Corporation; Robert W. Galvin, Motorola, Inc.; Walter E. Disney, Walt Disney Company; Mary Kay Ash, Mary Kay Corporation; and Howard Hughes, aviator, movie producer, and industrialist.

The 6,000-square-foot hall of fame exhibit was removed in 1995 and will be replaced by a new exhibit in 1999 at the Museum of Science and Industry. Meanwhile, a temporary exhibition with many of the original elements—a wall of plaques, videos, and interactive exhibits—has been installed at the museum.

The Museum of Science and Industry, which opened in 1933, has more than 2,000 exhibit units in six learning zones—communications, energy and the environment, the human body, manufacturing, space and defense, and transportation. It is best known for its replica of a coal mine, the *U-505* (a German submarine captured in 1944), space artifacts, an Omnimax theater, and hands-on exhibits.

National Business Hall of Fame, Museum of Science and Industry, 57th St. and Lake Shore Dr., Chicago, IL 60637. Phone: 312/684–7141. Hours: summer 9:30–5:30 daily;

winter 9:30–4 Mon.–Fri., 9:30–5:30 Sat., Sun., and holidays. Museum admission: adults, $6; seniors, $5; children, $2.50; children under 5, free.

NATIONAL MINING HALL OF FAME AND MUSEUM. (See Mining category.)

PAPER INDUSTRY HALL OF FAME. (See Paper category.)

PETROLEUM HALL OF FAME. (See Petroleum category.)

PLASTICS HALL OF FAME. (See Plastics category.)

QUACKERY HALL OF FAME. (See Unusual Halls of Fame section.)

RADIO HALL OF FAME. (See Radio and Television category.)

ROCK AND ROLL HALL OF FAME AND MUSEUM. (See Music category.)

RV/MH HALL OF FAME AND MUSEUM. (See Mobile Homes category.)

TELEVISION ACADEMY HALL OF FAME. (See Radio and Television category.)

CAMPING

FAMILY CAMPING HALL OF FAME, Allenstown, New Hampshire. Individuals who have made significant contributions to family camping are enshrined in the Family Camping Hall of Fame, which is part of the Museum of Family Camping in Bear Brook State Park in Allenstown, New Hampshire. The museum and the hall of fame were founded and opened in 1993.

The museum and hall of fame are the result of early efforts by the late Roy B. Heise, a campground owner and collector of camping materials, who wanted to preserve camping history and encourage others to enjoy the outdoors. The dream became a reality after his death in 1991, when his family was instrumental in obtaining space for the museum in New Hampshire's largest developed park.

Among the 18 persons in the hall of fame are President Theodore Roosevelt, who was a naturalist, conservationist, and leader in the national park movement; George T. Wilson, an educator who started the Milwaukee Family Camping Association; Wally Byam, founder of the Airstream Company and creator of one of the earliest family camping and caravaning organizations, the Wally Byam Caravan Club International; Ellsworth "Hank" Nathan, founder of the National Campers and Hikers Association; Horace Sowers Kephart, author of major camping books and articles; and L. L. Bean, early advocate of camping and founder of the L. L. Bean sporting goods company.

The hall of fame features portraits and plaques of the honorees. The museum also contains many historical camping materials, such as camp stoves, sleeping bags, reflector ovens, kitchen boxes, and tents, as well as a 1935 primitive campsite, a 1938 travel trailer, and a 1947 tent trailer.

Family Camping Hall of Fame, Museum of Family Camping, Bear Brook State Park, Rte. 28, Allenstown, NH 03275. Phone: 603/230–4768. Hours: Memorial Day–Columbus Day 10–4 daily. Admission: free.

CARTOON ART

INTERNATIONAL MUSEUM OF CARTOON ART HALL OF FAME, Boca Raton, Florida.

Many of the world's leading cartoonists are enshrined in the International Museum of Cartoon Art Hall of Fame in Boca Raton, Florida. The museum, which began as the Museum of Cartoon Art in a castle-like mansion in Rye, New York, in 1975, moved to its present location in Florida in 1991 and is now expanding from 26,000 to 60,000 square feet.

The hall of fame, which is being increased in size from 450 to 1,200 square feet, has inducted 32 cartoonists, including Milton Caniff, "Terry and the Pirates"; Bud Fisher, "Mutt and Jeff"; Chester Gould, "Dick Tracy"; Walt Kelly, "Pogo"; Elzie Crisler Segar, "Popeye"; Mort Walker, "Beetle Bailey"; Chic Young, "Blondie"; and Charles Dana Gibson, illustrations.

The museum contains a wide range of works of cartoonists, including those honored in the hall of fame.

International Museum of Cartoon Art Hall of Fame, 201 Plaza Real, Boca Raton, FL 33432. Phone: 561/391–2200. Hours: 10–6 Mon.–Wed.; 10 A.M.–10 P.M. Thurs.–Sun. Admission: adults, $6; seniors, $5; students, $4; children 6–12, $3; children 5 and under, free.

CIRCUS

CLOWN HALL OF FAME AND RESEARCH CENTER. (See Clowns category.)

INTERNATIONAL CIRCUS HALL OF FAME, Peru, Indiana.

Peru, Indiana, calls itself the "circus capital of the world" and claims to have had more circus activity in the area than anywhere else in the world. The city, a railroad hub, was a focal point for the traveling industry from the golden age of the American circus in the late nineteenth century until the 1940s. At its peak, Peru was home to some of the most famous shows, including Hagebeck-Wallace, Sells-Floto, Terrell Jacobs, John Robinson, and Howes Great London. It later also served as the winter quarters for the Ringling Bros. and Barnum & Bailey Circus from 1929 until 1940, when John Ringling moved the circus to Sarasota, Florida.

Today, Peru is the home of the International Circus Hall of Fame, an annual

Circus City Festival, and the Peru Circus, where nearly 300 performers from elementary school through college present shows each July in their own downtown arena.

The hall of fame came to Peru after a group of townspeople learned that the Circus Hall of Fame in Sarasota was for sale. The original hall of fame had been founded in 1957 and operated until 1979, when the leased land on which it stood was sold. A circus enthusiast, who was eager to keep the artifacts from being auctioned off separately, bought the hall's entire collection. When the collection later became available, Indiana residents, companies, and the state government paid $450,000 to bring the circus artifacts and hall of fame to Peru. The first exhibits were presented in 1986. The International Circus Hall of Fame opened in 1990 in one of the original circus barns. It now operates from May through October and presents professional circus acts during the summer.

The hall of fame collection includes more than 40 vintage circus wagons and steam calliopes, costumes of performers, circus props, live animals, and such materials as posters, lithographs, and handbills from circuses around the world. At present, only part of the collection is displayed. Plans call for recreating circus buildings that formerly existed, one of which will be the main exhibit hall for the hall of fame. The site, which served once as the circus winter quarters, was designated a National Historic Landmark in 1988.

The hall of fame has had 124 individual and group inductions since 1958. Among those enshrined in a 10,000-square-foot gallery are circus owners, performers, and other personnel. They include John W. Ricketts, considered the "father" of the American circus; the Ringling brothers; animal trainer Clyde Beatty; cowboy performer Tom Mix; the Wallenda highwire troupe; the Zacchini brothers, human cannonballs; William "Buffalo Bill" Cody, who started the first wild west show; and aerialist Lillian Lietzel, the first person inducted, in 1958.

International Circus Hall of Fame, Rte. 124, PO Box 700, Peru, IN 46970. Phone: 317/ 472–7553. Hours: May 1–Oct. 31 10–4 Mon.–Sat., 1–4 Sun.; other times by appointment. Admission: adults, $2.50; students 12 and under, $1; preschool, free; groups— adults, $2; students, 50¢. During the performance season of June 29–Labor Day: adults, $5; seniors, $4; students 12 and under, $3; groups—adults, $4; seniors, $3; children 12 and under, $2.

CLOWNS

CLOWN HALL OF FAME AND RESEARCH CENTER, Delavan, Wisconsin. The art and history of clowning is celebrated at the Clown Hall of Fame and Research Center in Delavan, Wisconsin—the winter quarters of 26 circuses between 1847 and 1894, where P. T. Barnum's "Greatest Show on Earth" was founded in 1871, and where over 150 members of the nineteenth-century circus colony are buried.

The hall of fame began as an economic development project in 1987, when an office and exhibits opened in a small downtown building. Live performances were added, four major clown organizations affiliated themselves with the hall of fame, the first inductees were enshrined in 1989, and attendance climbed. In 1991, a former supermarket building of 15,000 square feet, quadruple the size of the first facility, became the hall of fame's home. The annual attendance now is approximately 32,000.

The first inductees were people well known to most Americans—Red Skelton, Lou Jacobs, Emmitt Kelly, Sr., Mark Anthony, Felix Adler, and Otto Griebling. The hall of fame now has 35 honorees, including Joseph Grimaldi, "father" of modern clowning; Bob Keeshan, television's first "Clarabell"; Oleg Popov, noted Russian clown; Roy "Cooky" Brown, from the *Bozo Circus* television show; Dimitri, the famous Swiss clown; Albert Fratellini, prominent French clown; Steve "T. J. Tatters" Smith, Ringling Brothers' clown college director and performance director; and Annie Fratellini, niece of the previously honored French clown and the first woman inducted.

The hall of fame also has a "Lifetime of Laughter Award," which has gone to such individuals as Larry Harmon, creator of television's "Bozo the Clown" character; Willard Scott, who played Ronald McDonald and Bozo on television before he became the *Today Show* weatherman; Max Patkin, the "Clown Prince of Baseball"; and Kohl and Company, a comedy and magic team.

The hall of fame has a large collection of clown costumes, shoes, props, photographs, portraits, and other clown-related materials. Visitors also can watch famous clown performances on video; see hundreds of clown faces painted on goose eggs; make up and act as clowns; and attend live clown shows in the 180-seat theater. In addition, the hall offers special programs, maintains an archive, assists with research, and helps organize international clown meetings.

Clown Hall of Fame and Research Center, 114 N. Third St., Delavan, WI 53115. Phone: 414/728–9075. Hours: summer 10–4 Mon.–Sat., 12–4 Sun.; varies other times of the year. Admission: museum $2.50, shows $3.50; museum and show $5.

INTERNATIONAL CIRCUS HALL OF FAME. (See Circus category.)

DANCE

DANCE HALL OF FAME, Saratoga Springs, New York. The Dance Hall of Fame at the National Museum of Dance in Saratoga Springs, New York, honors individuals who have made pioneering contributions to American professional dance. Formally named the Mr. and Mrs. Cornelius Vanderbilt Whitney Hall of Fame (in recognition of Mrs. Whitney's support of the museum), the hall of fame was established in 1987—a year after the opening of the nation's only museum devoted exclusively to dance.

The hall of fame—which covers all forms of professional dance, including

ballet, Broadway, modern, jazz, tap, and ethnic dance—has 23 inductees. They include such dance luminaries as Fred Astaire, George Balanchine, Isadora Duncan, Katherine Dunham, Martha Graham, Bill Robinson, Charles Weidman, Ted Shawn, Ruth St. Denis, Busby Berkeley, Jerome Robbins, John Martins, Alvin Ailey, Merce Cunningham, Paul Taylor, and Bronislava Nijinska.

The museum, which is open only during the summer tourist season, contains exhibits of artifacts, memorabilia, costumes, props, photographs, videos, and films, largely focusing on dancers and choreographers enshrined in the hall of fame. Special exhibitions also are organized in connection with new inductions.

The 35,000-square-foot museum is located in a building formerly known as the Washington Baths, a historic landmark, which functioned as a bath from 1920 to 1978, in Saratoga Spa State Park. It was then used as a carbon dioxide gas facility and a furniture factory. The structure was restored in 1986. In 1992, a three-story adjacent building was added to house the Lewis A. Swyer School for the Performing Arts. The museum's season coincides with other dance activities in the area, such as the summer residency of the New York City Ballet.

Dance Hall of Fame, National Museum of Dance, 99 S. Broadway, Saratoga Springs, NY 12866. Phone: 518/584–2225. Hours: Memorial Day–Labor Day 10–5 Tues.–Sun.; closed remainder of year. Admission: adults, $3.50; seniors and students, $2.50; children under 12, $1.

ETHNICITY

INTERNATIONAL HERITAGE HALL OF FAME, Detroit, Michigan. In 1985, the International Institute of Metropolitan Detroit and an organization of its friends opened an International Heritage Hall of Fame in Cobo Center to honor individuals who have made outstanding contributions to the cause of ethnicity and tradition and to the American way of life.

Founded in 1984, the hall of fame features photographic portraits of 62 persons in many walks of life, including community leader Kazutoshi Mayeda, former governor G. Mennen Williams, civic leader Bernice Gershenson, educator Arthur L. Johnson, and basketball star Isiah Thomas.

International Heritage Hall of Fame, Cobo Center, 1 Washington Blvd., Detroit, MI 48226. Phone: 313/871–8600. Hours: whenever Cobo Center is open. Admission: free.

FIREFIGHTING

NATIONAL FIREFIGHTING HALL OF HEROES, Phoenix, Arizona. The Hall of Flame Museum of Firefighting in Phoenix opened a National Firefighting Hall of Heroes honoring firemen and women for bravery in 1997. It differs from most halls of fame in that the initial 250 honorees were cited by others, rather than being selected by the museum, and will be exhibited only for three years, after which they will be replaced with another group of firefighting heroes.

Photographs, memorabilia, and other materials of the honored firefighters are displayed in a 3,500-square-foot gallery, which also contains a computer database on firefighters and the social history of firefighting. Those honored in the hall originally were cited for bravery by *Firehouse Magazine*, the Veterans of Foreign Wars, military services, and other organizations.

The Hall of Flame museum was founded in Lake Geneva, Wisconsin, in 1964, and then moved to Kenosha, Wisconsin, before opening in Phoenix in 1974. It started with the personal collection of George Getz, a businessman who founded the museum. The museum now has the world's largest collection of firefighting equipment and memorabilia, as well as exhibits on the history and development of firefighting equipment, 10,000 objects and graphic materials pertaining to the history of firefighting, and more than 40,000 photographs.

Among the equipment pieces are a 1725 Newsham pumper, the nation's oldest firefighting rig; a 1961 Mercedes fire truck; a Studebaker truck with runners for use in the snow; nineteenth-century horse carts, used only in parades; hand-pumpers from the 1800s; and such other materials as uniforms, helmets, axes, buckets, paintings, and illustrations.

National Firefighting Hall of Heroes, Hall of Flame Museum of Firefighting, 6101 E. Van Buren St., Phoenix, AZ 85008. Phone: 602/275–3473. Hours: 9–5 Mon.–Sat.; 12–4 Sun.; closed New Year's Day, Thanksgiving, and Christmas. Admission: adults, $5; seniors, $4; students 6–17, $3; children under 6, free.

INVENTION

INVENTURE PLACE, NATIONAL INVENTORS HALL OF FAME, Akron, Ohio. The National Inventors Hall of Fame was founded in 1973 by the United States Patent and Trademark Office and the National Council of Intellectual Property Law Associations to honor those who conceived major technological advances using the nation's patent system. In 1976, the hall was established as a stand-alone organization. Exhibits on hall of fame inductees and patent models were displayed in the foyer of the Patent and Trademark Office in Arlington, Virginia, until it was decided to find a permanent home to house the exhibits. A nationwide search and bidding competition followed, with Akron, Ohio, being selected for the site in 1988.

Akron leaders proposed incorporating the hall into a new science center dedicated to creativity, innovation, and invention. In 1995 Inventure Place, National Inventors Hall of Fame, opened with the mission "to inspire creativity and invention" through hall of fame and hands-on, science-oriented exhibits. The 77,000-square-foot, five-story building, with 25,000 square feet of exhibits, was built at a cost of $38 million and now has an estimated annual attendance of 300,000.

Among the 120 inventors enshrined in the hall are Thomas Alva Edison, inventor of the electric lamp, phonograph, and motion picture projector, who

had 1,093 patents to his name; Alexander Graham Bell, the telephone; Eli Whit-
ney, the cotton gin; Orville and Wilbur Wright, powered flight; Charles Good-
year, vulcanization-strengthened rubber; George Eastman, inventor of dry, rolled
film and the hand-held camera; Philo Taylor Farnsworth, first television system;
John Deere, the practical steel plow; Theodore H. Maiman, the ruby laser; and
George Washington Carver, crop rotation and soil enrichment methods.

The hands-on exhibits enable visitors to aim a laser at an amplifier and
speaker to create sound, draw animated animals to make a cartoon, take apart
a dishwasher, pilot a helicopter, build a dam and locks in pools of water, put
together a computer, build a sound system, and engage in other creative activ-
ities.

Inventure Place also has an Inventors Workshop, with tools, materials, and
open-ended, interactive exhibits; sponsors summer invention camps for students;
and offers the B. F. Goodrich Collegiate Inventors Program, which annually
honors inventive problem-solving by college and university students.

Inventure Place, National Inventors Hall of Fame, 221 S. Broadway, Akron, OH 44308-
1505. Phone: 216/762–4463. Hours: 9–5 Tues.–Sat.; 11–5 Sun.; closed Mondays from
Memorial Day to Mar. 1. Admission: adults, $7.50; seniors and children 3–17, $6;
children 2 and under, free; groups of 25 or more, $5.50 each.

LABOR

LABOR HALL OF FAME, Washington, D.C. Labor leaders and others whose
contributions have enhanced the quality of life, improved working conditions,
and advanced opportunities for profitable employment for Americans are hon-
ored in the Labor Hall of Fame in Washington, D.C. Founded in 1988, the hall
of fame, consisting of exhibit kiosks, is sponsored by the Friends of the De-
partment of Labor and is located in the lobby of the Frances Perkins Labor
Department Building.

Among the 20 inductees are such giants of the labor union movement as
Samuel Gompers, George Meany, John L. Lewis, A. Philip Randolph, Walter
P. Reuther, Philip Murray, Sidney Hillman, David Dubinsky, and William
Green; worker activists Eugene V. Debs, Mary Anderson, and Mary Harris
''Mother'' Jones; former secretaries of labor Frances Perkins, James P. Mitchell,
and Arthur J. Goldberg; Senator Robert F. Wagner; industrialists Cyrus S. Ching
and Henry J. Kaiser; and labor relations innovators John R. Commons, a creative
force behind social legislation involving trade unionism and collective bargain-
ing, and George W. Taylor, known for his achievements in arbitration, media-
tion, wage regulation, and the study of industrial relations.

Labor Hall of Fame, U.S. Dept. of Labor, Frances Perkins Labor Dept. Bldg., 200 Con-
stitution Ave., N.W., Washington, DC 20210. Phone: 202/371–6422. Hours: 8:30–4
Mon.–Fri.; group tours by appointment; closed federal holidays. Admission: free.

LAW ENFORCEMENT

AMERICAN POLICE HALL OF FAME AND MUSEUM, Miami, Florida. The American Police Hall of Fame and Museum in Miami, Florida, has the largest number of honorees of all halls of fame. Over 6,000 local, county, state, and federal law enforcement officers killed in the line of duty since the hall and museum opened in 1960 have been enshrined.

The hall of fame and museum—sponsored by the American Federation of Police and the National Association of Chiefs of Police—was founded to serve as a memorial for officers who died in performing their duties; to assist families left behind; and to further public education about law enforcement. It now has an annual attendance of over 110,000.

Names of law enforcement officers killed are added each week to a white marble wall in the heart of the 48,000-square-foot facility, which was formerly the Miami headquarters of the Federal Bureau of Investigation. Homage also is paid to the officers slain during the last year at an annual Peace Officers Memorial Day ceremony.

More than 11,000 objects are on display, ranging from artifacts from the 1700s to the most contemporary police equipment. Visitors can see firearms of all types; such police vehicles as patrol cars, SWAT trucks, motorcycles, and the actual police car from the futuristic movie *Blade Runner*; approximately 8,000 shoulder patches from law enforcement agencies; and exhibits on courageous officers and notorious criminals, the St. Valentine's Day massacre in Chicago, President John F. Kennedy assassination, and such means of punishment as a guillotine, stockade, jail cell, electric chair, and gas chamber. A video theater shows films on crime prevention and how citizens can help police.

The hall of fame/museum also has an interdenominational chapel, offers grief counseling to the survivors of slain officers, and provides college and university scholarships to the children of officers killed in the line of duty.

American Police Hall of Fame and Museum, 3801 Biscayne Blvd., Miami, FL 33137. Phone: 305/573–0070. Hours: 10–5 daily; closed Christmas. Admission: adults, $6; seniors, $3; students, $1.50; police officers and family survivors, free.

SOUTH CAROLINA CRIMINAL JUSTICE HALL OF FAME, Columbia, South Carolina. The South Carolina Justice Hall of Fame in Columbia honors law enforcement officers in the state who have been killed in the line of duty, and it presents exhibits on the historical and contemporary aspects of law enforcement. It was founded in 1979 following an act of the state legislature.

The hall of fame memorial room contains plaques of 198 officers killed since 1882. The exhibits feature objects related to the history of law enforcement in the state, such as moonshine stills, police equipment, counterfeit money, and photographs. The 6,000-square-foot facility has an auditorium in which public safety programs are presented on such topics as traffic and bicycle safety,

stranger danger, vandalism, and substance abuse. The annual attendance is 25,000.

Criminal Justice Hall of Fame, South Carolina Dept. of Public Safety, 5400 Broad River Rd., Columbia, SC 29210. Phone: 803/896–8755. Hours: 8–5 Mon.–Fri.; 10–4 Sat.; 1–5 Sun.; closed state holidays. Admission: free.

TEXAS RANGER HALL OF FAME AND MUSEUM, Waco, Texas. Officers with outstanding service in the Texas Rangers, the nation's oldest law enforcement agency with statewide jurisdiction, are honored in the Texas Ranger Hall of Fame and Museum, in Fort Fisher Park in Waco. The Texas Rangers, created in 1823 to protect early settlements against Indian attack, have evolved into one of the best-known law enforcement agencies in the world.

The museum was established as a department of the City of Waco in 1968, with the hall of fame being added in 1975. The facility disseminates knowledge and inspires appreciation of the Texas Rangers in the context of the history of Texas and the American West, serves as the principal repository for artifacts and archives relating to the Texas Rangers, and promotes the economic development of the area through its activities.

Twenty-six Texas Rangers have been inducted into the hall of fame. They include Stanley Keith Guffey, who was killed by a kidnapper while rescuing a 2-year-old girl; Frank Hamer, who hunted the notorious Bonnie and Clyde; and Bill McDonald, a life-service ranger.

The museum, which has been expanded several times, covers 25,000 square feet, of which 8,000 is devoted to exhibits. It contains memorabilia, weapons, and archives of the Texas Rangers from its earliest days to the present. It also has a wide range of other western artifacts and materials, such as artifacts of Wild West shows, Mexican vaqueros, the Emperor Maximilian of Mexico, buffalo hunters, trail drivers, and the U.S. cavalry.

Among its prized possessions are an 18-pound saddle with gold, silver, and 293 precious stones, which has been called ''the finest saddle in the world''; Jim Bowie's knife and rifle; the Walker Colt, designed by Texas Ranger Captain Sam Walker to produce more firepower during the Mexican War; and the famed Winchester 73 lever-action rifle.

Texas Ranger Hall of Fame and Museum, Fort Fisher Park, PO Box 2570, Waco, TX 76702–2570. Phone: 813/750–8631. Hours: 9–5 daily; closed New Year's Day and Christmas. Admission: adults and students, $3.50; children, $1.50.

MINING

NATIONAL MINING HALL OF FAME AND MUSEUM, Leadville, Colorado. Men and women who pioneered the discovery, development, and processing of the nation's resources are enshrined in the National Mining Hall of Fame and Museum in Leadville, Colorado. Founded in 1987, this federally char-

tered nonprofit has honored 126 individuals in the mining, equipment, engineering, construction, government, research, education, labor, and related fields.

The hall of fame/museum is located in a 70,000-square-foot Victorian former school building in what was once a leading mining center and is still the highest incorporated city in the United States at 10,152 feet. Leadville became a booming frontier mining town after a rich silver deposit was found in 1860; by 1880, it had a population of 30,000. However, as mining receded, the number of residents decreased to approximately one-tenth of its peak.

Among those honored in the hall of fame are Horace Tabor, who made a fortune from Leadville silver discoveries; Alexander Agassiz, noted scientist, geologist, and industrial leader; Daniel Guggenheim, leading copper industry figure; Joseph A. Jeffrey, developer of the first commercial coal-cutting machine; Levi Strauss, who made canvas work pants for prospectors; John B. Stetson, who invented the Stetson hat while prospecting in Colorado; John L. Lewis, longtime president of the United Mine Workers; Otto Mears, builder of roads into mining towns in Colorado's San Juan Mountains; Mary Harris "Mother" Jones, a labor agitator who helped to form the International Workers of the World ("Wobblies"); and Herbert C. Hoover, a prominent mining engineer who later became president of the United States.

Engraved plaques of the inductees are featured in the hall of fame portion of the museum. Other exhibits include walk-through replicas of underground coal and hard rock mines; gold specimens, documents, photographs, and artifacts related to the nation's 17 gold rushes; mineral specimens, including 35 from the Smithsonian Institution; a gold display from Colorado and the Harvard University Mineralogical Museum; hand-carved dioramas depicting gold-mining scenes; early mining tools; machinery; and a model railroad. The museum/hall of fame attracts more than 27,000 visitors a year.

National Mining Hall of Fame and Museum, 120 W. Ninth St., PO Box 981, Leadville, CO 80461. Phone: 719/486–1229. Hours: May–Oct. 9–5 daily; Nov.–Apr. 10–2 Mon.–Fri. Admission: adults, $4; seniors, $3.50; children 6–12, $2; children under 6, free.

MOBILE HOMES/RECREATIONAL VEHICLES

RV/MH HALL OF FAME AND MUSEUM, Elkhart, Indiana. The founding of the RV/MH Hall of Fame and Museum in Elkhart, Indiana, can be traced to 1972, when the publishers of eight trade magazines decided at a Mobile Home Manufacturers Association meeting to honor pioneers of the recreational vehicle and manufactured housing industry and to preserve its heritage. The result was the formation of the RV/MH Heritage Foundation and its three components—a hall of fame, museum, and library.

In 1990, the RV/MH Hall of Fame and Museum opened in the foundation's 20,000-square-foot building in Elkhart, the center of the recreational vehicle and manufactured housing industry. It pays tribute to 164 inductees cited for their

contributions to the advent, growth, and development of the industry, and it contains historical collections and exhibits pertaining to it.

Among those who have been inducted into the hall of fame are such company founders and industry leaders as Wally Byam, of Airstream; Wilbur Schult, Schult Homes; Arthur Sherman, Covered Wagon; John K. Hanson, Winnebago; Thomas H. Corson, Coachman; James L. Clayton, Clayton Homes; and Elmer Frey, Marshfield Homes. Others enshrined include Sheldon Coleman, Coleman; R.A. Woodall, Woodall's Directories; and Art Rouse, Good Sam Club and Trailer Life Publications.

In addition to the plaques and photographs of hall of famers, the museum has exhibits on the history of the RV/MH industry, early recreational trailers and mobile homes from the 1930s through the 1960s, house trailers that developed into today's manufactured homes, camping accessories, memorabilia, advertising materials, and a research library.

RV/MH Hall of Fame and Museum, RV/MH Heritage Foundation, 801 Benham Ave., Elkhart, IN 46514. Phone: 219/293–2344. Hours: 9–5 Mon.–Fri.; group appointments Sat.–Sun. Admission: free.

MUSIC

ALABAMA JAZZ HALL OF FAME MUSEUM, Birmingham, Alabama. More than 180 nationally recognized jazz musicians are honored in the Alabama Jazz Hall of Fame Museum in Birmingham. The hall of fame was founded in 1978 and opened as a museum, with the help of the City of Birmingham, in 1993.

Among the jazz greats inducted into the hall of fame are keyboardist Sun Ra, trumpeter Wilbur Bascomb, guitarist John Collins, vocalist Nat "King" Cole, bassist Willie Ruff, trumpeter Erskine Hawkins, drummer Jo Jones, and composer W.C. Handy, considered the "father of blues."

In addition to exhibits on the hall of famers, the museum has displays of instruments of some of the honorees, material on Alabama musicians of famous bands, and interactive computers that bring up biographies and music on demand.

Alabama Jazz Hall of Fame Museum, 1631 Fourth Ave., N., Birmingham, AL 35204. Phone: 205/254–2731. Hours: 10–5 Tues.–Sat.; 1–5 Sun. Admission: free.

ALABAMA MUSIC HALL OF FAME, Tuscumbia, Alabama. The Alabama Music Hall of Fame was established in 1980 by the state legislature to honor Alabama's greatest achievers in all forms of music. A statewide referendum in 1987 voted to build a 12,500-square-foot exhibit hall, which opened in 1990 in Tuscumbia and now attracts 85,000 visitors annually. Plans call for the addition of a library of southern music and a 1,000-seat auditorium and theater as part of phases II and III.

Twenty-seven performing and nonperforming music stars have been inducted

into the hall of fame, and approximately 400 others have received contemporary achievement awards. Among those enshrined are performers Nat "King" Cole, W. C. Handy, Hank Williams, Sonny James, Erskine Hawkins, Dinah Washington, and Jimmie Rodgers; music groups such as the Delmore Brothers, the Commodores, and Alabama; and music industry innovators and executives Buddy Killen, Sam Philips, Rick Hall, and Jerry Wexler.

The exhibits feature portraits, memorabilia, photographs, awards, figurines, and other materials of the inductees and other achievers in the music field. Among the displays are Elvis Presley's original recording contract, costumes worn by Lionel Richie and the Commodores, the Alabama's tour bus, a recording studio, and wax figures of Nat "King" Cole and Hank Williams.

Alabama Music Hall of Fame, Hwy. 72 W., PO Box 709, Tuscumbia, AL 35674. Phone: 205/381–4417, 800/239–2643. Hours: 9–5 Mon.–Sat.; 1–5 Sun. Admission: adults, $6; seniors, $5; children, $3; groups, $4 per person.

BILL MONROE MUSEUM AND BLUEGRASS HALL OF FAME, Morgantown, Indiana. Outstanding bluegrass music performers are honored at the Bill Monroe Museum and Bluegrass Hall of Fame in Morgantown, Indiana. The seasonal museum/hall of fame was founded in 1992 by Bill Monroe, considered the "father of bluegrass."

More than a dozen persons have been inducted into the hall of fame, including such bluegrass stars as Lester Slat, Earl Scruggs, the Stanley Brothers, and the Sullivan Family. The hall of fame, which contains plaques and photographs of those enshrined, occupies a gallery in the 4,800-square-foot museum, which features instruments, awards, photographs, and other materials pertaining to bluegrass and country music.

Bill Monroe Museum and Bluegrass Hall of Fame, 3163 State Rd. 135, Morgantown, IN 46160. Phone: 812/988–6422. Memorial Day–Oct. 9–5 Tues.–Sat.; closed remainder of year. Admission: adults, $4; seniors, $3; children under 12, free.

COUNTRY MUSIC HALL OF FAME AND MUSEUM, Nashville, Tennessee. The Country Music Hall of Fame and Museum in Nashville is one of the nation's most visited and active popular arts museums. In addition to museum collections and exhibits, it operates historic sites, reissues classic recordings, publishes books, produces educational materials, and offers teaching and consulting programs in country music and related music forms. It attracts more than 250,000 visitors each year.

Since 1961, the hall of fame has honored performers, songwriters, and music executives for their outstanding work in country music, which began with Anglo-Celtic folk songs of southern settlers and is now known by many names— hillbilly, cowboy, bluegrass, honky-tonk, Cajun, and rockabilly, as well as country.

The Country Music Hall of Fame and Museum was founded in 1964 and moved into its building in 1967. Nearly half of the facility's 35,000 square feet

is devoted to 20 exhibit areas honoring the greats in the country music and tracing the heritage and highlights of the field. The hall of fame/museum plans to move into a new 100,000-square-foot building in 1999.

Fifty-seven individuals have been enshrined in the hall of fame. They include such country stars as Roy Acuff, Minnie Pearl, Johnny Cash, Willie Nelson, Gene Autry, Roger Miller, Eddy Arnold, Jimmie Rodgers, Ernest Tubb, Merle Haggard, Loretta Lynn, Roy Rogers, Tennessee Ernie Ford, Chet Atkins, Marty Robbins, Red Foley, Tex Ritter, Hank Williams, Patsy Cline, and the Carter Family. Each is represented in the hall by a bronze plaque featuring a sculptured likeness and biography.

Over 5,000 historical objects can be seen in the exhibit halls. They include costumes, instruments, original song manuscripts, and other country music materials, displayed with oversized graphics, touch-screen interactive computers, films, videos, and other contemporary exhibit techniques.

More than 300 past and present artists are represented by bronze stars in terrazzo blocks at the building's entrance. Among the exhibits in the museum are the story of the Grand Ole Opry, Elvis Presley's 1960 ''solid gold'' Cadillac, Webb Pierce's 1962 customized Pontiac convertible, Thomas Hart Benton's 6-by-10-foot mural on country music, and displays of Gibson musical instruments, songs and songwriters, styles of country music, personal items of stars, and clips and objects from country music in movies.

The hall of fame/museum also operates two historic sites—RCA's 1957 Studio B, the oldest recording studio in Nashville, and Hatch Show Print, founded in 1879 and now one of the oldest working letterpress poster print shops in America. Admission to RCA's Studio B and the Music Row Trolley Tour, a trolley ride through the old music neighborhood of several blocks, are included in the admission to the Country Music Hall of Fame and Museum.

The library and media center houses more than 200,000 recorded discs, 60,000 historical photographs, 5,000 films and videotapes, and thousands of posters, books, periodicals, song books, sheet music, and audio tapes. It also has clipping files on over 1,000 country music entertainers and organizations.

Country Music Hall of Fame and Museum, 4 Music Square East, Nashville, TN 37203. Phone: 615/256–1639. Hours: Memorial Day–Labor Day 8–6 daily; Sept.–May 9–5 daily; closed New Year's Day, Thanksgiving, and Christmas. Admission: adults, $9.95; children 6–11, $4.95; children under 6, free.

LEGENDS AND SUPERSTARS HALL OF FAME, Nashville, Tennessee, and Branson, Missouri. The Legends and Superstars Hall of Fame, a tribute to America's pop culture, is located in two cities, Nashville, Tennessee, and Branson, Missouri. The hall of fame evolved from Nashville's Elvis Presley Museum, which closed in 1993. The museum was founded in 1978 by Jimmy and Kathy Velvet, who now operate the two hall of fame sites.

Unlike most halls of fame, there are no inductions. Rather, the hall of fame

consists of photographs, costumes, cars, movie props, and personal possessions of approximately 600 entertainers—most items purchased from the stars by the hall owners. Among those celebrated are Elvis Presley, Liberace, Elton John, Dolly Parton, and Conway Twitty.

The Nashville hall of fame occupies 6,200 square feet and has approximately 80,000 visitors, while the Branson site has 32,000 square feet and an attendance of over 130,000.

Legends and Superstars Hall of Fame, 1520 Demonbreun St., Nashville, TN 37203. Phone: 615/256–8311. Hours: 9 A.M.–9 P.M. Mon.–Sat. Admission: adults, $7.95; seniors and children over 6, $4.95; children 6 and under, free.

Legends and Superstars Hall of Fame, 506 N. Main St., PO Box 1607, Branson, MO 65615–1607. Phone: 417/334–2290. Hours: 9 A.M.–9 P.M. Mon.–Sat. Admission: adults, $7.95; seniors and children over 6, $4.95; children 6 and under, free.

MISSISSIPPI MUSIC HALL OF FAME, Jackson, Mississippi. The Mississippi Music Hall of Fame is one of the newest halls of fame. Founded in 1996, it is part of the Jim Buck Ross Mississippi Agriculture and Forestry Museum living history complex in Jackson. The new 10,000-square-foot building celebrates the state's rich musical heritage, which influenced the development of America's popular music.

Sixteen artists were the initial inductees: B. B. King and Robert Johnson, blues; Jimmie Rodgers, Charley Pride, Tammy Wynette, and Jerry Clower, country; Leontyne Price and William Grant Still, classical; the Blackwood Brothers, Pop Staples, the Staples Singers, and the Mississippi Mass Choir, gospel; Lester Young and Dee Barton, jazz; and Elvis Presley, Jimmy Buffett, and Bo Diddley, rock and roll.

Mississippi Music Hall of Fame, 1150 Lakeland Dr., Jackson, MS 39216. Phone: 601/ 354–6113. Hours: 9–5 Mon.–Sat.; 1–5 Sun.; closed New Year's Day, Thanksgiving, and Christmas Eve and Day. Admission: adults, $3; seniors, $2.75; students, $1; children 5 and under with adult, free.

NATIONAL OLDTIME FIDDLERS' HALL OF FAME, Weiser, Idaho. The National Oldtime Fiddlers' Hall of Fame in Weiser, Idaho, grew out of square dancing and fiddlers' contests. Started in 1953 by the chamber of commerce, the hall of fame now honors winners of national, state, and regional fiddlers' competitions. Weiser annually hosts the National Oldtime Fiddlers' Contest during a community jamboree held the third full week of June.

The hall of fame, located in the Weiser Community Center, contains plaques, photographs, fiddles, memorabilia, and records relating to fiddling champions and competitions.

National Oldtime Fiddlers' Hall of Fame, Weiser Community Center, 10 E. Idaho Ave., Weiser, ID 83672. Phone: 208/549–0452. Hours: 9–5 Mon.–Fri.; closed holidays. Admission: free.

OKLAHOMA JAZZ HALL OF FAME, Tulsa Oklahoma. More than 200 jazz greats from Oklahoma and elsewhere (who have impacted jazz in the state) are enshrined in the Oklahoma Jazz Hall of Fame in Tulsa. The hall, founded in 1988 and opened the following year, is located in the Greenwood Cultural Center.

Photographs, biographical information, artifacts, and memorabilia of such jazz standouts as Chesney Baker, Earl Bostic, Barney Kessel, and Jimmie Rushing can be seen at the hall of fame.

Oklahoma Jazz Hall of Fame, Greenwood Cultural Center, 322 Greenwood Ave., Tulsa, OK 74120. Phone: 918/582–1741. Hours: 9–5 Mon.–Fri.; 10–1 Sat.; closed major holidays. Admission: free.

ROCK AND ROLL HALL OF FAME AND MUSEUM, Cleveland, Ohio. Of all the halls of fame, the Rock and Roll Hall of Fame and Museum probably had the most competitive bidding for its site and the greatest fanfare over its development and opening. The media were saturated for years with stories and pictures about its induction ceremonies, fundraising, site selection process, building design, and grand opening.

The Rock and Roll Hall of Fame Foundation was founded in 1983 to honor musicians and industry professionals who had had a profound impact on the art form of rock and roll. Elaborate award ceremonies were held each year, while a nationwide search was under way to find an appropriate home for the hall of fame and museum. After considering such sites as New York City, Philadelphia, and Nashville, organizers selected Cleveland, Ohio, where disk jockey Alan Freed popularized the term "rock 'n' roll" in the early 1950s. City leaders raised $65 million of the $92 million needed to build a spectacular, 150,000-square-foot, seven-floor building, designed by I.M. Pei, on Cleveland's lakefront. It now has an annual attendance of approximately a million—largest among halls of fame. Because of its popularity, a $10-million, 30,000-square-foot addition is already being planned.

The hall of fame/museum opened in 1995 with a downtown parade, fireworks, and an all-star concert with more than 20 acts, including Chuck Berry, James Brown, Johnny Cash, Aretha Franklin, John Fogerty, Little Richard, Snoop Doggy Dogg, Soul Asylum, and Bruce Springsteen. An estimated 250,000 people attended various aspects of the opening celebration.

Approximately 50,000 square feet of the building are devoted to exhibits covering the hall of fame, early influences, city scenes, rock and roll and media, rock and roll and fashion, and such leading performers as Elvis Presley, Michael Jackson, Madonna, Alice Cooper, U2, the Beatles, Jimi Hendrix, the Supremes, Bruce Springsteen, and the Rolling Stones.

Inductees are selected in four Rock and Roll Hall of Fame categories—performers, nonperformers, early influences, and lifetime achievement. The hall of fame has inducted 141 acts from its 1983 inception through 1997. They include

such performers as Chuck Berry, Elvis Presley, James Brown, Tina Turner, Ray Charles, the Beatles, Ruth Brown, the Who, Janis Joplin, the Jackson Five, Jefferson Airplane, David Bowie, the Rolling Stones, and Gladys Knight and the Pips. Their names are etched in dark glass next to small cases containing revolving black-and-white photographs of the honorees, and quotations.

Among the objects on display in the museum are John Lennon's famed collarless Beatles suit and his Sergeant Pepper uniform, four of Michael Jackson's most famous costumes, and the battered money case Howlin' Wolf carried on the road for years. The stylistic influences of artists from ten genres can be accessed by touching video screens. At another set of video monitors it is possible for visitors to play back 500 of the greatest songs in rock and roll history. Among the outfits in the fashion section are those worn by metal rockers Kiss and Axl Rose of Guns 'n Roses, and by Aretha Franklin.

Rock and Roll Hall of Fame and Museum, 1 Key Plaza, Cleveland, OH 44114. Phone: 216/781–7625. Hours: 10–5:30 daily (also to 9 Wed.); closed New Year's Day, Thanksgiving, and Christmas. Admission: adults, $14.95; seniors and children under 11, $11.50.

NATIVE AMERICANS

NATIONAL HALL OF FAME FOR FAMOUS AMERICAN INDIANS, Anadarko, Oklahoma. Sculpted bronze busts of 41 Native Americans honored for their contributions to their people and to the development of American way of life can be seen at the National Hall of Fame for Famous American Indians, in Anadarko, Oklahoma. Approximately 40,000 visitors come to see the tribute each year.

Thirty-eight of the busts are in an outdoor sculpture garden, while three that are fragile and in need of repairs are in the adjoining City of Anadarko Visitors Center. The hall of fame was founded in 1952—many years after the late Logan Billingsley of Katonah, New York, conceived the memorial while employed with the United States Indian Service in Anadarko, before Oklahoma became a state. A bust of Billingsley is located at the west entrance outside the hall of fame area.

Among the American Indians honored are Sacajawea, the Shoshoni woman who served as guide and interpreter for the Lewis and Clark expedition to the Pacific coast in 1804–1806; Sequoyah, inventor of the Cherokee alphabet and contributor to the science of written language; Charles Curtis (Kaw), only person of Indian descent to serve as vice president of the United States (elected with Herbert Hoover in 1928); and such well-known chiefs and warriors as Pontiac (Ottawa), Osceola (Seminole), Blackhawk (Sac and Fox), Sitting Bull (Sioux), Tecumseh (Shawnee), Cochise (Chiricahua Apache), Geronimo (Apache), and Chief Joseph (Nez Percé).

Others honored include Pocahontas (Powhatan), a chiefain's daughter who

saved Capt. John Smith's life; John Ross and Stand Waite, Cherokee leaders who took different sides during the Civil War; Roberta Lawson (Delaware), first Indian woman to become national president of the National Federation of Women's Clubs; Maj. Gen. Clarence I. Tinker (Osage), highest ranking Army officer of Indian ancestry; Jim Thorpe (Sac and Fox), star football player and all-around athlete; and Will Rogers (Cherokee), noted entertainer and humorist.

National Hall of Fame for Famous American Indians, U.S. Hwy. 62 E., PO Box 548, Anadarko, OK 73005. Phone: 405/247–5555. Hours: 9–5 Mon.–Sat.; 1–5 Sun.; closed New Year's Day, Thanksgiving, and Christmas. Admission: free.

NOTABLE AMERICANS

GALLERY OF ALSO RANS. (See Unusual Hall of Fame section.)

HALL OF FAME FOR GREAT AMERICANS, the Bronx, New York. Founded in 1900 and dedicated in 1901, the Hall of Fame for Great Americans in the Bronx, New York, was the first American hall of fame to use the term "hall of fame" to describe such a tribute to outstanding individuals. It is located in a 630-foot open-air colonnade that initially was part of New York University and was transferred to Bronx Community College of the City University of New York in 1973.

The granite colonnade, located on a scenic bluff overlooking the Harlem and Hudson rivers, was designed by renowned architect Stanford White. Today, it is considered one of New York's architectural treasures and is listed in the National Register of Historic Places.

The colonnade contains bronze busts of 98 of the 102 distinguished American men and women elected to the hall of fame since its founding at the turn of the century. It winds around three neoclassic buildings, including the Gould Memorial Library, which was modeled after the Pantheon in Rome. Four busts still remain to be made and installed, although the last selections were made in 1976.

The hall was founded by New York University to encourage a deeper appreciation of noteworthy individuals who made significant contributions to the American experience. The busts—which contain a plaque with each inductee's contribution—are grouped by categories, such as scientists and inventors, statesmen, lawyers and judges, artists and performers, educators and reformers, theologians, and writers.

Among those enshrined are such prominent figures as George Washington, Thomas Jefferson, Abraham Lincoln, Thomas Edison, Harriet Beecher Stowe, Alexander Graham Bell, Booker T. Washington, John James Audubon, Mark Twain, and Franklin Delano Roosevelt. The hall also includes others who are not as well known, including Mary Lyon, educator and feminist; Matthew Fontaine Maury, oceanographer; Maria Mitchell, astronomer; and Edward Alexander MacDowell, composer and pianist.

The busts are the work of some of America's greatest sculptors—Daniel Chester French, who created the Lincoln Memorial; James Earle Fraser, whose work included the "Justice" and "Law" figures for the U.S. Supreme Court building; Frederick MacMonnies, whose reliefs grace the Washington Arch in New York City; and Augustus Saint-Gaudens, who sculpted the Lincoln bust and later was elected to the hall himself.

Hall of Fame for Great Americans, Bronx Community College, University Ave. and W. 181st St., Bronx, NY 10453. Phone: 718/220–6003. Hours: 10–5 daily. Admission: free.

NATIONAL HALL OF FAME FOR FAMOUS AMERICAN INDIANS. (See Native Americans category.)

NATIONAL STATUARY HALL, Washington, D.C. The National Statuary Hall—consisting of a collection of 96 statues contributed by 50 states in commemoration of notable citizens—was America's first hall of fame. It was established in 1864 by an act of Congress to honor those "illustrious for their historic renown or for distinguished civic or military services." It is located at the U.S. Capitol in Washington.

The Statuary Hall concept began in the 1850s, as the House of Representatives was preparing to move into its new wing in 1857; the former amphitheater-style chamber was to become simply a thoroughfare between the rotunda and the new wing. In 1853, a former member of the House, Gouverneur Kemble, called for the chamber to be used as a gallery for historical paintings, but some congressmen felt that the space was better suited for the displays of busts and statuary. A little over a decade later, Representative Justin S. Morrill introduced legislation which created the National Statuary Hall to enable each state to recognize and provide statues of two citizens deserving of commemoration in the chamber.

The first statue—of Nathanael Greene, a Revolutionary War general from Rhode Island—was installed in 1870. It was followed in 1872 by statues of Roger Sherman, the only founding father who signed all four of America's first state papers, Connecticut; Roger Williams, who colonized Rhode Island and stood for religious freedom; and Jonathan Trumbull, adviser to George Washington and champion of the rights and liberties of the American people, Connecticut.

Many other notables were added in the years that followed, including Presidents George Washington, Thomas Jefferson, Andrew Jackson, Abraham Lincoln, and Ulysses S. Grant; colonial and revolutionary leaders Samuel Adams, Benjamin Franklin, John Hancock, and Alexander Hamilton; political figures John C. Calhoun, Stephen F. Austin, Henry Clay, Sam Houston, Jefferson Davis, William Jennings Bryan, William E. Borah, and Huey P. Long; military leaders Robert E. Lee, Philip Kearney, and Lew Wallace; and such others as John Winthrop, Massachusetts colony leader; Marcus Whitman, Northwest missionary; Brigham Young, Mormon founder of Utah; Charles M. Russell, painter and

sculptor; Esther H. Morris, Wyoming suffrage pioneer; Frances Sequoya, inventor of the Cherokee Indian Nation alphabet; Frances E. Willard, temperance movement leader; and Will Rogers, humorist.

Forty-six states have contributed two statues each; four have only one and are eligible for an additional statue (Nevada, New Mexico, North Dakota, and Wyoming). The statues, which average seven feet in height, became so numerous that it became necessary to expand their display to several other areas of the Capitol beyond the original Statuary Hall in the old House chamber. Statues now also can be found in the first- and second-floor House and Senate connecting corridors, the Hall of Columns, and the east central front entrance hall.

National Statuary Hall, U.S. Capitol, Washington, DC 20515. Phone: 202/228–1222. Hours: 9–4:30 daily, although may vary slightly occasionally; closed New Year's Day, Thanksgiving, and Christmas. Admission: free.

NATIONAL WOMEN'S HALL OF FAME. (See Women category.)

PAPER

PAPER INDUSTRY HALL OF FAME, Neenah, Wisconsin. Individuals who have pioneered or helped the world's paper industry to flourish are honored in the Paper Industry Hall of Fame at the Neenah Historical Society in Neenah, Wisconsin. Founded in 1994, the hall of fame recognizes achievement in all aspects of the paper industry—pulp and paper, board, forest products, converters, allied industries, trade associations, and academic institutions.

The first six inductees in 1995 were Johannes A. Van den Akker, professor emeritus of physics, Institute of Paper Chemistry; William R. Kellett, retired president, Kimberly-Clark Corporation; John Alfred Kimberly, co-founder and president, Kimberly Clark Corporation; Elis Olsson, founder and chairman, Chesapeake Corporation; Jaakko Poyry, founder and chairman, Jaakko Poyry Group Consulting Engineers; and Richard B. Scudder, retired coinventor of the newspaper de-inking process and founder of the Garden State Paper Company.

Plans are under way to build a separate facility to house the Paper Industry Hall of Fame.

Paper Industry Hall of Fame, Neenah Historical Society, 336 Main St., PO Box 366, Neenah, WI 54957–0366. Phone: 414/722–7224. Hours: 9–12 Mon., Tues., Fri.; closed major holidays. Admission: free.

PETROLEUM

PETROLEUM HALL OF FAME, Midland, Texas. Leaders and innovators in the petroleum industry are enshrined in the Petroleum Hall of Fame at the Permian Basin Petroleum Museum, Library, and Hall of Fame in Midland, Texas.

Hall of fame inductions began in 1968, and a gallery devoted to honorees was part of the museum when the latter opened in 1975.

The hall of fame has honored 95 petroleum figures, including George T. Abell, early oil and gas producer in the Permian Basin; Ronald K. DeFord, geologist and University of Texas professor; H. B. Fuqua, former chairman of the Texas Pacific Coal and Oil Company and Fort Worth National Bank; Berte R. Haigh, developer of many oil and gas leasing techniques; Howard R. Hughes, Sr., inventor of the rock bit and founder of Hughes Tool Company; and Dean E. Lounsbery, a geologist instrumental in Phillips Petroleum discoveries and leasing in the Permian Basin.

A photograph and information about each honoree can be seen in the hall of fame gallery. Other museum exhibits feature the history of oil exploration and production, with the emphasis on West Texas oil fields; the geology and paleontology of the region; technology related to petroleum; and examples of early drilling rigs and other equipment. The museum also has an archives center with extensive documents, photographs, films, letters, diaries, and other materials pertaining to the oil history of West Texas and the Permian Basin portion of New Mexico.

The museum's building was dedicated by President Gerald R. Ford in 1975; then–Vice President George Bush opened the museum's north wing in 1981. It now has an annual attendance of approximately 45,000.

Petroleum Hall of Fame, Permian Basin Petroleum Museum, Library, and Hall of Fame, 1500 Interstate 20 West, Midland, TX 79701. Phone: 915/683–4509. Hours: 9–5 Mon.–Sat.; 2–5 Sun.; closed Thanksgiving and Christmas Eve and Day. Admission: adults, $4; seniors, $3; children 6 through high school, $2; children under 6, free.

PHOTOGRAPHY

INTERNATIONAL PHOTOGRAPHY HALL OF FAME AND MUSEUM, Oklahoma City, Oklahoma. The International Photography Hall of Fame and Museum in Oklahoma City, Oklahoma, commemorates the history, science, art, people, events, and places that have shaped the development of photography. The Photographic Art and Science Foundation, founded in 1965, initially opened a museum at the Brooks Institute of Photography in Santa Barbara, California, in 1978. When the space was no longer available, the museum leased space in the Center in Oklahoma City, adopting its present name in 1982. The Kirkpatrick Center cultural complex houses seven museums and several galleries, all independently operated, which can be seen with a single admission.

The International Photography Hall of Fame and Museum, which occupies 22,000 square feet, honors the pioneers and major innovators of photography. Among the 49 inducted are such early photographers and developers as Louis-Jacques-Mande Daguerre, Mathew B. Brady, Eadweard Muybridge, Peter Henry Emerson, Joseph-Nicéphore Niepce, and George Eastman, and more recent fig-

ures as Ansel Adams, Laszlo Moholy-Nagy, Edward Steichen, Alfred Steiglitz, Edwin Land, and Margaret Bourke-White.

The hall of fame/museum has panel tributes to each inductee, as well as thousands of photographs and hundreds of antique cameras and equipment, many of which are on display. It also has the world's largest photomural, a 360-degree laserscape of the Grand Canyon. The annual attendance is approximately 100,000.

International Photography Hall of Fame and Museum, Kirkpatrick Center, 2100 N.E. 52nd St., Oklahoma City, OK 73111. Phone: 405/424–4055. Hours: 9–6 Mon.–Sat.; 12–6 Sun. Admission: adults, $6; seniors, $5; children, 3–12, $3.50; children under 3, free.

PLASTICS

PLASTICS HALL OF FAME, Leominster, Massachusetts. Significant contributors to the progress of the plastics industry are enshrined in the Plastics Hall of Fame, located at the National Plastics Center and Museum in Leominster, Massachusetts. The hall was started in 1972 by *Modern Plastics* magazine in cooperation with the Society of the Plastics Industry. It was located at the society's headquarters in Washington, D.C., until 1990, when it was moved to its present site. The selections now are made by the all-industry Plastics Academy.

Approximately 100 inventors, designers, scientists, engineers, manufacturers, and industry leaders have been inducted into the hall of fame. They include such innovators as Leo H. Baekeland, discoverer of the ''Bakelite'' synthetic resin; Wallace Hume Carothers, the Du Pont chemist who developed nylon; George Eastman, who perfected the process for making photographic dry plates and flexible film; and Garland B. Jennings, whose work on the process and product development of rigid vinyls enabled their application in pipe, electrical conduit, siding, packaging, and other uses.

The hall of fame gallery makes use of video and interactive computer programming to obtain detailed information about inductees and their contributions. The museum also contains exhibits on the history and nature of the industry, many early machines to produce plastic products, representative plastic products, and a Discovery Center for children. It also offers live demonstrations on the chemistry of plastics, a micromolder that shows how plastic containers are recycled, and a hands-on laboratory that enables visitors to learn about the chemistry of polymers. The latter two experiences are also the highlight of a traveling van program.

Plastics Hall of Fame, National Plastics Center and Museum, 210 Lancaster St., PO Box 639, Leominster, MA 01453. Phone: 508/537–9529. Hours: 11–4 Wed.–Sat.; closed major holidays. Admission: adults, $2; seniors and children under 12, $1.

POULTRY

AMERICAN POULTRY HALL OF FAME, Beltsville, Maryland. Individuals who have contributed to the advancement of poultry science and industry are enshrined in the American Poultry Hall of Fame, established in 1953 by the American Poultry Historical Society. Originally consisting of portraits displayed at the University of Maryland in College Park, the hall of fame has been located at the U.S. Department of Agriculture's National Agricultural Library in Beltsville, Maryland, since 1970.

The hall of fame is now composed of plaques of the 72 inductees on the second floor of the agricultural library, which also has more than 30 collections pertaining to poultry, featuring such materials as photographs, documents, and even political cartoons.

Among those persons who have been inducted are Frank Perdue, poultry producer; Dr. Mary Pennington, food scientist; Jesse Jewell, meat chicken marketing pioneer; and James Gwen, poultry historian.

American Poultry Hall of Fame, National Agricultural Library, Special Collections, U.S. Dept. of Agriculture, 10301 Baltimore Blvd., Beltsville, MD 20705–2351. Phone: 301/ 504–5261. Hours: 8–4:30 Mon.–Fri.; closed federal holidays. Admission: free.

QUILTING

QUILTERS HALL OF FAME, Marion, Indiana. The Quilters Hall of Fame in Marion, Indiana, is dedicated to honoring those who have made outstanding contributions to the world of quilting, to celebrating quilt-making as an art form, and to preserving the nation's quilting heritage. Founded in 1979, the hall of fame will be moving into the historic Marie Webster House after restoration is completed in 1998.

Twenty-eight women and men have been inducted into the hall of fame. They include Marie Webster, designer, entrepreneur, and author of the first quilt book; Sally Garoutte, founder of the American Quilt Study Group; Michael James, contemporary art quilter; Joyce Gross, pioneering quilt historian; and Karey Bresnhan, founder of Quilts, Inc., and director of the International Quilt Festival.

Donation of the 1902 Marie Webster House, a National Historic Landmark, will enable the hall of fame to have comprehensive exhibits on those enshrined, as well as the quilt collection and the history, nature, and contributions of quilting. The current emphasis is on quilt research, special exhibitions, lectures, tours, show-and-tell sessions, and induction ceremonies.

Quilters Hall of Fame, Marie Webster House, PO Box 681, Marion, IN 46952. Phone: 317/664–9333. Hours: to be determined. Admission: adults, $3; seniors and students, $2.

RADIO AND TELEVISION

RADIO HALL OF FAME, Chicago, Illinois. The Radio Hall of Fame is part of the Museum of Broadcast Communications, located in the Chicago Cultural Center, the city's elegant former central library building. The hall of fame recognizes and showcases contemporary talent from today's diverse programming formats, as well as pioneers who helped shape the medium during its infancy.

The Radio Hall of Fame was founded by the Emerson Radio Corporation in 1988. The Museum of Broadcast Communications assumed administration of the hall in 1991, held its first induction ceremony in 1992, and moved to the cultural center in 1993. The hall of fame now serves approximately 200,000 visitors each year.

Sixty-seven individuals and 27 radio programs have been enshrined in the hall of fame. Among the radio stars inducted are Fred Allen, Jack Benny, Arthur Godfrey, Groucho Marx, Bob Hope, Dick Clark, Eve Arden, Edgar Bergen, Red Skelton, and Garrison Keillor. In addition, the honorees include such newscasters as Edward R. Murrow and Lowell Thomas; commentators like Larry King, Paul Harvey, and Rush Limbaugh; band leaders Tommy Dorsey, Benny Goodman, and Kay Kyser; and radio innovators and executives such as Lee DeForest, Guglielmo Marconi, Edwin H. Armstrong, David Sarnoff, and Frank Stanton. The hall also has an Emerson Award for distinguished lifetime achievement in production, management, or technology. The four recipients have been Leonard Goldenson, Edward F. McLaughlin, Gordon McLendon, and Rick Sklar.

Among the radio programs cited are *Amos 'n Andy*, *The Lone Ranger*, *You Bet Your Life*, *Don McNeill's Breakfast Show*, *The Shadow*, *The Burns & Allen Show*, *Grand Ole Opry*, *Mercury Theatre of the Air*, *The Romance of Helen Trent*, *All Things Considered*, and *CBS World News Roundup*.

The museum and hall of fame have one of the greatest radio archives in existence. It includes memorabilia of many radio stars and shows, including Charlie McCarthy and friends, Jack Benny's vault, Fibber McGee's closet, and over 50,000 hours of radio broadcasts. The 15,000-square-foot facility also has a state-of-the-art radio studio, a television studio where visitors can make videos of themselves as anchorpersons, and an archive of more than 6,000 television shows.

Radio Hall of Fame, Museum of Broadcast Communications, Chicago Cultural Center, Michigan Ave. at Washington St., Chicago, IL 60602. Phone: 312/629–6000. Hours: 10–4:30 Mon.–Sat.; 12–5 Sun.; closed major holidays. Admission: free.

TELEVISION ACADEMY HALL OF FAME, North Hollywood, California. Individuals and programs recognized for their outstanding contributions to television are honored in the Television Academy Hall of Fame by the Academy of Television Arts and Sciences. The achievements are celebrated with bas-reliefs, bronze busts, and life-size and miniature statues in an outdoor plaza adjacent to the academy's headquarters in North Hollywood, California.

A 27-foot golden "Emmy" is the focus of the Hall of Fame Plaza, which opened in 1991. The hall of fame program was started in 1984 by the Academy of Television Arts and Science, but it did not have a permanent exhibit area until the academy moved its present facilities, which also include a 600-seat theater and conference center.

An East Coast version of the Television Academy Hall of Fame is located at the Disney-MGM Studios Theme Park in Orlando, Florida. It replicates the original plaza in California under a five-year agreement reached in 1992, which also calls for the theme park to be site of the annual hall of fame awards ceremony.

Eighty-one television actors, newscasters, talk show hosts, producers, directors, writers, executives, and others in the field, and one television program—the *I Love Lucy* series—have been inducted into the hall of fame. They include such television figures as comedians Milton Berle, Lucille Ball, Sid Caesar, Carol Burnett, Jack Benny, Bob Hope, Red Skelton, and Bill Cosby; actors Carroll O'Connor, James Garner, Danny Thomas, Alan Alda, Mary Tyler Moore, and Michael Landon; newscasters Edward R. Murrow, Eric Sevareid, Walter Cronkite, and Barbara Walters; talk show hosts Johnny Carson, Phil Donahue, and Oprah Winfrey; producers Fred Coe, Norman Lear, and David Susskind; writers Paddy Cheyefsky and Rod Serling; executives David Sarnoff, William S. Paley, and Ted Turner; and others, including puppeteer Burr Tillstrom, singer Perry Como, commentator Bill Moyers; oceanographer Jacques-Yves Cousteau, and sportscaster Howard Cosell.

Three are recognized with life-size statues (Lucille Ball, Jack Benny, and Johnny Carson), while three others are honored with small statues (Carol Burnett, Jackie Gleason, and Ed Sullivan). Four persons are memorialized with bas-reliefs—Gracie Allen, George Burns, Steve Allen, and Walter Cronkite. Among the many individuals with bronze busts are Milton Berle, Walt Disney, Joyce Hall, Ernie Kovacs, Danny Thomas, Norman Lear, and Sylvester L. "Pat" Weaver, Jr. Two of the sculptures are housed in the reception area of the academy building. Approximately half of the hall of fame honorees do not have bas-reliefs, busts, or statues in the outdoor plaza, but plans call for their addition in the future.

Television Academy Hall of Fame, Academy of Television Arts and Sciences, 5220 Lankershim Blvd., North Hollywood, CA 91601. Phone: 818/754–2800. Hours: open 24 hours. Admission: free.

REGIONAL HISTORY

APPALACHIAN HALL OF FAME, Norris, Tennessee. The Appalachian Hall of Fame is part of the Museum of Appalachia, a living history mountain museum in Norris, Tennessee with numerous restored log cabins and buildings and over

250,000 objects from the past. The hall of fame is located in a three-story, 15,000-square-foot, antebellum-style structure at the 65-acre museum.

The museum was founded in 1968 and the hall of fame in 1992 by their owner, John Rice Irwin, who was fascinated with stories about early eastern Tennessee pioneers and began collecting relics and other materials in the region at an early age. Its attendance has grown to 100,000 annually.

Approximately 165 people have been honored in the Appalachian Hall of Fame. They include outstanding, unusual, interesting, or colorful individuals closely connected with the southern Appalachian Mountains. Among those in the hall are Cordell Hull, a longtime U.S. secretary of state who is considered the "father" of the United Nations; Sgt. Alvin C. York, celebrated World War I hero; Howard Baker, Jr., former U.S. Senate majority leader and White House chief of staff; Alex Haley, the author of *Roots*; Gen. John Sallings, last survivor of the Civil War; Roy Acuff, country music star; Alex Stewart, prominent Appalachian pioneer; and "Tater Hole" Joe, who lived in a hole in the ground.

The hall of fame building contains personal and interesting materials on the honorees, as well as regional exhibits on such topics as Native Americans, children, music, folk art, basketry, quilts, and medicine. In the main display barn, the museum has one of the nation's largest and most diverse pioneer and frontier collections, including handmade musical instruments, Kentucky rifles, carpenter's tools, agricultural equipment, barrels, spinning and weaving equipment, furniture, locks, traps, axes, and folk art.

Most of the log cabins date to the early 1800s. The museum also has a log church, a log schoolhouse, farm animals, gardens, and such special events as a Fourth of July celebration and "shooting" of the anvil; a fall homecoming, featuring the culture and heritage of Appalachia, with over 400 musicians, singers, craftspeople, artisans, and demonstrators of rural, pioneer, and mountain activities; and an old-fashioned Christmas program presented in a dirt-floored pioneer cabin, a turn-of-the-century homestead house, and the log schoolhouse.

Appalachian Hall of Fame, Museum of Appalachia, Hwy. 61, PO Box 0318, Norris, TN 37828. Phone: 423/494–7680 or 423/494–0514. Hours: 8–5 daily; extended hours in summer; closed Christmas. Admission: adults, $6; seniors, $5; students, $4; families, $16.

LAKE PLACID HALL OF FAME. (See Winter Sports category.)

ROUTE 66 HALL OF FAME, McLean, Illinois. The Route 66 Hall of Fame—honoring the people and places that gave historic Route 66 such a special character—is located in a hallway at Dixie Truckers Home, a large truck stop and restaurant in McLean, Illinois, about halfway between Chicago and St. Louis. It is the only indoor hall of fame that is open 24 hours every day.

The hall of fame was started in 1990 by the Route 66 Association of Illinois to celebrate the history of the famous roadway. The Dixie Truckers Home was selected as the site for the hall of fame because of its long association with the

highway. The truck stop has been owned and operated by the descendants of the founder, J. P. Walters, since it opened in 1928, two years after Route 66 was dedicated.

The hall of fame has 27 members. They include a wide range of individuals with a relationship to Route 66, such as a longtime waitress, a former gas station owner, a retired state trooper, an insurance company founder, a newspaperman and inventor, and a truck driver who drove the highway for 58 years.

Photographs and memorabilia can be seen on the walls and in showcases in the 600-square-foot hallway. They include such diverse objects as a Tucker car nameplate, a sign used in a television series, a can of ''Root 66'' root beer, soybean license plates, hood ornaments, route signs, hubcaps, and model trucks.

Route 66 Hall of Fame, Dixie Truckers Home, McLean, IL 61754. Phone: 309/874–2323. Hours: open 24 hours. Admission: free.

RIVER HISTORY

NATIONAL RIVERS HALL OF FAME, Dubuque, Iowa. The National Rivers Hall of Fame, which honors men and women for their contributions to the nation's inland rivers, is located in the Mississippi River Museum in Dubuque, Iowa. Founded in 1986, the hall of fame occupies a 1,500-square-foot gallery in the 29,000-square-foot museum on a five-acre harbor site that includes three buildings and two river boats.

Thirty-seven explorers, inventors, writers, artists, musicians, and others having a river connection have been enshrined in the hall of fame. They include such familiar names as Marquette and Jolliet, Lewis and Clark, Mark Twain, and Robert Fulton. The hall of fame exhibits consist of large illuminated photographs and panels of information about the honorees.

In addition to the hall of fame, the Mississippi River Museum, established by the Dubuque County Historical Society in 1979, includes the Woodward Riverboat Museum; the National Landmark steamboat *William M. Black*; a 15-minute film, *River of Dreams*, featuring the history, sights, and sounds of the Mississippi; and exhibits and artifacts covering 300 years of river history.

National Rivers Hall of Fame, Mississippi River Museum, Third Street Ice Harbor, PO Box 266, Dubuque, IA 52004–0266. Phone: 319/557–9545. Hours: 10–5:30 daily; closed New Year's Day, Thanksgiving, and Christmas. Admission: adults, $6; children 6–15, $3; children 5 and under, free; families, $18.

SPACE

ASTRONAUT HALL OF FAME. (See Aviation and Space category.)

INTERNATIONAL AEROSPACE HALL OF FAME. (See Aviation and Space category.)

INTERNATIONAL SPACE HALL OF FAME. (See Aviation and Space category.)

U.S. ASTRONAUT HALL OF FAME. (See Aviation and Space category.)

STATE NON-SPORTS HALLS OF FAME

ALABAMA JAZZ HALL OF FAME. (See Music category.)

ALABAMA MUSIC HALL OF FAME. (See Music category.)

ALABAMA AVIATION HALL OF FAME. (See Aviation and Space category.)

ARIZONA HALL OF FAME. (See Women category.)

AVIATION HALL OF FAME AND MUSEUM OF NEW JERSEY. (See Aviation and Space category.)

GEORGIA AVIATION HALL OF FAME. (See Aviation and Space category.)

MISSISSIPPI MUSIC HALL OF FAME. (See Music category.)

OKLAHOMA JAZZ HALL OF FAME. (See Music category.)

SOUTH CAROLINA CRIMINAL JUSTICE HALL OF FAME. (See Law Enforcement category.)

SOUTH DAKOTA HALL OF FAME, Chamberlain, South Dakota. The South Dakota Hall of Fame in Chamberlain has inducted 419 individuals in 15 categories since it was founded in 1978. The inductees were honored for contributing to the development of the state or for outstanding achievement in their chosen fields, such as agriculture, business, government, and sports.

The honorees include such figures as Tom Brokaw and Mary Hart in television; former senator and presidential candidate George McGovern; Myron Swan, noted accordionist; and longtime senator Jim Abdnor. In addition to photographs and information about the honorees, the exhibits range from county history books and works of art to artifacts from pioneer and Indian days.

South Dakota Hall of Fame, 100 W. Lawler Ave., PO Box 180, Chamberlain, SD 57325. Phone: 605/734–4216. Hours: 8–5 Mon.–Fri.; closed state holidays. Admission: free.

TEXAS RANGER HALL OF FAME AND MUSEUM. (See Law Enforcement category.)

VIRGINIA AVIATION HALL OF FAME. (See Aviation and Space category.)

WISCONSIN AVIATION HALL OF FAME. (See Aviation and Space category.)

TEACHING

NATIONAL TEACHERS HALL OF FAME, Emporia, Kansas. Exceptional teachers from kindergarten through high school are honored in the National Teachers Hall of Fame, founded and opened in 1992 in Emporia, Kansas. The hall of fame occupies approximately one-third of the 35,000-square-foot former library of the defunct College of Emporia.

Twenty-five teachers have been inducted into the hall of fame, which is conducting a $10 million fundraising campaign. Approximately $3 million will be used to expand and enhance the exhibit program, which now consists of plaques, photographs, memorabilia, and artifacts.

National Teachers Hall of Fame, 1320 C of E Dr., Emporia, KS 66801. Phone: 316/341–5660. Hours: Mon.–Fri.; 9–12 Sat.; other times by appointment; closed holidays. Admission: free.

TELEVISION. (See Radio and Television category.)

TOWING AND RECOVERY

INTERNATIONAL TOWING AND RECOVERY HALL OF FAME AND MUSEUM, Chattanooga, Tennessee. Towing companies, wrecker engineers, salesmen, and manufacturers are honored in the International Towing and Recovery Hall of Fame and Museum in Chattanooga, Tennessee. Founded as a traveling exhibition in a trailer in 1984, the hall of fame opened as a museum in a renovated downtown building in 1995.

Photographs and descriptions of 122 inductees from 14 countries are featured, as well as a range of early tow trucks, tows, tools, and other equipment related to towing and recovery vehicles and other objects.

International Towing and Recovery Hall of Fame and Museum, 401 Broad St., Chattanooga, TN 37402. Phone: 423/267–3132. Hours: 10–4:30 Mon.–Fri.; 11–5 Sat.–Sun.; closed major holidays. Admission: adults, $3.50; seniors and children 5–18, $2.50.

WESTERN HERITAGE

LEA COUNTY COWBOY HALL OF FAME AND WESTERN HERITAGE CENTER, Hobbs, New Mexico. The Lea County Cowboy Hall of Fame and Western Heritage Center is one of the few halls of fame to be located on a college campus—New Mexico Junior College, which is two miles north of Hobbs, New Mexico.

It was founded in 1978 when Dale "Tuffy" Cooper, a rancher and rodeo performer, presented the idea to Sylvia Mahoney, the college's rodeo coach, and then to R.N. Tydings, its interim president. Tydings and the college board were enthusiastic about the proposal, feeling that the hall of fame/heritage center and the rodeo program would complement each other. A 5,000-square-foot building was completed in 1982, and a western art gallery was added recently.

The hall of fame honors persons from Lea County who have been outstanding in rodeo or who have made exceptional contributions to the county as a pioneer, rancher, or cowboy or cowgirl. Fifty men and women have been inducted into the hall. Lea County has more world champion rodeo titles than any other county in the nation. Among the champions honored are Jake McClure, Clay Mc-Gonagill, Troy Fort, Roy Cooper, Guy Allen, and "Baldy."

The exhibits include memorabilia of the inductees; a chronological history of the county, featuring scenes depicting Indians, exploration, homesteading, open range, as well as town histories and western and southwestern fine art; and a collection of buckles, saddles, trophies, programs, and other materials pertaining to professional, amateur, and college cowboys and cowgirls. Poetry readings, programs on history and heritage, and lectures are presented before a large needlepoint screen, created by 18 local needle crafters, on the history of Lea County.

Lea County Cowboy Hall of Fame and Western Heritage Center, 5317 Lovington Hwy., Hobbs, NM 88240. Phone: 505/392–5518 or 505/392–1275. Hours: 10–5 Fri.; 1–5 Sat.; tours by appointment; closed college holidays, spring break, and Christmas. Admission: free.

NATIONAL COWBOY HALL OF FAME AND WESTERN HERITAGE CENTER, Oklahoma City, Oklahoma. The settlement, development, and popularization of the American West is celebrated at the National Cowboy Hall of Fame and Western Heritage Center in Oklahoma City, Oklahoma. The organization was founded in 1954 and became a museum in 1965. It now is one of the nation's largest (220,000 square feet) and best attended (over 200,000 visitors annually) combination halls of fame and museums.

The hall of fame/heritage center, established to preserve the history of, and to honor those who have made significant contributions to, the American West, has three halls of fame, the Rodeo Hall of Fame, started in 1955 to recognize cowboys and cowgirls for their bronc riding, bulldogging, roping, and other accomplishments; the Great Westerners Hall of Fame, initiated in 1958 to honor

individuals and organizations for epitomizing or making significant contributions to the development of the West; and the Great Western Performers Hall of Fame, created in 1958 to enshrine actors, singers, and other entertainers for their enduring contributions to the West in their performances and lives.

Among the 184 Rodeo Hall of Fame inductees are Samuel Thomas Privette, noted bronc rider and promoter; Bill Pickett, the black cowboy credited with inventing bulldogging; Vicente Oropez, who introduced trick and fancy roping from his native Mexico; Bill Linderman, a two-time world all-around cowboy champion, who strengthened the Rodeo Cowboys Association while president and then secretary-treasurer; and such other multiple world champions as Jim Shoulders, Dean Oliver, and Larry Mahan.

The rodeo hall also recognizes great bucking horses (such as Steamboat, Midnight, Five Minutes 'til Midnight, and Hell's Angel), an outstanding rope horse (Baldy), and a tremendous bucking bull (Tornado). Several of the bucking horses and the bull are buried along the Trail of Great Cow Ponies on the grounds.

The 228 cited in the Great Westerners Hall of Fame include Samuel Houston, first president of the Republic of Texas and later state governor and U.S. senator; Willa S. Cather, prominent author of novels about pioneer days on the western plains; Chief Joseph, leader of the Nez Percé tribe, in the Northwest; Esther Hobart Morris, who helped to make Wyoming the first territory with women's suffrage and became the first woman public official in the United States; and Theodore Roosevelt, twenty-sixth president of the United States, who was a western enthusiast and worked to conserve natural resources.

Such motion picture stars as Tom Mix, Roy Rogers, Dale Evans, Gene Autry, Barbara Stanwyck, Gary Cooper, Jimmy Stewart, Walter Brennan, Jack Palance, and John Wayne are among the 43 honored in the Great Western Performers Hall of Fame. An entire room is devoted to John Wayne, featuring his movie memorabilia, western artifacts, and collection of kachina dolls.

In addition, the facility has a Founders' Hall with busts, plaques, and photographs of cowboys, ranchers, merchants, industrialists, journalists, and other builders of the American West whose memories are perpetuated by their families and friends.

An extensive collection of western works of art and artifacts also can be seen at the museum. The works of such early western artists as Charles M. Russell, Frederic Remington, Charles Schreyvogel, Albert Bierstadt, and Nicolai Fechin, as well as many contemporary artists, are displayed. They include five of the world's largest western landscape paintings—16-by-20-foot works by Wilson Hutley, and the original plaster version of the 18-foot sculpture *End of the Trail*, by James Earle Fraser.

Among the exhibits is the Joe Grandee Museum of the Frontier West, a collection of approximately 8,000 western artifacts from the nineteenth century collected by Grandee—firearms, clothing, military items, and American Indian material. Another outstanding exhibit is the "West of Yesterday," a re-created

old western town with such features as a boardwalk, gunshop, general store, saloon, saddle shop, hotel, blacksmith shop, and marshal's office, as well as an authentic sod house, chuck wagon, sheepherder's wagon, and simulated gold mine.

The hall of fame/heritage center also presents many temporary exhibitions and special events, such as the Western Heritage Awards Program and National Academy of Western Art Exhibition, and serves as cosponsor of the national finals of the World Series Rodeo.

National Cowboy Hall of Fame and Western Heritage Center, 1700 N.E. 63rd St., Oklahoma City, OK 73111. Phone: 405/478–2250. Hours: Memorial Day–Labor Day 8:30–6; Labor Day–Memorial Day 9–5; closed New Year's Day, Thanksgiving, and Christmas; Admission: adults, $6.50; seniors, $5.50; children 6–12, $3.25.

NATIONAL COWGIRL HALL OF FAME AND WESTERN HERITAGE CENTER, Fort Worth, Texas. The National Cowgirl Hall of Fame and Western Heritage Center is in transition. Founded in Hereford, Texas, in 1975, it has relocated to Fort Worth and is in the process of planning a new museum facility.

The hall of fame/heritage center, which has 124 inductees, honors and documents the lives of women who have distinguished themselves as exemplifying the pioneer spirit of the American West. It includes rodeo performers, such as trick ropers and riders, as well as others who have contributed to western heritage.

Among those who have been enshrined are Jeanette Katherine Worthington, six-time all-around rodeo world champion; Alice Greenough Orr, four-time world champion saddle bronc rider; Lucille Mulhall, a Wild West show performer who was first called a "cowgirl," by Will Rogers; Sacajawea, the Shoshoni Indian interpreter and guide for the Lewis and Clark expedition; Annie Oakley, Wild West show sharpshooter; Henrietta Chamberlain King, codeveloper of the first American breed of cattle and matriarch of the world's largest ranch; Georgia O'Keeffe, artist; Willa Cather, author; Patsy Cline, country and western singer; and Dale Evans, western motion picture and television star.

The hall of fame/heritage center occupied 6,000 square feet and had a 2,000 annual attendance in Hereford, a cattle center and the site of the All Girl Rodeo each year. Plans call for a larger facility in Fort Worth that will attract more visitors.

National Cowgirl Hall of Fame and Western Heritage Center, 111 W. Fourth St., Suite 300, Fort Worth, TX 76102. Phone: 817/336–4475. Hours and admission: still to be determined.

NATIONAL HALL OF FAME FOR FAMOUS AMERICAN INDIANS.
(See Native Americans category.)

PENDLETON ROUND-UP/HAPPY CANYON HALL OF FAME, Pendleton, Oregon. The Pendleton Round-Up/Happy Canyon Hall of Fame was

founded in 1969 to honor contestants, stock contractors, photographers, financial boosters, volunteers, and others who have made contributions to the success of the annual rodeo and pageant in Pendleton, Oregon.

Seventy-nine people have been inducted into the hall of fame, which is located in a 1,600-square-foot room under the south grandstand of the Round-Up grounds. Construction is to begin shortly on a new 20,000-square-foot building for the hall of fame.

Among those honored in the hall are Roy Raley, founder of the Round-Up and Happy Canyon pageant; Clarence Burk, Walla Walla Indian chief of the Round-Up; the Bishop brothers, owners of the Pendleton Woolen Mills; the Hamleys, owners of Hamley and Co., saddlemakers; Melissa Parr, 1928 queen of the Round-Up; Mabel Strickland, 1927 queen, contestant, and best all-around cowgirl; Clark McEntrie, three-time all-around cowboy; and Don McLaughlin, eight-time world champion roper.

In addition to plaques devoted to the honorees, the hall of fame contains a full-body mount of Warpaint, the famed bucking horse; delicate beadwork, saddles, clothing, firearms, awards, and photographs; and other materials relating to history and highlights of the Round-Up and Happy Canyon activities.

Pendleton Round-Up/Happy Canyon Hall of Fame, 1205 S.W. Court Ave., Pendleton, OR 97801. Phone: 541/278–0815. Hours: May–Oct. 10–5 daily; other times by appointment. Admission: free.

PRORODEO HALL OF FAME AND MUSEUM OF THE AMERICAN COWBOY, Colorado Springs, Colorado. Rodeo performers, lifestyle, and development over the last century are featured at the ProRodeo Hall of Fame and Museum of the American Cowboy in Colorado Springs, Colorado. The hall of fame was created in 1979 (and the Museum of the American Cowboy added to its name in 1989) by the Professional Rodeo Cowboys Association to preserve the legacy of rodeo competitions and to honor its champions.

The association—originally named the Cowboys Turtle Association because cowboys allegedly were slow in getting things done—was founded in 1936 when a number of cowboys performing at the Boston Garden walked out, largely in protest of the low prize money (which was less than the sum of their entry fees). Some rodeo purses now exceed several million dollars.

The Professional Rodeo Cowboys Association became the sanctioning body for professional rodeo. It now sanctions approximately 800 meets each year. The first rodeo competition, involving only saddle bronc riding, occurred in Deer Trail, Colorado, in 1869; and the initial modern-day rodeo was held in Prescott, Arizona, in 1888. However, it was not until 1959 that the first world championships were held, in Dallas.

The hall of fame has had 140 inductions, 121 people and 19 animals. Those enshrined cover the spectrum of rodeo—contestants, stock contractors, clowns, announcers, contract personnel, other notables of the sport, and rodeo animals. The honorees include world all-around champions Larry Mahan, Leo Camarillo,

Casey Tibbs, and Sharkey Irwin; saddle bronc riders Pete Knight and Yakima Cannute; bull riders Jim Shoulders, Ken Roberts, and Charles Sampson; steer wrestlers Homer Pettigrew and Bill Pickett; roper Ben Johnson; bucking horses Hell's Angel, Midnight and Five Minutes 'til Midnight; and fighting bulls Oscar and Tornado. Among the inductees are two father-and-son duos and four brothers.

The Hall of Fame Gallery has an exhibit case for each inductee, containing plaques, photographs, gear, memorabilia, and trophies. Changing art exhibitions are presented throughout the museum, and rodeo animals and a sculpture garden can be seen outside the building. An oversized bronze statue of nine-time world champion Casey Tibbs on his famed saddle bronc Neckie greets more than 50,000 visitors at the entrance each year.

The 25,000-square-foot hall of fame/museum was expanded to 45,000 square feet in 1996. The Hall of Fame Gallery and office space were enlarged, a new National Finals Gallery was added to display materials pertaining to the rodeo ''super bowl,'' and a large outdoor activity center with a full-size arena and barn was constructed.

ProRodeo Hall of Fame and Museum of the American Cowboy, 101 Pro Rodeo Dr., Colorado Springs, CO 80191–2396. Phone: 719/528–4764. Hours: 9–5 daily; closed New Year's Eve and Day, Easter, Thanksgiving, and Christmas. Admission: adults, $6; seniors, $5; children 5–12, $3; children under 5, free.

TEXAS RANGER HALL OF FAME AND MUSEUM. (See Law Enforcement category.)

WOMEN

ARIZONA HALL OF FAME MUSEUM, Phoenix, Arizona. The Arizona Hall of Fame Museum in Phoenix began as the Arizona Women's Hall of Fame in 1981; it assumed its present name in 1987, when the state renovated the 1908 Carnegie Library building for its home. The original hall of fame was started by the Governor's Office for Women, which turned its operations over to the Department of Library, Archives, and Public Records and the Arizona Historical Society. It now is part of the Museum Division of the Arizona State Library.

The hall of fame still inducts only women, those who have made significant contributions to the state. Sixty-three have been enshrined in the hall, including Sharlot Hall, first state historian; Frances Lillian Willard Munde, first woman elected to the Arizona State Senate; Rachel Emma Allen Berry, first woman member of the Arizona House of Representatives; Mary Elizabeth Jane Colter, architect and designer for the Fred Harvey restaurants and hotels; and Sandra Day O'Connor, first woman Supreme Court justice.

The 10,000-square-foot museum has exhibits on current hall of fame inductees and groups of people who have made contributions to the state. Among the

recent exhibitions have been ''Fred Harvey and the Harvey Girls in Arizona''and ''Healers, Hicksters, and Heroes: Medicine in Territorial Arizona.'' The annual attendance is approximately 13,000.

Arizona Hall of Fame Museum, 1101 W. Washington St., Phoenix, AZ 85007. Phone: 602/255–2110. Hours: 8–5 Mon.–Fri.; closed major holidays. Admission: free.

BURLESQUE HALL OF FAME AND MUSEUM. (See Unusual Halls of Fame section.)

LADIES PROFESSIONAL GOLF ASSOCIATION HALL OF FAME. (See Golf category.)

NATIONAL COWGIRL HALL OF FAME AND WESTERN HERITAGE CENTER. (See Western Heritage category.)

NATIONAL WOMEN'S HALL OF FAME, Seneca Falls, New York. The National Women's Hall of Fame is part of the Seneca Falls Historic District in Seneca Falls, New York, where the nation's women's suffrage movement began. In 1884, a ''Declaration of Sentiments'' was adopted at a meeting of approximately 300 women and men at the first women's rights convention. The declaration stated that ''it is the duty of the women of this country to secure to themselves their sacred right to the elective franchise.''

The hall of fame was founded in 1969 to recognize women who have made significant national contributions to art, athletics, business, government, philanthropy, humanities, science, and education. The first induction was in 1973, when 20 women were honored, including Elizabeth Cady Stanton, an early women's rights proponent and one of the principal organizers of the first convention; Susan B. Anthony, suffrage movement leader; Marian Anderson, considered the nation's greatest contralto; and Margaret Chase Smith, longtime U.S. senator from Maine.

Among the more than 136 notable women now enshrined in the hall of fame are Jane Addams, social worker; Mary McLeod Bethune, educator; Rachel Carson, biologist and author; Emily Dickinson, poet; Amelia Earhart, aviator; Betty Friedan, feminist; Helen Hayes, actress; Mary Harris Jones, labor leader; Margaret Mead, anthropologist; Georgia O'Keeffe, artist; Rosa Parks, civil rights activist; Jeanette Rankin, first woman elected to Congress; Sally Ride, astronaut; Eleanor Roosevelt, author, diplomat, and humanitarian; Rosalyn Yalow, scientist; and Mildred Didrikson Zaharias, athlete.

The hall of fame exhibits consist largely of large panels with brief biographies, artifacts, and photographs of the women honored. They are arranged in groupings according to the areas of achievement.

The National Women's Hall of Fame moved into its present home, a historic 1916 former bank building, in 1979. It is near the Women's Rights National Historical Park Visitor Center, which has 19 life-sized statues of the women and

men who called for and participated in the 1884 women's rights convention. The annual attendance is approximately 35,000.

National Women's Hall of Fame, 76 Fall St., PO Box 335, Seneca Falls, NY 13148. Phone: 315/508–8060. Hours: May–Oct. 9:30–5 Mon–Sat.; 12–4 Sun; Nov.–Apr. 10–4 Wed.–Sat.; 12–4 Sun.; closed New Year's Day, Thanksgiving, and Christmas. Admission: adults, $3; seniors and students, $1.50; children under 6, free; families, $7.

QUILTERS HALL OF FAME. (See Quilting category.)

UNITED STATES FIELD HOCKEY ASSOCIATION HALL OF FAME. (See Field Hockey category.)

WOMEN'S INTERNATIONAL BOWLING CONGRESS HALL OF FAME. (See Bowling category.)

Unusual
Halls of Fame

BARBIE DOLLS

BARBIE DOLL HALL OF FAME, Palo Alto, California. The Barbie Doll Hall of Fame in Palo Alto, California, is an ever-growing collection of more than 18,000 Barbie Dolls and outfits—including those of her boyfriend Ken, her best friend Midge, and others—assembled by Evelyn Burkhalter, founder of the privately operated museum. She started the hall of fame in 1984 with approximately 5,000 dolls and costumes.

The dolls are largely in chronological dioramas showing the changes in fashions and women's roles over the years. Mrs. Burkhalter's prized possessions are the original 1959 Barbie Dolls produced by Mattel. Over a half-billion dolls of Barbie and friends have been produced since then.

The hall of fame originally was in a workroom behind the clinical audiology office of her husband Robert. In later years, the hall of fame was moved to an expanded space in front of the doctor's office, because of its popularity and the need for additional space as the collection grew.

Barbie Doll Hall of Fame, 433 Wavery St., Palo Alto, CA 94301. Phone: 415/326–5841. Hours: 1:30–4:30 Tues.–Fri.; 10–12 noon and 1:30–4:30 Sat.; closed major holidays. Admission: adults, $6; children under 12, $4.

BULLS

BULL HALL OF FAME, Plain City, Ohio. The Bull Hall of Fame in Plain City, Ohio, was established in 1989 by Select Sires, a federation of 11 farmer-owned artificial insemination cooperatives that provides semen to livestock

breeders throughout the world. The hall honors bulls for their exceptional semen and output.

Eighteen bulls have been named to the hall of fame, usually one a year. Their photographs are featured on a wall of the facility. In addition, tours are given for visitors to see many of the approximately 1,300 bulls at the facility, a video on the artificial insemination process, and the marble tombstones of five of the prized bulls buried on the grounds.

Bull Hall of Fame, Select Sires, 11740 U.S. Route 42, North, PO Box 143, Plain City, OH 43064–0143. Phone: 614/873–4683. Hours: 8:30–4 daily; closed major holidays. Admission: free.

BURLESQUE

BURLESQUE HALL OF FAME AND MUSEUM, Helendale, California. The Burlesque Hall of Fame and Museum—located on a 40-acre ranch in Helendale, California—celebrates one of the most flamboyant theatrical and entertainment eras in America's history, the heyday of stripteasers and exotic dancers. The site, also known as Exotic World, is the home of Dixie Evans, former exotic dancer, today the curator and past president of Exotique Dancers of America, Inc., which is devoted to improving and promoting the image of exotic dancers.

The hall of fame plays special tribute to 11 stars in the field—Gypsy Rose Lee, Josephine Baker, Sally Rand, Lili St. Cyr, Tempest Storm, Blaze Starr, Georgia Southern, Rose LaRose, Jennie Lee, Stacy Farrell, and Jeanine France. Its displays also cover the careers of many other strippers and dancers.

The 2,000-square-foot museum has the largest collection of burlesque photographs in the nation and extensive collections of costumes, G-strings, pasties, props, posters, playbills, and memorabilia—including Sally Rand's fans, shoes, and street clothes.

A reunion of old and new exotic dancers has been held in the spring for more than 30 years. The facility is halfway between Barstow and Victorville, off Route 66.

Burlesque Hall of Fame and Museum, 29053 Wild Rd., Helendale, CA 92342. Phone: 619/243–5261. Hours: 10–4 daily. Admission: free.

COCKROACHES

COCKROACH HALL OF FAME, Plano, Texas. Michael Bohdan, a professional exterminator, has one of the most unusual halls of fame, in his Pest Shop in Plano, Texas. He started the promotional Cockroach Hall of Fame in 1990 "to help educate people about bugs and roaches in a funny way."

Twenty-eight dressed-up cockroaches are in the hall of fame. They are displayed in cases in his retail store and have such names as Marilyn Monroach,

Elvis Roachley, Ross Peroach, and Liberoache. In addition, the shop has representative roach species, extremely large and hissing roaches (from Madagascar), and various other bugs on exhibit, as well as occasional roach races.

Cockroach Hall of Fame, 3331-B W. 15th St., Plano, TX 75075. Phone: 214/519–0355. Hours: 12–5 Mon.–Fri.; 12–3 Sat. Admission: free.

CRAYONS

CRAYOLA HALL OF FAME, Easton, Pennsylvania. Binney & Smith, Inc., founded the Crayola Hall of Fame at its manufacturing plant in Easton, Pennsylvania, in 1990 to tell the story of the company and its crayon products and to honor the first eight Crayola colors, which were retired that year. The hall of fame was so popular, attracting approximately 300,000 visitors annually, that it was expanded and moved to a new visitor center—called "The Crayola Factory"—at the Two Rivers Landing cultural center as part of an Easton downtown urban renewal project in 1996.

The 20,000-square-foot Crayola Factory enables visitors to learn about the company's history, see Crayola crayons and markers being made, and interact with more than a dozen exhibits with related creative activities. Visitors are able to color giant glass walls, finger paint, make prints, mix paints, decorate a 3-D sculpture, and create posters, greeting cards, and other works with a computer. The hall of fame recognizes the most important moments and characters in Crayola history.

Crayola Hall of Fame, Binney & Smith, Inc., The Crayola Factory, Two Rivers Landing, 30 Centre Sq., Easton, PA 18042–7744. Phone: 610/515–8000. Hours: 9:30–5 Tues.–Sat.; 12–5 Sun.; closed New Year's Day, Easter, Thanksgiving, and Christmas. Admission: adults and children, $6; seniors, $5.50; children under 2, free; discounts for groups.

HAMBURGERS

HAMBURGER HALL OF FAME, Seymour, Wisconsin. The Hamburger Hall of Fame is located in Seymour, Wisconsin, which became the official "Home of the Hamburger" in a nationwide poll conducted by the White Castle hamburger chain. It was at the Outagamie County Fair in Seymour in 1885 that Charles R. Nagreen (better known as "Hamburger Charlie") gave birth to the modern hamburger.

As an enterprising young food vendor, 15-year-old Nagreen, who was selling meatballs at the fair, noticed that most people kept moving past his food stand even though, he was convinced, he had a good product and many of the people were hungry. He decided he needed to make the meatballs portable, so he flattened them and placed them between two pieces of bread, producing the first hamburgers. Nagreen continued to work county fairs in the area for 65 years.

The hamburger is celebrated in Seymour with the Hamburger Hall of Fame and an annual "Burger Fest," with the frying of a giant 1,000-pound burger, a parade, entertainment, children's activities, and a craft sale, held the first Saturday in August.

The hall of fame houses artifacts, paraphernalia, documents, and publications relating to the history of the hamburger, including the hamburger memorabilia collection of Jeffrey Tennyson, author of *Hamburger Heaven*, and the grill used to cook the world's largest hamburger (5,520 pounds, enjoyed by 13,000 visitors) at the 1989 Burger Fest. Approximately 5,000 people visit the 1,000-square-foot museum, founded in 1993.

Hamburger Hall of Fame, 126 N. Main St., Seymour, WI 54165. Phone: 414/833–9522.
 Hours: Memorial Day–Labor Day 10–4; closed Fourth of July. Admission: free.

MEDICAL DEVICES

QUACKERY HALL OF FAME, Minneapolis, Minnesota. The Museum of Questionable Medical Devices in Minneapolis is called the "Quackery Hall of Fame" because it features the world's largest collection of items of medical equipment that pretend to cure illnesses. Over 250 such devices are in this 1,200-square-foot facility in the St. Anthony Main complex.

Founded in 1989 by Robert McCoy, the museum consists of equipment on loan from the original quackery museum in St. Louis (now in the custody of the St. Louis Science Center), the American Medical Association, the Food and Drug Administration, the National Council Against Health Fraud, and other such sources.

Among the alleged miracle-cure devices on display are a prostate gland warmer, a machine which uses lights to diagnose ailments and kill insects, a device that turns water into a cure-all and bad wine into good, a rectal dilator for curing hemorrhoids, a food-operated breast-enlarger pump, a machine that can make a person younger, and a mini-rake for growing hair on bald heads. McCoy frequently appears on television programs to show and explain the medical gadgetry.

Museum of Questionable Medical Devices, 2219 S.E. Main St., Minneapolis, MN 55414.
 Phone: 612/379–4046. Hours: 5–9 P.M. Tues.–Thurs.; 5–10 P.M. Fri.; 11 A.M.–10 P.M.
 Sat.; 12 noon–5 Sun.; closed holidays. Admission: free.

PRESIDENTIAL LOSERS

GALLERY OF ALSO RANS, Norton, Kansas. Unlike typical halls of fame, the Gallery of Also Rans at the First State Bank in Norton, Kansas, honors the losers rather than the winners. It is a gallery of portraits of official candidates for the office of president of the United States who were not elected.

W. W. Rouse, president of the bank for many years, came up with the idea in 1965 after reading Irving Stone's *They Also Ran*, which analyzed a half-dozen presidential candidates who did not win. He originally wanted to locate the gallery adjacent to a replica of an 1859 stagecoach station (Station 15). When it did not work out, he put the gallery in his bank building, a renovated movie theater with plenty of extra room.

The gallery is on the mezzanine overlooking the tellers in the First State Bank. It features the framed official Library of Congress portraits and a brief biography of those who have lost presidential elections.

Among the candidates who lost elections and are depicted in the gallery are Henry Clay, Horace Greeley, William J. Bryan, Charles E. Hughes, Robert M. LaFollette, Alfred E. Smith, Thomas E. Dewey, Adlai Stevenson, Barry Goldwater, Michael Dukakis, and Bob Dole. The gallery also has portraits of some elected presidents who lost at other times, including Thomas Jefferson, John Adams, Andrew Jackson, Grover Cleveland, Theodore Roosevelt, Herbert Hoover, Richard M. Nixon, and Jimmy Carter.

Gallery of Also Rans, First State Bank, 105 Main St., PO Box 560, Norton, KS 67654. Phone: 913/877–3341. Hours: 9–3 Mon.–Fri.; 9–11:30 Sat. closed bank holidays. Admission: free.

SNEAKERS

HALL OF FUMES, Montpelier, Vermont. The Hall of Fumes is the result of an annual promotional competition to select "the world's worst rotten sneakers." The winning entry each year is displayed with past winning sneakers in an exhibit case at the Recreation Department's gymnasium in Montpelier, Vermont.

The International Rotten Sneaker Contest began in Montpelier in 1976. Combe, Inc., maker of "Odor-Eaters" foot care products, headquartered in White Plains, New York, became the sponsor in 1988 and began the exhibition the following year. In 1995 the company, which also produces "Just for Men" hair color products, sponsored a "Face of the Year" competition in Cooperstown, New York. It selected the best facial hair, with the winner being the inaugural inductee in the Facial Hair Hall of Fame (which does not have a home). The contest since has been modified and no longer is limited to facial hair.

Hall of Fumes, Recreation Dept. Gym, 55 Barre St., Montpelier, VT 05602. Phone: 802/223–5141. Hours: varies, when gym is open. Admission: free.

Statuary
Halls of Fame

HALL OF FAME FOR GREAT AMERICANS. (See Notable Americans category.)

NATIONAL HALL OF FAME FOR FAMOUS AMERICAN INDIANS. (See Native Americans category.)

NATIONAL STATUARY HALL. (See Notable Americans category.)

NEW YORK YANKEES MEMORIAL PARK. (See Baseball category.)

TELEVISION ACADEMY HALL OF FAME. (See Radio and Television category.)

Walks of Fame

ATLANTA CELEBRITY WALK, Atlanta, Georgia. The Atlanta Celebrity Walk is a tribute to famous Georgians. Started in 1985, the marble inlay walk-way stretches from Peachtree Center and Independence Avenue to the World Congress Center in Atlanta. Each 3-by-3-foot sidewalk flagstone contains a bronze outline of the State of Georgia and the honoree's name, field, and year inducted.

Fourteen persons have been cited thus far, in a variety of fields. They include Martin Luther King, Jr., civil rights leader; Ray Charles, musical entertainer; Juliette Gordon Lowe, founder of the Girl Scouts of America; Hank Aaron, baseball star; Margaret Mitchell, author of *Gone with the Wind*; Andrew Young, former Atlanta mayor and United Nations ambassador; and Robert Woodruff, founder of the Coca-Cola Company.

Atlanta Celebrity Walk, 3180 Clairemont Rd., Suite 703, Atlanta, GA 30329. Phone: 770/662–4151. Hours: open 24 hours. Admission: free.

HOLLYWOOD WALK OF FAME, Hollywood, California. Over 2,065 movie, television, radio, recording, and theater celebrities are honored in the Hollywood Walk of Fame, which stretches for nearly 2.5 miles in the heart of California's motion picture capital. The names of entertainment greats and near-greats are enshrined in the sidewalks of Hollywood Boulevard from Gower Street to Sycamore Avenue and along Vine Street from Yucca Street to Sunset Boulevard.

The Hollywood Walk of Fame was started by the Hollywood Chamber of Commerce in 1960. The initial eight celebrities were drawn from a hat of nominees. It was an experimental project to see how the public would react to the

concept; the response was highly favorable—and sidewalk places were provided for 2,500 stars.

The first eight inductees were actors Olive Borden, Ronald Colman, Preston Foster, Burt Lancaster, and Joanne Woodward; directors Edward Sedgwick and Ernest Torrence; and comedian Louis Fazenda. Since then, from 12 to 20 persons have been selected annually. The program is now administered by the chamber of commerce and the Hollywood Historic Trust.

Among the many stars in the Hollywood Walk of Fame are Mary Pickford, Charlie Chaplin, Shirley Temple, Clark Gable, Marilyn Monroe, Julie Andrews, Steve McQueen, Billie Holiday, Bette Midler, Bing Crosby, Elvis Presley, Groucho Marx, Bob Hope, Ingrid Bergman, Judy Garland, Fred Astaire, Gene Kelly, Tom Cruise, Michael Jackson, Tom Hanks, and even Bugs Bunny and Lassie. Others are less well known, such as Carl Laemmie, founder of Universal Pictures; Thomas Ince, early Hollywood producer; and directors Sam Wood and Mitchell Leisen. Some celebrities have been honored in several categories, but only Gene Autry, the singing cowboy, has been cited in all five fields.

Along the Hollywood Walk of Fame is the courtyard of stars at Mann's Chinese Theater, formerly known as Grauman's Chinese Restaurant, at 6925 Hollywood Boulevard. A collection of footprints, handprints, and autographs of nearly 200 past and present movie celebrities can be seen in the concrete sidewalk. The practice began inadvertently in 1927, when silent film star Norma Talmadge accidentally stepped into a sidewalk of wet cement and then added her autograph and handprints. Shortly afterward, Mary Pickford and Douglas Fairbanks did the same thing—on purpose—and a tradition was born.

Since then many stars have left footprints, handprints, autographs, and even more: John Wayne left a fist print; Roy Rogers, a print of his six-shooter and of the hoofs of his horse, Trigger; Betty Grable, a leg print and greetings to the military forces; Jimmy Durante, a print of his nose; and Charlie McCarthy, Edgar Bergen's dummy, a drawing of his top hat and monocle.

Hollywood Walk of Fame, Hollywood Chamber of Commerce, 7018 Hollywood Blvd., Hollywood, CA 90028. Phone: 213/469–8311. Hours: open 24 hours. Admission: free.

PALM SPRINGS WALK OF STARS AND GALLERY WITHOUT WALLS, Palm Springs, California.

The city of Palm Springs, California, has two hall of fame outdoor programs, the Palm Springs Walk of Stars and the Gallery Without Walls, located side by side along historic Palm Canyon Drive.

The Walk of Stars, a sidewalk plaque program started in 1992, honors more than 50 past and present residents from the entertainment field who have lived in Palm Springs, including Marilyn Monroe, Elizabeth Taylor, Bob Hope, Frank Sinatra, Liberace, Elvis Presley, Sonny Bono, Harpo Marx, Dinah Shore, and Buddy Rogers.

The Gallery Without Walls, a sculpture undertaking which began as part of a public arts program in 1994, recognizes individuals and groups for

significant contributions to the development and improvement of Palm Springs. Among the ten persons honored are Lucille Ball, Frank Sinatra, Liberace, and Charles Chaplin. The groups cited for their work are the Agua Caliente Band of Cahilla, Hispanic Influence, and the Entertainment Industry (with two sculptures).

Palm Springs Walk of Stars and Gallery Without Walls, Downtown Development Center, 190 W. Amado, Palm Springs, CA 92262. Phone: 619/325–8979. Hours: open 24 hours. Admission: free.

RADIO CITY MUSIC HALL SIDEWALK OF STARS, New York, New York. Radio City Music Hall in New York City started a "Sidewalk of Stars" in 1993 but then abruptly halted the program without explanation. The sidewalk tributes have been removed, and the program now is under review. The program was designed to honor some of the great performers who have appeared in that world-famous theater.

Singer-actress Liza Minnelli was the first to have an 11-inch bronze disk with a star and her signature placed in the sidewalk under the marquee at 50th Street and Sixth Avenue. Thirteen other individual and group performers also were honored, but not all the sidewalk tributes were installed.

Among the performers selected for the "Sidewalk of Stars" were Ray Charles, Michael Crawford, Whitney Houston, Julio Iglesias, Shirley MacLaine, Barry Manilow, Bette Midler, Diana Ross, Frank Sinatra, Tina Turner, and Andrew Lloyd Webber, as well as the Music Hall's Rockettes and the theater's Christmas Spectacular Show.

Radio City Music Hall Sidewalk of Stars, 1260 Sixth Ave., New York, NY 10020. Phone: 212/632–4087. Program now under review.

ST. LOUIS WALK OF FAME, St. Louis, Missouri. Seventy-five past and present St. Louisans are honored for their achievements and contributions in the St. Louis Walk of Fame in the University City Loop area of the Missouri city.

The walk of fame—which covers sidewalks from the 6200 to 6600 blocks of Delmar Boulevard—contains tributes with bronze stars and plaques describing the accomplishments of the enshrined. The sponsoring nonprofit organization was started in 1988 by Joseph Edwards, owner of the nearby Blueberry Hill Pub and Restaurant, who wanted to recognize the city's outstanding achievers.

Among those honored are city founder Auguste Chouteau; explorer William Clark; newspaper pioneers Joseph Pulitzer and Elijah Lovejoy; poets T. S. Eliot and Eugene Field; aviator Charles A. Lindbergh; baseball stars Yogi Berra, Lou Brock, Dizzy Dean, and Stan Musial; actors Buddy Ebsen, John Goodman, Betty Grable, Vincent Price, and Shelly Winters; musicians Chuck Berry, Miles Davis, and Scott Joplin; scientists Harry Commoner, Arthur Holly Compton, and Carl and Gerty Cori; playwright Tennessee Williams; entertainers Josephine Baker and Tina Turner; dancer Katherine Dunham; boxer Henry Armstrong;

comedians Phyllis Diller and Redd Fox; authors Maya Angelou and William Burroughs; civil rights activists Dred and Harriet Scott and Dick Gregory; broadcasters Dave Garroway and Bob Costas; and President Ulysses S. Grant.

St. Louis Walk of Fame, 6504 Delmar Blvd., St. Louis, MO 63130. Phone: 314/727-7827. Hours: open 24 hours. Admission: free.

SANTA CLARITA VALLEY WALK OF WESTERN STARS, Santa Clarita, California. The Santa Clarita Valley Walk of Western Stars honors western actors who have lived or worked in that California valley and have contributed to the western filming, entertainment, or literacy history of the area. The Santa Clarita community of Newhall has been the home of western stars and film making since 1903.

The western walk of fame, which began in 1981, consists of 53 bronzed-saddle plaques in the walkways along San Fernando Road from William S. Hart Park to Ninth Street in downtown Newhall. New names were added annually until an earthquake hit the area in 1994 and destroyed the auditorium near where the plaques are located. Plans call for resumption of the program with the construction of a new conference center in 1988.

Many of filmland's best-known western actors are honored, immortalized in bronze and terrazzo tile along the streets of old Newhall. They include such cowboy stars as William S. Hart, Tom Mix, Hoot Gibson, Gene Autry, Roy Rogers, John Wayne, Harry Carey, Sr., Clayton Moore, Tex Ritter, Dale Robertson, Ben Johnson, Hugh O'Brien, and Jack Palance. Among the western women actors recognized are Dale Evans, Amanda Blake, Virginia Mayo, Jane Russell, and Katharine Ross.

Santa Clarita Valley Walk of Western Stars, 22565 Paraguay Dr., Santa Clarita, CA 91350–2345. Phone: 805/253–7230. Hours: open 24 hours. Admission: free.

SURFING WALK OF FAME, Huntington Beach, California. The pioneers and champions of surfing are honored in the Surfing Walk of Fame in Huntington Beach, California. The first inductions were in 1994. Plaques are placed in the sidewalk from the pier to the corner of Main Street and Pacific Coast Highway. The walk of fame is two blocks from the International Surfing Museum, one of the sponsors, which has photographs and information on those enshrined.

Among the surfers cited are Bruce Brown, Robert August, and Duke Kahanamoku, considered the "father of surfing" for having popularized the sport in the 1920s. The museum also has exhibits on surfing history, equipment, memorabilia, art, and motion pictures.

Surfing Walk of Fame, Main St. and Pacific Coast Hwy., and International Surfing Museum, 411 Olive St., Huntington Beach, CA 92648. Phone: 714/960–3483. Hours: walk of fame open 24 hours; museum—summer: 12 noon–5 daily; winter: 12 noon–5 Wed.–Sun. Admission: walk of fame free; museum—adults, $2; students, $1; children under 6, free.

WEST TEXAS WALK OF FAME, Lubbock, Texas. The West Texas Walk of Fame in Lubbock pays tribute to individuals who have gained national recognition in the fields of art, music, or entertainment and have an affiliation with Lubbock or the West Texas region. The program, conducted by Civic Lubbock, Inc.—began in 1980 and now honors 32 persons with bronze plaques in sidewalks at the Lubbock Memorial Civic Center complex.

Buddy Holly, the ''father'' of rock and roll, was the first to be inducted. An 8-foot 6-inch bronze statue of Holly also serves as the focal point and induction site for the walk of fame. Among the others who have been honored are country music stars Waylon Jennings, Mac Davis, Jimmy Dean, Tanya Tucker, Bob Wills, and the Gatlin Brothers; rockabilly standouts Roy Orbison, Joe Ely, and Buddy Knox; songwriters/performers Sonny Curtis and Gary P. Nunn; and actors G. W. Bailey and Barry Corbin.

The walk of fame is located between Seventh and Eighth Streets and Avenues O and Q in the civic center area.

West Texas Walk of Fame, Memorial Civic Center, City of Lubbock, 1501 Sixth St., Lubbock, TX 79401. Phone: 806/767–2241. Hours: open 24 hours. Admission: free.

Rings of Fame

DALLAS COWBOYS RING OF HONOR, Irving, Texas. The Dallas Cowboys Ring of Honor, located on the wall above the professional football team's bench at Texas Stadium in Irving, salutes former players and coaches who have made outstanding contributions to the club. Started as the Dallas Cowboys Hall of Fame in 1975, the name was changed to the present Ring of Honor the following year.

Ten former Cowboys are currently honored. They include longtime coach Tom Landry, who led the team to two Super Bowl victories and five National Football Conference titles during his 1960–1988 career; quarterbacks Don Meredith and Roger Staubach; running backs Tony Dorsett and Don Perkins; linebackers Chuck Howley and Lee Roy Jordan; defense tackles Bob Lilly and Randy White; and defensive back Mel Renfro.

Dallas Cowboys Ring of Honor, Texas Stadium, Irving, TX 75063–4999. Phone: 214/556–9900. Hours: whenever stadium open. Admission: no additional charge beyond cost of event.

DENVER BRONCOS RING OF FAME, Denver, Colorado. The Denver Broncos honor their greatest players and administrators who played significant roles in the professional football team's history in the Ring of Fame at Mile High Stadium in Denver, Colorado. Started in 1984, the Ring of Fame displays the names of 15 inductees on the facade just below the third level of the stadium's east stands.

The first former players named to the Ring of Fame were running back Floyd Little, defensive end Rich Jackson, wide receiver Lionel Taylor, and safety Austin "Goose" Gonsoulin. Former owner Gerald H. Phipps became the first nonplayer to be honored, in 1985.

Among the others in the Ring of Fame are quarterbacks Frank Tripucka, Charley Johnson, and Craig Morton; defensive back Billy Thompson; defensive end Paul Smith; linebackers Randy Gradishar and Tom Jackson; cornerback Louis Wright; wide receiver Haven Moses; and kicker Jim Turner.

Denver Broncos Ring of Fame, Mile High Stadium, Denver, CO 80204. Phone: 303/ 649–9000. Hours: whenever stadium open. Admission: no additional charge beyond cost of event.

KANSAS CITY CHIEFS RING OF HONOR, Kansas City, Missouri. Each year, the Kansas City Chiefs professional football team adds the name of one of its players, coaches, or executives to its Ring of Honor at Arrowhead Stadium in Kansas City, Missouri. It signifies that the individual has been selected for the Chiefs Hall of Fame.

The process, which began in 1970, has produced 26 inductees, including Lamar Hunt, the owner, and such outstanding players as quarterback Len Dawson, defensive lineman Buck Buchanan, and linebackers Willie Lanier and Bobby Bell. The Ring of Honor signage gives the honorees' names, uniform numbers, and years of service.

Kansas City Chiefs Ring of Honor, Arrowhead Stadium, 1 Arrowhead Dr., Kansas City, MO 64129. Phone: 816/924–9300. Hours: whenever stadium open. Admission: no additional charge beyond cost of event.

WASHINGTON HALL OF STARS, Washington, D.C. Outstanding sports figures in the Washington, D.C., area are honored in the Washington Hall of Stars, which rings the mezzanine level of Robert F. Kennedy Memorial Stadium in the nation's capitol. Started in 1982, this outdoor ring of fame features the names and fields of players, coaches, owners, and others for their contributions in various professional sports, such as baseball, football, basketball, hockey, and boxing.

Seventy-five persons have inducted, including such stellar players as Walter Johnson, Harmon Killebrew, Frank Howard, George Selkirk, Eddie Yost, Gil Hodges, Josh Gibson, and Roy Sievers, baseball; Joe Theisman, John Riggins, Sam Huff, Sonny Jurgensen, Dave Butz, Bill Dudley, and Charley Taylor, football; Elvin Hayes and Wes Unseld, basketball; Sugar Ray Leonard, boxing; and Lee Elder and Deane Beman, golf. Among the managers, coaches, and owners honored are Joe Cronin, Vince Lombardi, Red Auerbach, Bucky Harris, Jack Kent Cooke, Clark Griffith, and George Marshall.

Washington Hall of Stars, Robert F. Kennedy Memorial Stadium, 2400 E. Capitol St., S.E., Washington, DC 20003. Phone: 202/547–9077. Hours: whenever stadium open. Admission: no additional charge beyond cost of event.

Halls of Fame in Other Countries

AUSTRALIA

NEW SOUTH WALES HALL OF CHAMPIONS, Homebush, New South Wales. The New South Wales Hall of Champions, established in Sydney in 1978 and now located in the new State Sports Centre at Homebush Bay, honors Australian athletes from that region who have excelled at state, national, and international levels. An advisory committee recommends persons for the hall of fame to the Minister for Sport, who makes the final decision.

The hall of fame, which has inducted 260 outstanding athletes, occupies the entrance hallway leading to the hockey arena. Among those enshrined are Shane Gould and Dawn Fraser in swimming, Donald Bradman in cricket, and Evonne Goolagong Cawley in tennis.

The honorees are featured on a "Wall of Champions," containing a large action photograph of each athlete with biographical information. Several showcase exhibits contain uniforms, medals, equipment, certificates, and other materials pertaining to the hall of famers and their sports. Other exhibits are devoted to the history of sports in Australia, recent donations of sporting materials, and objects from the collections.

New South Wales Hall of Champions, State Sports Centre, Australia Ave., Homebush, New South Wales, Australia 2140 (PO Box 135, Flemington Market, NSW, Australia 2129). Phone: 02–763–0111. Hours: 9 A.M.–9 P.M. daily. Admission: free.

CANADA

AQUATIC HALL OF FAME AND MUSEUM OF CANADA, Winnepeg, Manitoba. The Aquatic Hall of Fame and Museum of Canada was founded upon

completion of the Pan-Am natatorium complex created for the 1967 Pan American Games in Winnipeg, Manitoba. It has since become Canada's most popular hall of fame, with an annual attendance of over 400,000.

The hall honors Canadians who have attained international recognition in aquatics by winning gold medals in Olympic, World, Commonwealth, or Pan American competition, or by distinguished service in the field over a number of years.

Among the 106 inductees are George Hodgson and Sasa "Alex" Baumann, both double Olympic gold medal winners; Peg Seller, founder of synchronized swimming; Sylvie Bernier, Olympic gold medal diver; and Carolyn Waldo-Baltzer, double gold-medal winner in Olympic synchronized swimming.

The hall of fame exhibits include memorabilia, photographs, posters, and works of art. Other displays cover the history of aquatics and feature the Cutty Sark Club worldwide collection of ship models and aquatics artifacts.

Aquatic Hall of Fame and Museum of Canada, 25 Poseidon Bay (mailing address: 600-330 Portage Ave.), Winnipeg, Manitoba, Canada R3C 0C4. Phone: 204/956–0490. Hours: 8 A.M.–10 P.M. daily. Admission: free.

BRITISH COLUMBIA SPORTS HALL OF FAME AND MUSEUM, Vancouver, British Columbia. The British Columbia Sports Hall of Fame and Museum in Vancouver, Canada, was founded in 1966 to honor the province's outstanding athletes, teams, and builders of sport. Housed for 25 years in a room in the B.C. Building on the Pacific National Exposition grounds, it now occupies 20,000 square feet on the third floor near Gate A in B.C. Place Stadium. The "SportHall," as it is called, moved into the stadium in 1991 and completed work on the facility in 1995.

The hall of fame/museum has 20 galleries, which feature inductees and highlights of sports in British Columbia from the early 1800s to the present. In addition to artifacts, photographs, and memorabilia, the exhibits make use of the latest interactive technology with touch-screen computers, videos, and illustrations.

The hall of fame section contains tributes to 189 individuals and 33 teams. Photographs and biographical sketches of athletes are displayed in the Hall of Champions; coaches, officials, and administrators are honored in the Hall of Builders. Among those enshrined are Harry Jerome, a track star who was named male athlete of British Columbia's first century; Dorothy Lidstone, record-breaking women's world archery champion; Paul Rowe, considered one of the greatest fullbacks in Canadian football; Frank Fredrickson, who led the Winnipeg Falcons to an Olympic hockey title in 1920; Dave Fryatt, who devoted 52 years to the development of soccer in the province, in Canada, and internationally; Ann Mundigel Meraw, who set seven world records in women's marathon swimming; Hugh Fisher, a double medalist in kayaking in the 1984 Olympics; Hedley Woodhouse, a leading jockey, with 2,600 victories; and Archie McKinnon, legendary track and swimming coach.

Two of Canada's most inspirational athletes, Terry Fox and Rick Hansen, are featured in two other galleries. Fox, who lost his right leg to cancer, attempted to run across Canada to raise money for cancer research but was forced to stop about midway because of his health. Hansen spent two years going around the world in a wheelchair to show what a handicapped person could accomplish and to further public understanding of people with disabilities.

British Columbia Sports Hall of Fame and Museum, Gate A, B.C. Place Stadium, 777 Pacific Blvd., South, Vancouver, British Columbia, Canada V5B 4Y8. Phone: 604/ 687–5520. Hours: 10–5 daily; closed New Year's Day and Christmas. Admission: adults, $6; seniors and children, $4; children 5 and under, free; families, $15; groups of 10 or more, $3.50 per person.

CANADA'S AVIATION HALL OF FAME, Wetaskiwin, Alberta. Canada's Aviation Hall of Fame, a tribute to the people who pioneered and advanced aviation in Canada, is housed in the aviation hangar of the Reynolds-Alberta Museum in Wetaskiwin, Alberta. Founded in Calgary in 1973, it was located in Edmonton for 18 years before it moved to its present site in 1992, when the museum opened.

The hall of fame has 153 inductees, who have had exceptional lives benefitting Canadian aviation as civilian and military pilots, doctors, scientists, aeronautical engineers, and administrators. Among those enshrined are W. R. ''Wop'' May, World War I fighter pilot and early commercial pilot; William Avery ''Billy'' Bishop, who shot down 72 enemy aircraft and received the Victoria Cross in World War I; W. R. Turnbull, an engineer-designer-inventor who built the first wind tunnel in Canada, made significant improvements in propellers, and was noted for his systematic approach to aeronautical research; Grant McConachie, a one-time bush pilot who became an airline executive and opened numerous Pacific commercial routes; and R. A. ''Bud'' White who piloted a CF-40 Starfighter to a Canadian altitude record of 100,100 feet in 1967.

Memorabilia, photographs, and vintage aircraft are part of the hall of fame exhibits. The Reynolds-Alberta Museum also has over 100 major artifacts, interactive exhibits, audiovisual presentations, and the seasonal operation of early bicycles, automobiles, aircraft, and agricultural and industrial machinery pertaining to the history of ground and air transportation, agriculture, and other selected Alberta industries.

Canada's Aviation Hall of Fame, Reynolds-Alberta Museum, Hwy. 13, PO Box 6360, Wetaskiwin, Alberta, Canada T9A 2G1. Phone: 403/361–1351. Hours: 9–5 daily, but 9–7 daily June 29–Sept. 2; closed New Year's Day, Good Friday, and Christmas Eve and Day. Admission: adults, $5.50; children 7–17, $2.25; children 6 and under, free; families, $13; discounts for groups.

CANADA'S SPORTS HALL OF FAME, Toronto, Ontario. Canada's oldest hall of fame museum, Canada's Sports Hall of Fame, recognizes outstanding achievement by Canadians in sports. Established and opened in 1955, the hall of fame has been located at Exhibition Place in Toronto since 1967.

The publicly supported hall of fame, which honors, preserves, and promotes Canada's sports history, selects leading athletes each year to be inducted into the hall. So far, 389 persons in nearly 50 sports have been enshrined. Among the inductees are Bobby Orr, hockey; Kurt Browning, figure skating; Nancy Greene, alpine skiing; Fergie Jenkins, baseball; Susan Nattrass, trapshooting; Marilyn Bell, swimming; and Northern Dancer, horse racing.

The 22,000-square-foot facility has three floors of exhibits. The exhibits include tributes to hall of famers and contain many of their Olympic medals, uniforms, equipment, trophies, memorabilia, photographs, and other materials. Among the varied displays are historic bicycles and tricycles, antique canoes, a 120-year-old rowing shell, curling stones, Jacques Villeneuve's Indy racing car, and touch-screen kiosk videos. Some of Canada's national awards for sports achievement also are kept at the museum, which has an annual attendance of approximately 100,000.

Canada's Sports Hall of Fame, Exhibition Pl. Toronto, Ontario, Canada M6K 3C3. Phone: 416/260–6789. Hours: 10–4:30 daily. Admission: free.

CANADIAN FIGURE SKATING HALL OF FAME, Gloucester, Ontario. The Figure Skating Hall of Fame, established in 1990, is located in the offices of its initiator—the Canadian Figure Skating Association in Gloucester, Ontario. Information and photographs of inductees are on a hallway wall, while trophies, artifacts, and memorabilia are displayed in cases throughout the association's headquarters.

Thirty-five athletes, coaches, officials, and other contributors to the sport have been enshrined in the hall of fame, including Barbara Ann Scott, a Canadian, North American, European, World, and Olympic champion in 1942–48; Donald Jackson, who held the senior men's Canadian, North American, and World Titles in 1959–62; Barbara Wagner and Robert Paul, Canadian, North American, World, and Olympic pair champions in 1956–60; and Otto and Maria Jelinek, Canadian, North American, and World pair champions in 1961–62.

The Canadian Figure Skating Association is the world's largest figure skating organization, with over 200,000 members in more than 1,450 clubs.

Canadian Figure Skating Hall of Fame, Canadian Figure Skating Assn., 1600 James Naismith Dr., Gloucester, Ontario, Canada K1B 5N4. Phone: 613/748–5635. Hours: 8:30–4:30 Mon.–Fri.; closed major holidays. Admission: free.

CANADIAN FOOTBALL HALL OF FAME AND MUSEUM, Hamilton, Ontario. Players and others who have contributed to the development of Canadian football are honored in the Canadian Football Hall of Fame and Museum in Hamilton, Ontario. The facility also collects, exhibits, and interprets artifacts and other memorabilia relating to the history of all levels of Canadian football.

The city of Hamilton, home of the Hamilton Tiger-Cats, was selected as the site for the hall of fame and museum in 1962 in a national competition. After

approximately a decade of collecting and development, the hall of fame and museum opened in a new 25,000-square-foot glass and marble building next to City Hall at the time of the Grey Cup championship game in Hamilton in 1972.

The central portion of Canadian Football Hall of Fame and Museum is devoted to the 176 players, coaches, officials, and administrators enshrined in the hall of fame. It contains a steel bust and brief biography of each honoree. Among the inductees are such outstanding players (most of whom starred on winning Grey Cup teams) as Ken Ploen, Winnipeg Blue Bombers quarterback; Russ Jackson, Ottawa Rough Riders quarterback; George Reed, Saskatchewan Roughriders running back; Jim Young, British Columbia Lions receiver; Angelo Mosca, tackle for the Hamilton Tiger-Cats, Ottawa Rough Riders, and Montreal Alouettes; and Tom Wilkinson, quarterback for the Toronto Argonauts, British Columbia Lions, and Edmonton Eskimos.

Canadian football differs somewhat from that played in the United States. It has 12 players rather than 11, the field is longer and wider, and a team is allowed three instead of four tries to make ten yards and a first down. In addition to the 12-man game, all levels of Canadian football—including six- and eight-man teams of the past and even touch football—are covered in exhibits.

Exhibits include a history of football, championship teams, evolution of equipment, theater highlights of memorable games, interactive exhibits, and the Grey Cup, featuring the trophy awarded to the Canadian Football League champion, and the Schenley Trophy, given to the best player from 1953 to 1988.

The hall of fame/museum has more than 30,000 objects in its collections. They include playing equipment, trophies, game and record footballs, jackets, banners, documents, and other such items, as well as more than 15,000 photographs and over 6,300 films and videos. The oldest artifact is the Montreal Challenge Cup from 1873.

The facility also offers five educational programs for visiting school groups and a number of traveling exhibitions on Canadian football.

Canadian Football Hall of Fame and Museum, 58 Jackson St., West, Hamilton, Ontario, Canada L8P 1L4. Phone: 905/528–7566. Hours: 9:30–4:30 Tues.–Sat.; closed holidays. Admission: adults, $3; seniors and students, $1.50; children under 14, $1; families, $8.

CANADIAN GOLF HALL OF FAME, Oakville, Ontario. The Canadian Golf Hall of Fame, operated by the Royal Canadian Golf Association, moved into a new 8,000-square-foot building at the Glen Abbey Golf Club in Oakville, Ontario, in 1996 after sharing a former monastery overlooking the golf course with the Canadian Open headquarters since 1976. It formerly was known as the Royal Canadian Golf Association Museum and Canadian Golf Hall of Fame.

Forty-six persons have been inducted since founded in 1971. They include amateur and professional golfers, administrators, and others, such as Jack Nicklaus (for his role in designing the Glen Abbey golf course). Among those inducted are Gary Cowan, two-time winner of the U.S. amateur championship;

George Knudson, eight-time PGA champion; Sandra Post, winner of the LPGA and eight other titles; and Marlene Stewart Streit, winner of the Canadian, American, British, and Australian tournaments.

The hall of famers are honored in a gallery with plaques featuring sketches and biographical information. Other exhibits trace the development of golf through equipment, fashion, architecture, rules, and maintenance. The hall of fame/museum has an extensive collection of historical materials, including a rare feather ball, long-nose clubs, early irons, and trophies, such as the 1904 Olympic trophy won by a Canadian (the last time golf was played in the Olympics), 1975 Commonwealth Trophy (won by a Canadian); and all four Canadian Open trophies since 1904.

Canadian Golf Hall of Fame, Leonard E. Shore Bldg., Glen Abbey Golf Club, 1333 Dorval Dr., Oakville, Ontario, Canada L6J 4Z3. Phone: 905/849–9700. Hours: 10–6 Thurs.–Mon. or by appointment; closed New Year's Day and Christmas. Admission: adults, $4; seniors and children, $3; families, $8.

CANADIAN LACROSSE HALL OF FAME, New Westminster, British Columbia.

The city of New Westminster in British Columbia is a hotbed of lacrosse in Canada. In 1963, local lacrosse enthusiasts, with the blessing of the city council, approached the Canadian Lacrosse Association for a charter to establish a hall of fame in the field. The charter was granted in 1964, and the Canadian Lacrosse Hall of Fame became incorporated in 1965. Two years later, the hall of fame opened in New Westminster's Centennial Community Centre.

Lacrosse has a long history in Canada, with the nation's first lacrosse club going back to the 1840s. Many of the rules of the game were set in 1869, with the publication of *The National Game of Canada*, by William George Beers.

The Canadian Lacrosse Hall of Fame has inducted over 325 players and builders of outdoor, field, and box lacrosse. Among those honored have been Dr. W. G. Beers, considered the "father" of organized lacrosse in Canada; Lionel Conacher, voted Canada's athlete of the first half-century; Edouard "Newsy" Lalonde, chosen as the most outstanding lacrosse player of the half century; Clifford "Doughy" Spring, who played for 32 years in senior lacrosse; Bill Whittaker, called the greatest goalie of all time by many; and Mervin E. Ferguson, who served as president of three national sports organizations, including the Canadian Lacrosse Association.

The exhibits include plaques, sticks, trophies, photographs, and other materials related to lacrosse.

Canadian Lacrosse Hall of Fame, 65 E. Sixth Ave., PO Box 308, New Westminster, British Columbia, Canada V3L 4Y6. Phone: 604/526–4281. Hours: by appointment. Admission: free.

CURLING HALL OF FAME AND MUSEUM IN CANADA, Kitchener, Ontario.

The Curling Hall of Fame and Museum of Canada, which began its hall of fame program in 1973 and was a traveling exhibition until recently, will now

finally have a permanent home. It is scheduled to open in an 8,000-square-foot facility in Kitchener, Ontario, in late 1997.

The hall of fame, a joint effort of the Canadian Curling Association and Canadian Ladies Curling Association, has honored 287 curlers, builders, and teams since its founding. Among the curling legends in the hall of fame are Ken Watson, known as the "king of curling" for his curling skill, articles, books, and leadership in developing curling; Garnet Campbell, who participated in ten Macdonald "Brier" competitions in his 25-year curling career; Ernie Richardson, four-time winner of the Macdonald "Brier" tournament and Scotch Cup world curling championship; Dr. Vera Pezer, a member of a four-time women's championship team who became a leading sports psychologist; and Joyce McKee, a member of nine championship teams and recipient of the 1985 Curl-Canada Award (now the Herb Millham Award) for her outstanding contributions to the sport of curling.

The hall of fame/museum has exhibits on the honorees and the history and nature of curling, as well as the largest curling reference library outside Scotland.

Curling Hall of Fame and Museum of Canada, 122 Frederick St., Kitchener, Ontario, Canada N2H 2L9. Phone: 519/587–0094. Hours: 10–4 Tue.–Sun.; closed holidays. Admission: free.

DAREDEVIL HALL OF FAME, Niagara Falls, Ontario. The Daredevil Hall of Fame, which is part of the 1800s-style Niagara Falls Museum in Niagara Falls, Ontario, Canada, honors jumpers, swimmers, boaters, rafters, tightrope walkers, barrel riders, and others who have challenged Niagara Falls—many of them failing to survive the experience.

The exploits of more than 30 daredevils are chronicled in the hall of fame, added in the 1950s to the offerings of the museum, which was founded in 1827 and has 26 galleries and over 700,000 artifacts.

Among the daredevils remembered are Sam Patch, the first to jump from the cliff, near Goat Island in 1829; tightrope walker Jean Francois Gravelet, who billed himself as "The Great Blondin" and made his first crossing of the gorge in 1859; George Hazlett and Bill Potts, who shot the rapids in a slat-and-stave container in 1886; Annie Taylor, a barrel rider who was the first to conquer the falls in 1901; and Bobby Leach, a seven-time barrel rider and jumper, who survived the falls only to slip on an orange peel and die while touring New Zealand at the turn of the century.

Many of the barrels and other equipment used by the daredevils are on display, as well as photographs and other materials relating to their adventures. Among the other exhibits at the museum are Egyptian mummies, dinosaur fossils, rocks and minerals, early weapons, freaks of nature, and displays on Niagara's power and industry. The four-story museum is located in a former corset factory.

Daredevil Hall of Fame, Niagara Falls Museum, 5651 River Rd., PO Box 960, Niagara Falls, Ontario, Canada L2E 6V8. Phone: 905/356–2151. Hours: summer 8:30 A.M.–

11 P.M. daily; winter 10–5 daily. Admission: adults, $6.75; seniors, $6.25; students, $4.95; children 5–10, $3.95; student groups, 9–13, $3.50; 5–8, $3; K–4, $2.75.

HOCKEY HALL OF FAME, Toronto, Ontario. The Hockey Hall of Fame, a shrine to the history, study, and greats of hockey, is located in the historic former Bank of Montreal building in downtown Toronto. The hall of fame spent $15 million in the move in 1993 to the 52,000-square-foot restored structure from its former site on the nearby Canadian National Exhibition grounds. It now has an annual attendance of over 300,000.

Funded by the National Hockey League, the hall of fame was founded in 1943 and has operated a museum-like facility since 1961. It has inducted more than 300 hockey players, builders, and officials, including such stars as Maurice "The Rocket" Richard, Fred Taylor, Yvan Cournoyer, Gordie Howe, Edouard "Newsy" Lalonde, Bobby Orr, Jack Stewart, Jacques Plante, Harry Broadbent, Bobby Hull, Ivan Johnson, Terry Sawchuk, Phil Exposito, Frank Mahovlich, Stan Mikita, and Alex Delvecchio.

Portraits and biographies of the honorees are displayed in the Bell Great Hall, which also contains cases of trophies—such as the Vezina, Hart, and Calder—and the most prized hockey trophy of all, the Stanley Cup. The memorabilia, equipment, and films of many of the hall of famers also can be seen in other exhibits.

Among the exhibit halls are several that feature great moments of the game; a replica of the Montreal Canadiens' dressing room; a behind-the-scenes look at hockey broadcasting; a comprehensive team directory, made accessible by lasers and videos; an interactive video hockey game; an international hockey section; and a display reliving family hockey memories. The hall of fame also has two theaters that show hockey films and a resource center with literature and reference material on the sport.

Hockey Hall of Fame, BCE Pl., 30 Yonge St., Toronto, Ontario, Canada M5E 1X8. Phone: 410/360–7735. Hours: 9–6 Mon.–Sat.; 10–6 Sun. Admission: adults, $8.75; seniors and children 13 and under, $5.75; special rates for groups.

INTERNATIONAL HOCKEY HALL OF FAME, Kingston, Ontario. The International Hockey Hall of Fame—a part of the International Ice Hockey Federation Museum in Kingston, Ontario, Canada—dates back to 1943. That is when the National Hockey League and the Canadian Amateur Hockey Association approved the creation of a hall of fame in Kingston to honor those who have contributed to the development of hockey, nationally or internationally.

The two-story museum, named the International Hockey Hall of Fame and Museum until its affiliation with the federation in 1993, opened in 1978; it was enlarged to its present 9,500 square feet in 1978. The first floor is devoted to the hall of fame and outstanding professional hockey players from throughout the world, while the second features the Capt. James T. Sutherland Memorial Lounge, named for the pioneer hockey player, manager, and league president

considered the "father" of hockey in Ontario. The lounge pays tribute to the builders of hockey and contains memorabilia of great North American amateur and professional teams.

More than 200 hockey players, officials, and builders have been inducted into the hall of fame, including such hockey stars as Fred "Cyclone" Taylor, Eddie Shore, Edouard "Newsy" Lalonde, Howie Morenz, Leonard "Red" Kelly, Aurel Joliat, Alan "Scotty" Davidson, Charlie Conacher, Francis "King" Clancy, Bill Mosienko, Walter "Babe" Pratt, Milt Schmidt, Gordie Howe, and Bobby Hull.

Among the artifacts, memorabilia, and other materials on display are an early hockey stick used in 1886–88; the first hockey cards, from 1906–09; 20-inch blades used by skaters a century ago; sweaters of three hockey greats—Gordie Howe, Bobby Hull, and Dit Clapper; one of the first hockey player contracts (for Alf Smith of Ottawa); and the battered skates of Scotty Davidson and referee Mike Rodden.

International Hockey Hall of Fame, International Ice Hockey Federation Museum, Alfred and York Sts., PO Box 82, Kingston, Ontario, Canada K7L 4V6. Phone: 613/544-2355. Hours: mid-June–Labor Day 10–5 daily; other times by appointment; closed major holidays. Admission: adults, $2; seniors and children over 13, $1.50; children under 13 with parents, free; families, $4.

MONTREAL YM/YWHA SPORTS HALL OF FAME. (See American All-Sports category—listed with New York Jewish Sports Hall of Fame.)

NAISMITH INTERNATIONAL BASKETBALL CENTRE AND HALL OF FAME, Almonte, Ontario. The Naismith International Basketball Centre and Hall of Fame is a memorial to Dr. James Naismith, the founder of basketball, at his birthplace in Ramsay Township near Almonte, Ontario, in Canada. It is located in a century-old farmhouse on the land of his birth, about a half-hour drive from Ottawa.

The Naismith Foundation and the hall of fame were created in 1989, and the museum-like facility opened in 1993. So far, 25 individuals and five teams have been inducted into the hall of fame, in five categories—athletes, coaches, builders, officials, and teams. They include Dr. Naismith; Jack Donohue, coach of the Canadian national team in 1972–88; coach J. Percy Page and the Edmonton Grads team; Isiah Thomas, general manager of the Toronto Raptors; John "Wink" Willox, longtime official; and Beverly Smith, member and captain of the 1996 Canadian Olympic basketball team.

The exhibits consist of the personal effects of Dr. Naismith, photographs and artifacts relating to Canadian basketball, and items from various Canadian events.

Plans call for a $4 million, multifunctional complex to be built on 15 acres of the Naismith farm within a few years. It will feature interpretive, interactive, and historical exhibits in addition to the hall of fame.

Naismith International Basketball Centre and Hall of Fame, PO Box 1991, Almonte, Ontario, Canada K0A 1A0. Phone: 613/256–0491. Hours: May–Oct. 9–5 Mon.–Fri.; 12–5 Sat.–Sun.; other times by appointment. Admission: donation.

NEW BRUNSWICK SPORTS HALL OF FAME, Fredericton, New Brunswick. The New Brunswick Sports Hall of Fame, devoted to the Canadian province's sports heritage and outstanding sports figures, is located in an 1881 building within the historic military compound in Fredericton. Founded by the province in 1970, the hall of fame moved into its present home in the John Thurston Clark Building in 1977.

The hall of fame has inducted 135 persons and teams in two categories—81 individuals athletes and 14 sports teams, and a broad category of 40 sports builders that includes coaches, officials, organizers, administrators, executive members, sponsors, and patrons.

Among those enshrined are Ron Turcotte, the jockey who rode Secretariat to the Triple Crown in horse racing; Gordon Drillon, former National Hockey League scoring champion; Danny Grant, former NHL rookie of the year and 50-goal scorer; and Charles Gorman, 1926 world speedskating champion.

In addition to original charcoal portraits of inductees, the hall of fame has exhibits on baseball, basketball, curling, golf, track and field, hockey, speed skating, and horse racing. Special exhibits also are organized annually on some aspect of New Brunswick's sports heritage. The 2,300-square-foot facility will be increased to 6,500 square feet, mostly exhibit space, by 1998.

New Brunswick Sports Hall of Fame, 503 Queen St., PO Box 6000, Fredericton, New Brunswick, Canada E3B 5H1. Phone: 506/453–3747. Hours: May–Labor Day 10–4 daily; day after Labor Day–Apr. 12–4 Mon.–Fri.; closed major holidays during winter. Admission: free.

NORTHWESTERN ONTARIO SPORTS HALL OF FAME, Thunder Bay, Ontario. The Northwestern Ontario Sports Hall of Fame in Thunder Bay, Ontario, Canada, honors 96 athletes, 44 sports builders, and 30 teams from that region for their outstanding achievements and contributions. Founded in 1976, the hall of fame opened in 1978 and recently moved into a 6,000-square-foot space.

Plaques with photographs are devoted to such sports figures and teams as Alex Delvecchio, a hockey star who played with the Detroit Red Wings for 23 seasons and on seven National Hockey League and three Stanley Cup championship teams; Steve Collins, a ski jumper who competed in three Olympic Games, represented Canada in World Cup events, and set a 90-meter hill record in Lahti, Finland, in 1980; Bill Sawchuk, a member of the Canadian national swim team who held numerous national and international titles and won a record-setting seven medals at the 1978 Commonwealth Games; the Al Hackner Curling Rink team, which won the Canadian men's curling title and the region's first world curling championship; and Jack Adams, a onetime hockey player

who coached and managed the Detroit Red Wings for 35 years, winning 12 NHL championships and seven Stanley Cups.

Northwestern Ontario Sports Hall of Fame and Museum, 219 May St., South, Thunder Bay, Ontario, Canada P7E 1B5. Phone: 807/622–2852. Hours: 10–5 Tues.–Sun.; closed Christmas. Admission: adults, $2; seniors and children, $1.

OLYMPIC HALL OF FAME AND MUSEUM, Calgary, Alberta. The Olympic Hall of Fame and Museum in Calgary, Alberta, in Canada, is a legacy of the XV Olympic Winter Games in Calgary in 1988. It opened in Olympic Park the day before the games began and celebrates the history of Winter Olympics, the organizing and pageantry of the Calgary Olympics, and the Canadians who have won medals in the Winter Olympics.

The hall of fame/museum is located in a three-story, 10,500-square-foot building in Olympic Park, which now also serves as a training center, public ski area, and visitors center. It is the world's largest Winter Olympics museum and has an annual attendance of more than 60,000.

The hall of fame has inducted 50 Canadians—nine individual Olympics medalists, 30 members of Olympic teams, five persons for their work in developing Canadian winter sports, and six for furthering the Olympic spirit.

Among the individual Olympic medal winners enshrined are Nancy Greene, Anne Heggtveit, Kathy Kreiner, and Kerrin Lee-Gartner, alpine skiing; Gaetan Boucher and Cathy Priestner, speed skating; Brian Orser and Barbara Ann Scott, figure skating; and Mangus Goodman, hockey. The team medalists were in bobsledding, figure skating, and hockey.

Olympic Hall of Fame and Museum, 88 Canada Olympic Rd., S.W., Calgary, Alberta, Canada T3B 5R5. Phone: 403/247–5455. Hours: summer 8 A.M.–9 P.M. daily; winter 10–5; closed Christmas. Admission: adults, $3.75; seniors and children, $2.75; families, $10.

SASKATCHEWAN SPORTS HALL OF FAME AND MUSEUM, Regina, Saskatchewan. The Saskatchewan Sports Hall of Fame and Museum in Regina began as the Molson's Sports Hall of Fame with a few photographs at the brewery in 1966. The hall of fame was established as an independent organization with a new name in 1971. Three years later, a temporary gallery was opened in the Saskatchewan Sport and Recreation Unlimited Building. The hall of fame moved in 1979 into its present home in the renovated Land Titles Building, which became a designated provincial heritage site. In 1990, "museum" was added to the hall of fame's name as its collections and exhibits grew and its space was expanded to 5,000 square feet.

The hall of fame has inducted 141 athletes, 88 sports builders (coaches, officials, administrators, and others), and 79 teams. Among the diverse recent additions to the hall have been Gordon Kluzak, Boston Bruins hockey star; Irene Haworth Lacy, champion gymnast; Joanne McTaggart, one of Canada's premier runners in the 1970s; Richard Schell, a wheelchair athlete who won gold medals

in international shooting competitions; Eugene Hearn, speed skating racer, coach, and international official; Diane Lemon, synchronized swimmer, coach, judge, and administrator; Lloyd Saunders, sports commentator and broadcaster; and Don Stephonshev, basketball official. Canadian and other championship teams in football, basketball, hockey, volleyball, curling, bowling, and trap-shooting also are in the hall.

Saskatchewan Sports Hall of Fame and Museum, 2205 Victoria Ave., Regina, Saskatch-
ewan, Canada S4P 0S4. Phone: 306/780–9232. Hours: 9–5 Mon.–Fri.; May–Oct. and
holidays—also 1–5 Sat.–Sun. Admission: free.

FRANCE

PANTHÉON, Paris. The Panthéon in Paris, France, is a grandiose monument to the nation's illustrious dead. Designed by Jacques-Germain Soufflot and built between 1764 and 1781, the structure was originally commissioned as a basilica by Louis XV in gratitude for his recovery from an illness. In 1791, after the French Revolution, it was transformed into a national shrine.

The French Panthéon—which got its name from the Pantheon temple in an-cient Rome, a temple to the gods built in 27 B.C. and converted to a Christian church in A.D. 609—is constructed in the form of a Greek cross. It is located on Mont Sainte-Geneviève, on the site of an early Christian basilica in which the remains of Ste. Geneviève were kept.

The Panthéon's crypt holds the remains of many of France's distinguished statesmen, heroes, and thinkers, including Voltaire, Zola, Rousseau, and Hugo.

Panthéon, pl. du Panthéon, Paris, France. Phone: 01–43–54–34–51. Hours: Oct.–Mar.
10–5:30 daily; Apr.–Sept. 10–6 daily; closed Jan. 1, May 1 and 11, Nov. 25, and Dec.
25. Admission: 32 French francs.

GERMANY

DEUTSCHES MUSEUM EHRENSAAL, Munich. The first modern-day Eu-ropean hall of fame was established in 1925 at the Deutsches Museum, a major science and technology museum in Munich, Germany. Called the Ehrensaal, the hall of fame honors primarily early German scientists, engineers, inventors, and others for their significant contributions to the advancement of science or tech-nology.

Since its founding the hall of fame has enshrined 40 persons, including such notables as Otto Lilienthal, whose 2,000 glider flights helped lead the way to winged and powered flight; Nicolaus Copernicus, developer of the heliocentric system of astronomy; Johann Kepler, discoverer of Kepler's laws of planetary motion and considered the founder of modern optics; Albert Einstein, developer of the theory of relativity and the law of photoelectricity; Max Planck, originator and developer of quantum theory and known for his work relating to thermo-

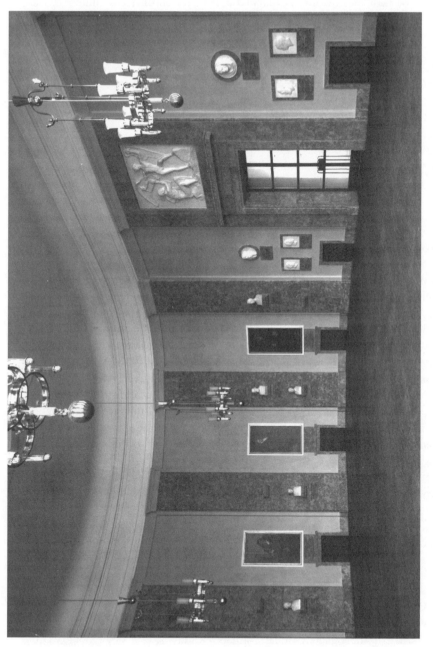

The Ehrensaal at the Deutsches Museum in Munich, Germany, was the first modern-day European hall of fame. Established in 1925, it primarily honors early German scientists, engineers, inventors, and others for their contributions to the advancement of science and/or technology. Courtesy Deutsches Museum.

dynamics, mechanics, and electrical and optical problems associated with the radiation of heat and quantum theory; Werner Heisenberg, contributor to the development of quantum mechanics and the principle of indeterminacy; Justus von Liebig, founder of agricultural chemistry; and Georg Simon Ohm, discoverer of the relationship between the strength of an unvarying electrical current, the electromagnetic force, and resistance of a circuit (known as Ohm's law).

The hall of fame gallery consists of photographs, busts, and reliefs of the honorees and exhibit cases containing various historical documents relating to their work. Nearly all the inductees were named during the early years of the hall.

The Deutsches Museum, which opened in 1906 and now covers nearly 500,000 square feet, traces the development of science and technology from its origins to the present through 53 exhibit areas. It has an annual attendance of approximately 1.3 million.

Deutsches Museum Ehrensaal, Museumsinsel 1, D-80538 Munich, Germany. Phone: 089–2179–1. Hours: 9–5 daily; closed major holidays. Admission: adults, 10 Deutsche marks; students, 4 Deutsche marks; families, 22 Deutsche marks.

RUHMESHALLE, Munich. The Ruhmeshalle in Munich, Germany, was constructed in 1843–53 by King Ludwig I of Bavaria as a temple of honor for Bavarians who had made significant contributions to science, art, and their country. The triple-winged hall of Doric columns on the hill overlooking Theresia Field were designed by Leo von Klenze in the style of a huge ancient altar.

The busts of 74 honored Bavarians were placed along the colonnade, and additional busts later were installed for a total of 79. Among the notables honored are painters Albrecht Altdorfer and Karl Rottman, architects Balthasar Neumann and Leo von Klenze, sculptors Veit Stoß and Ludwig Schwanthaler, generals Graf von Tilly and Graf von Pappenheim, historians/theologians Konrad Peutinger and Peter Cancasius. The Ruhmeshalle was badly damaged during World War II and some busts were replaced with memorial plaques.

A 51-foot bronze statue of "Bavaria," designed by Ludwig Schwanthaler, cast by Ferdinand von Miller, and installed in 1850, greets visitors at the entrance. Its hollow interior has stairs leading to an observation platform.

Ruhmeshalle, Theresienhöle 16, 80339 Munich, Germany. Phone: 089–508725. Hours: Apr.–Sept.—10–12 and 2–5 daily; Oct.–Mar.—hall of fame closed, but "Bavaria" statue can be visited 10–2 and 2–6 daily. Admisssion: adults, 3 Deutsche marks; children 2 Deutsche marks.

WALHALLA, Donaustauf. Walhalla is a temple in the Danube valley near Donaustauf, Germany, built in 1830–42 by King Ludwig I of Bavaria to honor great German philosophers, soldiers, artists, scientists, and other notables. In German and Norse mythology, warrior maidens chose who were to die and bring their souls to Walhalla (also spelled Valhalla).

This Doric temple, patterned after the Parthenon, had 96 busts on the main level and 64 commemorative tablets of older or lesser-known heroes beneath the gallery when it opened in 1842. The total number of persons now honored is 187 (with 123 busts and 64 tablets).

Walhalla, Walhalla Str. 48, 93093 Donaustauf, Germany. Phone: 09403–961680. Hours: Apr.–Sept. 9–5:45 daily; Oct. 9–4:45; Nov.–Mar. 10–11:45 and 1–3:45 daily. Admission: adults, 3 Deutsche marks; students, 2 Deutsche marks.

GREAT BRITAIN

WESTMINSTER ABBEY, London. The earliest version of a "hall of fame" is Westminster Abbey in London, England. It is best known as the place where kings and queens are crowned and many are buried in ornate tombs. But it also is where the nation pays tribute to its illustrious statesmen, poets, authors, musicians, scientists, military leaders, and other people of distinction through burial or monuments.

Westminster Abbey originally was the abbey church of a Benedictine monastery. The first church on the site is said to have been built in 616 by the Saxon King Sebert of Essex. In 1050–65, Edward the Confessor constructed a Norman-style church, which was demolished in 1245 by Henry III, who initiated a long period of Early English and Gothic construction, extending until the mid-eighteenth century.

British monarchs since William I have been crowned in Westminster Abbey, which also is the burial place of many kings and queens. Noted statesmen and other distinguished persons have been buried or honored with monuments in the abbey since the fourteenth century.

Many of the monuments at the north transept honor statesmen, largely dating from the eighteenth and nineteenth centuries, including William Ewart Gladstone and Pitt the Elder. The Poets' Corner in the south transept began with the tomb of Geoffrey Chaucer in 1556, which was followed by the tombs and memorials of other great men of letters, including John Dryden, Alfred Tennyson, and Ben Johnson.

Among the others buried in the abbey are David Garrick the actor, William Camden the historian, Henry Purcell the musician, and Charles Darwin the scientist. A number of monuments also have been erected to prominent persons who are buried elsewhere, such as William Shakespeare, John Milton, William Wordsworth, Charles Dickens, and Winston Churchill.

Westminster Abbey, Dean's Yard, London SW1P 3PA, Great Britain. Phone: 0171–222–5152. Hours: 9–4 Mon., Tue., Thur., and Fri.; 9 A.M.–7:45 P.M. Wed. (free 6–7:45); 9–2 Sat.; 3:45–5 Sun.; closed during services, Good Friday, and Dec. 24–26. Admission: nave, free; royal chapels and Poets' Corner—adults, 4 British pounds; students, 2 pounds.

WIMBLEDON LAWN TENNIS MUSEUM, Wimbledon, England. All Wimbledon champions and every major player since the advent of open tennis in 1968 constitute an informal "hall of fame" at the Wimbledon Lawn Tennis Museum adjacent to the historic Centre Court in Wimbledon, England, near London. The museum first opened in 1977 as part of the centenary celebration of the Wimbledon championships. It was demolished in 1984 to permit expansion of the Centre Court and reopened in 1985 to display its ever-increasing collection of historic equipment, memorabilia, ephemera, and objects associated with Wimbledon and lawn tennis history.

The introductory sections of the museum tell the story of lawn tennis from its origin in the 1870s to the 1990s. The centerpiece of the main gallery is an exhibit where figures in various tennis dress are shown in such settings as a Victorian tennis tea party and an Edwardian picnic in a 1920s pavilion.

The museum also has displays on how the lawn tennis racket was developed, such memorabilia as letter racks and mourning broaches, films on tennis, and interactive units on the winners of all major tennis championships around the world since 1968.

Wimbledon Lawn Tennis Museum, All England Club, Church Rd., Wimbledon, London, England SW19 5AE. Phone: 0181–946–6131. Hours: 10:30–5 Tues.–Sat. 2–5 Sun.; closed holidays and the Friday, Saturday, and Sunday prior to the Wimbledon Championships and the middle Sunday of the tournament. Admission: 2 British pounds.

ISRAEL

INTERNATIONAL JEWISH SPORTS HALL OF FAME, Netanya. The International Jewish Sports Hall of Fame originally was conceived in Los Angeles in 1979 as a means of raising funds to support the USA team for the 1981 Maccabiah Games for Jewish athletes in Israel and to publicize the Sports for Israel organization, which assists the Wingate Institute for Physical Education and Sports in that country. The idea developed into a permanent hall of fame museum that opened at the Wingate Institute near Netanya, in 1981. Funds now are being raised for a separate $2 million hall of fame and Israel Sports Museum building.

Jewish athletes from throughout the world who have excelled in the Olympics, world championships, and other sports events—as well as others related to sports—now are honored in triangular-shaped cases containing photographs and biographical information, in the 3,000-square-foot museum. Also on display are various memorabilia, sports artwork, a sculpture in memory of the sports men and women who died in the Holocaust, and another memorializing the athletes who were slain at the 1972 Munich Olympics.

The hall of fame has inducted 233 outstanding Jewish athletes, coaches, broadcasters, and other sports figures. They include Hank Greenberg, Barney Dreyfuss, and Sandy Koufax, baseball; Red Auerbach, Dolph Schayes, and Abe

Saperstein, basketball; Barney Ross, Benny Leonard, and Jackie Fields, boxing; Sid Luckman, Marshall Goldberg, and Ron Mix, football; Mark Spitz, swimming; Agnes Keleti, gymnastics; Dick Savitt, tennis; Irene Kirzenstein and Lillian Copeland, track and field; Irving Jaffee, ice skating; Henry Wittenberg, wrestling; Ike Berger and Frank Spellman, weight lifting; and Mel Allen and Howard Cosell, broadcasting.

In addition to the International Jewish Sports Hall of Fame, 17 mostly local, state, and regional Jewish sports halls of fame can be found in the United States and Canada. They usually take the form of photographs or plaques on the walls of community or recreational centers. Some, such as the New York Jewish Sports Hall of Fame in Commack, also have artifacts or exhibits.

International Jewish Sports Hall of Fame, Wingate Institute for Physical Education and Sports, Wingate Post Office, Netanya, Israel 42902. Phone: 09–639521. Hours: 8–4: 30 Sun.–Thur.; Fri. and other times by appointment; closed on religious holidays. Admission: free.

JAPAN

JAPANESE BASEBALL HALL OF FAME AND MUSEUM, Tokyo. The Japanese Baseball Hall of Fame and Museum, which opened in 1959 and moved to Gate 21 of the Tokyo Dome in 1988, traces the history of baseball (with emphasis on Japan), honors outstanding Japanese players, and displays a wide variety of historic and contemporary baseball equipment, memorabilia, and photographs from Japan.

The hall of fame/museum, which attracts approximately 130,000 visitors annually, has seven parts—exhibits on the origin and development of professional baseball, the science of baseball, and the hall of fame, as well as a temporary exhibition gallery, a baseball information system, and a library.

The hall of fame honors more than 120 inductees, selected by a panel of 220 sportswriters. They include such prominent Japanese baseball stars as Eiji Sawamura, Sadaharu Oh, and Shigeru Nagashima.

Japanese Baseball Hall of Fame and Museum, Tokyo Dome, 1-3-61, Koraku, Bunkyo-ku, Tokyo 112, Japan. Phone: 03–3811–3600. Hours: Apr.–Sept. 10–6 Tues.–Sun.; Oct.–Mar. 10–5 Tues.–Sun.; closed Dec. 28–Jan. 1 and Tues. when national holidays fall on Mon. (when it is open). Admission: adults, 400 yen; children, 200 yen.

MEXICO

PROFESSIONAL BASEBALL HALL OF FAME OF MEXICO, Monterrey. The Professional Baseball Hall of Fame of Mexico got its start in 1939, when fans used newspaper ballots to select the first five honorees. In 1973, the Professional Teams Association created a selection committee composed of sports-

writers and named Cuauhtémoc Moctezuma Brewery as the official sponsor and home of the hall of fame. The hall, housed in a 13,200-square-foot building on the brewery's premises in Monterrey, now has an annual attendance of 145,000.

The hall of fame, which honors Mexican professional baseball players and others involved in the sport, has 122 inductees, including such stars as Roberto Avila, Martin Dihigo, Lázaro Salazar, José Luis Gomez, Roy Campanella, Baldomero Almada, Jorge Pasquel, Adolfo Luque, Héctor Espino, and Josh Gibson.

The facility has three main areas—the Hall of Immortals, with photos, memorabilia, and biographical information about hall of famers; the Hall of Trophies, containing trophies and autographed baseballs; and the Hall of Fame, featuring plaques of the honorees. It also has a section, called the Monterrey Sports Museum, with exhibits on boxing, bullfighting, soccer, football, motor racing, and other sports.

Being inducted into the hall of fame has an unusual benefit. Those enshrined receive complimentary life insurance from the Cuauhtémoc Moctezuma Brewery, which has paid insurance benefits to the families of six deceased players.

The brewery also planned to build a $7 million home for the Mexican Soccer Hall of Fame in Guadalajara in 1995, but plans were put off because of the state of the national economy. The company sponsors a professional soccer league, as well as beach volleyball, cycling, motor racing, and apprentice bullfighting circuits. It also is part owner of five pro baseball teams and owns a football franchise.

Professional Baseball Hall of Fame of Mexico, 2202 N. Alfonso Reyes Ave., Monterrey, N.L. 64442, Mexico. Phone: 8–328–5745. Hours: 9–5 Tues.–Fri.; 10:30–6 Sat.–Sun. Admission: free.

NEW ZEALAND

NEW ZEALAND SPORTS HALL OF FAME, Wellington. The New Zealand Sports Hall of Fame was founded in Wellington, the nation's capitol, in 1990, as a cooperative effort of the New Zealand Olympic and Commonwealth Games Association, the New Zealand Sports Foundation, the Hillary Commission, the New Zealand Assembly for Sport, and the city of Wellington. Its purpose is to honor outstanding athletes and others for their contributions to the advancement of sports in New Zealand.

A display area with several dozen exhibits now exists in the hall of fame headquarters. Ninety-nine individuals and nine teams have been inducted into the hall of fame and are featured in the exhibits. They include Sir Edmund Hillary, mountaineering; Jean Batten, aviation; Peter Snell, athletics; Mark Todd, an equestrian; George Nepia, of the rugby union; Richard Hadlee, cricket; and John Walker, athletics.

Plans call for the hall of fame to be part of the new Wellington Sports Stadium, a large multipurpose indoor-outdoor complex now being constructed and

expected to be completed by 2000. The hall of fame exhibits will have tributes to those enshrined and make use of photographs, busts, artifacts, memorabilia, and other materials from a growing collection. The stadium also may have other exhibits on New Zealand sports, such as rugby, cricket, Olympics medalists, and America's Cup yacht races.

New Zealand Sports Hall of Fame, Dalmuir House, 114 The Terrace, First Floor, PO Box 3179, Wellington, New Zealand. Phone: 04–473–0388. Hours: 9–5 Mon.–Fri.; closed major holidays. Admission: free.

SINGAPORE

SINGAPORE SPORTS HALL OF FAME. The Singapore Sports Hall of Fame is a component of the Singapore Sports Museum, founded in 1983 by the Singapore Sports Council with the help of a $10,000 contribution from the International Olympic Committee. The hall of fame is one of the seven galleries in the museum located in the Republic of Singapore's National Stadium.

The museum seeks to inform, educate, and entertain the public of Singapore's sporting heritage, honor the nation's outstanding athletes, and serve as a repository for sports objects of historical, aesthetic, and scientific importance. To be selected for the hall of fame, athletes and teams must have been the winners or runner-ups in World or Asian Games competitions.

Thirteen individuals and five teams have been inducted into the hall of fame. They include Wong Peng Soon, four-time all-England champion; Adelene Wee, 1985 world Master's champion; and Tan Howe Liang, who won a silver medal at the 1960 Olympics and is Singapore's only Olympic medalist.

In addition to the hall of fame, other galleries cover sports in colonial times, indigenous traditional sports, involvement in sports, regional games, the Olympics, and a roll of honor for coaches, boys, and girls of the year in sports. The museum is located on the second level of the west entrance at the National Stadium.

Singapore Sports Hall of Fame, Singapore Sports Museum, National Stadium, 15 Stadium Rd., Singapore, Republic of Singapore 397718. Phone: 65–340–9500. Hours: 9–4:30 Mon.–Fri.; 9–12:30 Sat. Admission: free.

Appendix

Geographical Guide to Hall of Fame Museums and Exhibits

UNITED STATES

ALABAMA

Birmingham

Alabama Aviation Hall of Fame (Southern Museum of Flight)
Alabama Jazz Hall of Fame Museum
State of Alabama Sports Hall of Fame

Talladega

International Motorsports Hall of Fame (Talledega Superspeedway)
 Alabama Sports Writers Hall of Fame
 Automobile Racing Club of America Hall of National Champions
 Quarter Midgets of America Hall of Fame
 Western Auto Mechanics Hall of Fame
 World Karting Hall of Fame

Tuscaloosa

Paul W. Bryant Museum (University of Alabama)

Tuscumbia

Alabama Music Hall of Fame

ALASKA

Knik

Canine Hall of Fame for Lead Dogs (Knik Museum)
Dog Mushers' Hall of Fame (Knik Museum)

ARIZONA

Phoenix

Arizona Hall of Fame Museum
National Firefighting Hall of Heroes (Hall of Flame Museum of Firefighting)

Winslow

Astronaut Hall of Fame (Meteor Crater Museum of Astrogeology)

CALIFORNIA

Anaheim

Orange County Sports Hall of Fame (Anaheim Stadium)

Hellendale

Burlesque Hall of Fame and Museum

Hollywood

Hollywood Walk of Fame (Hollywood Boulevard and Vine Street)

Huntington Beach

Surfing Hall of Fame

Los Angeles

Southern California Jewish Sports Hall of Fame

North Hollywood

Television Academy Hall of Fame (Academy of Television Arts and Sciences)

Palm Springs

Palm Springs Walk of Stars and Gallery Without Walls (Palm Canyon Drive)

Palo Alto

Barbie Doll Hall of Fame

San Diego

International Aerospace Hall of Fame (San Diego Aerospace Museum)
Breitbard Hall of Fame (San Diego Hall of Champions Sports Museum)

San Francisco

Bay Area Sports Hall of Fame (San Francisco International Airport and Oakland
Coliseum)

Santa Clarita

Santa Clarita Valley Walk of Western Stars (San Fernando Road)

Soda Springs

Western America Ski Hall of Fame (Western Skiport Museum, Boreal Ski Area)

COLORADO

Colorado Springs

ProRodeo Hall of Fame and Museum of the American Cowboy
U.S. Racquetball Hall of Fame (U.S. Racquetball headquarters)
World Figure Skating Museum and Hall of Fame
 United States Skating Hall of Fame
 World Figure Skating Museum and Hall of Fame

Crested Butte

Mountain Bike Hall of Fame and Museum (Crested Butte Heritage Museum)

Denver

Denver Broncos Ring of Fame (Mile High Stadium)

Leadville

National Mining Hall of Fame and Museum

Vail

Colorado Ski Museum-Ski Hall of Fame

CONNECTICUT

Hartford

Connecticut Sports Museum and Hall of Fame (Hartford Civic Center)

DISTRICT OF COLUMBIA

Washington

Labor Hall of Fame (Frances Perkins Labor Department Building)
National Jewish American Sports Hall of Fame (B'nai B'rith Klutznick National
 Jewish Museum)
National Statuary Hall (the Capitol)
United States Chess Hall of Fame (U.S. Chess Center)
Washington Hall of Stars (Robert F. Kennedy Memorial Stadium)

FLORIDA

Boca Raton

International Museum of Cartoon Art Hall of Fame

Bradenton

Senior Athletes Hall of Fame (Freedom Village Retirement Community)

Clearwater Beach

Pro Beach Volleyball Hall of Fame (Clearwater Beach Memorial Civic Center)

Coral Gables

Tom Kearns University of Miami Sports Hall of Fame (University of Miami)

Dania

International Fishing Hall of Fame (International Game Fish Association)

Fort Lauderdale

International Swimming Hall of Fame

Hernando

Ted Williams Museum and Hitters Hall of Fame

Lake City

Florida Sports Hall of Fame and Museum

Lake Worth

National Museum of Polo and Hall of Fame

Miami

American Police Hall of Fame and Museum

Ocala

International Drag Racing Hall of Fame (Don Garlits Museum of Drag Racing)

Ponte Vedra Beach

World Golf Hall of Fame (World Golf Village)
 Ladies Professional Golf Association Hall of Fame
 PGA Tour Hall of Fame
 Professional Golfers' Association of America Hall of Fame

St. Petersburg

National Shuffleboard Hall of Fame (St. Petersburg Shuffleboard Club)

Tampa

Show Jumping Hall of Fame and Museum (Busch Gardens)

Titusville

U.S. Astronaut Hall of Fame

Winter Haven

Water Ski Hall of Fame

GEORGIA

Athens

Collegiate Tennis Hall of Fame (Henry Feild Tennis Complex, University of Georgia)

Atlanta

Atlanta Celebrity Walk (World Congress Center)

Macon

Georgia Sports Hall of Fame

Warner Robins

Georgia Aviation Hall of Fame (Museum of Aviation)

IDAHO

Weiser

National Oldtime Fiddlers' Hall of Fame (Weiser Community Center)

ILLINOIS

Arlington Heights

National Italian American Sports Hall of Fame (moving to Chicago)

Chicago

Blackhawks/Bulls Hall of Fame (United Center)
Comiskey Park Hall of Fame (Comiskey Park)
Merchandise Mart Hall of Fame (Merchandise Mart)
National Business Hall of Fame (Museum of Science and Industry)
Radio Hall of Fame (Museum of Broadcast Communications)

Des Plaines

Chicagoland Sports Hall of Fame (Maryville Academy)

McLean

Route 66 Hall of Fame (Dixie Truckers Home)

Northbrook

Chicago's Jewish Sports Hall of Fame

INDIANA

Elkhart

RV/MH Hall of Fame and Museum (RV/MH Heritage Foundation)

Indianapolis

Indianapolis Motor Speedway Hall of Fame Museum (Indianapolis Motor Speedway)
National Track and Field Hall of Fame (Hoosier Dome)

Marion

Quilters Hall of Fame (Marie Webster House)

Morgantown

Bill Monroe Museum and Bluegrass Hall of Fame

New Castle

Indiana Basketball Hall of Fame

Peru
International Circus Hall of Fame

South Bend
College Football Hall of Fame

IOWA

Dubuque
National Rivers Hall of Fame (Mississippi River Museum)

Knoxville
National Sprint Car Hall of Fame and Museum (Knoxville Raceway)

KANSAS

Abilene
Greyhound Hall of Fame
State of Kansas Sports Hall of Fame

Bonner Springs
National Agricultural Center and Hall of Fame

Emporia
National Teachers Hall of Fame

Norton
Gallery of Also Rans (First State Bank)

Wichita
National Baseball Congress Hall of Fame (Lawrence-Dumont Stadium)

KENTUCKY

Lexington
United Professional Horsemen's Association Hall of Fame (American Saddle Horse Museum)

LOUISIANA

Kenner
Saints Hall of Fame

Natchitoches
Louisiana Sports Hall of Fame (Northwestern State University Coliseum)

Shreveport
Shreveport–Bossier City Sports Museum of Champions

Ishpeming

United States National Ski Hall of Fame and Museum

Lake Linden

International Frisbee Hall of Fame (Houghton County Historical Museum)

Muskegon

Muskegon Area Sports Hall of Fame (Muskegon County Museum)

Novi

Motorsports Museum and Hall of Fame of America (Novi Expo Center)

Orchard Lake

National Polish-American Sports Hall of Fame (Dombrowski Fieldhouse, St. Mary's College)

West Bloomfield

Michigan Jewish Sports Hall of Fame

MINNESOTA

Eveleth

United States Hockey Hall of Fame

Minneapolis

Original Baseball Hall of Fame of Minnesota
Quackery Hall of Fame (Museum of Questionable Medical Devices, St. Anthony Main complex)

MISSISSIPPI

Jackson

Mississippi Music Hall of Fame (Jim Buck Ross Mississippi Agriculture and Forestry Museum complex)
Mississippi Sports Hall of Fame and Museum
National Agricultural Aviation Museum and Hall of Fame (Jim Buck Ross Mississippi Agriculture and Forestry Museum complex)

Petal

International Checkers Hall of Fame

MISSOURI

Branson

Legends and Superstars Hall of Fame

MAINE

Portland

Maine Sports Hall of Fame

MARYLAND

Annapolis

Intercollegiate Sailing Hall of Fame (Robert Crown Hall, U.S. N

Baltimore

Lacrosse Hall of Fame Museum

Beltsville

American Poultry Hall of Fame (National Agricultural Library, U.
Agriculture)

Rockville

Greater Washington Jewish Sports Hall of Fame

MASSACHUSETTS

Holyoke

Volleyball Hall of Fame

Leominster

Plastics Hall of Fame (National Plastics Center and Museum)

Springfield

Naismith Memorial Basketball Hall of Fame

MICHIGAN

Ann Arbor

Margaret Dow Towsley Sports Museum (Schembechler Hall, Universit
gan)

Dearborn

Automotive Hall of Fame

Detroit

International Afro-American Sports Hall of Fame and Gallery (Old Wayn
Building)
International Heritage Hall of Fame (Cobo Center)
State of Michigan Sports Hall of Fame (Cobo Center)

Flint

Greater Flint Afro-American Hall of Fame (Flint Public Library and Bersto
house)
Greater Flint Area Sports Hall of Fame (IMA Sports Arena)

Kansas City

Kansas City Chiefs Ring of Honor (Arrowhead Stadium)
National High School Sports Hall of Fame (National Federation of State High
 School Associations)

St. Louis

International Bowling Museum and Hall of Fame
 American Bowling Congress Hall of Fame
 Bowling Proprietors Association of America Hall of Fame
 Professional Bowlers Association Hall of Fame
 Women's International Bowling Congress Hall of Fame
St. Louis Cardinals Hall of Fame Museum (in International Bowling Museum and
 Hall of Fame)
St. Louis Jewish Sports Hall of Fame
St. Louis Walk of Fame

Springfield

Missouri Sports Hall of Fame

NEBRASKA

Lincoln

Roller Skating Hall of Fame (National Museum of Roller Skating)

NEW HAMPSHIRE

Allenstown

Family Camping Hall of Fame

NEW JERSEY

East Rutherford

Sports Hall of Fame of New Jersey (Continental Airlines Arena, Meadowlands
 Sports Complex)

Somerville

United States Bicycling Hall of Fame

Teterboro

Aviation Hall of Fame and Museum of New Jersey (Teterboro Airport)

Wayne

YM/YWHA of Northern Jersey Sports Hall of Fame

Wildwood

Marbles Hall of Fame (George F. Boyer Historical Museum)

NEW MEXICO

Alamogordo

International Space Hall of Fame (The Space Center)

Hobbs

Lea County Cowboy Hall of Fame and Western Heritage Center

NEW YORK

Bronx

Hall of Fame for Great Americans (Bronx Community College)
New York Yankees Memorial Park (Yankee Stadium)

Canastota

International Boxing Hall of Fame

Cooperstown

Corvette Hall of Fame and Americana Museum
National Baseball Hall of Fame and Museum

Commack

New York Jewish Sports Hall of Fame (Suffolk Y Jewish Community Center)

Goshen

Harness Racing Museum and Hall of Fame

Lake Placid

Lake Placid Hall of Fame

Livingston Manor

Catskill Fly Fishing Museum Hall of Fame

New York City

Radio City Music Hall Sidewalk of Stars

Oneonta

National Soccer Hall of Fame

Saratoga Springs

Dance Hall of Fame (National Museum of Dance)
National Museum of Racing and Hall of Fame
Saratoga Harness Racing Museum and Hall of Fame

Seneca Falls

National Women's Hall of Fame

Weedsport

D.I.R.T. Hall of Fame and Classic Car Museum (Cayuga County Fair Speedway)

NORTH CAROLINA

Raleigh

North Carolina Sports Hall of Fame (North Carolina Museum of History)

Salisbury

National Sportscasters and Sportswriters Hall of Fame

NORTH DAKOTA

Jamestown

North Dakota Sports Hall of Fame (Jamestown Civic Center)

OHIO

Akron

All-American Soap Box Derby Museum and Hall of Fame
Inventure Place, National Inventors Hall of Fame

Canton

Canton Jewish Community Center Hall of Fame
Pro Football Hall of Fame

Cleveland

Rock and Roll Hall of Fame and Museum

Cleveland Heights

JCC Sports Hall of Fame

Columbus

Columbus Jewish Community Center Hall of Fame

Plain City

Bull Hall of Fame (Select Sires)

Vandalia

Trapshooting Hall of Fame and Museum (Amateur Trapshooting Association)

Wright Patterson Air Force Base (Dayton)

National Aviation Hall of Fame

OKLAHOMA

Anadarko

National Hall of Fame for Famous American Indians

Oklahoma City

International Gymnastics Hall of Fame and Museum
International Photography Hall of Fame and Museum (Kirkpatrick Center)
National Cowboy Hall of Fame and Western Heritage Center
National Softball Hall of Fame and Museum

Stillwater

National Wrestling Hall of Fame and Museum (Oklahoma State University)

Tulsa

Oklahoma Jazz Hall of Fame (Greenwood Cultural Center)

OREGON

Pendleton

Pendleton Round-Up/Happy Canyon Hall of Fame (Pendleton Round-Up Rodeo)

Portland

State of Oregon Sports Hall of Fame Museum

PENNSYLVANIA

Brookhaven

Delaware County Athletes Hall of Fame (Brookhaven Borough Hall)

Collegeville

United States Field Hockey Association Hall of Fame (Helfferich Hall, Ursinus College)

Easton

Crayola Hall of Fame (Two Rivers Landing)

Foxburg

American Golf Hall of Fame (Foxburg Country Club)

Philadelphia

Philadelphia Jewish Sports Hall of Fame

Pittsburgh

Western Pennsylvania Jewish Sports Hall of Fame

State College

Penn State Football Hall of Fame (Greenberg Indoor Sports Complex, Pennsylvania State University)

Williamsport

Little League Baseball Hall of Excellence (Peter J. McGovern Little League Baseball Museum)

York

Weightlifting Hall of Fame

PUERTO RICO

San Juan

Puerto Rico Sports Hall of Fame (Sixto Escobar Stadium)

RHODE ISLAND

Bristol

America's Cup Hall of Fame (Herreshoff Marine Museum)

Newport

International Tennis Hall of Fame and Museum
National Croquet Hall of Fame (Newport Art Museum)
Singlehanded Sailors Hall of Fame (Museum of Yachting)

Providence

Rhode Island Jewish Athletes Hall of Fame

SOUTH CAROLINA

Aiken

Aiken Thoroughbred Racing Hall of Fame

Belton

South Carolina Tennis Hall of Fame

Columbia

South Carolina Criminal Justice Hall of Fame

Darlington

NMPA Stock Car Hall of Fame/Joe Weatherly Museum

SOUTH DAKOTA

Chamberlain

South Dakota Hall of Fame

Lake Norden

South Dakota Amateur Baseball Hall of Fame

Spearfish

National Fish Culture Hall of Fame (D.C. Booth Historic Fish Hatchery)

Sturgis

National Motorcycle Museum and Hall of Fame

TENNESSEE

Chattanooga

International Towing and Recovery Hall of Fame and Museum

Grand Junction

Field Trial Hall of Fame

Knoxville

University of Tennessee Football Hall of Fame (Neyland-Thompson Sports Center)

Nashville

Car Collectors Hall of Fame
Country Music Hall of Fame and Museum
Legends and Superstars Hall of Fame
Tennessee Sports Hall of Fame (Nashville Arena)

Norris

Appalachian Hall of Fame (Museum of Appalachia)

TEXAS

Fort Worth

National Cowgirl Hall of Fame and Western Heritage Center

Irving

Dallas Cowboy Ring of Honor (Texas Stadium)

Lubbock

West Texas Walk of Fame (Lubbock Memorial Civic Center)

Midland

Petroleum Hall of Fame (Permian Basin Petroleum Museum, Library, and Hall of Fame)

Plano

Cockroach Hall of Fame (Pest Shop)

San Antonio

National Skeet Shooting Hall of Fame Museum (National Skeet Shooting Association)

Waco

Texas Ranger Hall of Fame and Museum
Texas Sports Hall of Fame
 Texas Baseball Hall of Fame
 Texas High School Basketball Hall of Fame
 Texas High School Football Hall of Fame
 Texas Sports Hall of Fame
 Texas Tennis Hall of Fame

Woodland

Texas Golf Hall of Fame (Tournament Players Course)

VERMONT

Montpelier

Hall of Fumes (Recreation Department gymnasium)

VIRGINIA

Mount Solon

National Jousting Hall of Fame (Natural Chimneys Park)

Petersburg

United States Slo-Pitch Softball Association Hall of Fame Museum

Portsmouth

Virginia Sports Hall of Fame

Richmond

Virginia Aviation Hall of Fame (Virginia Aviation Museum)

WASHINGTON

Long Beach

World Kite Museum and Hall of Fame

WISCONSIN

Delavan

Clown Hall of Fame and Research Center

Green Bay

Green Bay Packer Hall of Fame

Hayward

National Fresh Water Fishing Hall of Fame

Milwaukee

Milwaukee Jewish Community Center Sports Hall of Fame

Neenah

Paper Industry Hall of Fame (Neenah Historical Society)

Oshkosh

EAA Air Adventure Museum halls of fame (Wittman Field)
 EAA Aircraft Homebuilders Hall of Fame
 EAA Antique/Classics Hall of Fame
 EAA Warbirds Hall of Fame
 Flight Instruction Hall of Fame
 International Aerobatic Hall of Fame
 Wisconsin Aviation Hall of Fame

Saint Germain

International Snowmobile Racing Hall of Fame and Museum

Seymour

Hamburger Hall of Fame

OTHER COUNTRIES

AUSTRALIA

Homebush Bay, New South Wales

New South Wales Hall of Champions (State Sports Centre)

CANADA

Almonte, Ontario

Naismith International Basketball Centre and Hall of Fame

Calgary, Alberta

Olympic Hall of Fame and Museum (Olympic Park)

Fredericton, New Brunswick

New Brunswick Sports Hall of Fame

Gloucester, Ontario

Canadian Figure Skating Hall of Fame (Canadian Figure Skating Association)

Hamilton, Ontario

Canadian Football Hall of Fame and Museum

Kingston, Ontario

International Hockey Hall of Fame

Kitchener, Ontario

Curling Hall of Fame and Museum of Canada

Montreal, Quebec

Montreal YM/YWHA Sports Hall of Fame

New Westminster, British Columbia

Canadian Lacrosse Hall of Fame (Centennial Community Centre)

Niagara Falls, Ontario

Daredevil Hall of Fame (Niagara Falls Museum)

Oakville, Ontario

Canadian Golf Hall of Fame (Glen Abbey Golf Club)

Regina, Saskatchewan

Saskatchewan Sports Hall of Fame and Museum

Thunder Bay, Ontario

Northwestern Ontario Sports Hall of Fame and Museum

Toronto, Ontario

Canada's Sports Hall of Fame (Exhibition Place)
Hockey Hall of Fame

Vancouver, British Columbia

British Columbia Sports Hall of Fame and Museum (B.C. Place Stadium)

Wetaskiwin, Alberta

Canada's Aviation Hall of Fame (Reynolds-Alberta Museum)

Winnipeg, Manitoba

Aquatic Hall of Fame and Museum of Canada

FRANCE

Paris

Panthéon

GERMANY

Donaustauf

Walhalla

Munich

Deutsches Museum Ehrensaal
Ruhmeshalle

GREAT BRITAIN

London

Westminster Abbey

Wimbledon

Wimbledon Lawn Tennis Museum

ISRAEL

Netanya (Wingate)

International Jewish Sports Hall of Fame (Wingate Institute for Physical Education
and Sports)

JAPAN

Tokyo

Japanese Baseball Hall of Fame and Museum (Tokyo Dome)

MEXICO

Monterrey

Professional Baseball Hall of Fame of Mexico (Cuauhtémoc Moctezuma Brewery)

NEW ZEALAND

Wellington

New Zealand Sports Hall of Fame (Wellington Sports Stadium)

SINGAPORE

Singapore

Singapore Sports Hall of Fame (Singapore Sports Museum)

Selected Bibliography

Armstrong, Jan. "Does the World Need Another Hall of Fame? Another Museum? Another Shrine?" *History News*, Vol. 47, No. 2, March/April 1992, pp. 14–17.

Best, David. "Formalizing Fame." *American Way*, June 1983, pp. 175–178.

Danilov, Victor J. "Halls of Fame: An American Phenomenon." *Curator*, Vol. 29, No. 4, December 1986, pp. 245–258.

Dickson, Paul, and Robert Skole. *The Volvo Guide to Halls of Fame*. Washington, DC: Living Planet Press, 1995.

Harris, Patricia, and David Lyon. "Sports Museums." *Adventure Road*, September/October 1989, pp. 12, 14–15.

International Association of Sports Museums and Halls of Fame of Members Directory 1997. Lafayette, LA: International Association of Sports Museums and Halls of Fame, 1997.

Jones, Thomas C., ed. *The Halls of Fame: Featuring Specialized Museums of Sports, Agronomy, Entertainment and the Humanities*. Chicago: J. G. Ferguson Publishing Co., 1977.

Krupinski, Joe. "Those Halls Full of the Famous." *Newsday*, Sept. 29, 1985, pp. 25, 27.

Linn, Alan. "The Fame of the Game." *USAir*, January 1988, pp. 89–92, 95, 97.

Soderberg, Paul, Helen Washington, and Jaques Cattell Press. *The Big Book of Halls of Fame in the United States and Canada*. New York: R. R. Bowker Co., 1977.

Index

Numbers in **bold** refer to main entries.

Academy of Television Arts and Sciences, 45, 188. *See also* Television Academy Hall of Fame

Accounting Hall of Fame, 5

Agricultural Hall of Fame, 153. *See also* National Agricultural Center and Hall of Fame

Agricultural halls of fame, 153–54. *See also* Bull Hall of Fame; National Agricultural Aviation Museum and Hall of Fame; National Agricultural Center and Hall of Fame

Aiken Thoroughbred Racing Hall of Fame, 6, **146**

Alabama Aviation Hall of Fame, 9, 38, **156–57**

Alabama Jazz Hall of Fame, 28, 39, 44–46, 57, 63, **176**

Alabama Music Hall of Fame, 10, 23, 35, 41, 52, 60, 66, 69, **176–77**

Alabama Sports Hall of Fame, 5, 35, 130. *See also* International Motorsports Hall of Fame

Alabama Sports Writers Hall of Fame, 130. *See also* International Motorsports Hall of Fame

All-American Soap Box Derby Museum and Hall of Fame, 34, 36, 42, **139**

All-sports halls of fame, 8, 75–93. *See also names of specific halls of fame*

Amateur Softball Association, 140. *See also* National Softball Hall of Fame and Museum

Amateur Trapshooting Association, 147. *See also* Trapshooting Hall of Fame and Museum

American Amateur Racquetball Association, 133. *See also* U.S. Racquetball Hall of Fame

American Amateur Union, 149. *See also* Weightlifting Hall of Fame

American Automobile Association, 129. *See also* Indianapolis Motor Speedway Hall of Fame Museum

American Bicycle Hall of Fame, 67–68

American Bowling Congress Hall of Fame, 7, 102. *See also* International Bowling Museum and Hall of Fame

American Federation of Police, 173. *See also* American Police Hall of Fame and Museum

American Golf Hall of Fame, **119**

American Police Hall of Fame and Museum, 5, 10, 15, 22, 28, 37, 41, 43, 46, 56, 60, 66, 68, **173**

American Poultry Hall of Fame, 32, 187

American Poultry Historical Society, 187. *See also* American Poultry Hall of Fame

American Saddle Horse Museum, 108

American Water Ski Educational Foundation, 149. *See also* Water Ski Hall of Fame

America's Cup Hall of Fame, 9, 39, **134–35**

Anheuser-Busch, Inc., 29, 97. *See also* St. Louis Cardinals Hall of Fame Museum

Appalachian Hall of Fame, 6, 10, 23, 29, 40, 53, 61, 64, **189–90**

Aquatic Hall of Fame and Museum of Canada, 4, 7, 9, 24, 30, 36–37, 43–44, 47–48, 58, 67, 69, 217–18

Archives, 58, 60–61

Arizona Hall of Fame Museum, 23, 38, 45, 58, **198–99**

Arizona Historical Society, 198. *See also* Arizona Hall of Fame Museum

Armstrong, Jan, 2. *See also* International Tennis Hall of Fame, and Museum

Association of North Dakota Amateur Baseball Leagues Hall of Fame, 86. *See also* North Dakota Sports Hall of Fame

Astronaut Hall of Fame, 5, 54, **157**

Atlanta Celebrity Walk, **209**

Attendance at halls of fame, 4, 46–47

Australian hall of fame, 217. *See also* New South Wales Hall of Champions

Automobile halls of fame, 10, 130, 154–59. *See also names of specific halls of fame*

Automobile Old Timers Club, 28, 154. *See also* Automotive Hall of Fame

Automobile Racing Club of America Hall of National Champions, 130. *See also* International Motorsports Hall of Fame

Automotive Hall of Fame, 10, 14, 20, 28, 65, **154–55**

Aviation and space halls of fame, 9–10, 156–64. *See also names of specific halls of fame*

Aviation Hall of Fame and Museum of New Jersey, 15, 23, 42, 44, 57, 69, **157–58**

Baird, Vaughn L., 67. *See also* Aquatic Hall of Fame and Museum of Canada

Barbie Doll Hall of Fame, 5, 10, 14, 23, 30, **201**

Baseball halls of fame, 8, 93–98. *See also names of specific halls of fame*

Baseball Writers of America, 95. *See also* National Baseball Hall of Fame and Museum

Basketball halls of fame, 8–9, 99–100. *See also names of specific halls of fame*

Bay Area Sports Hall of Fame, 6, 8, 32, **75**

Beach volleyball hall of fame, 100–101. *See also* Pro Beach Volleyball Hall of Fame

Bibliography, Selected, 257

Bicycle halls of fame, 101–2. *See also* American Bicycle Hall of Fame; Mountain Bike Hall of Fame and Museum; United States Bicycling Hall of Fame

Big Book of Halls of Fame in the United States and Canada, The, 1–2, 15

Billingsley, Logan, 181. *See also* National Hall of Fame for Famous American Indians

Bill Monroe Museum and Bluegrass Hall of Fame, **177**

Binney & Smith, Inc., 203. *See also* Crayola Hall of Fame

Blackhawks/Bulls Hall of Fame, **122–23**

Bluegrass Hall of Fame, 177. *See also* Bill Monroe Museum and Bluegrass Hall of Fame

B'nai B'rith Klutznick National Jewish Museum. *See also* National Jewish American Sports Hall of Fame

Bob Hoffman Weightlifting Hall of Fame, 149. *See also* Weightlifting Hall of Fame

Bohdan, Michael, 202. *See also* Cockroach Hall of Fame

Booth, D. C., Historic Fish Hatchery, 32, 42, 44, 112

Bowling halls of fame, 7–8, 102. *See also names of specific halls of fame*

Bowling Proprietors Association of America Hall of Fame, 7, 102. *See also* International Bowling Museum and Hall of Fame

Boxing halls of fame, 102–3. *See also* Hall of Fame of Boxing; International Boxing Hall of Fame

Boyer, George F., Historical Museum, 37, 49, 126

Brandon, E. Howard, 155. *See also* Car Collectors Hall of Fame

Breitbard, Bob, 76. *See also* Breitbard Hall of Fame

Breitbard Athletic Foundation, 75. *See also* Breitbard Hall of Fame

Breitbard Hall of Fame, 12, 22, **75–76**

British Columbia Hockey Hall of Fame, 66

British Columbia Sports Hall of Fame and Museum, 9, 24, 64, **218–19**

British halls of fame, 4, 7, 10, 14, 17, 47, 49, 231–32. *See also names of specific halls of fame*

Broadcasting and Cable Hall of Fame, 5

Bronx Community College. *See* Hall of Fame for Great Americans

Bryant, Paul W., 7, 87

Bryant, Paul W., Museum, 7, 87

Bull Hall of Fame, 10, 14, **201–2**

Burkhalter, Evelyn, 201. *See also* Barbie Doll Hall of Fame

Burlesque Hall of Fame and Museum, 10, 15, **202**

Busch Gardens, 6, 107. *See also* Show Jumping Hall of Fame and Museum

Business and industry halls of fame, 6, 10, 46, 65, 164–66. *See also names of specific halls of fame*

Camping hall of fame, 166–67. *See also* Family Camping Hall of Fame

Canada's Aviation Hall of Fame, 7, 10, 25, 34, 43, 47, 58, 61, 64, **219**

Canada's Sports Hall of Fame, 4, 9, 24, 30, 34, 36, 38, 40, 43–44, 47–48, 58, 67, 70, **219–20**

Canadian Amateur Hockey Association, 224. *See also* International Hockey Hall of Fame

Canadian Country Music Hall of Fame, 68

Canadian Curling Association, 223. *See also* Curling Hall of Fame and Museum in Canada

Canadian Figure Skating Association, 24, 30, 220. *See also* Canadian Figure Skating Hall of Fame

Canadian Figure Skating Hall of Fame, 34, 36, 40, 43–44, 47, 70, **220**

Canadian Football Hall of Fame and Museum, 7, 24, 58, 61, **220–21**

Canadian Football League, 13, 37, 221

Canadian Golf Hall of Fame, 24, **221–22**

Canadian halls of fame, 4, 7, 9–10, 24–25, 30, 36–37, 42–44, 47, 58, 61, 64, 69–70, 217–28. *See also names of specific halls of fame*

Canadian Lacrosse Association, 222. *See also* Canadian Lacrosse Hall of Fame

Canadian Lacrosse Hall of Fame, **222**

Canadian Ladies Curling Association, 222. *See also* Curling Hall of Fame and Museum in Canada

Canine Hall of Fame for Lead Dogs, 14, **106–7**. *See also* Dog Mushers' Hall of Fame

Canton Jewish Community Center Hall of Fame, 85

Car Collectors Hall of Fame, 5, 30, **155**

Cartoon art hall of fame, 167. *See also* International Museum of Cartoon Art Hall of Fame

Catskill Fly Fishing Museum and Hall of Fame, 15, **111**

Checkers hall of fame, 103. *See also* International Checkers Hall of Fame

Chess hall of fame, 104. *See also* United States Chess Hall of Fame

Chicagoland Sports Hall of Fame, 6, 32, 38, 68, **76–77**

Chicago's Jewish Sports Hall of Fame, 85

Chicago Sports Hall of Fame, 76–77. *See also* Chicagoland Sports Hall of Fame

Circus halls of fame, 167–68. *See also* Clown Hall of Fame and Research Center; International Circus Hall of Fame

Classic Car Museum, 127

Cleland, Alexander, 95. *See also* National Baseball Hall of Fame and Museum

Clown Hall of Fame and Research Center, 5, 23, 32, 41, 56, 60, 63, **168–69**

Clown halls of fame, 168–69. *See also* Clown Hall of Fame and Research Center; International Circus Hall of Fame

Cockroach Hall of Fame, 10, **202–3**

Collections at halls of fame, 52–54. *See also names of specific organizations*

College and university halls of fame, 7, 28, 104–5. *See also names of specific halls of fame*

College Football Hall of Fame, 7–8, 12, 15, 20, 29, 34, 36, 39, 41, 43, 45, 51, 54, 56, 64, 68, **113–14**

Collegiate Tennis Hall of Fame, 6, **144**

Colorado Ski Museum-Ski Hall of Fame, 69, **137**

Colorado Sports Hall of Fame, 5

Columbus Jewish Community Center Hall of Fame, 85

Combs, Inc., 205. *See also* Hall of Fumes

Comiskey Park Hall of Fame, **93–94**

Company-founded halls of fame, 28–29. *See also names of specific halls of fame*

Connecticut Sports Museum and Hall of Fame, 8, 23, **77**

Corvette Hall of Fame and Americana Museum, 14, 30, **155–56**

Country Music Hall of Fame and Museum, 4, 6, 10, 22, 35, 41, 43, 45, 47, 51–54, 58, 60, 66, 69, **177–78**

Cowboy/cowgirl halls of fame, 10, 194–98. *See also names of specific halls of fame*

Cowboys Turtle Association, 197. *See also* ProRodeo Hall of Fame and Museum of the American Cowboy

Crayola Hall of Fame, 14, **203**

Crested Butte Heritage Museum, 32, 39, 101

Croquet Foundation of American, 105. *See also* National Croquet Hall of Fame

Croquet hall of fame, 105. *See also* National Croquet Hall of Fame

Cuauhtémoc Moctezuma Brewery, 234. *See also* Professional Baseball Hall of Fame of Mexico

Curling Hall of Fame and Museum in Canada, 24, 30, 61, 63, **222–23**

Dallas Cowboys Ring of Honor, 5, 23, **215**

Dance Hall of Fame, 14, 23, 28, 36, 58, **169–70**

Daredevil Hall of Fame, 7, 10, 24–25, 34, 40, 47, **223–24**

Dawson, William F., 2, 67. *See also* International Swimming Hall of Fame

D. C. Booth Historic Fish Hatchery, 32, 42, 44, 112

Delaware County Athletes Hall of Fame, 6, 8, 15, 49, 66, **77–78**

Denver Broncos Ring of Fame, **215–16**

Deutsches Museum Ehrensaal, 7, 10, 24, 30, 34, 47, 58, 61, **228–30**

Directory of hall of fame museums and exhibits, 73–235

D.I.R.T. Hall of Fame and Classic Car Museum, **127**

Dirt track racing, 127. *See also* D.I.R.T. Hall of Fame and Classic Car Museum

Dixie Truckers Home, 6, 51, 190–91

Dog Mushers' Hall of Fame, **106–7**. *See also* Canine Hall of Fame for Lead Dogs

Dog racing halls of fame, 105–6. *See also names of specific halls of fame*

Dog sledding hall of fame, 106–7. *See also* Canine Hall of Fame for Lead Dogs; Dog Mushers' Hall of Fame

Don Garlits Museum of Drag Racing, 46, 53, 129–30

Drag racing, 129–30. *See also* Don Garlits Museum of Drag Racing; International Drag Racing Hall of Fame

Drivers Independent Race Tracks (D.I.R.T.), 127. *See also* D.I.R.T. Hall of Fame and Classic Car Museum

EAA Air Adventure Museum halls of fame, 7, 9, 53, 61, 64, **158–59**. *See also names of specific halls of fame*

EAA Aircraft Homebuilders Hall of Fame, 158. *See also* EAA Air Adventure Museum halls of fame

EAA Antique/Classics Hall of Fame, 158. *See also* EAA Air Adventure Museum halls of fame

EAA Warbirds Hall of Fame, 158. *See also* EAA Air Adventure Museum halls of fame

Edison Institute of the Ford Foundation, 129. *See also* Indianapolis Motor Speedway Hall of Fame Museum

Education programs at halls of fame, 58–62. *See also names of specific halls of fame*

Ehrensaal. *See* Deutsches Museum Ehrensaal

Emerson Radio Corporation, 29, 188. *See also* Radio Hall of Fame

Equestrian halls of fame, 107–8. *See also names of specific halls of fame*

Ethnic halls of fame, 8, 108–9, 170. *See also names of specific halls of fame*

Evans, Dixie, 202. *See also* Burlesque Hall of Fame and Museum

Exhibitions, temporary, 56–58, 67

Exhibitions, traveling, 57–58, 222

Exhibits at halls of fame, 33, 49–59, 64. *See also names of specific halls of fame*

Experimental Aircraft Association (EAA), 159. *See also* EAA Air Adventure Museum halls of fame

Facial Hair Hall of Fame, 206

Facilities of halls of fame, 30, 32, 34.

See also names of specific halls of fame

Family Camping Hall of Fame, 6, 44, 47, 63, 69, **166–67**

FarmTown U.S.A., 153–54. *See also* National Agricultural Center and Hall of Fame

Field hockey hall of fame, 109. *See also* United States Field Hockey Association Hall of Fame

Field Trial Hall of Fame, 6, **109–10**

Figure skating halls of fame, 110–11, 220. *See also names of specific halls of fame*

Firefighting hall of fame, 170–71. *See also* National Firefighting Hall of Heroes

Fishing halls of fame, 8, 111–13. *See also names of specific halls of fame*

Flight Instruction Hall of Fame, 158. *See also* EAA Air Adventure Museum halls of fame

Florida Sports Hall of Fame and Museum, 8, 28, 35, 38, 44–45, 63, 66, 70, **78**

Florida Sports Writers Association/Florida Sportscasters Association, 28, 78. *See also* Florida Sports Hall of Fame and Museum

Football halls of fame, 8, 113–18, 220–21. *See also names of specific halls of fame*

Foreign halls of fame, 217–35. *See also* Halls of fame in other countries; *names of specific organizations*

Founders of halls of fame, 27–30

France, William H. G., Sr., 28. *See also* International Motor Sports Hall of Fame

French halls of fame, 4, 7, 10, 14, 17, 49, 228. *See also* Panthéon

Frick, Ford, 95. *See also* National Baseball Hall of Fame and Museum

Friends of the Department of Labor, 172. *See also* Labor Hall of Fame

Frisbee hall of fame, 119. *See also* International Frisbee Hall of Fame

Funding of halls of fame, 43–48, 70

Gallery of Also Rans, 51, **204–5**
Gallery Without Walls, 210. *See also* Palm Springs Walk of Stars and Gallery Without Walls
Games halls of fame, 75–151. *See also names of specific halls of fame*; Sports and games halls of fame
Garlits, Don, Museum of Drag Racing, 46, 53, 129–30
Geographical guide to hall of fame museums and exhibits, 239–56
George F. Boyer Historical Museum, 37, 44, 126
Georgia Aviation Hall of Fame, 9, 13, 35, 39, 51, 53, 66, **159–60**
Georgia Prep Sports Hall of Fame, 78. *See also* Georgia Sports Hall of Fame
Georgia Sports Hall of Fame, 39, 44, 65, **78–79**
German halls of fame, 4, 7, 10, 14, 58, 61, 228–31. *See also names of specific halls of fame*
Getz, George, 171. *See also* National Firefighting Hall of Heroes
Golf halls of fame, 8, 119–20, 221–22. *See also names of specific halls of fame*
Governing bodies of halls of fame, 34–36, 39
Government-initiated halls of fame, 29–30, 35, 45. *See also names of specific halls of fame*
Greater Flint Afro-American Hall of Fame, 7, **79**
Greater Flint Area Sports Hall of Fame, 5, **79**
Greater Washington Jewish Sports Hall of Fame, 85
Great Westerners Hall of Fame, 194–95. *See also* National Cowboy Hall of Fame and Western Heritage Center
Great Western Performers Hall of Fame, 195. *See also* National Cowboy Hall of Fame and Western Heritage Center
Green Bay Packer Hall of Fame, 8, 22, 29, 55, 60, **114–16**
Greyhound Hall of Fame, 5, 22, 32, **105–6**

Greyhound Track Operators Association, 106. *See also* Greyhound Hall of Fame
Gymnastics hall of fame, 121. *See also* International Gymnastics Hall of Fame and Museum

Hall of Fame for Great Americans, 4–5, 10, 18–19, 27, 36, 45, 49, 69, **182–83**
Hall of Fame Hall of Fame exhibition, 67
Hall of fame museums and exhibits: closings, 67–68; contents, 5, 16; definitions, 1–2, 26; directory, 73–235; growth, 15–16, 63–71; history, 17–25, 63–64; honorees, 14–15, 17–18; induction criteria, 36–37; locations, 6–8, 239–56; number, 2, 4; operations, 27–48, 70; overview, 1–16; selection process, 14, 36–40; types, 1, 4–6. *See also names of specific halls of fame and other aspects*
Hall of Fame of Boxing, 67
Hall of Flame Museum of Firefighting, 5, 29, 65, 170–71
Hall of Fumes, 10, 14, **205**
Halls of fame in other countries, 4, 7, 9–10, 13–15, 23–25, 30, 34, 36, 42–44, 47, 49, 58, 61, 64, 69–70, 217–35. *See also names of specific halls of fame*
Hamburger Hall of Fame, **203–4**
Hamburger Hall of Fame (restaurant), 14
Hammons, John Q., 28, 82. *See also* Missouri Sports Hall of Fame
Harness racing halls of fame, 121–22. *See also* Harness Racing Museum and Hall of Fame; Saratoga Harness Racing Museum and Hall of Fame
Harness Racing Museum and Hall of Fame, 28, 32, 39, 41, 45–46, 50, 65, **121–22**
Harridge, William, 95. *See also* National Baseball Hall of Fame and Museum
Hedges, Dick, 27, 82. *See also* Muskegon Area Sports Hall of Fame
Hellenic Athletic Hall of Fame, 66
Helms Athletic Foundation Hall of Fame, 18, 20, 68

Herreshoff Marine Museum, 9, 39, 134–35

Hitters Hall of Fame, 40, 49, 63, 98. *See also* Ted Williams Museum and Hitters Hall of Fame

Hockey Hall of Fame, 4, 7, 24, 30, 34, 36, 42–43, 47–48, 58, 61, **224**

Hockey halls of fame, 122–23, 224–25

Hollywood Walk of Fame, 5, 10, 15, 22, 46, **209–10**

Hot Dog Hall of Fame, 68

Houghton County Historical Museum, 6, 64, 119

Hulman, Tony, 129. *See also* Indianapolis Motor Speedway Hall of Fame Museum

Ice hockey halls of fame, 122–23, 224–25. *See also names of specific halls of fame*

Indiana Basketball Hall of Fame, 22, 29, 36, 43–44, 46, 56, 64, 68, **99**

Indianapolis Motor Speedway Hall of Fame Museum, 2, 8, 22, 38, 46–47, 53, **127–29**

Industrial halls of fame. *See* Business and industry halls of fame; *names of specific halls of fame*

Intercollegiate Sailing Hall of Fame, **135–36**

Intercollegiate Tennis Association, 144. *See also* Collegiate Tennis Hall of Fame

International Aerobatic Hall of Fame, 15, 158. *See also* EAA Air Adventure Museum halls of fame

International Aerospace Hall of Fame, 9, 42, 47, 53–54, 66, 69, **160**

International Afro-American Sports Hall of Fame and Gallery, 8, 50, **79–80**

International Association of Sports Museums and Halls of Fame, 66–67

International Best-Dressed Hall of Fame, 5

International Bowling Museum and Hall of Fame, 7–8, 12, 29, 41, 55–56, 97, **102**

International Boxing Hall of Fame, 9, 12, 52, 61, **102–3**

International Checkers Hall of Fame, 9, 28, 61, **103–4**

International Circus Hall of Fame, 6, 15, 32, 68, **167–68**

International Drag Racing Hall of Fame, 46, 53, **129–30**

International Fishing Hall of Fame, 65–66, **111–12**

International Frisbee Hall of Fame, 6, 64, **119**

International Game Fish Association, 111–12. *See also* International Fishing Hall of Fame

International Gymnastics Hall of Fame and Museum, 15, 66, **121**

International Heritage Hall of Fame, **170**

International Hockey Hall of Fame, 24, 30, **224–25**

International Jewish Sports Hall of Fame, 9, 25, 30, 70, 85, **232–33**

International Motorsports Hall of Fame, 7–8, 23, 28, 32, 38, 40, 53, 60, 69, **130–31**

International Museum of Cartoon Art Hall of Fame, 6, 29, 64–65, **167**

International Museum of Surgical Science and Hall of Fame, 68

International Palace of Sports Hall of Fame, 67

International Photography Hall of Fame and Museum, 58, **185–86**

International Skating Union, 110. *See also* World Figure Skating Museum and Hall of Fame

International Snowmobile Racing Hall of Fame and Museum, 14, 34, 42, 69, **138–39**

International Soap Box Derby, Inc., 36. *See also* All-American Soap Box Derby Museum and Hall of Fame

International Space Hall of Fame, 9, 14, 35–36, 40, 42, 47, **161**

International Surfing Museum, 212. *See also* Surfing Walk of Fame

International Swimming Hall of Fame, 2, 9, 15, 22, 32, 41, 45, 60–61, 67, 69, **143–44**

International Tennis Hall of Fame and Museum, 2, 8, 22, 28, 32–33, 35, 41, 43, 56, 61, 69, **145**

International Towing and Recovery Hall of Fame and Museum, **193**

International Women's Sports Hall of Fame, 66

Inventors Hall of Fame, 171–72. *See also* Inventure Place, National Inventors Hall of Fame

Inventure Place, National Inventors Hall of Fame, 4, 29, 35, 37, 40–41, 43–44, 47, 56, 58, 60, 63–64, **171–72**

Irwin, John Rice, 40, 190. *See also* Appalachian Hall of Fame

Israeli hall of fame, 232–33. *See also* International Jewish Sports Hall of Fame

Israel Sport Museum, 70. *See also* International Jewish Sports Hall of Fame

Jackson Touchdown Club, 18, 81. *See also* Mississippi Sports Hall of Fame and Museum

Japanese Baseball Hall of Fame and Museum, 4, 7, 9, 24, 47, 61, **233**

Japanese hall of fame, 4, 7, 9, 24, 47, 61, 253. *See also* Japanese Baseball Hall of Fame and Museum

JCC Sports Hall of Fame, 85

Jewish halls of fame, 8–9, 25, 30, 47, 65, 70, 84–85, 225, 232–33. *See also names of specific halls of fame*

Jim Buck Ross Mississippi Agriculture and Forestry Museum complex. *See* Mississippi Music Hall of Fame; National Agricultural Aviation Museum and Hall of Fame

Joe Weatherly Museum, 8, 47, 132–33

Jousting hall of fame, 123

Junior Achievement, Inc., 165. *See also* National Business Hall of Fame

Kansas City Chiefs Ring of Honor, **216**

Kearns, Tom, University of Miami Sports Hall of Fame, 28, 54, 92–93

Kenneth Ritchie Wimbledon Library, 232. *See also* Wimbledon Lawn Tennis Museum

King Ludwig I of Bavaria, 17, 230. *See also* Ruhmeshalle

Kirkpatrick Center, 58, 185–86

Kiting hall of fame, 124. *See also* World Kite Museum and Hall of Fame

Knik Museum, 14, 106–7

Labor Hall of Fame, 23, 54, **172**

Lacrosse Foundation, 124. *See also* Lacrosse Hall of Fame Museum

Lacrosse Hall of Fame Museum, 9, 14, 28, 35, 39, 41, 43, 68, **124–25**

Lacrosse halls of fame, 124–25, 222. *See also* Lacrosse Hall of Fame Museum

Ladies Professional Golf Association Hall of Fame, 120. *See also* World Golf Hall of Fame

Lake Placid Hall of Fame, **150**

Law enforcement halls of fame, 10, 173–74. *See also names of specific halls of fame*

Lea County Cowboy Hall of Fame and Western Heritage Center, 23, 35, 42, 55, **194**

Legends and Superstars Hall of Fame, 5, 10, **178–79**

Libraries and archives at halls of fame, 58, 60–61. *See also names of specific halls of fame*

Little League Baseball Hall of Excellence, 5, **94**

Local sports halls of fame, 125–26. *See also names of specific halls of fame*

Louisiana Sports Hall of Fame, 8, **80**

Lowe, J. L., 28. *See also* Alabama Jazz Hall of Fame Museum

McCaig-Wellborn International Motorsports Research Library, 60, 131. *See also* International Motorsports Hall of Fame

McGovern, Peter J., Little League Baseball Museum, 5, 94

Maine Sports Hall of Fame, 7, 23, 32, 36, 39, 44, 46, **80–81**

Marbles Hall of Fame, 37, 44, **126**

Margaret Dow Towsley Sports Museum, 7, **81**

Marketing of halls of fame, 70. *See also names of specific halls of fame*

Maryville Academy. *See* Chicagoland Sports Hall of Fame

Medical halls of fame 5, 10, 14, 68, 204

Membership programs at halls of fame, 45–48. *See also names of specific halls of fame*

Merchandise Mart Hall of Fame, 10, 15, 22, **164–65**

Meteor Crater Museum of Astrogeology, 5, 54, 157

Mexican hall of fame, 233–34. *See* Professional Baseball Hall of Fame of Mexico

Michigan Jewish Sports Hall of Fame, 85

Middle Tennessee Sportswriters and Broadcasters Association, 91. *See also* Tennessee Sports Hall of Fame

Milwaukee Jewish Community Center Sports Hall of Fame, 85

Mining hall of fame, 174–75. *See also* National Mining Hall of Fame and Museum

Mission statements of halls of fame, 12–13

Mississippi Music Hall of Fame, 23, 50–51, 65, **179**

Mississippi River Museum. *See* National Rivers Hall of Fame

Mississippi Sports Hall of Fame and Museum, 28, 35, 40, 43, 56, **81–82**

Missouri Sports Hall of Fame, 8, 28, 39, 44, 46, 57, 63, 65, 70, **82**

Mobile home hall of fame, 39, 46, 68, 175–76

Molson's Sports Hall of Fame, 227. *See also* Saskatchewan Sports Hall of Fame and Museum

Monroe, Bill, Museum, and Bluegrass Hall of Fame, 177

Montreal YM/YWHA Sports Hall of Fame, 85

Motorcycle hall of fame, 126–27. *See also* National Motorcycling Museum and Hall of Fame

Motorsports Hall of Fame, 131. *See also* Motorsports Museum and Hall of Fame of America

Motor sports halls of fame, 8, 127–33. *See also names of specific halls of fame*

Motorsports Museum and Hall of Fame of America, 34, 49, 56, 63, **131**

Mountain Bike Hall of Fame and Museum, 32, 39, **101**

Museum of Appalachia. *See* Appalachian Hall of Fame

Museum of Aviation. *See* Georgia Aviation Hall of Fame

Museum of Broadcast Communications. *See* Radio Hall of Fame

Museum of Family Camping. *See* Family Camping Hall of Fame

Museum of Farming, 153–54. *See also* National Agricultural Center and Hall of Fame

Museum of Questionable Medical Devices, 5, 10, 14, 204

Museum of Science and Industry. *See* National Business Hall of Fame

Museum of the American Cowboy. *See* ProRodeo Hall of Fame and Museum of the American Cowboy

Museum of Yachting. *See* Singlehanded Sailors Hall of Fame

Music halls of fame, 9–10, 176–81. *See also names of specific halls of fame*

Muskegon Area Sports Hall of Fame, 6, 8, 28, **82–83**

Muskegon County Museum. *See* Muskegon Area Sports Hall of Fame

Naismith, Dr. James, 99, 225. *See also* Naismith International Basketball Centre and Hall of Fame; Naismith Memorial Basketball Hall of Fame

Naismith Foundation, 225. *See also* Naismith International Basketball Centre and Hall of Fame

Naismith International Basketball Centre and Hall of Fame, 7, 14–15, 24, 34, 43–44, 47, 64, 70, **225–26**

Naismith Memorial Basketball Hall of
 Fame, 2, 8, 22, 30, 39, 43, 45, 51, 54–
 56, 67, **99–100**
National Agricultural Aviation Museum
 and Hall of Fame, 42, 68, 153–54,
 161
National Agricultural Center and Hall of
 Fame, 10, 13, 22, 29, 38, 42, 53, 60–
 61, **153–54**
National Association of Chiefs of Police,
 173. *See also* American Police Hall of
 Fame and Museum
National Aviation Hall of Fame, 9, 29,
 39, 43, 65–66, **162**
National Baseball Congress Hall of Fame,
 8, 64, **94**
National Baseball Hall of Fame and Mu-
 seum, 2, 5, 8, 20–21, 30, 38, 41, 45,
 47, 51–52, 57, 60–61, **95–96**
National Baseball Library, 60, 96. *See
 also* National Baseball Hall of Fame
 and Museum
National Bird Dog Museum, 109. *See
 also* Field Trial Hall of Fame
National Business Hall of Fame, 6, 10,
 46, 65, **165–66**
National Council of Intellectual Property
 Law Associations, 171. *See also* Inven-
 ture Place, National Inventors Hall of
 Fame
National Cowboy Hall of Fame and
 Western Heritage Center, 5, 10, 22, 30,
 35, 37, 39, 41, 43, 46–47, 53–55, 60,
 65, **194–96**
National Cowgirl Hall of Fame and
 Western Heritage Center, 29, 66, **196**
National Croquet Hall of Fame, 9, 32,
 54, 58, 64, **105**
National Farmers Memorial, 153–54. *See
 also* National Agricultural Center and
 Hall of Fame
National Federation of State High School
 Associations, 83. *See also* National
 High School Sports Hall of Fame
National Firefighting Hall of Heroes, 5,
 29, 65, **170–71**
National Fish Culture Hall of Fame, 32,
 42, 44, **112**

National Football Foundation, 114. *See
 also* College Football Hall of Fame
National Fresh Water Fishing Hall of
 Fame, 8, 15, 22, 32, 41, 44–46, 53, 68–
 69, **112–13**
National Greyhound Association, 106.
 See also Greyhound Hall of Fame
National Hall of Fame for Famous Amer-
 ican Indians, 10, 22, 27, 38, 42, 49,
 181–82
National High School Band Directors
 Hall of Fame, 66
National High School Sports Hall of
 Fame, 66, **83**
National Hockey League, 224, 226
National Italian American Sports Hall of
 Fame, 8, 65, **83–84**
National Jewish American Sports Hall of
 Fame, 8, 65, **84**
National Jousting Hall of Fame, **123**
National Mining Hall of Fame and Mu-
 seum, 10, 15, 28, 38–39, 44, 54–55,
 57, 69, **174–75**
National Motorcycling Museum and Hall
 of Fame, 63, **126–27**
National Motorsports Press of America
 (NMPA), 132. *See also* NMPA Stock
 Car Hall of Fame/Joe Weatherly Mu-
 seum
National Museum of Dance. *See* Dance
 Hall of Fame
National Museum of Polo and Hall of
 Fame, 9, 65, **133**
National Museum of Racing and Hall of
 Fame, 12, 22, 34, 41, 43, 46, 54, 57,
 70, **146–47**
National Museum of Roller Skating, 34,
 39, 60, 133–34
National Oldtime Fiddlers' Hall of Fame,
 10, **179**
National Plastics Center and Museum.
 See Plastics Hall of Fame
National Polish-American Sports Hall of
 Fame, 8, 23, 28, **84**
National Rivers Hall of Fame, 42, 51, 53,
 69, **191**
National Shuffleboard Hall of Fame, 9, **136**

National Skeet Shooting Association, **136–37**. *See also* National Skeet Shooting Hall of Fame Museum

National Skeet Shooting Hall of Fame Museum, 60, 66, 136–37

National Soccer Hall of Fame, 32, 66, 70, **139–40**

National Softball Hall of Fame and Museum, 28, 38, 40, 45, 50, 61, 69, **140–41**

National Sportscasters and Sportswriters Hall of Fame, 65, **141–42**

National Sprint Car Hall of Fame and Museum, 23, 35, 40, 42, 57, 61, 63, 69, **131–32**

National Statuary Hall, 5, 10–11, 17, 29, 45, 49, **183–84**

National Teachers Hall of Fame, 63, **193**

National Track and Field Hall of Fame, **147**

National Wildlife Heritage Center, 109. *See also* Field Trial Hall of Fame

National Women's Hall of Fame, 10, 12–13, 22, 40, 44–46, 51, 58, 60, 69, **199–200**

National Wrestling Hall of Fame and Museum, 28, 32, 44, **151**

Native Americans hall of fame, 181–82. *See also* National Hall of Fame for Famous American Indians

Neenah Historical Society. *See* Paper Industry Hall of Fame

Negro Baseball Hall of History, 68

New Brunswick Sports Hall of Fame, 24, 30, **226**

New Mexico Junior College. *See* Lea County Cowboy Hall of Fame and Western Heritage Center

New Mexico Office of Cultural Affairs, 36, 161. *See also* International Space Hall of Fame

Newport Art Museum. *See* National Croquet Hall of Fame

New South Wales Hall of Champions, 7, 9, 25, 34, 38, 58, **217**

New York Jewish Sports Hall of Fame, 47, **84–85**

New York University. *See* Hall of Fame for Great Americans

New York Yankees Memorial Park, 5, 18, **96–97**

New Zealand hall of fame, 234–35. *See also* New Zealand Sports Hall of Fame

New Zealand Olympic and Commonwealth Games Association, 234. *See also* New Zealand Sports Hall of Fame

New Zealand Sports Hall of Fame, 9, 15, 25, 30, 70, **234–35**

Niagara Falls Museum. *See* Daredevil Hall of Fame

NMPA Stock Car Hall of Fame/Joe Weatherly Museum, 8, 47, **132–33**

Non-sports halls of fame, 4, 9–10, 12–14, 153–200. *See also names of specific halls of fame*

North Carolina Museum of History, 50, 64, 85–86

North Carolina Sports Hall of Fame, 50, 64, **85–86**

North Dakota Cowboy Hall of Fame, 66

North Dakota Sports Hall of Fame, 6, 15, **86**

North Dakota Sports Hall of Honor, 86. *See also* North Dakota Sports Hall of Fame

Northwestern Ontario Sports Hall of Fame, 24, **226–27**

Northwestern State University, 8, 80

Notable Americans halls of fame, 182–84. *See also names of specific halls of fame*

"Odor-Eaters" foot care products, 10, 14, 205

Oklahoma Jazz Hall of Fame, 10, **180**

Oklahoma State University, 28, 32, 44, 51

Olympic Beer Company, 76. *See also* Chicagoland Sports Hall of Fame

Olympic Hall of Fame and Museum, 24, 36, 43–44, 70, **227**

Olympic halls of fame, 18, 20, 24, 36–37, 43–44, 70, 150, 227. *See also names of specific halls of fame*

Operational costs of halls of fame, 43–44

Orange County Sports Hall of Fame, **86–87**

Original Baseball Hall of Fame of Minnesota, 30, **97**

Palm Springs Walk of Stars and Gallery Without Walls, 64, **210–11**
Panthéon, 4, 7, 10, 14, 17, 49, **228**
Paper hall of fame, 184. *See also* Paper Industry Hall of Fame
Paper Industry Hall of Fame, 6, 15, 23, 64, 66, **184**
Patent and Trademark Office. *See* Inventure Place, National Inventors Hall of Fame
Paul W. Bryant Museum, 7, **87**
Pendleton Round-Up Happy Canyon Hall of Fame, **196–97**
Pendleton Round-Up Rodeo, 196–97
Penn State All-Sports Hall of Fame, 65
Penn State Football Hall of Fame, 7, 28, 65, 116
Pennsylvania State University, 7, 28, 65, 116
Permian Basin Petroleum Museum, Library, and Hall of Fame. *See* Petroleum Hall of Fame
Peter J. McGovern Little League Baseball Museum, 5, 94
Petroleum Hall of Fame, 6, 10, 29, 54, **184–85**
PGA Tour Hall of Fame, 120. *See also* World Golf Hall of Fame
Philadelphia Jewish Sports Hall of Fame, 85
Photographic Art and Science Foundation, 185. *See also* International Photography Hall of Fame and Museum
Photography hall of fame, 185–86. *See also* International Photography Hall of Fame and Museum
Pickle Packers Hall of Fame, 5
Plastics Academy, 186. *See also* Plastics Hall of Fame
Plastics Hall of Fame, 6, 14, 35, 60, 64, **186**
Poberezny, Paul H., 159. *See also* EAA Air Adventure Museum halls of fame
Poker Hall of Fame, 68

Polo hall of fame, 133. *See also* National Museum of Polo and Hall of Fame
Poultry hall of fame, 187. *See also* American Poultry Hall of Fame
Presidential losers hall of fame, 204–5. *See also* Gallery of Also Rans
Pritikin, Renny, 67
Pro Beach Volleyball Hall of Fame, 15, 23, 29, 42, 44–45, 65, **100–101**
Professional Baseball Hall of Fame of Mexico, 4, 7, 9, 24, 30, 34, 40, 48, 58–59, 70, **233–34**
Professional Bowlers Association Hall of Fame, 102. *See also* International Bowling Museum and Hall of Fame
Professional Golfers' Association of America Hall of Fame, 120. *See also* PGA Tour Hall of Fame; World Golf Hall of Fame
Professional Rodeo Cowboys Association, 197–98. *See also* ProRodeo Hall of Fame and Museum of the American Cowboy
Professional Teams Association, 30, 233. *See also* Professional Baseball Hall of Fame of Mexico
Pro Football Hall of Fame, 2, 5, 8, 15, 22, 30–31, 34, 38, 41, 43, 45, 47, 49, 51, 56, 61, 116
ProRodeo Hall of Fame and Museum of the American Cowboy, 10, 51, 57, 60, 65, **197–98**
Public programming 58–62
Puerto Rico Sports Hall of Fame, 38–39, 65, **87**

Quackery Hall of Fame, 5, 10, 14, **204**
Quarter Midgets of America Hall of Fame, 130. *See also* International Motorsports Hall of Fame
Quilters Hall of Fame, 36, 65, **187**
Quilting hall of fame, 187. *See also* Quilters Hall of Fame

Racquetball hall of fame, 133. *See also* U.S. Racquetball Hall of Fame

Radio and television halls of fame, 188–89. *See also* Radio Hall of Fame; Television Academy Hall of Fame

Radio City Music Hall Sidewalk of Stars, **211**

Radio Hall of Fame, 5, 10, 23, 28–29, 38–39, 46–47, 57, 60, 69, **188**

Recovery and towing hall of fame, 193

Recreational vehicle/mobile home hall of fame, 175–76 *See also* RV/MH Hall of Fame and Museum

Regional history halls of fame, 189–91. *See also names of specific halls of fame*

Reid, M. H. "Lefty," 67. *See also* Canada's Sports Hall of Fame; Hockey Hall of Fame

Reyes, Alejandro Aguilar, 30. *See also* Professional Baseball Hall of Fame of Mexico

Reynolds-Alberta Museum. *See* Canada's Aviation Hall of Fame

Rhode Island Jewish Athletes Hall of Fame, 85

Rice, Grantland, 114. *See also* College Football Hall of Fame

Rings of fame, 5, 23, 215–16. *See also names of specific halls of fame*

Rings of honor, 5, 23, 215–16

River history hall of fame, 191. *See also* National Rivers Hall of Fame

Rochester Jewish Athletes Hall of Fame, 85

Rock and Roll Hall of Fame and Museum, 3, 5, 10, 23, 29–30, 39, 41, 43, 45–46, 51, 63, 66, **180–81**

Rock and Roll Hall of Fame Foundation, 180. *See also* Rock and Roll Hall of Fame and Museum

Rodeo Hall of Fame, 194–95 *See also* National Cowboy Hall of Fame and Western Heritage Center

Rodeo halls of fame, 10, 194–98. *See also names of specific halls of fame*

Roland Palmedo National Ski Library, 138. *See also* United States National Ski Hall of Fame and Museum

Roller Skating Hall of Fame, 34, 39, 60, **133–34**

Rose Bowl Hall of Fame, 117–18

Ross, Jim Buck, Mississippi Agriculture and Forestry Museum complex. *See* Jim Buck Ross Mississippi Agriculture and Forestry Museum complex

Route 66 Association of Illinois, 190. *See also* Route 66 Hall of Fame

Route 66 Hall of Fame, 6, 51, **190–91**

Royal Canadian Golf Association, 221. *See also* Canadian Golf Hall of Fame

Ruhmeshalle, 7, 10, 17, 49, **230**

RV/MH Hall of Fame and Museum, 39, 46, 68, **175–76**

RV/MH Heritage Foundation, 175. *See also* RV/MH Hall of Fame and Museum

Ryan, Barbara, 30. *See also* Canadian Figure Skating Hall of Fame

Sailing halls of fame, 8–9, 134–36. *See also names of specific halls of fame*

St. Louis Cardinals Hall of Fame Museum, 7–8, 29, 40, **97–98**. *See also* International Bowling Museum and Hall of Fame

St. Louis Jewish Sports Hall of Fame, 85

St. Louis Walk of Fame, **211–12**

St. Mary's College, 8, 23, 28, 84

Saints Hall of Fame, 35, 42, 49, **118**

San Diego Aerospace Museum. *See* International Aerospace Hall of Fame

San Diego Hall of Champions Sports Museum, 12, 22, 75–76

Santa Clarita Valley Walk of Western Stars, **212**

Saratoga Harness Racing Museum and Hall of Fame, 14, 42, **122**

Saskatchewan Sports Hall of Fame and Museum, 13, 24, 37, **227–28**

Scott, Myron, 139. *See also* All-American Soap Box Derby Museum and Hall of Fame

Select Sires, 201–2. *See also* Bull Hall of Fame

Seneca Falls Historic District, 199–200. *See also* National Women's Hall of Fame

Senior Athletes Hall of Fame, 6, 32, 42, 51, 65, **88**

Sherman, Jacob, 40. *See also* Daredevil Hall of Fame

Show Jumping Hall of Fame and Museum, 6, **107–8**

Shreveport-Bossier City Sports Museum of Champions, 5, 35, 50, **88**

Shuffleboard hall of fame, 9, 136

Siegman, Joseph, 30. *See also* International Jewish Sports Hall of Fame

Singapore hall of fame, 235. *See also* Singapore Sports Hall of Fame

Singapore Sports Council, 30, 235. *See also* Singapore Sports Hall of Fame

Singapore Sports Hall of Fame, 7, 9, 14–15, 25, 30, 34, **235**

Singapore Sports Museum, 235. *See also* Singapore Sports Hall of Fame

Singlehanded Sailors Hall of Fame, 14, 47, 51, 60, **135**

Skeet shooting hall of fame, 136–37. *See also* National Skeet Shooting Hall of Fame Museum

Skiing halls of fame, 137–38. *See also names of specific halls of fame*

Sneakers hall of fame, 205. *See also* Hall of Fumes

Snowmobiling hall of fame, 138–39. *See also* International Snowmobile Racing Hall of Fame and Museum

Soap box racing, 139. *See also* All-American Soap Box Derby Museum and Hall of Fame

Soccer hall of fame, 139–40. *See also* National Soccer Hall of Fame

Soderberg, Paul, Helen Washington, and other coeditors, *The Big Book of Halls of Fame in the United States and Canada*, 1–2

Softball halls of fame, 140–41. *See also* National Softball Hall of Fame and Museum; United States Slo-Pitch Softball Association Hall of Fame Museum

South Carolina Athletic Hall of Fame, 66

South Carolina Criminal Justice Hall of Fame, 35, 41–42, 44, 60, **173–74**

South Carolina Tennis Hall of Fame, 32, 42, 45, 47, 50, 68, **145–46**

South Carolina Tennis Patrons Foundation, 145. *See also* South Carolina Tennis Hall of Fame

South Dakota Amateur Baseball Hall of Fame, 8, 22, **98**

South Dakota Hall of Fame, 23, **192**

Southern California Jewish Sports Hall of Fame, 85

Southern Museum of Flight. *See also* Alabama Aviation Hall of Fame

Space Center, The. *See* International Space Hall of Fame

Space halls of fame, 9–10, 156–64. *See also names of specific halls of fame*

Special events at halls of fame, 58. *See also names of specific halls of fame*

Speed skating, 141–50. *See also* Lake Placid Hall of Fame

Sports and games halls of fame, 2, 4, 8–9, 12, 14, 75–151. *See also names of specific halls of fame*

Sports Association Hall of Fame, 86. *See also* North Dakota Sports Hall of Fame

SportsHall, 9, 24, 64, 218–19

Sports Hall of Fame of New Jersey, 64, **88–89**

Sports media halls of fame, 130, 141–42. *See also names of specific halls of fame*

Sprint car racing, 131–32. *See also* National Sprint Car Hall of Fame and Museum

Staffs of halls of fame, 40–43

State Athletic Hall, 39, 44, 65, 78–79

State non-sports halls of fame, 192. *See also names of specific halls of fame*

State of Alabama Sports Hall of Fame, 29, 32, 44, 51–54, 56, **89**

State of Kansas Sports Hall of Fame, 15, **89–90**

State of Michigan Sports Hall of Fame, **90**

State of Oregon Sports Hall of Fame Museum, 14, 40, 66, **90–91**

State sports halls of fame, 142–43. *See also names of specific halls of fame*

Statuary halls of fame, 5, 7, 10, 17–18, 27, 36, 49, 207. *See also names of specific halls of fame*

Stock car racing, 132–33. *See also* NMPA Stock Car Hall of Fame/Joe Weatherly Museum

Sundby, Glenn M., 121. *See also* International Gymnastics Hall of Fame and Museum

Surfing Walk of Fame, 64, 143, **212**

Sutherland, James T., 30, 224–25. *See also* Hockey Hall of Fame; International Hockey Hall of Fame

Swimming hall of fame, 143–44. *See also* International Swimming Hall of Fame

Talledega Superspeedway. *See* International Motorsports Hall of Fame

Teaching hall of fame, 193. *See also* National Teachers Hall of Fame

Ted Williams Museum and Hitters Hall of Fame, 40, 49, 63, **98**

Television Academy Hall of Fame, 10, 23, 27, 37, 45–46, 49, 64, 69, **188–89**

Television hall of fame, 188. *See also* Radio and television halls of fame; Television Academy Hall of Fame

Tennessee Sports Hall of Fame, 65, **91**

Tennis halls of fame, 8, 144–46, 232. *See also names of specific halls of fame*

Texas Baseball Hall of Fame, 91–92. *See also* Texas Sports Hall of Fame

Texas Golf Hall of Fame, 38, 51, **119–20**

Texas High School Basketball Hall of Fame, 91–92. *See also* Texas Sports Hall of Fame

Texas High School Football Hall of Fame, 91–92. *See also* Texas Sports Hall of Fame

Texas Ranger Hall of Fame and Museum, 10, 29, 35, 38, 40–41, 69, **174**

Texas Sports Hall of Champions. *See* Texas Sports Hall of Fame

Texas Sports Hall of Fame, 7–8, 32, 44, 46, 51, 58, 63, 68–69, **91–92**

Texas Tennis Hall of Fame, 55, 91–92. *See also* Texas Sports Hall of Fame

Thoroughbred racing halls of fame, 146–47. *See also* Aiken Thoroughbred Racing Hall of Fame; National Museum of Racing and Hall of Fame

Tom Kearns University of Miami Sports Hall of Fame, 28, 54, **92–93**

Towing and recovery hall of fame, 193

Towsley, Margaret Dow, Sports Museum, 7, 81

Track and field hall of fame, 147

Trapshooting Hall of Fame and Museum, 38–39, 46–47, 50, **147–48**

Trotting Horse Club of America, 28. *See also* Harness Racing Museum and Hall of Fame

Trotting Horse Museum, 121. *See also* Harness Racing Museum and Hall of Fame

United Professional Horsemen's Association Hall of Fame, **108**

United State Air Force Museum. *See* National Aviation Hall of Fame

United States Amateur Confederation of Roller Skating, 133–34. *See also* Roller Skating Hall of Fame

United States Bicycling Hall of Fame, 32, 44, **101–2**

United States Capitol. *See* National Statuary Hall

United States Chess Hall of Fame, 9, 15, **104**

United States Department of Agriculture, National Agricultural Library, 187. *See also* American Poultry Hall of Fame

United States Department of Labor, 23, 54, 172

United States Field Hockey Association Hall of Fame, **109**

United States Figure Skating Association, 28, **110–11**. *See also* United States Skating Hall of Fame

United States Hockey Hall of Fame, 9, 23, 34, 42, 44, 51, 110–11, **123**

United States Lacrosse Coaches Association, 28. *See also* Lacrosse Hall of Fame Museum

United States National Ski Hall of Fame
and Museum, 22, 36, 39, 44, 51, **137–
38**
United States Naval Academy, 135–36
United States Skating Hall of Fame, 28,
110. *See also* World Figure Skating
Museum and Hall of Fame
United States Ski Association, 137. *See
also* United States National Ski Hall of
Fame and Museum
United States SloPitch Softball Associa-
tion Hall of Fame Museum, 23, 39, 47,
141
United States Weightlifting Federation,
149. *See also* Weightlifting Hall of
Fame
University halls of fame, 7, 28, 104–5
*See also names of specific halls of
fame*
University of Alabama, 7, 87
University of Georgia, 6, 44
University of Miami, 28, 54, 92–93
University of Michigan, 7, 81
University of Tennessee Football Hall of
Fame, 7, 28, **118**
Unusual halls of fame, 5, 10, 14, 201–5.
*See also names of specific halls of
fame*
Ursinus College, 109
U.S. Astronaut Hall of Fame, 9, 46, 56,
60, **162–63**
USA Track & Field, 147. *See also* Na-
tional Track and Field and Field Hall
of Fame
U.S. Chess Center 9, 15
U.S. Racquetball Hall of Fame, 49, **133**
U.S. Space Camp Florida, 60, 162–63.
See also U.S. Astronaut Hall of Fame

Valhalla. *See* Walhalla
Van Alen, James, 28. *See also* Interna-
tional Tennis Hall of Fame and Mu-
seum
Velvet, Jimmy and Kathy, 178. *See also*
Legends and Superstars Hall of Fame
Virginia Aviation Hall of Fame, 6, **163–
64**

Virginia Aviation Museum, 6, 163
Virginia Historical Society, 163. *See also*
Virginia Aviation Hall of Fame
Virginia Sports Hall of Fame, 40, 45, 54,
66, **93**
Volleyball Hall of Fame, 29, 42, 44, 66,
148–49
Volleyball halls of fame, 148–49. *See
also* Pro Beach Volleyball Hall of
Fame; Volleyball Hall of Fame
Volunteers at halls of fame, 40–43

Walhalla, 7, 10, 14, 17, 49, **230–31**
Walker, Charles C., 28, 103. *See also* In-
ternational Checkers Hall of Fame
Walks of fame, 5, 209–13. *See also
names of specific halls of fame*
Washington Hall of Stars, **216**
Water Ski Hall of Fame, 35, 45, 50, 69,
149
Water skiing hall of fame, 149. *See also*
Water Ski Hall of Fame
Watkins Community Museum of History
15, 89–90
Weatherly, Joe, Museum. *See* NMPA
Stock Car Hall of Fame/Joe Weatherly
Museum
Weightlifting Hall of Fame, 29, **149–50**
Western America Ski Hall of Fame, 32,
40, 49, **138**
Western Auto Mechanics Hall of Fame,
130. *See also* International Motorsports
Hall of Fame
Western heritage halls of fame, 10, 194–
98. *See also names of specific halls of
fame*
Western Pennsylvania Jewish Sports Hall
of Fame, 85
Western Skiport Museum, 32, 40, 49,
138
Westminster Abbey, 4, 7, 10, 14, 17, 47,
49, **231**
West Texas Walk of Fame, **213**
Whitney, Mrs. Cornelius Vanderbilt, 28,
169. *See also* Dance Hall of Fame
William M. Black steamboat, 53, 191. *See
also* National Rivers Hall of Fame

Williams, Ted, 40, 49, 63, 98
Williams, Ted, Museum and Hitters Hall
 of Fame, 40, 49, 63, 98
Wimbledon Lawn Tennis Museum, 9, 25,
 61, **232**
Wingate Institute for Physical Education
 and Sports. *See* International Jewish
 Sports Hall of Fame
Winter Olympics, 150. *See also names of
 specific halls of fame*
Wisconsin Aviation Hall of Fame, 158.
 See also EAA Air Adventure Museum
 halls of fame
Women's halls of fame, 198–200. *See
 also names of specific halls of
 fame*
Women's International Bowling Congress
 Hall of Fame, 7, 102. *See also* Interna-
 tional Bowling Museum and Hall of
 Fame
World Figure Skating Museum and Hall
 of Fame, 15, **110–11**

World Golf Hall of Fame, 8, 65–66, **120**.
 See also names of specific halls of fame
World Golf Village, 120. *See also* World
 Golf Hall of Fame
World Karting Hall of Fame, 130. *See also*
 International Motorsports Hall of Fame
World Kite Museum and Hall of Fame,
 42, 46, **124**
World Sports Humanitarian Hall of Fame,
 66
Wrestling hall of fame, 151. *See also* Na-
 tional Wrestling Hall of Fame and Mu-
 seum
Wright-Patterson Air Force Base. *See* Na-
 tional Aviation Hall of Fame

Yerba Buena Gardens Center for the
 Arts, 67
YM/YWHA of Northern Jersey Sports
 Hall of Fame, 85
York Barbell Company, 29, 149. *See also*
 Weightlifting Hall of Fame

About the Author

VICTOR J. DANILOV is Director of the Museum Management Program at the University of Colorado at Boulder. Dr. Danilov was president and director of Chicago's Museum of Science and Industry for fifteen years. He is author of 18 books including *University and College Museums, Galleries, and Related Facilities* (1996), *Museum Careers and Training*: *A Professional Guide* (1994), *A Planning Guide for Corporate Museums, Galleries, and Visitor Centers* (1992), *Corporate Museums, Galleries, and Visitor Centers: A Directory* (1991), and *America's Science Museums* (1990), all from Greenwood Press.

ISBN 0-313-30000-3

90000>

EAN

9 780313 300004

HARDCOVER BAR CODE